HOLLYWOOD PUZZLE FILMS

From *Inception* to *The Lake House,* moviegoers are increasingly flocking to narratologically complex puzzle films. These puzzle movies borrow techniques—like fragmented spatio-temporal reality, time loops, unstable characters with split identities or unreliable narrators—more commonly attributed to art cinema and independent films. The essays in *Hollywood Puzzle Films* examine the appropriation of puzzle film techniques by contemporary Hollywood dramas and blockbusters through questions of narrative, time, and altered realities. Analyzing movies like *Source Code, The Butterfly Effect, Donnie Darko, Déjà Vu,* and adaptations of Philip K. Dick, contributors explore the implications of Hollywood's new movie mind games.

Warren Buckland is Reader in Film Studies at Oxford Brookes University. He is the author/editor of nine books, including *The Routledge Encyclopedia of Film Theory* (with Edward Branigan; Routledge, 2013), *Film Theory and Contemporary Hollywood Movies* (Routledge, 2009), and *Studying Contemporary American Film: A Guide to Movie Analysis* (with Thomas Elsaesser; Bloomsbury, 2002). He also edits the *New Review of Film and Television Studies.*

T0390755

Previously published in the AFI Film Readers series
Edited by Edward Branigan and Charles Wolfe

HOLLYWOOD PUZZLE FILMS

EDITED BY

WARREN BUCKLAND

Routledge
Taylor & Francis Group

NEW YORK AND LONDON

First published 2014
by Routledge
711 Third Avenue, New York, NY 10017

and by Routledge
2 Park Square, Milton Park, Abingdon, Oxon OX14 4RN

Routledge is an imprint of the Taylor & Francis Group, an informa business

Library of Congress Cataloging-in-Publication Data

Hollywood puzzle films / edited by Warren Buckland.
 pages cm — (AFI film readers)
 Includes bibliographical references and index.
 1. Motion pictures—Philosophy. 2. Narration
(Rhetoric) 3. Space and time in motion pictures. 4. Motion
pictures—United States—History—20th century. I. Buckland,
Warren.
 PN1995.H61475 2014
 791.43′684—dc23
 2013049216

ISBN: 978-0-415-62245-5 (hbk)
ISBN: 978-0-415-62246-2 (pbk)
ISBN: 978-0-203-10604-4 (ebk)

Typeset in Spectrum
by Apex CoVantage, LLC

Printed and bound in the United States of America by
Edwards Brothers Malloy on sustainably sourced paper

For F. W.

contents

figures and tables

figures

tables

introduction

ambiguity, ontological pluralism,

and cognitive dissonance in

the hollywood puzzle film

w a r r e n b u c k l a n d

Are mainstream Hollywood films becoming too smart for their own good, or at least too smart to make sense? There was a time when only obscure art-house films with subtitles left you wondering, "What the hell was that?" Not now. *Source Code* is the latest in a line of supersmart sci-fi works, such as *Inception* and *The Adjustment Bureau*, whose plotting is so complex, whose big ideas are so big, you'll find you're still in the dark when the cinema lights go on.

<div align="right">(Landesman 2011, 15)</div>

How can our new abilities to store vast amounts of data, to automatically classify, index, link, search, and instantly retrieve it, lead to new kinds of narratives?

<div align="right">(Manovich 2001, 237; emphasis in the original)</div>

Since the 1990s, Hollywood filmmakers have increasingly appropriated the narratological innovations of the puzzle film—innovations more commonly associated with international art cinema and American independent

filmmaking. Contemporary Hollywood's act of appropriation is of course not new. Spielberg and Lucas remade classical Hollywood B-movie serials as high budget mainstream blockbusters; quality horror films such as *Alien* (1979) and *Silence of the Lambs* (1991) have incorporated the conventions of low-budget exploitation horror movies; and Hollywood more generally remakes successful films from Asia and Europe.

Hollywood filmmakers have not passively embraced en masse puzzle film conventions: instead, a small number of filmmakers actively appropriate its conventions in an attempt to adapt to new technological, historical, and social circumstances (while other, more conventional filmmakers nostalgically look back to traditional, stable forms of storytelling). These claims need unpacking. First, 'a small number of filmmakers.' For Lev Manovich, film is positioned at the interface between narrative (premised on linearity and cause-effect logic) and database (a nonlinear structured collection of items). He argues that very few filmmakers consciously position themselves at this interface, with the exception of Dziga Vertov and Peter Greenaway (2001, 236–243). The potential exists for all filmmakers to exploit the tension between the narrative and database dimensions of cinema; most, however, follow the traditional linear, causal narrative logic. The potential also exists for all filmmakers to reject linear narrative in favor of a more flexible form of filmmaking that I'm calling puzzle films (Buckland 2009b). Yet, in Hollywood, only a small number of filmmakers take up the challenge—a challenge that injects novelty but also unpredictability and uncertainty into the stringent economic conditions of Hollywood filmmaking (puzzle films therefore belong to the 'excessive' side of Hollywood, along with genres such as melodrama). This volume focuses on the few filmmakers who do take up the challenge.

Second, what are the 'new technological, historical, and social circumstances' to which puzzle filmmakers are the 'answer'? A number of accounts have been offered, particularly involving technological circumstances:

> Thinking about why this kind of fragmented narrative has become so widespread on the contemporary scene, including films such as *Memento* and *Run Lola Run* and contemporary fiction ranging from *Gravity's Rainbow* to *House of Leaves*, we speculate that as the flow of information and the technologies of interconnectivity have increased exponentially across the globe with the advent of the microcomputer, distributed processing, the Internet and the World Wide Web, the art of storytelling has dramatically changed . . . The technologies of virtual reality feed back into the culture to change perceptions of how stories are conceived and created, even when the technology is not literally present.
>
> (Hayles and Gessler 2004, 497)

It is now possible to discern new developments [in filmic narrative] that reflect both the contradictory tensions of globalization, and the widespread obsession with theories of chaos, chance, and networks. Nowhere are these changes more acutely revealed than in 'fractal' films, filmic portrayals of urban space which is no longer shaped by the linear mappings of modernity, but is posited as both entirely random and yet at the same time structured by complexity, simultaneity, and violent encounters.

(Everett 2005, 159)

[The modular narrative] is not simply a response to the mediating role of digital technology in contemporary society, or to the rise of the database as a cultural model. It also serves as one of the most recent extensions of a modern and postmodern discourse that continues to rethink the human experience of time in relation to science, technology and social and industrial organization.

(Cameron 2008, 2)

These statements and hypotheses point to the exponential rise of 'new media'—computer technology, network culture, virtual reality, "technologies of interconnectivity"—to explain the rise of puzzle films. The implicit premise here is that new media digitally (that is, numerically) codes data, which are open to algorithmic manipulation, unlike analogue media (Manovich 2001, 27–31). The numeric coding and algorithmic manipulation make digital media malleable, variable, scalable, contingent, and serendipitous, rather than fixed and permanent, allowing for increased combination and fragmentation.

However, are these arguments permeated with technological determinism? Have the changes in technology *caused* a change in narrative? Responses to this last question range over a continuum. At one end, Everett talks about a mirror-like reflective relation between cause (globalization, network technologies) and effect (complex storytelling, fractal narratives). Moreover, she says the films "reveal" these causes; the causes are embedded in the films and simply need to be unearthed and observed. Cameron is more nuanced in his argument, for he identifies two contributing causes: complex storytelling, in the form of modular narratives, *responds to* technological developments (here, narrative is not automatically and passively manipulated by an external cause; instead, it reacts to an external cause). In addition, he argues that complex storytelling is part of a wider epistemological shift in rethinking identity, reality, and especially time. Hayles and Gessler's final sentence quoted above is instructive: "The technologies of virtual reality *feed back* into the culture to change perceptions

3

of how stories are conceived and created" (emphasis added). Feedback is a dynamic, unpredictable form of control, in which entities influence each other. But with technologies of virtual reality feeding back into the culture, the feedback model quickly becomes complicated. An adequate model of the feedback between culture and technology will involve numerous entities and links, and predicting the control and influence between those entities is almost impossible; the model becomes as complex as the phenomena it is attempting to analyze. Manovich overcomes this problem by using the computer term "transcoding" (the translation of information from one format to another) to posit a two-way influence between culture and digital technology—although he largely writes about the way computers "significantly influence the traditional cultural logic of media" (2001, 46). In the epigraph opening this introduction, Manovich discusses the influence of database logic on narrative, an issue that Jan Simons takes up in "complex narratives" (the opening chapter of this volume).

Finally, in contrast to models of causality at one end, plus feedback and transcoding, milder forms of causality in the middle, Garrett Stewart positions himself at the opposite end of the causality spectrum (at least in terms of technology). He examines a number of coincidences involving the demise of the photographic image and the realist narrative, and the rise of the postfilmic digital image. He asks why "the gradual erosion of cinema's photographic base should so often *coincide* with plots obsessed by the psychosomatic contours of human temporality and human memory.... Why this *coincidence* of the postfilmic image and the postrealist narrative, and where specifically?" (2007, 3; emphases added). What exactly is the function of the word *coincided* here? Literally, it means happening in the same place and at the same time. But the etymology of the word (Latin co + incidere, to befall) also suggests an accidental and chance association, cancelling out any suggestion of a direct causal relation between the two events. Stewart is not, therefore, committing himself to a causal-essentialist account of puzzle films but to a pragmatic account.

Stewart also poses his question in a slightly different manner, by stating that he is investigating the way the emergence of a new material base for the image (a digital rather than optical base) is alluded to in those images (and sometimes inscribed in their plots): "In the continuous illusion of screen optics, how can, or do, cinematic effects allude to their own means of visibility—to the technologies that either generate or imprint, then copy and project, their images?" (2007, 1). Stewart notes that allusion is a form of intertextual reference. He investigates how the image's digital base is referenced within its images (perhaps this is more a matter of *intra*textual reference, in which the signified alludes to the signifier). Neither coincidence nor allusion implies causality. Stewart is simply pointing out that these coincidences and allusions have already taken place in contemporary films, and this is the starting point of his research.

In terms of the rise of puzzle films in the new media age, we therefore have a choice of positing a direct causal link between digital technology and filmmaking; or positing a complex feedback loop or a simpler two-way influence (a transcoding operation); or analyzing what has already taken place in Hollywood filmmaking in the new media age. The chapters in this volume are located at different positions along this continuum. In my chapter on video game logic in *Source Code,* for example, I use Manovich's appropriation of the computer term *transcoding* to argue that video game logic has become a cultural form that has influenced narrative filmmaking.

<center>*</center>

In my previous volume on puzzle films (Buckland 2009b), I defined puzzle films in terms of their storytelling properties[1]—fragmented spatio-temporal reality, time loops, a blurring of the boundaries between different levels of reality, unstable characters with split identities or memory loss, multiple, labyrinthine plots, unreliable narrators, and overt coincidences. (Of course, not every trait in this list is to be found in every puzzle film.) I also argued that a puzzle plot is intricate in the sense that the arrangement of events is not just complex in Aristotle's use of the term (in which events are interwoven) but is entangled. While some of these techniques and themes have structured the plots of Hollywood films from previous decades, their frequency, exaggerated use, and intensity have proliferated since the 1990s, creating a trend within the Hollywood film (primarily blockbusters and dramas) that represents what Thomas Elsaesser calls "epistemological problems (how do we know what we know) and ontological doubts (about other worlds, other minds)" (2009, 15) and what Stewart identifies as "the new cultural dispensation of virtual space and time" (2007, 2). In other words, these puzzle films challenge deep-seated cultural conventions that regulate and try to stabilize consciousness and representation, plus the attendant concepts that support these conventions (agency, discrete identity, memory, temporal linearity, singularity, etc.).

One prevalent way in which consciousness and representation are destabilized is through the entanglement of the actual (realized) world and unrealized possible worlds, an interaction that codifies the actual world as contingent and malleable, rather than permanent and fixed. We find a parallel argument to the possible worlds theory in new media theory, where new media "is not something fixed once and for all, but something that can exist in different, potentially infinite versions" (Manovich 2001, 36). This possible worlds theme in puzzle films adds complexity by entangling actual and potential (different ontological levels), sometimes blurring the boundaries between levels, making it difficult to distinguish between them. Such entangling is usually motivated by the counterfactual desire to change the past or alter the direction of the future ('what if' or 'what might have been' scenarios). The manifestation of this counter-factual world on screen can be rationalized via psychology (the protagonist's desire to change the past,

which invariably relates to his or her dysfunctional childhood, based on loss and trauma) or via history (to a nation's historical trauma and guilt), or it can be rationalized as a fantasy to foil a terrorist attack that has already taken place, made possible via science fiction genre conventions (in which the possible world is actualized via new forms of technology or via time travel). We also find a series of sub-themes involving the artificial manipulation of identity, and a technological refiguring of the human/nonhuman and the self/other boundaries.

Hayles and Gessler's discussion of *slipstream fiction,* a term first coined by Bruce Sterling (1989), is relevant in this respect. The fuzzy term *slipstream* names fictions set in present, everyday reality, but these fictions contain inexplicable, anti-realistic (that is, anti-mimetic) elements. The key to slipstream fiction is that the fictional world is not unified but is formed from two or more incompatible realities, creating a sense of cognitive dissonance.[2] In puzzle films generally, dissonance is generated by different ontological levels, in which it becomes difficult to unambiguously assign a represented event to one particular reality. Slipstream fiction is not so much a genre as an effect generated by several genres. Hayles and Gessler discuss slipstream in contemporary cinema in terms of a sliding scale, where it combines with science fiction at one extreme (they cite *Dark City* and *Thirteenth Floor*) to dramas or thrillers and mysteries where there are no science fiction elements (*Mulholland Dr.*). The complexity of puzzle films emerges primarily from ontological pluralism—the entangling of incompatible (e.g., actual/possible) worlds, the ambiguous boundaries between those worlds, and the cognitive dissonance they generate.[3]

But why would filmmakers (especially in Hollywood) choose to exploit the malleable nature of digital media and structure their films in a more complex manner? We could argue that Hollywood appropriates the puzzle film phenomenon after it has been established in other filmmaking traditions and has proven itself to be popular and profitable. But this is insufficient in itself as an explanation. In addition, puzzle films carry out a filmmaking task that cannot be conveyed in simpler, more classical filmmaking. For example, in my contribution to my previous puzzle films book, I analyzed the complexity of *Lost Highway* (David Lynch, 1997), highlighting how a schizoid character's nonlinear (Möbius strip) trajectory, involving character duplication, character transformation (in the sense that one character transforms into another), faulty memories, and so on, cannot be manifest in the canonical narrative structure of classical Hollywood filmmaking (Buckland 2009a). Moreover, in terms of information theory, the complex structure of a film like *Lost Highway* carries more informational content because it is more disorderly and unpredictable (or innovative) than a classical film, which has less information content because it is more orderly and predictable. One consequence of this increase in informational content is that puzzle films encourage repeat viewing and a cult

following. They create an active fan base that interprets the films in all their minutiae, unpacking the films' ambiguities, improbabilities, and plot inconsistencies on blogs or dedicated web pages.

chapter contents

A number of contributors to this volume analyze the Hollywood puzzle film's ontological pluralism and cognitive dissonance (without necessarily using these terms), while others are skeptical that the ontological pluralism of the Hollywood puzzle film is radically ambiguous or that it creates cognitive dissonance. The latter argue that the puzzles and complexity manifest in Hollywood films are relatively (in comparison to independent American or international art house filmmaking) bound, ordered, and controlled: that is, they reduce dissonance by imposing a teleological structure onto a sequence of psychologically motivated narrative events[4] (for example, the possible world is clearly recoded as a deranged character's psychological fantasy). This point leads to three questions that structure this collection of essays, creating a tension throughout the volume:

1. Are Hollywood studios adopting a new form of storytelling—the complex puzzle film—and presenting its ontological pluralism and cognitive dissonance to a mass audience, or have they diluted the puzzle film to fit their preexisting stable formulas (classical storytelling, the blockbuster, the heist genre, the conspiracy thriller, science fiction, the romantic drama)?
2. What is the link between new media and new forms of complex storytelling, such as puzzle films (addressed above)?
3. Can we continue discussing puzzle films in narratological terms, or do we need to move beyond narratology to other theoretical frameworks such as new media theory, complex systems theory, network theory, or game theory, or even shift focus to significant or intense moments in the films rather than attempt to map their overall structure?

Hollywood Puzzle Films comprises fifteen chapters (all previously unpublished, except the first chapter) and is divided into four sections: Narratology and Systems Theory; *Inception,* the Archetypal Hollywood Puzzle Film; The Science Fiction Hollywood Puzzle Film; and The Drama Hollywood Puzzle Film.

Section one comprises two chapters that present overviews of theoretical approaches to puzzle films. In the opening chapter, "Complex Narratives," Jan Simons brings together narratology, game theory, and complexity theory to untangle the intricate nature of complex narratives in contemporary cinema. He presents an overview of the different

concepts—forking-path narratives, mind-game films, modular narratives, multiple-draft films, database narratives, puzzle films, subjective stories, and network narratives—used in current film theory to discuss complex narratives, arguing that "new media structures (such as databases and 'navigable spaces'), virtual realities, (including phenomena such as parallel worlds, forking paths, and imagined 'others'), and nonlinear temporality emerge as the most salient features of the complex film."

For Maria Poulaki, complex narrative films, although they do tell stories, nonetheless highlight the limitations of narrative as a structuring principle and therefore emphasize the limitations of narratology as a theoretical approach to complex narrative films. In her contribution to this volume, Poulaki argues,

> It is no longer enough to show how complex films are *not* conventional narratives; the need for a positive definition and description of their processes has become apparent. In films characterized as 'complex narratives', such as the puzzle films, it is more the 'complex' than the 'narrative' that can bring fresh insight into their structure, through the introduction of an alternative theoretical framework: not the one of narratology but that of complex systems theory.

Poulaki proposes a systems theoretical framework (based on the work of sociologist Niklas Luhmann)—specifically, the theory of self-reference—to examine the complexity of Hollywood puzzle films. This theory of self-reference is not the same as modernist techniques of alienation. Instead, from a systems theory perspective, the process of self-reference adds complexity to the puzzle films.

Section two is devoted to the archetypal Hollywood puzzle film, Christopher Nolan's science fiction thriller *Inception* (2010). *Inception* is known for its embedded form of ontological pluralism but equally for the minimal ambiguity between the different realities it presents on screen (thereby creating minimal dissonance). The film goes out of its way to distinguish the different dream levels, only creating ambiguity about whether the reality Cobb enters at the end is real or just another dream level.

The first two chapters of this section present narratological analyses of the film, while the following three adopt a comparative analysis approach, comparing *Inception* to *Shutter Island* (Scorsese, 2010), *Source Code* (Duncan Jones, 2011—a film that reappears several times in this volume), and, somewhat surprisingly (at least initially), Kiarostami's *Five Dedicated to Ozu* (2003). Geoff King presents a straightforward analysis of *Inception*, focusing on the spectator's (in)ability to follow its complex storytelling. He argues, however, that "*Inception* continues to obey a number of more typical or

classical Hollywood norms, even if each element might in itself offer more cognitive challenges than is usual for productions of such solidly mainstream status." The film is structured according to the typical Hollywood dual-focused narrative (genre plot/romance plot), in which the two plots are intertwined (rather than entangled), and it is also centered on star performances and spectacular attractions.

Elliot Panek considers the value of diagrams to analyze puzzle films and uses *Inception* as a case study. He develops a diagram to visually depict variance in the film's narration—specifically, variance in the range of knowledge conferred to characters and spectators. He argues,

> the amount of knowledge a film's narration allows an audience to possess can be measured relative to the amount of knowledge it allows characters to possess. At any given moment, the audience may be permitted to have more, less, or the same amount of knowledge of events or states of affairs as the protagonists or antagonists.

Panek draws out a number of insights from his diagram, especially concerning the relationship between the protagonist (Cobb) and his main antagonists, Mal and Fischer.

Paolo Russo also uses diagrams in order to compare *Inception* to *Shutter Island,* noting their thematic similarities (both films use dreams, memories, and hallucinations to construct complex narratives) but, more importantly, their structural and narrational differences. More specifically, he analyzes the films' screenplays to argue that "*Shutter Island* ultimately revolves around specific strategies of unreliable narration as a result of the particular use of focalization techniques; in *Inception,* the representation of dreams achieves levels of complexity that question all perceptual logic of time and space as the result of a singular, linear cognitive process."

Allan Cameron and Richard Misek identify both *Inception* and *Source Code* as modular narratives—a distinct, flexible form of contemporary storytelling in the digital age that "foreground[s] and segment[s] narrative time through processes of reordering, repetition and recursion" (see also Cameron 2008). More specifically, *Inception* is an anachronic modular narrative, one that entangles different times (primarily past and present), while *Source Code* is a forking-path modular narrative, one that repeats the same scene/module with slight variations, leading to different narrative trajectories with each repetition (and conferring upon the film the structure of a video game, something I explore in my chapter in the next section). Modularity therefore allows a high degree of uncertainty and instability to permeate a narrative. Yet, these radical structures are tempered within the Hollywood environment via exposition and spatial metaphors, which function to spatialize time, making it legible. But, these films also temporalize space,

creating modulations of spacetime: "Blending spatialized time and temporalized space, these films thus articulate and overlay a range of spatiotemporal models."

In the third comparative analysis in this section of the book, William Brown compares *Inception* to what looks at first sight to be a very simple art house film, Abbas Kiarostami's *Five Dedicated to Ozu* (2003)—which consists of five long static takes. Brown presents a careful exposition of chaos theory, complexity theory, and fractals, theories that form the background to his argument that Kiarostami's film is just as complex as *Inception*. He locates complexity, not in the film's form but in the audience's responses: "A visually complex film like *Inception* leads to a simple/poor variety of responses, while a visually simple film like *Five* leads to a complex variety of responses."

While all the films in this volume contain elements of science fiction (which, like slipstream, is difficult to define, as Sobchack makes clear in the opening chapter of *Screening Space* [1987]), the first two chapters of section three address head on the science fiction elements of contemporary puzzle films. In "Philip K. Dick, the Mind-Game Film, and Retroactive Causality," Thomas Elsaesser revisits what he calls the "mind-game film." He traces its origins back to Philip K. Dick, focusing not only on the many actual Dick adaptations but also on "Dick clones," films that borrow tropes from Dick's science fiction. Virtually ignored during his lifetime, Dick's remarkable influence on contemporary Hollywood, as Elsaesser points out, is "posthumous" and thus an example of retroactive causality, a key structural feature in his fiction. Dick's life, therefore, imitated his work, which Elsaesser treats as an extended meditation on retroactivity, where the present rewrites the past, from the perspective of the future. Dick's work is suggestive to filmmakers because his paradoxical thought experiments are articulated through a layered, entangled reality conceived as "both constructed/delusional [paranoid] and resistant/consequential [hysterical]." Elsaesser examines two film adaptations: *A Scanner Darkly* (2006), an example of the hysterical version of reality, and *Minority Report* (2002), an example of the paranoid version of reality, while contrasting Spielberg's more classical "negative feedback" construction with Dick's "positive feedback" loop.

Garrett Stewart examines the way *Déjà Vu* (Tony Scott, 2006) and *Source Code* employ the science fiction mode of the instrumental marvelous (in the form of extravagant digital technology) to articulate the current anxiety of terrorism and to overcome that anxiety through time travel, alternate universes, and surveillance, which work together to retroactively prevent the terrorism. The plot twists prevalent in these films introduce alternative endings in the form of a parallel world, where the errors in the actual world can be set right and where mortality can be transcended. Furthermore, these plot twists can be motivated not simply by tracing them back to the psychosis of the films' protagonists; they are caused by the use of (military) computer technology.

In my contribution, "*Source Code*'s Video Game Logic," I develop the argument that video game logic is a cultural form of new media that influences narrative filmmaking. I analyze *Source Code*'s hybrid mixture of conventional narrative logic and video game rules, a mixture that creates an unusual and complex structured film.

Bruce Isaacs examines Richard Kelly's cult film *Donnie Darko* (2001) and his problematic *Southland Tales* (2006) in order "to 'read' the way in which time is opened to complex, creative, paradoxical forms of subjective experience." Isaacs emphasizes the radical openness of these films and therefore avoids trying to fit them into a single linear, coherent framework where everything falls into place and makes sense. Both films therefore maintain ambiguous relations between their separate worlds, and both create cognitive dissonance. Yet, Isaacs notes a significant difference between the two films: whereas *Donnie Darko* is still overshadowed by Hollywood's classical paradigm, *Southland Tales* is radically indeterminate, with no framing device attempting to render coherent its dispersed textuality.

In section four, on drama puzzle films, we see how the puzzle film phenomenon has influenced the Hollywood drama. These films are set in everyday reality, involving childhood experiences, romance, domestic conflict, or infidelity. But this ordinary reality is combined with ontological pluralism (with various degrees of ambiguity), mental illness, and/or science fiction elements (especially time travel), although, unlike the films analyzed in section three, these films downplay science fiction and promote drama.

One of the differences between science fiction puzzle films and drama puzzle films is spelled out by Paul Cobley in his chapter devoted to unraveling *Vantage Point* (Pete Travis, 2008): "The film eschews 'otherworldly' events in favor of 'realism' and a commitment to that which is broadly probable in the known world. It uses complex narration to dramatize quotidian psychological experiences of memory and perception rather than in the service of complementing the fantastic . . . or the supernatural." Cobley unpacks reviewers' "unjust" negative ratings of the film and their attempts to come to terms with the complexity of its shifting vantage points before he goes on to consider its pronouncements on witnessing and the trauma of terrorism.

In his chapter on *The Butterfly Effect* (Eric Bress and J. Mackye Gruber, 2004), Edward Branigan follows Thomas Elsaesser's lead by identifying subdivisions within the puzzle film (camouflage, flip, and impossible) and by emphasizing that mind game and puzzle films prioritize spectators' pattern recognition. Branigan examines the dynamics of the spectator's activity and pattern recognition when watching *The Butterfly Effect*, as well as *The Sixth Sense* (M. Night Shyamalan, 1999). He focuses on how spectators conceive "hypothetical time tracks," which involves "keeping in mind a small number of alternatives and possible timelines." *The Butterfly Effect*,

for example, consists of "a series of typical Hollywood plots arranged as alternative timelines," while in *The Sixth Sense,* "a story of [child] abuse appears in the interstices of the plot as a concealed and suppressed, but existent, timeline." In an appendix, Branigan outlines five judgment heuristics and six cognitive biases prominent in practical reasoning and identifies how they function in *The Sixth Sense.* Branigan's approach is to treat puzzle films as a heightened instance of a spectator's interpretive activities generally in watching a film and later renarrating from memory its significance and value.

Lucy Bolton presents a lucid account of the three narrative worlds in *The Hours* (Stephen Daldry, 2002), highlighting the way they are intertwined throughout the film. More specifically, Bolton balances a discussion of each world with an analysis of how the worlds interact, the moments the film crosses from the life of Virginia Woolf in 1924 (plus one scene set in 1941), to Laura Brown in 1951, and Clarissa Vaughan in 2001 (the boundaries between the three worlds are therefore clearly marked). Bolton also sets up an interesting opposition between a puzzle narrative analysis and a phenomenological study of intense moments in a film.

In the final chapter, Gary Bettinson presents a narrational analysis of *Premonition* (Mennan Yapo, 2007) and *The Lake House* (Alejandro Agresti, 2006) (the latter a Hollywood remake of the Korean film *Il Mare*) and asks, "By what narrational strategies do these films hoodwink the viewer?" With their focus on achieving the Hollywood ending (especially narrative closure and, in the case of *The Lake House,* a happy ending and the formation of the heterosexual couple), he argues, "For all their narrational complexity . . . Hollywood puzzle films conjure temporary gaps, feints, surprise disclosures, and other tactics of deception by relying on the most basic of the viewer's cognitive propensities and proclivities." Bettinson employs cognitive theories of narration to spell out in precise terms the specific hypothesis formation processes and *syuzhet* (or plot) manipulations evident in these two films made for a mainstream audience. He also considers the role of intertextual allusion (references to other films, such as *Premonition*'s allusion to *Rosemary's Baby*) and the casting of famous Hollywood actors in these Hollywood puzzle films. This section of the book in particular addresses head on the first question mentioned above (Are Hollywood studios adopting a new form of storytelling, or have they diluted the puzzle film to fit their preexisting stable formulas?). The drama puzzle film emphasizes that the Hollywood formula for closure, the formation of the heterosexual couple, is dominant (although the 2001 narrative world in *The Hours* significantly ends on the reestablishment of a lesbian couple). This form of closure is also dominant in a number of Hollywood's science fiction puzzle films. But there, the obstacles to closure are overwhelming. Just consider *Source Code,* the improbable and insurmountable impediments to Colter Stevens's desire to form a couple with Christina, the identity

transformations and manipulations of space, time, and possible worlds he has to surmount in order to walk off hand in hand with his beloved.

notes

1. I am not attempting to develop a monothetic or essentialist definition of Hollywood puzzle films, which would involve identifying all their necessary and sufficient conditions. Instead, I develop a polythetic definition, a definition based on the "possession of a clustered subset of some set of properties, no one of which is necessary but which together are sufficiently many" (Chakravartty 2007, 158) to define an entity (e.g., a film) as a member of a class. Wittgenstein's notion of "family resemblance" is also a form of polythetic definition. We shall see below that the clustered subset of properties privileged in the Hollywood puzzle film include ontological pluralism (the entangling of incompatible worlds), the ambiguous boundaries between those worlds, and the cognitive dissonance they generate.
2. See James Patrick Kelly and John Kessel, "Slipstream, the Genre That Isn't." In *Feeling Very Strange: The Slipstream Anthology.* Edited by James Patrick Kelly and John Kessel, vii–xv. San Francisco: Tachyon Publications, 2006.
3. Cognitive dissonance can itself be theorized as a cultural cause of puzzle films—puzzle films are expressing the contemporary zeitgeist feeling of dissonance (which, in turn, is caused in part by the proliferation of new media technologies).
4. It is also possible to speculate that the reduction of cognitive dissonance can be located not only in the films themselves but also in some theorists' attempts to reduce dissonance by trying to fit puzzle films into a classical narrative schema in order to render them more intelligible.

references

Buckland, Warren. 2009a. "Making Sense of *Lost Highway.*" In *Puzzle Films: Complex Storytelling in Contemporary Cinema,* 42–61. Oxford: Wiley-Blackwell.

Buckland, Warren (ed.). 2009b. *Puzzle Films: Complex Storytelling in Contemporary Cinema.* Oxford: Wiley-Blackwell.

Cameron, Allan. 2008. *Modular Narratives in Contemporary Cinema.* Houndmills, Basingstoke: Palgrave Macmillan.

Chakravartty, Anjan. 2007. *A Metaphysics for Scientific Realism: Knowing the Unobservable.* Cambridge: Cambridge University Press.

Elsaesser, Thomas. 2009. "Mind-Game Films." In *Puzzle Films: Complex Storytelling in Contemporary Cinema,* edited by Warren Buckland, 13–41. Oxford: Wiley-Blackwell.

Everett, Wendy. 2005. "Fractal Films and the Architecture of Complexity." *Studies in European Cinema* 2(3): 159–171.

Hayles, N. Katherine, and Nicholas Gessler. 2004. "The Slipstream of Mixed Reality: Unstable Ontologies and Semiotic Markers in *The Thirteenth Floor, Dark City,* and *Mulholland Drive.*" *PMLA: Publications of the Modern Language Association of America* 119(3, May): 482–499.

Landesman, Cosmo. 2011. "Source Code. Bold Concepts and a Hot Hero on a Mission Make the Slightly Silly Sci-Fi of Source Code a Hit." *The Sunday Times,* 3 April: 15.

Manovich, Lev. 2001. *The Language of New Media.* Cambridge, MA: MIT Press.

Sobchack, Vivian. 1987. *Screening Space: The American Science Fiction Film.* Enlarged edition. New York: Ungar.

Sterling, Bruce. 1989. "Slipstream." *SF Eye* 5(July). http://w2.eff.org/Misc/Publications/Bruce_Sterling/Catscan_columns/catscan.05.

Stewart, Garrett. 2007. *Framed Time: Toward a Postfilmic Cinema.* Chicago: University of Chicago Press.

warren buckland

14

narratology and

systems theory

complex narratives

one

j a n s i m o n s

the complexity of complex films

A number of recent, and some not so recent, films have spawned a debate on a possibly new type of cinema with unfamiliar forms of narration and narrative, and new and largely uncharted ways of audience address and spectator engagement. Since there is no consensus as to whether these films really are the harbingers of a new type of cinema or whether they are merely a "phenomenon" or a "tendency," as Thomas Elsaesser (2009, 39) suggests, or just a passing fad, it is not surprising that they go under different names such as "forking path narratives" (Bordwell 2002), "mind-game films" (Elsaesser 2009), "modular narratives" (Cameron 2006), "multiple-draft-films" (Branigan 2002), and even the oxymoron "database narratives" (Kinder 2002). To these one might add "puzzle films," "subjective stories," and "network narratives" (Bordwell 2006). In spite of all this diversity and the different ways of approaching and assessing this body of films, most theorists would agree to subsume these films under the predicate of complex narratives. However, this complexity is itself a rather complex

phenomenon, since each author seems to have different films and different aspects of film narrative in mind.

David Bordwell (2002, 89) focuses on forking-path narratives that present alternative and often mutually exclusive courses of action up from a certain fixed point, the fork. According to Bordwell, forking-path narratives "have stretched and enriched some narrative norms without subverting or demolishing them" (91). On the contrary, Bordwell takes great pains to show that "part of the pleasure of these films stem from their reintroduction of viewer-friendly devices in the context of what might seem to be ontologically or epistemologically radical possibilities" (ibid.). Forking-path narratives rather limit the potential complexities of unfamiliar and puzzling ideas such as alternative possible worlds, parallel histories, bifurcating time lines, and other noncommonsensical and counterintuitive concepts borrowed from recent developments in the sciences such as thermodynamics, quantum physics, and chaos theory and propagated in modern culture by technologies such as virtual realities and computer games. By applying "the canons and conventions of the medium" as well as the "well-entrenched strategies for manipulating time, space, causality, point of view, and all the rest" (ibid.), films such as *Sliding Doors* (Peter Howitt, 1998), *Run Lola Run* (Tom Tykwer, 1998), or *Blind Chance* (Krzysztof Kieślowski, 1987) reduce the complexity potential of forking-path narratives to what is perceptually and cognitively manageable for their audiences. Forking-path narratives, then, may push the envelope, but on closer analysis they turn out not to be complex at all.

Maybe for this reason, Edward Branigan (2002, 108), in a response to Bordwell, proposes "to retain the name 'forking-path' narrative as a way of marking a conservative, generic form of narrative." For Branigan, forking-path narratives are just a special, limiting case of a more general phenomenon underlying all narratives, for which he proposes to reserve the label 'multiple-draft' narrative. This label does not refer to formal properties of the narrative itself, but rather to the host of alternative plots, guesses, inferences, and hypotheses and other 'nearly true' constructs storytellers and spectators construe and entertain before they elide and 'overwrite' these with what Branigan would not mind calling a 'final cut.'[1] In a way Branigan takes a position opposite to Bordwell's: whereas the latter claims that forking-path narratives are not that complex, Branigan argues that since every narrative is the result of 'overwriting' multiple 'nearly true' drafts, every narrative is complex. Forking-path narratives have the merit of making this otherwise 'repressed' or 'implicit' complexity explicit.

However, the positions of Bordwell and Branigan are complementary rather than contradictory, since both authors deal with different aspects of the same process. One could argue that Bordwell deals with the formal means the filmmaker has available to guide the mental cognitive processes of 'eliding' and 'overwriting' the film spectator performs when

trying to come to grips with a film (and, as Branigan suggests, to 'over-write' the multiple 'nearly true' drafts that were left behind at the film-maker's mental editing table). Because Bordwell and Branigan each locate a film's complexity—or noncomplexity—at a different level, they are dealing with different orders of complexity that are not mutually exclu-sive or in competition with each other but rather that presuppose each other. The formal strategies and conventions Bordwell charts orient the processes of 'overwriting' film spectators go through in order to make sure they arrive at some intersubjective consensual understanding of the film. But by either arguing that forking-path narratives are only stretch-ing or extending already longstanding venerable narrative forms or only make explicit the cognitive processes underlying all film narratives, both authors actually deny that forking-path or multiple-draft film narratives are foreboding something like a new type of cinema. Since for them there is nothing really new about these films, they also exempt themselves from asking where the recent fascination of forking-path or multiple-draft film narratives might come from. Why look for an explanation if there's noth-ing to explain?

Allan Cameron (2006, 65) concurs with Bordwell in the assessment that most of the recent films that "display, as a central stylistic and the-matic concern, a fraught relationship between contingency and narrative order" do not "constitute a new norm in narrative cinema" and "follow a structure that is largely traditional and tends toward the chronological." Cameron is not so much concerned with forking-path or multiple-draft narratives but rather with what he, borrowing from Marsha Kinder (2002), calls "modular narrative films" that "foreground the relationship between the temporality of the story and the order of its telling" (2006, 65). He dis-cusses *21 Grams* (Alejandro Gonzáles Iñárritu, 2003) and *Irréversible* (Gaspar Noé, 2002) as prominent examples (to which one could add films such as *Pulp Fiction* [Quentin Tarantino, 1994] and *Memento* [Christopher Nolan, 2000]). For Cameron the complexity of these films lies in the tension (or 'dialectic') between linear and irreversible time on one hand and nonlin-ear, reversible time on the other. He correlates this with a tension between order and contingency, determinism and chaos, which these films set out to solve.

Cameron (2006, 69) explicitly refers to complexity theorists Ilya Prigogine and Isabelle Stengers (1984) when he claims that the "interplay between linear and nonlinear time in films such as *Memento* and *21 Grams* therefore parallels chaos theory's articulation of determinism and chaos, reversibility and irreversibility." This reference to complexity theory, as chaos theory is nowadays preferably called, is not meant as an elucida-tion of the formal structures that underlie the treatment of time in these films or the cognitive processes that guide the spectator in understand-ing the deviant ways in which *21 Grams* and *Irréversible* construct their *syuzhet*

(Bordwell 1985), but rather serves rhetorically to back up an interpretation that tries to 'make meaning' out of these films' treatment of time by suggesting analogies with theorizations of time in other 'semantic fields' (see Bordwell 1989, 41). Cameron's discussion of time in these films is more indebted to philosophers and literary critics like Paul Ricœur and Frank Kermode than it is to complexity theory.[2]

For Cameron as well as for Kinder, the novelty of modular narratives or what Kinder (2002, 6) calls "database narratives," then, lies in their exposing of "the dual processes of selection and combination that lie at the heart of all stories and that are crucial to language: the selection of particular data (characters, images, sounds, events) from a series of databases or paradigms, which are then combined to generate specific tales." As becomes clear from the films Kinder lists as examples, this 'laying bare' of the underlying process of construing a story and the elements out of which it is composed is modernist rather than postmodernist or poststructuralist. After all, she mainly focuses her discussion on the films of Luis Buñuel, whose strategies Kinder (2002, 8) thinks are "helpful in attempting to rethink the radical potential of interactive database narratives."[3]

In spite of their nods to complexity theory and quantum physics,[4] the approaches of Kinder and Cameron are 'Newtonian' insofar as they break up a narrative into its smallest units, which can then be recombined into an infinite array of new virtual configurations. For Kinder (2002, 6), then, database narratives "reveal the arbitrariness of the particular choices made, and the possibility of making other combinations which would create alternative stories." For Cameron, 'modular narratives' foreground rather than solve the tension between determinism and contingency, which is, according to Ilya Prigogine (1996, 11), exactly the dualism that has haunted Western thought ever since Epicurus. By dissecting narratives into their constitutive 'database units' or 'modules' and thus spatializing and 'dechronolizing' narratives, Kinder and Cameron take away 'the arrow of time' and remain firmly within the paradigm of modernism and structuralism.

Ultimately, database narratives and modular narratives are the most developed outcomes of tendencies that were already present in modes of narration other than classical Hollywood, which, as Kinder (2002, 4) explicitly and Cameron (2006, 4) only halfheartedly admit, and as the names they use to label their examples already suggest, have gained more prominence over the last decade due to the advent of new 'digital' media. Did not new media theorist Lev Manovich, for whom 'database logic' and 'navigable space' are among the main characteristics of 'the language of new media,' trace the roots of new media aesthetics back to the Russian 'New Vision' movement of the 1920s and more specifically to the montage practices of Dziga Vertov, whom he calls "a major 'database filmmaker' of the twentieth century" (2001, 239)?

Once one conceives of narratives as just one type of possible 'interfaces' to collections of data, a particular cause-and-effect driven sequence of actions and events appears as just one arbitrarily chosen trajectory through a database (227). Since in a database all data are simultaneously present, databases "do not have a beginning or end; in fact they do not have any development, thematically, formally, or otherwise that would organize their elements into a sequence" (218). Time, that is, is absent from databases and emerges merely as an effect of the narrative sequencing of data. Kinder and Manovich thus confirm what one of structuralism's leading theorists, Roland Barthes (1977, 99), once famously wrote, "One could say that temporality is only a structural category of narrative (of discourse), just as in language [*langue*] temporality only exists in the form of a system; from the point of view of narrative, what we call time does not exist, or at least only exists functionally, as an element of a semiotic system." 'True' time, according to Barthes, is just a 'realist,' 'referential illusion.' One could hardly be further removed from the conception of time and irreversible processes as developed in the new sciences of dynamic systems, thermodynamics, and complexity and chaos. If there is anything 'new' about database and modular narratives, it gets thoroughly domesticated in a repackaged but familiar modernist and structuralist discourse.

Forking-path, multiple-draft, database, and 'modular' narratives are not the only features of recent films that have drawn the attention of film scholars. In a more encompassing and ambitious attempt to chart "a 'certain tendency' in contemporary cinema," Thomas Elsaesser (2009, 14) suggests we call the films that belong to this phenomenon 'mind-game films' since these films have in common that they aim at "disorienting or misleading spectators" (15). Although Elsaesser too aligns these mind-game films with a venerable genealogy that includes films by Fritz Lang, Luis Buñuel, Alfred Hitchcock, Orson Welles, Akira Kurosawa, Alain Resnais, and Ingmar Bergman, he treats them cautiously and provisionally as

> indicative of a "crisis" in the spectator-film relation, in the sense that the traditional "suspension of disbelief" or classical spectator positions of "voyeur", "witness", "observer" and their related cinematic regimes or techniques (point of view shot, shot/countershot, "suture", restricted/ omniscient narration, "fly on the wall" transparency, *mise-en-scène* of the long take/depth of field) are no longer deemed appropriate, compelling, or challenging enough.
>
> (16)

Arguing against the conservative approach of Bordwell and others who "tend to reduce the films to business as usual" (21), Elsaesser joins Kinder (2002) and Manovich (2001) by taking up the challenges new media

technologies of data storage and retrieval pose to narrative by providing other ways of "sequencing and 'linking' data than that of the story" (Elsaesser 2009, 22). In passing, Elsaesser refers to new forms of narrative introduced by computer games and new takes on narratological issues suggested by mathematical and economical game theory, but eventually he takes a psychological and psychoanalytic approach to mind-game films. He claims that these revolve around paranoia, schizophrenia, and amnesia, which are not only "pathologies of individual lives" but also open out "to contemporary issues of consciousness and subjectivity in general" (25). Since these pathologies share a blurring of real and unreal, sane and insane, true and false, victim and agent, Elsaesser locates the narratological innovations of mind-game films mainly in how they deal with issues of reliability. The mind-game film no longer observes the common contract between the film and its spectators "that films do not 'lie'" (19). Mind-game films present the spectators with unreliable narrators and mendacious shots, and parallel worlds that are not marked off from the film's basic level of reality by superimposition, soft focus, or other conventional means, but neither do they eventually reveal the truth or a true state of affairs to the spectator.

Elsaesser invokes many reasons for the current fascination in the 'productive pathologies' he diagnoses in mind-game films, but in the end he seems to throw his arms in the air when he concludes that the mind-game film complies with the rules of the game in contemporary Hollywood, where films need to be produced that cater the demands of as many different 'interpretive communities' as possible:

> Thus, what appears as ambiguity or 'Gestalt-switch' at the level of perception, reception, and interpretation is merely confirmation of strategy at the level of production and marketing: with the mind-game film, the 'institution cinema' is working on 'access for all', and in particular, on crafting a multi-platform, adaptable cinema film, capable of combining the advantages of the 'book' with the usefulness of the 'video-game': what I have called the DVD-enabled movie, whose theatrical release or presence on the international film festival circuit prepares for its culturally more durable and economically more profitable afterlife in another aggregate form.
>
> (39)

However, if contemporary cinema has indeed become "a party to which everyone can bring a bottle," as Elsaesser (2009, 37) quotes Robert Zemeckis, then this access for all cinema is not as much a sign of the coming of age of cinema as it is a symptom that cinema is entering a sort of a state of

entropy, in which all possible arrangements of a film will look similar, and of which all possible descriptions will be equivalent.[5] Ironically, Bordwell (2002, 2006) comes to an exactly opposite conclusion. According to him, in spite of all superficial changes and innovations, Hollywood is a highly structured, stable, and robust system, which is highly redundant and predictable, and always seeks a kind of a homeostatic equilibrium between continuity and change. Whether chaotic or stable (if not static), this would, of course, also mean the end of film studies as a meaningful endeavor, since Hollywood consists either of too much or too little 'information' (e.g., in terms of possible descriptions).

The notion of entropy, of course, has many definitions, one of these being that entropy is a measurement of ignorance due to the approximate, macroscopic, and incomplete character of our observations. This view is certainly not shared by the sciences of complexity, but it might be applicable in the discussion of complex films. Complexity, after all, is not an intrinsic property of the phenomena under study but as much a function of the complexity of the concepts and language available to the observer (see Tsoukas and Hatch 2001, 986). So before starting to write obituaries, it might be worth our while to first take a look at film studies' conceptual and theoretical instruments of observation.

irreversible storylines

Although the above mentioned theorists indeed all take their own bottle to the party, each of them approaching different aspects of complex films from different angles, it nevertheless seems that new media structures (such as databases and 'navigable spaces'), virtual realities, (including phenomena such as parallel worlds, forking paths, and imagined 'others'), and nonlinear temporality emerge as the most salient features of the complex film. These phenomena are not easy to come to terms with within the framework of good old-fashioned narratology or film studies' concepts used to study issues such as identification, subject formation, and positioning in the apparatus of cinema. The discussion of temporality in complex films is quite symptomatic in this respect. Elsaesser (2009, 21), for instance, writes that "in these films (as indeed, some earlier ones as well), the most intriguing and innovative feature is this insistence on temporality as a separate dimension from consciousness and identity" but drops this issue on the way (unless 'non-linearity' and 'inverted causality' are implied in the mental 'pathologies' around which mind-game films revolve).

For Bordwell (2002, 92), temporality in forking-path films is not really an issue since after every bifurcation, each path "adheres to a strict line of cause and effect." As far as he is concerned, "forking paths are linear" (ibid.). Moreover, not all branches of a forking path narrative are equal, since the last one presupposes the knowledge the spectator has acquired

through the previously told branches, and because venerable narrative conventions make the spectator 'weigh' the ending, which in forking-path narratives usually is the "fullest and most satisfying revision," and then is privileged as the "final draft" of "what really happened" (100). From the perspective of the Hollywood system, forking-path films display more continuity than change: they are ordinary film stories with a couple of mostly counterfactual branches added to them (see also Bordwell 2006). Causality and linear chronology as well as the conventions of sequential plotting remain the familiar pillars of these films' temporality.

The most explicit discussion of temporality is to be found in Allan Cameron's (2006) analysis of *21 Grams* and *Irréversible*. It is also the best example of how good old fashioned narratological thinking gets in the way of understanding the role and meaning of temporality in the new sciences of complexity. For Cameron (2006, 69), these modular narratives are an attempt to negotiate "between the contingent and the predetermined." This description by itself already implies that (nonmodular) narratives are characterized by some sort of predeterminedness or predestination, and Cameron confirms this when he writes about *Irréversible*, "This is a story where the ending is already given. The actions of the characters, subsequently shown, can do nothing to change the outcome" (71).

But this is not a special feature of modular narratives or forking-path narratives but of narrative in general. As Branigan (2002, 107) writes, "The beginning of the film, in effect, is already past with respect to the film's narration, which proceeds from the future." Cameron simply conflates the three levels of narrative as defined by Gérard Genette (1972) and repeated in many variations by literary theorists. The events of a story and their relations are situated at the level of what has been variously called 'story' 'histoire,' or 'fabula.' The way in which these events are presented to or withheld from the spectator or reader constitutes the level of "le récit" (Genette 1972), "l'intrigue" (Ricœur 1990, 237), the "plot," or the "syuzhet" (Bordwell 1985), where, in the parlance of Kinder and Cameron, the 'data' or 'units' of the story are arranged and assembled. This is the level where the reversal of the order of events of the storyline of films such as *Memento* and *Irréversible* takes place. And finally there is the level of discourse, where questions such as Who is telling and from which perspective? are dealt with.

The narration of a story, however, can always only take place at a point in time after the related events (see Martin 1986, 86). The prescience—or "premonition" as Branigan (2002, 107) calls it—is nothing but the narrator's knowledge about past events that he or she is about to share with the audience. Since story events have already happened when the narrator starts telling them, there is never anything characters of the story can do about them anymore, regardless of the order in which the narrator chooses to disclose them. A sense of doom and predestination can

certainly be enhanced by having the plot start with the outcome, but this is a particular choice pertaining to the arrangement of the story data at the level of the plot or syuzhet—a rhetorical device used to great effect in many a film noir from the 1940s and the 1950s. But this rhetorical decision on the part of the narrator implies nothing about the degree of determination or contingency of the told events, which is a matter to be decided at the level of the story or fabula. In Cameron's argument, knowledge of past events becomes the capacity to predict events, and a reversal of the order of events becomes the mark of predestination, but these are all unwarranted claims. A sequence of events does not become less 'determined' or more contingent by altering the order in which it is presented.

Similar misunderstandings have risen in the nascent study of computer games. In an effort to set games apart from narratives, game studies scholar Gonzalo Frasca (2003a, 224) argues that a major difference between games and narratives is that the latter address an "external observer" who apprehends "what has happened," whereas the former address "involved players" who care about "what is going to happen." Frasca gives the example of the spectator of a film about a plane landing; the spectator cannot manipulate and influence the landing, "since film sequences are fixed and unalterable" (ibid.). A flight simulator, on the other hand "allows the player to perform actions that will modify the behavior of the system in a way that is similar to the behavior of the actual plane" (ibid.). Frasca correlates the pastness of narrative with fixedness and unalterability, whereas games are future-oriented and open-ended.

Everyone who has ever seen a Hitchcock movie knows from experience that a film spectator can care as much about 'what is going to happen' as any involved gamer. But more importantly, because Cameron Frasca and other 'ludologists' try to keep narratologists away from computer games, he elevates what is merely a phenomenological matter into a categorical and theoretical distinction (see Simons 2007b). Cyberliterature theorist Marie-Laure Ryan, for instance, writes that "when we read a narrative, even one in which the end is presented before the beginning, we adopt the outlook of the characters who are living the plot as their own destiny. Life is lived prospectively and told retrospectively, but its narrative replay is once again lived prospectively" (Ryan 2001, 113).

From the perspective of the narrator, then, all might already be 'determined,' but, as literary theorist Patrick O'Neill writes, from the point of view of the characters—and the 'external observers' of a story—a story world

> reveals itself as a world that is entirely provisional, fundamentally unstable, and wholly inescapable. In considering the implications of this statement, we find much to support the contention that . . . narrative is always and in

> a very central way precisely a game structure, involving its readers in a hermeneutic contest in which, even in the case of the most ostensibly solid non-fictional accounts, they are essentially and unavoidably off balance from the very start.
>
> (O'Neill 1996, 34)

From the perspective of the characters of a story, as well that of the reader or spectator, all are but 'determined' or 'predestined.' One could even argue that games are in a way more 'predestined' and 'determined' than narratives, because the possible outcomes of a game are determined by the rules of the game and because the possible actions of the players are constrained by those rules and the 'affordances' a particular game environment offers. Since the player is as much 'played' by the game as he or she is playing it, a gamer's agency is an illusion skillfully designed into the game's architecture.[6]

Because the differences between games and narratives are less fundamental than ludologists once claimed—Frasca (2003b, 92) eventually admitted that "ludologists love stories, too"—games might help us to understand better the role of temporality in narratives. In mathematical and economical game theory, of which John von Neumann, Oskar Morgenstern, John Nash, and Robert Axelrod are the most famous representatives, game theorists model games by charting all possible combinations of strategies available to a player and his or her opponent(s) together with the payoffs of those strategies. In a so-called 'extensive game' in which players make more than one move, this representation takes the form of a tree diagram, which charts the possible trajectories the players can follow through the 'state space' of the game until they reach one of the terminal nodes, which is labeled with the payoff for each strategy (a strategy being defined as the action the player chooses for every 'history' or 'subgame,' after which it is his or her turn to move [see Osborne 2004, 159]). Since (most) games are mind games in which a player has to figure out what action his or her opponent will choose on the basis of what he or she believes that the other player believes that he or she believes, and so forth (134). Assuming that every player wants to achieve an optimal outcome, game theorists therefore apply a form of reasoning they call 'backward induction.' This method consists of finding the 'optimal actions' of the players in the last subgames (the 'terminal histories' that end at the terminal nodes) and then taking off from that choice and finding the optimal actions in the preceding subgame, and so forth all the way back to the starting point of the game (see Osborne 2004, 169–170).

This method is very similar to narratology's method of *raisonner à rebours,* or backward reasoning to identify those events in a story that are presupposed by later events and that cannot be elided without destroying the

intelligibility of a story. That is, in order to understand how the end of a story was achieved, the narratologist does what the narrators of *Irréversible* do and what the main character of *Memento* does: they reason backwards from the end to identify the events that necessarily had to occur to make the 'terminal event,' the ending, possible (that is, the events that Roland Barthes [1977, 99] called 'cardinal events' or 'kernels'). The most salient difference between a game theorist's backward induction and a narratologists' backward reasoning is, of course, that the game theorist takes into account all possible outcomes because a player's strategy includes all choices he or she will make after every 'history' or subgame when it is his or her turn to move, even if those histories are unlikely to occur or even impossible (see Osborne 2004, 160), whereas the narratologist only takes the final event that actually occurred in the story as the point of departure for the backward reasoning. But this difference does not rise from a principled or categorical difference between games and narratives; it derives from the different perspectives from which game theorists and narratologists look at stories or histories.

It may come as a surprise that temporality plays an important role in this difference because the models of both narratology and game theory are atemporal. As Roland Barthes (1977, 99) wrote, narratology 'dechronolizes' and 'relogicizes' the 'narrative continuum,' and Martin Osborne (2004, 14) firmly states, "Time is absent from the model." It is precisely the atemporal dimension that makes it possible to reason forwards and backwards about a narrative or a game: by taking away the temporal dimension, narratologists and game theorists 'logify' (or 'reify') stories and games into reversible structures, just as the laws of Newtonian physics are "invariant with respect to time reversion" (Prigogine 1996, 11). New media and database-narrative theorists make a similar move when they oppose the spatial organization of a database (in which all data are simultaneously present) to the sequential, temporal organization of data in narratives (see Manovich 2001, 225). However, the models of narratology and game theory may be atemporal and reversible, but the processes they describe are not. This is exactly the point where narratology, game theory, and complexity theory converge.

Complexity theory uses tree diagrams or 'forking-path' schemata to model the behavior of complex dynamic systems. At each node or 'bifurcation,' the system "'chooses' one of the possible branches available when far from equilibrium," this choice being probabilistic rather than deterministic (Prigogine 1996, 68). These schemata are themselves atemporal, and as is the case with the game theoretical model of extensive games, they chart all the possible choices available to the 'system.' However, as Prigogine (1996, 70) writes, these models involve a "historical dimension" because "if we observe that the system is in state d_2, that means that it has gone through the states b_1, and c_1." This is exactly the kind of history narratologists try

to reconstruct with backward reasoning: if a story ends in the final state z, it must have gone through the state y, and if it has been in state y, it must previously have gone through state x, and so on. Game theory's backward induction uses the same reasoning: if a player wants to obtain payoff x, he or she should choose action c after subgame 2, action b after subgame 1, and action a at the starting point of the game.

At each 'cardinal node' of a story, after each subgame of game, and at each bifurcation, characters, players, or complex dynamic systems have to make a choice between the branches that are available to them—and that's the crucial point: once a choice has been made, there is no way back; in stories, games, and complex systems the 'arrow of time' only flows in one direction. Time in stories, games, and complex systems is irreversible: the atemporal models of narratology, game theory, and the sciences of complexity are only intellectual tools used to chart the 'state spaces': that is, the set of all possible configurations stories, games, and complex dynamical systems can take. Forking-path narratives represent in an admittedly modest and very partial way a part of the state space that opens up for the characters at a certain bifurcation point (the 'fork'). By presenting the viewer with an assortment of alternative trajectories through the state space, these forking-path narratives are indeed a cinematic version of the very common cognitive practice of weighing the possible alternative outcomes of certain actions or events, 'if only.' This weighing of alternative courses of events, to which game players certainly will be no strangers, is part of what Branigan (2006, 32) calls "perceiving narratively," which "operates to draw the future into desires expressed in the present as well as demonstrates how the present was caused by the past and how the present may have effects in the future." These questions are central to forking-path as well as database and modular narratives.

However, a character, a player, or a complex system can follow only one trajectory through this state space at the time (that is why Bordwell [2002, 100] rightly points out that the final version of a forking path is usually felt as showing "what really happened," and the other branches are perceived as counterfactual). A game player, too, can follow only one trajectory through a game's state space, which is why, as Gonzalo Frasca (2003a, 224) notes, "to an external observer, the sequence of signs produced by both the film and the simulation [i.e., a flight simulator—JS] could look exactly the same." This similarity between narratives and games has been extensively explored by, for instance, Lars von Trier; in his films narrators do not tell what happened to the characters but instead tell the characters what to do: they manipulate these film's characters in the same way players of a computer game manipulate their avatars (see Simons 2007a).[7]

Because the choices characters, game players, or complex systems make at each bifurcation point do make a difference for their future fates and because they cannot be undone, the sequentiality of events in narratives

and games—the 'arrow of time'—is not, as structuralists, semioticians, and new media and database narrative theorists seem to believe, an accidental result of the incapacity of humans—and algorithms, for that matter—to access data otherwise than sequentially. The 'arrow of time' is a major organizing and 'configurational' force in narratives, games, and dynamic systems. As Peter Brooks (1984, 10) wrote already more than twenty years ago in his study of "design and intention in narrative," aptly called *Reading for the Plot,* "the meaning dealt with by narrative, and thus perhaps narrative's raison d'être, is of and in time." "Plot," Brooks (ibid.) writes, "let us say in preliminary definition, is the logic and dynamic of narrative, and narrative itself a form of understanding and explanation." This insight is nowadays increasingly shared by the natural sciences, but its implications have perhaps not yet been realized by all film scholars or new media theorists in the humanities.

causality, complexity, and narrative

Database narratives and modular narratives such as *21 Grams* and *Memento* perform operations of 'reading backwards' and 'backward induction' that seem very similar to the analytic operations of narratologists and game theorists. These films, however, pursue slightly different ends: narratologists and game theorists try to identify the 'logical' structure of a narrative or the strategy of a player by looking for the actions and choices that are presupposed by the ending of the story or the outcome of a game. Reasoning backwards and backward induction are considered suitable methods because in stories, as narratologist Gérard Genette (1969, 94) once remarked, causes are determined by their effects: story events are 'functionally overdetermined' because they only serve to make subsequent events possible. Narrative is, according to Genette, based on a logic of "déterminations *retrogrades,*" which accounts for the "confusion of consecution and consequence" (ibid.), captured in the formula post hoc, ergo propter hoc, which, as Barthes (1977, 94) pointed out, is "a good motto for Destiny, of which narrative, all things considered is no more than the 'language.'" Indeed, for historians as well, who look backwards in time to detect the 'causes' for later 'effects,' this retrospective determinism often makes historical events look as if they necessarily had to happen.

This determinism is indeed questioned by the reversed narratives of *Irréversible* and *Memento*—and modular narratives such as, for instance, the films of Inárritu, *Amores Perros* (2000), *21 Grams,* and *Babel* (2006)—because, by reversing causes and effects, these films unravel the chain of 'destiny' and demonstrate that at every node other choices and possibilities were open for the characters, whether they were steered in one direction rather than another by mere chance or because at every node there were opportunities for others to lead them astray. In this sense, database narratives

and modular narratives can be considered as a special case of forking-path narratives because they too give rise to 'what if' and 'if only' questions. In this respect they are a filmic equivalent of 'virtual history,' an approach to history that does not (only) retrospectively look for causes of later events but attempts to look prospectively forward from the point of view of the protagonists of history and consider "*those alternatives which we can show on the basis of contemporary evidence that contemporaries actually considered*" (Ferguson 1999, 86; emphasis in the original). The historical courses of events that actually happened are, from this perspective, followed by just one of the many branches available at each turning point in history.

The argument against determinism is epistemological rather than ontological: one does not have to be committed to the existence of parallel realities, possible worlds, and the existence of virtual histories to critically investigate the notion of causality. Causality is, after all, not an independently existing relationship between objects and events but, in the real world as well as in narratives, an inference made by an observer. The German system theorist Niklas Luhmann (1999, 198), whose system theoretical approach of 'social systems' was influenced by theories of autopoiesis, argued that causality must itself be explained by the way a system engages with its environment and cannot serve to explain the existence and functioning of the system itself.[8] For 'systems' that want to act 'causally' upon their environment, it is relevant and significant to perceive and understand features of that environment causally. Causality, then, according to Luhmann (ibid.) is one of the means through which a human 'system' (whether an individual, a social group, or a social institution) tries to come to terms with its environment by reducing the latter's complexity to features that are relevant to its own functioning within and engaging with that environment. Narratives provide one very powerful way to tentatively and provisionally construe causal relationships among actions and events, especially when there are no general laws that account for the changes or 'transformations' between states in the world, whether this is a story world, a game world, the historical world, or a dynamical system (see Danto 1985, 251). By 'emplotting' a heterogeneous collection of units such as events, characters, intentions, goals, means, interactions, and so on, a narrative 'configures' what would otherwise be a simple succession of events into a 'meaningful whole' (Ricœur 1990, 105). This 'configuration,' which not only relates but also suggests explanations for events—"historians have their own modes of arguing, but these belong to the narrative domain" (165)—does not represent relations inherent to the related events themselves, but is a result of the 'emplotment' by the narrator: these are, in the words of Brooks (1984, 321), "interpretive relations." This is why Ricœur, following Hayden White (1973), questioned the rigid distinction between history and literature. Causality, then—and the sorts of causality ascribed to it—is not an independent feature of the external environment but a

convenient and useful way of describing that world. Narratives, that is, do not wrap contingent events into the straitjacket of deterministic causality but rather take the contingency of the events and incidents they relate as their point of departure. This contingency is, to paraphrase Peter Brooks (1984, 10), narrative's raison d'être.

This is where narratology, game theory, and the sciences of complexity meet. Although Bordwell (2006, 100) explains the fascination with complex narratives partially from the emergence of networks, network theory, and chaos theory in the 1980s and 1990s of the previous century, there is also a remarkable reverse movement. In complexity theory, the certainty of general laws has made place for uncertainties and probabilities. As Prigogine (1996, 5) writes, "In both classical and quantum physics, the basic laws now express possibilities. We need not only *laws*, but also *events* that bring an element of radical novelty to the description of nature." Since events and the relationships between events and their temporally ordered, sequential transformations are the stuff narratives are made of, the sciences nowadays look to the humanities for models to describe processes in complex, dynamical systems. To describe how a system came to point C through bifurcation points A and B requires "a contextually sensitive narrative understanding—in short, it needs a story with a plot" (Tsoukas and Hatch 2001, 994). Are stories not always about systems pushed away from equilibrium by some disturbing event? As historian Niall Ferguson (1999, 72) puts it, after having observed that modern developments in the natural sciences display a concern with changes over time, "Indeed, for this reason it is not wholly frivolous to turn the old question on its head and ask not 'Is history a science?' but 'Is science history?'"

Ironically, whereas the natural sciences have rediscovered the importance of history, substituted laws by probabilities and possibilities, and recognized the role of events in the generation of novelty and change, narratologists have 'dechronolized' and 'logicized' narratives in order to find causal connections, general patterns, and universal schemata that would govern their production and understanding. In narratology, causality has often been misunderstood in terms of what Roland Barthes (1977, 99), quoting Mallarmé, called "the primitive thunderbolts of logic": narratologists and new media theorists alike tend to equate temporality with linearity and linearity with determinism (see, for instance, Landow 1994). It is as if, in an effort to equal the (by now classical) sciences, structuralist and semiotic approaches of narratives, nowadays joined by new media theorists who see the "logic of the database" as a new "symbolic form" (Manovich 2001, 254), have thrown the baby out with the bathwater.

It may be true that complex narratives reduce the potential complexity of their storyworlds to cognitively and perceptively manageable proportions—the main function of 'narrative logic' is, after all, the reduction of complexity—but they also remind not only viewers but also film

scholars and new media theorists that there is a whole range of possibilities and probabilities, of chance and contingency, within the spectrum of deterministic causality and chaotic randomness. They remind us that we need to make our languages more complex to grasp the ways contemporary films cope with increasingly complex social and cultural environments (as pointed out by Elsaesser [2009]) by foregrounding the contingent, the possible, and the probable.

The good news is that, as with Poe's purloined letter, the solution to this challenge has been there for all to see all the time: contingency, probability, and change over time have always been the raw material of stories.[9]

notes

1. Referring to Daniel Dennett's (1991) argument for a multiple drafts model of consciousness, Branigan (2002, 106) points out that activities of both writing and filmmaking have become "fertile metaphors for the study of mind."
2. One of the reasons why Cameron does not elaborate on the analogy between complexity theory and the "interplay between linear and nonlinear time" (2006, 69) in *Memento* and *21 Grams* must be that both fields cannot be straightforwardly mapped onto one another. As Cameron himself points out, in complexity theory determinism is associated with reversible (Newtonian) time, whereas in the narratological accounts he refers to, determinism is strongly associated with irreversible linear time.
3. Among the filmmakers who have experimented with nonlinear narrative, Kinder (2002, 3) mentions Chris Marker, Alain Resnais, Agnès Varda, Peter Greenaway, and Raúl Ruiz.
4. Kinder (2002, 6–7) does not explicitly refer to these new paradigms in the sciences but alludes to these when she writes about European art films "created under the influence of narratology" and "more mainstream independents influenced by cyberfiction": "By always suggesting virtuality and the wave of potentialities linked to the uncertainty principle, such narratives inevitably raise meta-narrative issues." The terms *virtuality*, *waves*, and *uncertainty principle* clearly refer to quantum physics.
5. This is an admittedly loose and possibly even incorrect analogy with Ludwig Boltzmann's (1844–1906) formula for entropy, $S = K \log W$, which relates entropy to the number of microstates of a system (see Prigogine 1996, 19–23). Unfortunately there exist no linguistic markers for metaphor and irony.
6. "By watching many players interact with the system, the observer has begun to discern the devices that control the plot in the face of player interaction. This observer will conclude that the player has no true agency, that the player is not able to form any intentions within the dramatic world that actually matter. But the first-time player within the world is experiencing agency. The designer of the dramatic world could conclude—because they are designing the world for the player, not for the observer—that as long as the player experiences a true sense of interactive freedom (that is agency) transformation as variety is not an important design consideration" (Mateas 2004, 24).

jan simons

7. Examples are the voiceover narrator in *Europa* (Lars von Trier, 1991) who hypnotizes and directs Frank Kessel through postwar Germany, or Bess who, in *Breaking the Waves* (Lars von Trier, 1996), asks for and follows God's advice, or wanna-be writer Tom from *Dogville* (Lars von Trier, 2003), who directs Grace, who (maybe) is a figment of his own imagination (see Simons 2007a).
8. See also Hayles (1999, 131 ff).
9. This essay was first published in 2008 in the *New Review of Film and Television Studies*, 6(2): 111–126.

references

Barthes, Roland. 1977. *Image-Music-Text*. Selected and translated by Stephen Heath. London: Fontana/Collins.

Bordwell, David. 1985. *Narration in the Fiction Film*. London: Methuen.

Bordwell, David. 1989. *Making Meaning: Inference and Rhetoric in the Interpretation of Cinema*. Cambridge, MA: Harvard University Press.

Bordwell, David. 2002. "Film Futures." *SubStance* #97 31(1): 88–104.

Bordwell, David. 2006. *The Way Hollywood Tells It: Story and Style in Modern Movies*. Berkeley: University of California Press.

Branigan, Edward. 2002. "Nearly True: Forking Plots, Forking Interpretations. A Response to David Bordwell's 'Film Futures.'" *SubStance* #97 31(1): 105–114.

Branigan, Edward. 2006. *Projecting a Camera: Language Games in Film Theory*. London: Routledge.

Brooks, Peter. 1984. *Reading for the Plot: Design and Intention in Narrative*. New York: Alfred A. Knopf.

Cameron, Allan. 2006. "Contingency, Order, and the Modular Narrative: *21 Grams* and *Irréversible*." *The Velvet Light Trap* 58(fall): 65–78.

Danto, Arthur. 1985. *Narration and Knowledge (Including the Integral Text of Analytical Philosophy of History)*. New York: Columbia University Press.

Dennett, Daniel C. 1991. *Consciousness Explained*. Boston: Little, Brown.

Elsaesser, Thomas. 2009. "The Mind-Game Film." In *Puzzle Films: Complex Storytelling in Contemporary Cinema*, ed. Warren Buckland, 13–41. Oxford: Wiley-Blackwell.

Ferguson, Niall (ed.). 1999. *Virtual History: Alternatives and Counterfactuals*. New York: Basic Books.

Frasca, Gonzalo. 2003a. "Simulation versus Narrative: Introduction to Ludology." In *The Video Game Theory Reader*, ed. Mark J. P. Wolf and Bernard Perron, 221–235. London: Routledge.

Frasca, Gonzalo. 2003b. "Ludologists Love Stories, Too: Notes from a Debate That Never Took Place.'" In *Level Up: Proceedings of the Digital Games Research Conference 2003*, ed. Marinka Copier and Joost Raessens, 92–98. Utrecht: Utrecht University Press.

Genette, Gérard. 1969. *Figures II*. Paris: Éditions du Seuil.

Genette, Gérard. 1972. *Figures III*. Paris: Éditions du Seuil.

Hayles, N. Katherine. 1999. *How We Became Posthuman: Virtual Bodies in Cybernetics, Literature, and Informatics*. Chicago: University of Chicago Press.

Kinder, Marsha. 2002. "Hot Spots, Avatars, and Narrative Fields Forever: Bunuel's Legacy for New Digital Media and Interactive Database Narrative." *Film Quarterly* 55(4): 2–15.

Landow, George P. (ed.). 1994. *Hyper/Text/Theory*. Baltimore: Johns Hopkins University Press.

Luhmann, Niklas. 1999. *Zweckbegriff und systemrationalität: Über die function von zwecken in sozialen systemen.* Frankfurt am Main: Suhrkamp.

Manovich, Lev. 2001. *The Language of New Media.* Cambridge, MA: MIT Press.

Martin, Wallace. 1986. *Recent Theories of Narrative.* Ithaca, NY: Cornell University Press.

Mateas, Michael. 2004. "A Preliminary Poetics for Interactive Drama and Games." In *First Person: New Media as Story, Performance, and Game,* ed. Noah Wardrip-Fruin and Pat Harrigan, 19–33. Cambridge, MA: MIT Press.

O'Neill, Patrick. 1996. *Fictions of Discourse: Reading Narrative Theory.* Toronto: University of Toronto Press.

Osborne, Martin J. 2004. *An Introduction to Game Theory.* Oxford: Oxford University Press.

Prigogine, Ilya. 1996. *The End of Certainty: Time, Chaos, and the New Laws of Nature.* New York: Free Press.

Prigogine, Ilya and Isabelle Stengers. 1984. *Order Out of Chaos: Man's New Dialogue with Nature.* Toronto: Bantam.

Ricœur, Paul. 1990. *Time and Narrative,* vol. 1, trans. Kathleen McLaughlin and David Pellauer. Chicago: University of Chicago Press.

Ryan, Marie-Laure. 2001. *Narrative as Virtual Reality: Immersion and Interactivity in Literature and Electronic Media.* Baltimore: Johns Hopkins University Press.

Simons, Jan. 2007a. *Playing the Waves: Lars von Trier's Game Cinema.* Amsterdam: Amsterdam University Press.

Simons, Jan. 2007b. "Narrative, Games, and Theory." *Game Studies* 7(1). http://gamestudies.org.

Tsoukas, Haridimos and Mary Jo Hatch. 2001. "Complex Thinking, Complex Practice: The Case for a Narrative Approach to Organizational Complexity." *Human Relations* 54(8): 979–1013.

White, Hayden. 1973. *Metahistory: The Historical Imagination in Nineteenth-Century Europe.* Baltimore: Johns Hopkins University Press.

two

puzzled hollywood

and the return

of complex films

m a r i a p o u l a k i

While alternative forms of narration have made their appearance in *mainstream* cinema since the 'postclassical' Hollywood films of the 1970s (Elsaesser 2009a), in the mid-1990s a bolder tendency of experimentation with the narrative form emerged from the outskirts of popular production. The films of this cinematic tendency have often been discussed as *complex narratives*, borrowing this already-existing term from literary criticism and narratology.[1] Since the commercial success of Quentin Tarantino's *Pulp Fiction* (1994), complex films expanded widely, to the point that we can now, almost two decades after their spread, talk about a recognizable complex storytelling model that appears, in different forms, both in large Hollywood studio productions and in the so-called world cinema. Since the beginning, complex narrative structure connected films as diverse as *Run Lola Run* (Tykwer, 1998), *The Matrix* (Andy and Lana Wachowski, 1999), *The Sixth Sense* (Shyamalan, 1999), *Memento* (Nolan, 2000), and *Eternal Sunshine of the Spotless Mind* (Gondry, 2004).[2] Although the narrative means that such films used were not so novel,[3] their quantitative proliferation and popularization, which crosscut geographical and genre boundaries,[4] had a

significant impact on mainstream film narration as well, as recent Holly-wood productions indicate, from *The Jacket* (John Maybury, 2005) to *Source Code* (Duncan Jones, 2011) and *Inception* (Christopher Nolan, 2010).

If we tried to cluster the common characteristics of complex films, we could say that they have a nonsequential temporal and spatial structure; they also tend to contain multiple levels of reality and different but parallel and interconnected stories, with chance, coincidence, or fate often becoming central forces for the plot development. As Warren Buckland puts it, such films "embrace nonlinearity, time loops, and fragmented spatiotemporal reality" (2009, 6). This unconventional structuring is assumed to have a significant impact upon the viewer and his or her interpretative strategies. David Bordwell, who placed complex films in what he called "a third era" of Hollywood narrative experimentation (starting in the mid-1990s and lasting until today),[5] refers to many of them as "puzzle films" because they prompt the viewers "to discuss 'what really happened', to think back over what's has been shown, or to rewatch the film in the search for clues to the key revelations" (2006, 80).

The word *puzzle* may refer to the complexity of these narratives on a hermeneutic level because of the complicated events that take place in their plots and because they cannot be easily or at once deciphered; it can also refer to their textual structure and composition. In the same way that puzzles are composed by heterogeneous pieces, some of which resemble each other so much that we need to try out one after the other until we manage to proceed with the completion of the picture, puzzle films also try out different but similar narrative pieces. Their equally puzzled characters also need to access their personal truth piece by piece through repetitive and similar delusions (*The Jacket*), dreams (*Inception, Take Shelter* [Jeff Nichols, 2011]), memories (*Memento*), or even postmortem experiments (*Source Code*). Thus, the stories of puzzle films self-reflexively draw the attention to their own piecemeal textual structure, which, like their characters, follows nonlinear, reiterative steps from one spatiotemporal unit to the other.

Traditionally, narrative has been defined either as the object of narration, as the story in its particular articulation, or, especially since the 1980s with the influence of cognitive science (Bruner 1986), as a mode of representation and reasoning as old as humanity itself. Both narratives and the narrative mode of reasoning create links between events prioritizing the whole over the parts. Individual events make sense only as long as they are placed into a meaningful whole, supporting its constitution by being the causes of other events (Polkinghorne 1988). Events only make sense when the whole is completed and their placement in the chain of causality and temporal continuity is made definite. Even more so, this whole is presupposed in the beginning of every narrative, so that following it as readers, viewers, or recipients in general, we already know that the events

will make sense eventually, as they form parts of a larger system, which we struggle to construct or decipher. The above assumptions are interwoven with the (classical) notion of narrative, both when the latter is conceived through the structuralist perspective and when it is conceived through the more recent cognitive perspective.

Contemporary puzzle films are complex from a narratological perspective. Their 'stories' remain deliberately and emphatically open, rather than closed in a beginning-middle-end schema (Branigan 2002; Poulaki 2011; Simons 2008). They abound with instances of self-reflexivity, constantly calling into question the borders between the fictional and the factual, and they follow a descriptive and object-oriented rather than causality-driven presentation of their storyworlds (Bordwell 2007; Kinder 2002; Poulaki 2012). The causal-logical links in them are broken and, even more so, never entirely fixed. A question or ontological uncertainty (Elsaesser 2009b) still lingers in the end, like the spinning top of *Inception*. This creates a tension between complex films and a classical type of narrative, which is tied to a beginning-middle-end schema and causal-logical sequence—a type that in cinema is represented by the Hollywood tradition (certainly with notable exceptions).

In popular cinema, the classical narrative schemata started being challenged at the dawn of the postclassical Hollywood era (Elsaesser 2009a) and are being more decisively transgressed through the subsequent prevalence of complex films, which gradually moved from the margin to the mainstream. These films, although telling stories, and thus constituting narratives in this respect, nonetheless point at the limitations or, to use Gérard Genette's (1969) expression, "borders" of narrative and perhaps of narratology itself as a theoretical approach to them.

Narratology has always been addressing numerous cases of complexity, with modernist literature being one of the most prominent. However, its tendency to define narrative as a causal-logical succession of events and complex narration as what challenges this schema does not seem to provide further insight into the complex and nonlinear structure of complex films, particularly at this point in time when the latter seem to have established a new paradigm of cinematic storytelling. The expansion of puzzle films, from cinephile and indie films to big studio productions, makes it necessary to address their nonlinearity as such, as well as their particular modes of textual and cognitive organization.[6] It is no longer enough to show how complex films are *not* conventional narratives; the need for a positive definition and description of their processes has become apparent. In films characterized as 'complex narratives,' such as the puzzle films, it is more the 'complex' than the 'narrative' that can bring fresh insight into their structure, through the introduction of an alternative theoretical framework: not the one of narratology but that of complex systems theory. I will attempt to show how such insight may be gained, focusing

on one 'antinarrative' element proliferating in puzzle films: namely, their self-reference or reflexivity—as it is usually called.

self-reference in (complex) films

Accounts in art and film criticism show that there has been a growing tendency after the 1960s to consider self-reflexivity as "a crack in the mirror," according to Jay Ruby's expression. "To be reflexive is to reveal that films—all films, whether they are labeled fiction, documentary, or art— are created, structured articulations of the film-maker and not authentic, truthful, objective records" (Ruby 1988, 44). Self-reflexivity was a key characteristic of films made under influences such as the French "textuality turn" or Bertolt Brecht's "politicized esthetic" (Stam 1985, 7) between the late 1950s and the 1970s. Self-reflexivity is still largely considered, as Edward Branigan notes, one "anti-narrative device" among those of "irony, paradox, contradiction, novelty, or alienation" (1992, 84). The reflexive device in particular is "prescribed [as he notes,] to provide a critical and intellectual distance ('opacity') that frees the viewer from delusion" (ibid.).

Even though it has perhaps exhausted the 'radical' potential it once carried, self-reflexivity is one of the main characteristics of contemporary complex films, aided by techniques such as back projections and collages (Thanouli 2008, 11), and an overall heightened self-consciousness, in the sense that, as Thanouli maintains, "the narrating act comes forward" throughout the whole film, acknowledging the audience, providing them with clues to comprehend the story, and showing knowledgeability and spatiotemporal omnipresence (2006, 192).

In the 2006 special issue of *The Velvet Light Trap* on narrative and storytelling, Jason Mittell commented on the "operational reflexivity" that complex films show and described it as a "narrative special effect" (35). This type of reflexivity is, according to Mittell, very different from that of modernist reflexivity, whose result was the distancing of the viewers from the "spectacle." As he notes:

> This is not the reflexive self-awareness of Tex Avery cartoons acknowledging their own construction or the technique of some modernist art films asking us to view their constructedness from an emotional distance; operational reflexivity invites us to care about the storyworld while simultaneously appreciating its construction.
>
> (2006, 35)

In Mittell's view, complex narratives are not so much undermining the factitiousness of fiction as demonstrating the power of film narration into building appealing storyworlds.

In the same vein, Erlend Lavik notes that the way certain recent films attract the attention not only to their diegesis but also to the way their narratives are constructed develops hand-in-hand with their complex structure: "Those films that are cited in pretty much every account—*21 Grams, Adaptation, Fight Club, Memento,* and *Pulp Fiction,* for example—are both unmistakably complex and reflexive; moreover, their complexity and their reflexivity are intertwined" (2008, 37). It has also been suggested that in complex films such as the exemplary *Pulp Fiction,* reflexivity becomes a game in which the viewer finds pleasure and goes hand in hand with the films' complex structure so that "one's understanding of the story develops along with one's understanding of the structure of the film" (Feagin 1999, 173). It is a double metafictional and metanarrational effect that complex films achieve,[7] on the one hand by underlining and exposing the factitiousness of events taking place in the narrative, and on the other hand by doing the same with the narrational and cinematographic manipulations.

Using structuralist vocabulary, I argue that, even though self-reflexivity has mainly been approached through a film's enunciation (the context of the narrative act, including the speaker and the listener, and their relation), in contemporary complex films it is also a feature of the utterance, which, in this case, is the *syuzhet* (or plot). Self-reflexivity plays an important, constructive role in the textual organization of complex films. Its function has to do with serving what Jeffrey Williams calls (in the context of literature) an internal "self-circulating tropological economy," which exists "for its own sake and its own reproduction" (1999, 145). Here reflexivity appears as an operation that internally shapes the text's form, when itself seems to be constituted—as in *Inception* but also in older puzzle films such as *Run Lola Run* and *Eternal Sunshine*—through loops, resonances, and folds that create connections among different segments of the film, among the units through which the film's organization is continuously recomposed.

In Christopher Nolan's *Inception,* for instance, there is explicit reference to "closed loops" and paradoxes such as that of the Penrose stairs. The architecture of the film in this sense is very much reminiscent of the architecture of the dreams it contains. *Inception*'s reflexivity creates worlds inside, attracting us deeper into its fictional world and multiplying the levels of our dream instead of waking us up. Every self-reflexive 'kick' leads to another dream level rather than to a real situation outside the diegesis—what reflexivity à la Godard would achieve.

In complex films, self-reflexivity's effects of "distancing and estranging" are duplicated inside the storyworlds, where our avatars (the protagonists) also sense the presence of an agency (the dream's "architect") that manipulates their experience—in the same way that the narration manipulates our own as viewers. Thus, reflexivity creates self-similar, fractal architectures through which the storyworld constitutes itself by reproducing the

self-reflexive character of the viewer's own experience of the film. Thus, every self-reflexive turn of the plot at once refers to the inside and the outside of the screen and connects them in a loop of mutual constitution, which, in the last analysis, is diegetic, even though 'antinarrative.' Self-reflexivity involves the viewer more actively into the construction of the diegesis, as long as the latter includes both the storyworld and the spectator's world, as well as the links that connect the screen space with the viewer's space (Elsaesser 2006). Self-reflexivity, making the viewer aware of the two ends of this communication, triggers the complex constitution of an expanded diegetic world rather than its decomposition, and it becomes an organizing principle, as soon as it engages the spectator in the construction of this world, by maintaining an ongoing feedback between viewer and screen. Textual reflexivity generates the loops that allow this feedback to be established, and it does so not by self-conscious distancing, as in the Brechtian version of reflexivity, but by "a 'lowering' of self-consciousness and a different form of recursiveness" (Elsaesser 2009b, 24).

a systemic take on self-reference

The way that complex films organize is reminiscent of certain processes at work in complex systems, and especially that of self-reference, as described by sociologist Niklas Luhmann (2000). Luhmann explained the self-referential processes of systems as generating and growing in their complexity. It is the same function that I see self-reference performing in complex films.

A first point of contact between self-reference in systems theory and the self-referential processes involved in complex films can be made through Luhmann's discussion of self-referential modes in art (2000, 142). He suggests that through self-reference, artworks, among which he classifies novels, create a "doubling of reality . . . copied into the imaginary reality of the world of art" (2000, 143). Thus artworks reintroduce into their own form the basic distinction upon which art operates, namely a distinction of perception between the ordinary and the imaginary or even reality and illusion. Such doublings created within the artworks can be those between "reality and dream . . ., reality and play, reality and illusion, even reality and art" (ibid., 143). But, as all distinctions, they only point at the unity of the difference they introduce; namely, in the case of art, the absence of a dichotomy between reality and imagination. It is the system of art itself (here considered in its function in society and not through qualitative criteria) that represents this unity: in the realm of art, reality and illusion can coexist, since artworks are real objects that construct imaginary worlds. Through the various twists that many of them contain, complex (and puzzle) films seem to be inviting the viewer to observe their narrative worlds and to make distinctions between reality and illusion, producing

through these distinctions a unity that is the system of narrative, as Luhmann would have it.

As already broached, the metafictional aspect of complex films has to do mainly with the way they undermine the truthfulness of their own narratives. At the same time, the play between reality and illusion their plots establish is combined with a self-conscious narration that directly invites the viewer to participate in the construction of the diegesis, despite the unreal impression their storyworlds may create. To use again the example of *Inception,* it continuously trains viewers, like Cobb trains Ariadne, to learn how to use the thread that will take them out of the labyrinth—by recognizing the signs of each dream level and their points of connection (the 'kicks,' the paradoxes, the totems). More self-reflexive practices may also guide plot structuring in puzzle films, such as the openly suppressive narration (*Source Code*) or the time juggling (*The Jacket,* etc.) that Bordwell identifies (2007, 210–211). Such continuous and direct references to the film's own organizational conditions could be considered antinarrative, as they expose the film as construction of an external agency and therefore having, as every artifact, a factitious and at times even illusory status. However, instead of alienating the viewers, or making them reflect upon the film (by means of a subject-object relationship and positivist epistemology), self-reflexive techniques engage them, as already broached, in an increasingly complex communication.

If we think of film viewing in Luhmann's complex systemic terms, then, according to the triad of social, biological, and 'psychic' systems that he identified, the psychic system of the viewer and his or her cognitive organization exists in the 'environment' of the film system (which, as artworks and narratives, can be classified as a social system). The 'structural coupling' of these two systems (the viewer and the film; the one being in the environment of the other) is their communication. Thus, even the moments when the viewer of a puzzle film is caught by surprise, or the moments when the narration deceives him or her, presuppose structural coupling and, therefore, can be seen as instances that increase the communication between film system and viewer system, making the organization of both more complex and co-determined.

Thus, contrary to what has been characterized as a 'low level of communicativeness' in puzzle films (based on Meir Sternberg's taxonomy—see Bordwell 1985; Panek 2006), their unwillingness to 'tell everything' that they know and their 'openly suppressive narration' that flauntingly omits information from the spectator, as well as from the heroes (e.g., *Sixth Sense, Spider, The Jacket, Shutter Island, Adjustment Bureau*), might suggest a different form of communication, which engages the viewer more deeply and in fundamentally different ways; not ways of cognitive reflection but of systemic self-reference. The "id" of the narration, which "flaunts its uncommunicativeness" (Panek 2006, 85), might then be exactly the film's call for

a different, systemic communication, based on the structural coupling between two operationally closed systems: the one of the film and the other of the viewer.

the three levels of self-reference in puzzle films

Perhaps the predominant way through which self-reference is expressed in puzzle films, apart from the doublings of reality and illusion in them, is their nonsequential temporal structure, or time juggling. Time juggling is a narrational marker, providing, as Genette would have it, "data of voice" (1986, 70). Far from a random ordering of events in time, the nonsequentiality of complex films consists, not only in revisiting and 'replaying' past events through the perspective of another character (as it happens in *Pulp Fiction*) but more often in visiting parallel realities, making past, present, and future merge. In *The Jacket* (2005) and *Source Code* (2011), flash-forwards are inserted into the present to—again—offer a different perspective, with not always known subject or source (as in the rapid flashes of future scenes in front of Chicago's *Bean* sculpture in *Source Code*). These temporal 'implants' introduce curiosity and doubt into the now lived experience— of both the character and the viewer. As time juggling effectuates a rapid change of perspective, introducing a mediation of experience by another (another moment in time and also another agency), it seems to me more relevant to self-reference than to time itself. Such self-referential moments in puzzle films tackle time as a preexisting force and reintroduce it as a side effect of the film system's gradual organization. In Luhmann's theory, time juggling corresponds to 'reflexivity,' the self-referential and organizational process that performs exactly the function of temporalizing a system. Reflexivity is combined with two other levels of self-reference: 'basal self-reference' and 'reflection.'

A system develops through its structural coupling with its environment and with other systems. It reduces the complexity of its environment by selecting elements (information) out of it and integrating them into its own structure. We may think of a film's development in time as such a succession of elements, new pieces of information added to the film's structure in the course of its duration. However, it is not a regular causal-logical chain of events that is implied here. In the complex systemic model, following information theory, what each time counts as information is what is least expected, an element that is selected by the system because it is important and relevant to its organization, even though it does not fit the already existing organization: that is why when it is introduced it constitutes an 'event' for the system. Every event creates a difference that needs to be assimilated into the system and requires the system to change and rearrange the internal relations between its elements. The process of selecting elements from the external environment is the first level

of systemic self-reference or what Luhmann called 'basal self-reference.' Every selection that a system makes needs to be important for the system, even though it's not easy to integrate. This means that new elements are selected only when they somehow resonate with existing elements and may build relations with them.

Events are treated by the system as singular moments in time. Each new event creates new relations among the system's elements, new 'befores' and 'afters.' Hence, time in complex systems emerges as a construction created by the difference each new event generates between a before and an after, through links to prior and expected events. The system every time accommodates the difference by assimilating it into its structure and acting "as if this difference was expected" (Luhmann 1995, 287). The self-referential process of reflexivity corresponds to this temporal rearrangement that events force into systems, which thus create their organization through spatiotemporal loops: by observing itself at different points of its evolvement—at the evental moments—the system creates for itself a temporal sequence: a past, a present, and a future that help organize and spatialize the flow of time. Through this continuous and self-referential process, linear time is created in a modular and nonlinear way and becomes the precarious and instantaneous product of a complex ongoing process of self-organization. The notion of 'reentry,' fundamental in Luhmann's systems theory, here becomes particularly relevant.[8] Luhmann borrowed this notion from the mathematician George Spencer-Brown (who in his work *Laws of Form* developed a calculus of first distinctions) and adopted it to his social systems theory. The paradox or contradiction that reentry suggests in logics was solved by Spencer-Brown through the insertion of time: two contradictory states of a form are not incompatible as long as they refer to different moments of the same form in time (Schlitz 2007, 17). The paradox that events—as agents of contradiction—introduce is thus solved through temporalization: creation of tentative temporal sequences in which events can be integrated.

In puzzle films, the event is each new piece of the puzzle (like the mysterious flashes that the protagonist of the recent blockbuster *Source Code* experiences every time he is reprogrammed) that does not fit the current temporal structure of the system and thus requires the viewer to reconsider the structure and change it, in a systemic reflexive mode: to create a new past, present, and future in which this piece will find its place, as happens in the case of *Source Code* when we see again these images toward the end of film. This recomposition of existing elements is also apparent in modular narratives as described by Allan Cameron (2008), when a revelation often proves the existing temporal sequence that viewers have established to be wrong (*Amores Perros, Babel*) and demands the construction of a new one. Thus, through the restructuring effectuated by time juggling, segments of puzzle films, from individual shots to entire scenes, become

temporalized. Through reflexivity, the present becomes a temporal chunk, a single unit in the structure of the film, an 'event,' and this is necessary in order for it to be linked to other prior or later events and to create new relations between them. In *Source Code,* restructuring does not happen only in the end but also in every reiterative step of the narrative: each new eight-minute trial given to the protagonist adds one more unit to the structure of the film and requires from the viewer a cognitive recomposition. As if mirroring what happens in the viewer's mind, the hero's mind is each time faced with a slightly altered environment (the car of the train he finds himself in), needing to make selections (basal self-reference) that reduce the external complexity but enhance the internal one, as the more his psychic system copes with new situations and learns from them, it becomes more refined. Through this repetitive trial process, the viewer also needs to accommodate to the new events by changing the existing structure, 'letting go' of the links to certain past events (for instance, the return of the bomber's wallet by another character) and maintaining others (the discovery of the bomb's position). The contradiction between the alternative versions is usually solved by the introduction of time: the previous sequence belongs to the past of the protagonist, while the new one is in the present. However, while this is easily solved in more conventional narratives, in puzzle films the viewer cannot ignore the gaps that the temporal reconstruction leaves open: the protagonist cannot have died in the past and live in the present; it is a doubling of reality that is needed in order to solve the contradiction.

Luhmann notes that every event is a self-referential element because it reflexively refers to other events (1995, 509n). If we think of this reference as spatiotemporal rather than just temporal, then with reflexivity, more than a restructuring of the (linear) temporal causal-logical sequence, what is effectuated is a *pattern* between the elements that have preceded and the new element. Reflexivity is the connection of the system's elements when they refer to one another. For the film, it is a self-referential process, a folding back onto itself, and a creation of a new structure through connecting disparate elements.[9] In *Inception,* the complexity of the film is gradually built through subsequent dream levels, all of which, however, relate to one another through recurrent elements, such as Edith Piaf's song, or the collapse of the dream's settings, which happens in a number of variations. As soon as the viewer establishes patterns among these elements after a number of repetitions, the navigation becomes easier. Reflexivity is vital for the overall self-reference of the film system: it underlines the belonging of the different dream levels to a common architecture, a structure that no matter how complicated, multifaceted, and recomposable is still solid and persistent.

Apart from the internal loops caused by the reflexive reference of one element to the other, it is also common that puzzle films end with one

more bigger loop, with the opening scene being repeated (*Pulp Fiction, The Final Cut, Inception*) slightly altered or through a different perspective toward the end of the film. This loop corresponds to the self-referential process of *reflection* in Luhmann's terms; that is, the self-reference of the system as a whole entity vis-à-vis its environment. Reflection in puzzle films does not bring closure; it rather opens the film system up, introducing one additional level of uncertainty: the system faces its own form within its environment and realizes its limits—like the climbers of a Penrose staircase when the third dimension is introduced.

In Luhmann's systems theory, the system is only operationally and not structurally closed; its self-reference produces an organization that becomes more complex by trying to render its environment meaningful, and to select from it the necessary resources (in information or energy) that will allow it to survive and evolve. By making its internal organization all the more refined and complex, a system gets prepared to accommodate even more complex environments and creates more ways to interact with them (Luhmann 1995, 37). As Luhmann notes in *Social Systems,*

> Self-reference produces recursive, circular closure, but closure does not serve as an end in itself, not even as the sole mechanism of preservation or as a principle of security. Instead, it is the condition of possibility for openness. All openness is based on closure, and this is possible because self-referential operations do not absorb the full meaning, do not totalize but merely accompany; because they do not conclude, do not lead to an end, do not fulfil a telos, but rather open out.
>
> (1995, 447)

In complex systems this loop-like process is never ending, while narratives are traditionally defined in narratology with regard to a beginning-middle-end schema, which always evokes a sense of closure. In the systems theoretical framework for film analysis I suggest here, this schema becomes itself a moment in time, and being observed it helps the constitution of a larger organization that goes on in and with time.

The three 'distinctions' to which the different levels of self-reference correspond according to Luhmann—namely, element-relation (basal self-reference), before and after (reflexivity), and system-environment (reflection)—are all operational. Like the fundamental distinction on which art operates, that of reality-illusion, all these separate distinctions only confirm the unity that makes them possible: the unity of reality and illusion (in art), of before and after (in reflexivity), of element and relation (in basal self-reference), and of system-environment (in reflection). Every distinction is made from a blind spot that at the particular point prevents

the system from seeing the unity, which another system, or the same system at another point in time, can observe (Luhmann 2000, 32).

Likewise, in puzzle films there is no difference between element and relation: the sudden unintelligible events become elements of the film's system and the relations that define it (the system does not exist without them); the past and the future that reflexivity separates are mixed and connected, through the parallel realities that the plots eventually suggest, and the film system is coupled with its environment of the viewer system, as the two develop and co-determine each other in continuous feedback.

pieces and aggregates: the complexity of puzzle films

Luhmann's systems theory was developed in the 1970s, but the processes of complexity it describes and its particular emphasis on self-reference makes it a framework through which systemic analysis of complex films can be established. Through this perspective, the 'complex' of complex films may refer to the study of wholes that are created out of pieces—like the ones of 'puzzle' films—and, most importantly, determined by those pieces. Luhmann tended to emphasize the powers of structure over those of individual elements. However, in the perpetual reorganization of systems through difference, through the unexpected and contingent, that he described,[10] we already find the seeds of a still emerging model of systems as configured in a nonlinear way through the constellations and connections between their elements. In the last decades, complex systems theory has further pursued this direction, and spread across different sciences, to the point that it is now considered the expression of a paradigm shift in the way we approach ourselves and the world we inhabit (Coveney 2003, 1057).

In the development of systems theories throughout the twentieth and the beginning of the twenty-first century, the *complex* seems to have become an indispensible part of the word *system*. This is indicative of a gradual turn, already manifest during the development of cybernetics, as Katherine Hayles shows, from the "top-down" control and maintenance of a systemic organization to a "bottom-up" constitution of the system, subject to dynamic transformation and unpredictable perturbations (1999, 225). Ian Bogost emphasizes the fact that in the 'new' complex systems theory—in opposition with other more classical strands of systems theory—bottom-up instead of top-down approaches gain ground, and the emphasis is placed on units and their decisive role in structuring systems (2006). Units are agents of complexity as long as they interact and form aggregates that are more than the sum of their parts, and by further becoming themselves subsystems of larger organizations, in an ever-expanding chain of growing complexity.

As with complex systems theory, which flourished partly because of the advances in computing (the 'butterfly effect' of chaos theory was after

all discovered via computer modeling of weather systems), the proliferation of complex films, too, has informational and technological causes. The possibility to take into account (and compute) the most minimal components of a system (such as the flapping of a butterfly's wings, in the metaphor of the butterfly effect) revealed how their impact might be tremendous for the shape that a system might take over time. As it happened in chaotic systems research, in the media field, too, information technologies now create the possibility to distinguish the individual components of the image (e.g., the pixel). There are certain scholars who have argued that contemporary complex films somehow incorporate digitization, introducing a 'database aesthetics' in their narrative form (Cameron 2008, 42; see also Cubitt 2004; Kinder 2002; Manovich 2001) and thus treating their narratives as composed by pieces (story chunks resembling data units) that can be successively and individually accessed. Cameron has stressed that complex films thus display modularity, which is a form of aggregation of units and also a characteristic feature of new media (Manovich 2001). These films highlight and remix their individual components, somehow reproducing at the plot level their ontological transformation. Modularity is an attribute of all complex systems—which are dynamic and tentative organizations subject to the different interrelations between the components (Varela 1990, 20). The theoretical approach of complex systems and its application to the analysis of complex films release the 'degrees of freedom' in the interactions of the components that they contain and, furthermore, in their self-organizing potential in creating meaningful wholes.

The insertion of the theoretical tools of complex systems theory serves the need to address the dynamic filmic and cognitive formations that emerge through the connection of heterogeneous and spatially distributed elements, such as the ones composing complex films. These new tools can therefore significantly contribute, conceptually as well as methodologically, to the analysis of these films because of the multiplicity and heterogeneity that not only their narrative but also their filmic form displays. A complex systems theory for complex films would translate between the two mutually unintelligible levels of the strictly computational properties of the digital, which lends its form to contemporary films, and the human consciousness, which still needs to incorporate it into a meaningful system. This process of translation would not, however, subordinate the one to the other. In contemporary media theory, the dilemma between narrative and database and their different media forms and types of data organization has been a point of controversy (see Manovich 2001). This dilemma is incarnated in the paradoxical form of complex films, as Marsha Kinder (among others) has indicated in her theorization of database narratives (2002). In my view, the solution is not to use complex films (or 'database narratives') as agents of reconciliation between narrative and database but to study in what ways these films 'fail' to fully accommodate either of these cultural

forms. This 'failure' results from the fact that complex films are neither databases nor narratives; they are complex systems. On the one hand, databases are not easily compatible with the idea of a system because their elements do not form a coherent whole. On the other hand, narrative has always been compatible with the idea of a meaningful and 'whole' system. What the contemporary and highly self-reflexive movies of the complex film tendency make possible is to trace how they build their complexity through processes of resonance between individual components or units, and how the forms they create are never whole or complete, neither in the beginning nor at the end.

As I already broached through the reference to puzzle films, in contemporary complex films that now also proliferate in Hollywood, the diegesis is internally 'multiplied' into several pieces—through scenes and shots that are repeated with variation like in forking-path films (see Bordwell 2002), introducing an alternative path of the story or adding new perspectives upon the same event (from *Run Lola Run* to *Source Code*). It is their textual multiplicity, their piecemeal structure, and their way of connecting the pieces through loops in time and space that allow and even necessitate the theoretical and methodological approach of these films as complex systems.

Puzzle films are complex because they are constituted by units that are presented individually, as they are at first disconnected from the other film units and out of causal-logical order. Even though narratively explained, these units are still abruptly inserted into the story as lapses, flashbacks/flash-forwards, or sudden transportations to parallel dimensions of reality. The insertion of the theoretical tools of complex systems theory serves exactly the need to analyze how the function of these abrupt insertions is to make patterns emerge out of these films' collage-like forms. Complex films model the mechanisms of complex systems, which base their systemic function upon the disparity of their individual elements. The distributed arrangement and nonlinear composition of heterogeneous units in puzzle films arguably affect and transform the way their diegetic world is organized. In a complex systemic methodological approach to films, the narrative organizing principles of time, causality, and space are not taken as starting points and preexisting axes that configure the films' diegetic organization. Rather, these principles cede their place to a patterning process that emerges from the complex interrelations and aggregations of textual units.

Especially in the strand of complex systems theory represented by nonequilibrium thermodynamics,[11] systems acquire their forms through the coresonance of their disparate units (Prigogine and Stengers 1997). The juxtaposition and parallelism of disparate units in puzzle films make them coresonate in the minds of viewers and create emergent forms when connected together. Past and present elements of a film are juxtaposed every time a new scene appears as incongruent with the already existing

organization. *Pattern* is an informal term used to refer to all kinds of forms emerging from disparate units, but taking into account the use of the term in certain strands of complex systems theory, it may as well be used to refer to the spectator's processing of complex films. Particularly in neurological models of distributed cognition, such as those of Varela, Thompson, and Rosch (*The Embodied Mind*) (1993) or Scott Kelso (*Dynamic Patterns*) (1995), the brain's pattern formation activity is described as an ongoing dynamical process. It works through synchronization and coresonance and gives rise to forms that are never stable or finite. The textual forms of complex films are depictions of this cognitive process: they invite us to make parallelisms and to form patterns through repeating and highlighting disparate units that never totally assimilate. The patterns that we form as spectators of complex films are similarly volatile and incomplete—open and dynamic systems rather than finite wholes.

complex cinema

In complex systems theory, 'drift' is the process through which a system moves from pattern to pattern, from one organization to the next. Francisco Varela described this drift as a "self-movement" that characterizes all "complex, nonlinear, and chaotic systems" (1999, 291). In them, "there is never a stopping or dwelling . . . state, but only permanent change punctuated by transient aggregates" (ibid.). The complex film tendency of the late 1990s, of which contemporary Hollywood puzzle films can be considered as successors, may be itself seen as a pattern, a temporary organization that combines systematicity and disparity, narrative and database, and a sign of cinema's own workings as a complex system, which follows a pattern-making drift in order to deal with the complexity of its environment.

Although emergent patterns appear as 'indiscernible' and 'noisy' to external observers, as cognitive philosopher Daniel Dennett puts it, "In the root case a pattern is 'by definition' a candidate for pattern *recognition*" (1991, 32). The complex narrative tendency was itself an emergent pattern in the 1990s, but later this pattern was not only recognized but also reproduced by big studios, which imitated the modes of narration that the first alternative complex films introduced. The reproduction of these modes of organization by Hollywood is not just the latest fad. It is rather the manifestation of popular cinema's own self-organizing process toward a new environment that challenges its established modes of narration. Populated by competing interactive media that enhance our self-reflexivity and portable screens that never entirely cut off the connection with the surrounding space, the current media environment of Hollywood challenges the studios' established storytelling patterns and necessitates openness, change, and adaptation.

The way that the textual/filmic space of individual films is constructed affects—and is affected by—the broader space in which cinematic production develops. Cinema thus displays a fractal-like (self-similar in different scales) architecture, which is characteristic of complex systems. And, as it happens with fractals, "understanding how a system works at one scale might lead to understanding how it works [at] other scales" (Manson 2001—paraphrasing Mandelbrot, the 'father' of fractal geometry). Thus, in order to understand the current transformation of Hollywood filmmaking, its complexity needs to be approached at two scales, both the micro-scale of film analysis and the macro-scale of analysis of the cinematic institution and its production and marketing practices. Complex systems theory may provide tools for cinematic analysis that can be applied to both scales, that of individual narrative films and that of the cinematic institution, and, most importantly, it may show how the modes of organization of one scale reflect and generate those of the other.

notes

1. Complex narratives have a long history in literature. Narrative 'complexity' has been discussed by literary critics in relation to texts coming from entirely different backgrounds: the tradition of 'metanarration,' extending from Cervantes (*Don Quixote,* 1605, 1615) and Lawrence Sterne (*Tristram Shandy,* 1759) to Italo Calvino; the literary modernism of, among others, James Joyce, Marcel Proust, and Virginia Woolf; or the late modernist movement of *nouveau roman,* are among the most oft-cited sources of complex narratives.
2. Other often mentioned examples include *12 Monkeys* (Terry Gilliam, 1995), *Lost Highway* (David Lynch, 1997), *Sliding Doors* (Peter Howitt, 1998), *Fight Club* (David Fincher, 1999), *Code Unknown* (Michael Haneke, 2000), *Donnie Darko* (Richard Kelly, 2001), *The Others* (Alejandro Amenábar, 2001), *Mulholland Drive* (David Lynch, 2001), *Irreversible* (*Irréversible,* Gaspar Noé 2002), *21 Grams* (Alejandro González Iñárritu, 2003), *Babel* (Alejandro González Iñárritu, 2006), and so on.
3. Complex narration is not new in cinema either. Unconventional and 'complex' ways to present stories have proliferated in the various modernist avant-gardes, the new waves of the 1960s and 1970s, the art film tradition, and even 'classical' Hollywood films in certain historical eras of 'narrative experimentation' (e.g., Orson Welles's *Citizen Kane,* RKO production, 1941). Besides Welles, other contemporary directors have been considered as pioneers of complex narratives in cinema: Alfred Hitchcock (*The Trouble with Harry,* 1955), Alain Resnais (*Last Year at Marienbad* [*L'année dernière à Marienbad*], 1961), Luis Buñuel (*The Obscure Object of Desire* [*Cet obscur objet du désir*], 1977), and Krzysztof Kieślowski (*Blind Chance* [*Przypadek*], 1987) are some oft-cited names. The work of these directors has been recently discussed through the lens of the contemporary complex film tendency: for Welles and Hitchcock, see Bordwell 2006, 74; for Resnais, see Cameron 2008, 34; for Buñuel, see Kinder 2002; for Kieślowski, see Cameron 2008, Bordwell 2006, and Perlmutter 2002.

4. Eleftheria Thanouli (2006, 2008) has discussed cases of postclassical narration not only in Hollywood but also in world cinema (*Amélie, The City of God, Chungking Express,* etc.).
5. Bordwell refers to three such eras: 1940 through 1955, mid-1960s through the early 1970s, and mid-1990s until today (Bordwell 2006, 72–73).
6. Several avant-garde literary movements, with the most striking example being perhaps that of *nouveau roman,* have relied on antinovelistic and narratively unconventional ways of structuring stories, as prominent literary critics have discussed (see Kermode 2000, 22). The difference of the contemporary 'complex narrative' tendency from such avant-garde experiments is the popularization and cultural pervasiveness that the traditionally unconventional means of narration now gain.
7. While metafiction concerns instances of self-reflexivity particularly in narrative fictions and has an antimimetic character, metanarration just 'thematizes' the act of narration and, when used in nonfictional narratives, can also serve the credibility of the narrated events (Neumann and Nünning 2010; see also Fludernik 2003).
8. Apart from Luhmann, Francisco Varela and mathematician Louis Kauffman have also developed the notion of reentry, extending it into a "calculus of self-reference" (see Kauffman and Varela 1980).
9. The process of reflexivity in puzzle films is reminiscent of Joseph Frank's 'reflexive reference,' the way that textual elements relate to other elements in a text, giving it a spatialized form (see Frank 1945).
10. Luhmann stressed the factor of contingency in systems. As he writes, "Action cannot be temporalized, cannot be anchored to a specific temporal point, without a certain component of surprise, without deviation from what is factually fixed. Therefore without an aspect of surprise there would be no structural formation because nothing would happen for other things to link onto" (Luhmann 1995, 288).
11. Kenneth Bailey (1994, 121) as well as Melanie Mitchell (2009, 297–298) refer to the nonequilibrium thermodynamics of Prigogine as one of the main currents in systems theory (Bailey) and predecessor of contemporary complexity theory (Mitchell).

references

Bailey, Kenneth. 1994. *Sociology and the New Systems Theory: Toward a Theoretical Synthesis.* Albany: State University of New York Press.

Bogost, Ian. 2006. *Unit Operations: An Approach to Videogame Criticism.* Cambridge, MA: MIT Press.

Bordwell, David. 1985. *Narration in the Fiction Film.* Madison: University of Wisconsin Press.

Bordwell, David. 2002. "Film Futures." *Substance* #97 31(1): 88–104.

Bordwell, David. 2006. *The Way Hollywood Tells It: Story and Style in Modern Movies.* Berkeley: University of California Press.

Bordwell, David. 2007. *Poetics of Cinema.* London: Routledge.

Branigan, Edward. 1992. *Narrative Comprehension and Film.* New York, NY: Routledge.

Branigan, Edward. 2002. "Nearly True: Forking Paths, Forking Interpretations." *Substance* #97 31(1): 105–114.

Bruner, Jerome. 1986. *Actual Minds, Possible Worlds.* Cambridge, MA: Harvard University Press.

Buckland, Warren. 2009. "Introduction: Puzzle Plots." In *Puzzle Films: Complex Storytelling in Contemporary Cinema,* ed. Warren Buckland, 1–12. Oxford: Wiley-Blackwell.

Cameron, Allan. 2008. *Modular Narratives in Contemporary Cinema.* Houndmills: Palgrave Macmillan.

Coveney, Peter V. 2003. "Self-Organization and Complexity: A New Age for Theory, Computation and Experiment." *Philosophical Transactions of the Royal Society A* 361: 1057–1079.

Cubitt, Sean. 2004. *The Cinema Effect.* Cambridge, MA: MIT Press.

Dennett, Daniel C. 1991. "Real Patterns." *The Journal of Philosophy* 88(1): 27–51.

Elsaesser, Thomas. 2006. "Discipline Through Diegesis: The Rube Film Between 'Attractions' and 'Narrative Integration'." In *The Cinema of Attractions Reloaded,* ed. Wanda Strauven, 205–223. Amsterdam: Amsterdam University Press.

Elsaesser, Thomas. 2009a. "Tales of Epiphany and Entropy: Paranarrative Worlds on YouTube." In *Film Theory and Contemporary Hollywood Movies,* ed. Warren Buckland, 150–172. London: Routledge.

Elsaesser, Thomas. 2009b. "The Mind-Game Film." In *Puzzle Films: Complex Storytelling in Contemporary Cinema,* ed. Warren Buckland, 13–41. Oxford: Wiley-Blackwell.

Feagin, Susan L. 1999. "Time and Timing." In *Passionate Views: Film, Cognition, and Emotion,* ed. Carl Plantinga and Greg M. Smith, 168–179. Baltimore: Johns Hopkins University Press.

Fludernik, Monika. 2003. "Metanarrative and Metafictional Commentary: From Metadiscursivity to Metanarration and Metafiction." *Poetica* 35: 1–39.

Frank, Joseph. 1945. "Spatial Form in Modern Literature: An Essay in Two Parts." *The Sewanee Review* 53(2): 221–240.

Genette, Gérard. 1969. *Figures II.* Paris: Seuil.

Genette, Gérard. 1986. *Narrative Discourse: An Essay in Method.* Ithaca, NY: Cornell University Press.

Hayles, Katherine N. 1999. *How We Became Posthuman: Virtual Bodies in Cybernetics, Literature and Informatics.* Chicago: University of Chicago Press.

Kauffmann, Louis H. and Varela, Francisco J. 1980. "Form Dynamics." *Journal of Social and Biological Structures* 3(2): 171–206.

Kelso, Scott J. A. 1995. *Dynamic Patterns: The Self-Organization of Brain and Behavior.* Cambridge, MA: MIT Press.

Kermode, Frank. 2000. *The Sense of an Ending.* Oxford: Oxford University Press.

Kinder, Marsha. 2002. "Hot Spots, Avatars, and Narrative Fields Forever: Buñuel's Legacy for New Digital Media and Interactive Database Narrative." *Film Quarterly* 55(4): 2–15.

Lavik, Erlend. 2006. "Narrative Structure in *The Sixth Sense:* A New Twist in 'Twist Movies'?" *The Velvet Light Trap* 58(1): 55–64.

Lavik, Erlend. 2008. "Changing Narratives: Five Essays on Hollywood History." PhD dissertation. Bergen: The University of Bergen Open Research Archive.

Luhmann, Niklas. 1995. *Social Systems.* Stanford: Stanford University Press.

Luhmann, Niklas. 2000. *Art As a Social System.* Stanford: Stanford University Press.

Manovich, Lev. 2001. *The Language of New Media.* Cambridge, MA: MIT Press.

Manson, Steven M. 2001. "Simplifying Complexity: A Review of Complexity Theory." *Geoforum* 32(3): 405–414.

Mitchell, Melanie. 2009. *Complexity: A Guided Tour.* Oxford: Oxford University Press.

Mittell, Jason. 2006. "Narrative Complexity in Contemporary American Television." *The Velvet Light Trap* 58: 29–40.

Neumann, Birgit and Ansgar Nünning. 2010. "Metanarration and Metafiction." In *The Living Handbook of Narratology,* ed. Peter Hühn et al., paragraph 20. Hamburg: Hamburg University Press. http://hup.sub.uni-hamburg.de/lhn/index.php/Metanarration_and_Metafiction.

Panek, Eliot. 2006. "The Poet and the Detective: Defining the Psychological Puzzle Film." *Film Criticism* 31(1/2): 62–88.

Perlmutter, Ruth. 2002. "Multiple Strands and Possible Worlds." *Canadian Journal of Film Studies* 11(2): 44–61.

Polkinghorne, Donald E. 1988. *Narrative Knowing and the Human Sciences.* Albany: State University of New York.

Poulaki, Maria. 2011. "Implanted Time: *The Final Cut* and the Reflexive Loops of Complex Narratives." *New Review of Film and Television Studies* 9(4): 415–434.

Poulaki, Maria. 2012. "Self-Reflexivity, Description, and the Boundaries of Narrative Cinema." *Cinéma & Cie* 18: 45–55.

Prigogine, Ilya and Isabelle Stengers. 1997. *The End of Certainty: Time, Chaos, and the New Laws of Nature.* New York: Free Press.

Ruby, Jay. 1988. "The Image Mirrored: Reflexivity and the Documentary Film." In *New Challenges for Documentary,* eds. Alan Rosenthal and John Corner, 64–77. Manchester: Manchester University Press.

Schlitz, Michael. 2007. "Space is the Place: The *Laws of Form* and Social Systems." *Thesis Eleven* 88(8): 8–30.

Simons, Jan. 2008. "Complex Narratives." *New Review of Film and Television Studies* 6(2): 111–126.

Stam, Robert. 1985. *Reflexivity in Film and Literature: From Don Quixote to Jean-Luc Godard.* Ann Arbor, MI: UMI Research Press.

Thanouli, Eleftheria. 2006. "Post-Classical Narration: A New Paradigm in Contemporary Cinema." *New Review of Film and Television Studies* 4(3): 183–196.

Thanouli, Eleftheria. 2008. "Narration in World Cinema: Mapping the Flows of Formal Exchange in the Era of Globalization." *New Cinemas: Journal of Contemporary Film* 6(1): 5–15.

Varela, Francisco J. 1990. "On the Conceptual Skeleton of Current Cognitive Science." In *Beobachter: Konvergenz der Erkenntnistheorien?,* ed. Niklas Luhmann, 13–24. Munich: Wilhelm Fink.

Varela, Francisco J. 1999. "The Specious Present: A Neurophenomenology of Time Consciousness." In *Naturalizing Phenomenology: Issues in Contemporary Phenomenology and Cognitive Science,* ed. Jean Petitot, Francisco J. Varela, Bernard Pachoud, and Jean-Michel Roy, 266–329. Stanford: Stanford University Press.

Varela, Francisco J., Evan Thompson, and Eleanor Rosch. 1993. *The Embodied Mind: Cognitive Science and Human Experience.* Cambridge, MA: MIT Press.

Williams, Jeffrey. 1999. *Theory and the Novel: Narrative Reflexivity in the British Tradition.* Cambridge, MA: Cambridge University Press.

inception, the archetypal

hollywood puzzle film

unraveling the puzzle

of *inception*

three

geoff king

Inception (Christopher Nolan, 2010) is without doubt the most prominent and biggest-budget of contemporary Hollywood articulations of the puzzle film, hence its prominent place in this volume. A Warner Bros. production made at a cost of some $160 million (plus another $100 million for marketing) and given a wide initial release in the US in mid-summer on 3,792 screens, it is a film on the scale of the largest of 'tent-pole' pictures, a domain of central importance to the commercial fortunes of the major studio distributors. One of the aims of this chapter is to examine exactly how far the puzzle dimension takes the film from the typical characteristics of such large-scale, star-led, spectacular productions, including close consideration of how a degree of narrative complexity or ambiguity is combined with more conventional Hollywood ingredients. I also seek to offer an explanation for the phenomenon constituted by the film. How might we account for the presence of a production that offers such a mixture of qualities, at the levels either of broader studio strategy or more proximate factors specific to the individual case? This chapter finishes with brief consideration of how this kind of film has also been interpreted in relation to

wider sociocultural factors, but the principal focus is on the more immediate industrial context.

"a dream within a dream; i'm impressed"

First, then, to the puzzling qualities of the film. Exactly how much of a puzzle does *Inception* present to the viewer? To what extent does it embrace the more challenging dimensions of the puzzle film as previously established in works further from the center of the commercial mainstream, in arenas such as those of the American indie film or international art cinema? (For more on this, see Bordwell 2006, 72–103; Buckland 2009; King 2005, 84–101.) There is no doubt that the film requires more work on the part of the viewer, if the details of the plotting are closely to be followed, than is typical of established 'classical' or canonical Hollywood-style narratives, cognitive work that is more characteristically found as a marker of the distinctive qualities of less mainstream productions. But how far does this go? A useful place to begin in some detail is with the opening of the film, to consider what degrees of clarity or puzzlement are established from the start and how, when, and to what extent the latter are resolved. This chapter will then go on to examine the broader structure of the film, with a particular focus on the nesting of dream experiences within dreams, and the potential ambiguity of the ending.

Inception begins with footage of what will prove to be the central character, Cobb (Leonardo DiCaprio), washed up on the shore, the images intercut with footage of two young children playing on a beach. The impression might be given that these occupy the same space and time, cuts between close shots of Cobb's face and the children implying an eye-line match and the light broadly similar in each case; sufficient cues are provided to link the two, initially at least, and to constitute what appears to be a deliberate encouragement of confusion. We then see Cobb being accosted by a figure with a gun (and nothing more of the children) and subsequently taken before an older Japanese character. We learn that Cobb was found in a delirious state but asking for the older figure by name and that he was "carrying nothing but this" (a pistol, which seems conventional enough for such a movie situation) "and this" (a small dark spinning top, which seems more enigmatic). A number of initial questions are thus established: Who are these two main characters? Where has Cobb been washed up from? What is his relationship with the older Japanese man? And, what are his intentions and what does the spinning top signify? It is important to note that little of this is particularly out of the ordinary for the opening sequence of a mainstream production (except perhaps the confusion relating to the shots of the children). It is quite common for openings to plunge the viewer into a situation *in media res*, without explanatory background information and to establish a number of initial points of enigma.

The question is: for how long is any of this sustained? In this case some is sustained, and further complicated, for a considerable part of the 148 minutes of the film.

Some substantial hints are offered as the sequence continues and some of the main parameters of the narrative begin to be established. The film offers a number of what Roland Barthes terms "partial" and "suspended" answers to the enigmas that it poses (the former defined as increasing rather than reducing the desire for full revelation, the latter a stoppage of the disclosure) (1974, 75). The Japanese character picks up the top and says he knows what it is and has seen one before, "many, many years ago," adding that it belonged to "a man I met in a half-remembered dream." A cut follows to the face of Cobb, eating hungrily, appearing suddenly to take note of what his interlocutor is saying, implying that the viewer should also be sure to pay close attention. A marked shift then occurs—as we hear what we realize is the voice of Cobb speaking on another occasion— to a shot of a younger Japanese figure to whom Cobb is now talking, and then back to Cobb in what we are led to assume to be this earlier moment (he is dressed smartly here, to make clear the distinction from the earlier sequence in which he is washed ashore). This immediately invites a question on the part of the viewer: Is this, somehow, the *same* Japanese figure at an earlier time, when he was young, as seems to be implied, even if this would appear to be a logical impossibility given that Cobb remains much the same age as in the preceding sequence?

The exchanges that follow, between Cobb, the Japanese character, later identified as Saito (Ken Watanabe), and a colleague of Cobb's, Arthur (Joseph Gordon-Levitt), establish some of the key narrative dimensions of the film in relation to the process of invading the minds of subjects while they are in dream states and Cobb's status as a leading practitioner of the art. Something of how such a process works is then dramatized in the revelation that much of the material on screen comprises parts of dreams or dreams-within-dreams. It is made clear that the second level of interchange between Cobb and Saito is taking place within a dream, when the dream world begins to fragment physically and we see some of the same characters in another level of reality from which the dream appears to originate. This is made most explicit when at one point Saito demonstrates his awareness of what is happening by commenting that "we're actually asleep." An added complication arises when a woman appears in this level of the narrative standing close to the edge of a building and asking Cobb, "If I jump, would I survive?" He identifies her by name as Mal (Marion Cotillard) and asks what she is doing there. She, subsequently, sides with Saito as a violent conflict develops between the Japanese character and Cobb, the latter established here as engaged on a mission to capture a secret document from Saito's safe.

The one dream ends, but it then transpires that the level above it is also a dream, and we are shifted up another level to a sequence on a bullet

train, at which point it becomes clear that Cobb and his team have failed in their espionage mission. The viewer is challenged to some extent through these sequences by the shifts from one level of dream or reality to another, but the process is also telegraphed quite clearly (a number of devices are employed to achieve this effect, including repeated close-ups of watches or clocks counting down in each level). The shifts of level here also serve importantly to prepare the viewer for the main plot of the film that is to follow. What makes this part of the film remain quite puzzling, however, is the presence of other unresolved issues. How any of this relates to the opening sequence, which might appear to occupy a primary level of reality, is unclear. The same goes for the status of Mal, to whom various further (dark) enigmatic references are made, primarily by Arthur. It is this sense of throwing a great deal of material at the viewer at more or less the same time that is one of the most cognitively demanding aspects of the film, as much as the offering of a series of nested dreams within dreams, during this opening movement or in the bulk of the narrative that follows.

Inception then proceeds to establish that Cobb has been physically separated from his two young children, but the reasons for this are not elaborated, and also that their mother appears to be dead, which only adds to the puzzle relating to Mal. A core aspect of the plot is then spelled out very clearly when Saito recruits Cobb to attempt an act of inception, the active planting of an idea in the mind of a businessman who is about to inherit a large company, in return for a promise that Saito will be able to lift the blockage that prevents Cobb from returning home to America (the nature of which remains unclear). Amid the skepticism of Arthur, Cobb reveals that he has done this once before (although we are not given any details until much later). We then see Cobb in Paris to recruit a new dream architect, Ariadne (Ellen Page). Her introduction to how the process of dream construction works also becomes that of the audience, a standard expository narrative device, but the viewer is here again likely to become somewhat overloaded with relatively complicated material relating to issues such as how the subconscious of the dreamer relates to the artificially constructed dreamscape, exposition that the viewer might or might not find entirely comprehensible. Ariadne becomes a surrogate for the viewer on several subsequent occasions ("I'm just trying to understand") in which Cobb gradually, in installments, explains aspects of the backstory involving himself and Mal.

The main plot of the film involves what appear to be five primary levels of reality and dreaming. The action occurs while the top-level reality of the main protagonists is a location on board a long-haul flight to the US during which they are under the influence of drugs that aide the dream-construction process. Within this is a dream level of action set in New York City, which includes an escape made in a van. Below this, with characters dreaming inside the van, is a setting in a hotel, from which another dream level takes us into a snowy outdoor landscape and a remote fortress

building. Within the latter is a final level that involves the ruins of a dream world created in the past by Cobb and Mal. The exact logic of the process at work is not necessarily entirely clear at all moments and in every detail, but the broad parameters of this structure are quite readily comprehensible. Close intercutting from one level to another provides enough information to establish the logic of the various relationships between them, although as with other aspects of the film the sheer volume of this is sufficient for at least some points of confusion to be likely on the part of the viewer.

The most challenging component of the film is probably the dimension involving the emotional backstory about Cobb and Mal, an element that has a habit of cutting across and adding further confusion to the more conspiracy-plot-oriented aspects of the pursuit from one level of dreaming to another. This remains the case despite the fact that this dimension is in itself quite conventional in marking a point of central character weakness or flaw. The fact that Mal is in fact dead, and therefore what we see of her is apparently only a subconscious projection, is established forty-one minutes into the film and the fact that Cobb is suspected of killing her (hence unable to return home), at approximately fifty minutes. A number of partial explanations of what was involved are provided, teasingly, much of the full story of what happened between the pair being spelled out around the eighty-minute mark. It is not until about 125 minutes, however, that we learn that Mal's fatal questioning of her reality status had originally been planted in her mind by Cobb—his previous experience with inception—to enable them to escape from a lower level of dream limbo, a doubt that carried over after her return to the real world. A full explanation of the opening sequence involving the elderly Japanese does not come until close to the end of the film when it is confirmed that this is Saito, located by Cobb in a limbo to which he was consigned after dying from a gunshot wound in another of the dream levels.

The final puzzle comes at the end, which leaves open the possibility that what appears to be a 'happy ending' might itself remain the imagined construct of another dream world. The central plot mission apparently accomplished, Cobb goes unproblematically through US customs, suggesting that Saito has managed to keep his side of the bargain, and is in the process of being reunited with his children. The camera pans across to the spinning top, the film having established earlier that it is Cobb's reality totem, an item known in its exact qualities only to him and through which he can determine that he occupies reality rather than being in the dream of someone else. In a dream, Cobb earlier relates to Ariadne, the top keeps spinning rather than coming to rest. In the final shot of the film, it continues to spin, and an abrupt cut to black and the main title is made before sufficient time has passed for it to be clear whether or not the top will fall.

The cinematic signifiers leading up to this moment are those of an emotionally satisfying positive conclusion, an effect produced particularly by

the upbeat driving and building nature of the music that accompanies the sequence depicting Cobb's arrival and successful passage through the airport, but the possibility is then introduced of the rug being pulled out from what might otherwise be a highly conventional ending. Hints are provided earlier, by Mal, that Cobb might have spent so much time in dream worlds that he no longer believes in the existence of a single reality and might thus have *chosen* to live in one particular dream. The viewer who picks up on any or all of this—which is far from guaranteed in every case—is left with an enduring puzzle, a 'final twist' that might itself be something of a convention in this kind of material but one that is perhaps unusual in its ambiguity, not providing the definite articulation of some kind of reversal.

At the textual level, the film offers plenty of overt exposition of the various processes entailed in the creation and navigation of the dream levels, and of additional central plot points. The norms of 'classical' Hollywood narrative structure seem broadly to be obeyed most of the time, even if the volume of exposition is greater than usual. A reasonably clear cause/effect structure is generally in place, even if all elements of this might be far from clear after a single viewing, seeds being planted for various elements that develop subsequently and clear indicators being used to establish the distinct identity of each of the main dream levels (heavy rain in New York, the distinctive warm tones of the hotel interior sequences, the snowbound landscape, the artifice and excesses of the world originally created by Cobb and Mal). The challenge, as suggested above, is primarily one of information overload and might exist in many cases in the following of relatively minor detail as much as in grasping the broader dreams-within-dreams conceit. Exactly how puzzling the film might be found by individual viewers is likely to vary from one case to another, within the parameters set in this way by the text, and from one viewing to another.

Viewers were certainly cued by critics to expect a greater degree of complexity than usual for mainstream Hollywood material, even if evaluative opinion of the film varied from the highly positive to questioning the degree of originality attributed to *Inception* by others. From the trade press (*Variety*: "fiendishly intricate," "challenges viewers" [Chang 2010]) to major 'quality' dailies (*Los Angeles Times*: "Specifics of the plot can be difficult to pin down . . . can remain tantalizingly out of reach" [Turan 2010]) and broader-market publications (*USA Today*: "the most complex of any summer movie" [Puig 2010]), a clear consensus seems to be established on this point. Some critics also noted the extent to which any demanding aspects of the narrative are balanced by more conventional material. As *The Washington Post* put it, "Even at its most tangled and paradoxical, 'Inception' keeps circling back to the motivation that has driven films from 'The Wizard of Oz' to 'E.T.': Cobb, finally, just wants to go home" (Hornaday 2010). Such an observation seems central to our understanding of the overall balance of qualities offered by the film. This point of focus—classically emotionally

driven via Cobb's desire to be reunited with his children—is sufficient to provide broad-scale orientation for the viewer even if it might not always be possible to follow the exact detail of every narrative step along the way. The same is true of the broader parameters of the conspiracy plot.

The status of the film as more complex or challenging than usual could also be seen as a selling point in its own right—if not necessarily for all potential viewers—by establishing the film as distinctive and as a prominent ground for much of the media coverage, with potential to attract some audiences that might be less inclined to view more conventional action/spectacle-based blockbusters. Films of this kind also encourage repeat viewing, whether in the cinema or on the small screen, in an attempt to gain greater understanding of the plot, multiple viewing being a dimension that often plays an important role in films that achieve larger than usual commercial success. The advertising of DVD releases often highlight this process, either via the additional opportunity to see the film itself or to take advantage of 'extra' features, in this case the promise of being able to 'go deeper into the dream' made in trailers for the *Inception* Blu-ray/DVD. The film certainly offers rewards to those who go back for repeat viewings and are able to pick up hints that are unlikely to be clear without more than one pass.

At its heart, though, *Inception* continues to obey a number of more typical or classical Hollywood norms, even if each element might in itself offer more cognitive challenges than is usual for productions of such solidly mainstream status, and even if the ending adds an ultimately unresolved conundrum. It has a main thematic plot (the 'inception' plan) coupled with a romantic/emotional subplot centered around the flawed male-lead character (his relationships with Mal and the children)—and plenty of ways in which the one becomes classically, conventionally entangled in the other. The film also offers a number of other more conventional blockbuster/action-movie appeals, including the central star presence and the provision of large-scale spectacle and action of various kinds. The existence of such elements goes a long way toward providing an explanation of the presence of the more challenging dimension of the film. If the latter remains greater than usual for a film of this kind, it is hard to imagine it existing at all in any large-scale production without the balancing presence of the former.

spectacular attractions

Leonard DiCaprio is clearly viewed as a key component of the film from a commercial perspective, his name given billing in quite large typeface above the title in poster and DVD-cover artwork, and his full-length figure presented front and center along with other members of the cast in a posed image against one of the backgrounds of the film. The background

employed in the artwork suggests another major ingredient in the marketing mix: an emphasis on the spectacular attractions offered by *Inception,* the element that figures most prominently alongside complexity of narrative in most critical responses. The spectacular dimension of the film can usefully be divided into two main parts: forms of spectacle broadly specific to this production, as markers of its 'unique selling point' and of what is presented generally in films of this kind as 'cutting edge' work in digitally generated specific effects, and more generic elements of spectacular Hollywood action.

The poster/cover/website artwork features the main protagonists standing in the middle of a city street. Behind them, the ground appears to tilt upwards at about 90 degrees, part of one of the 'bending reality' effects used in the dreamscapes of the film. *Inception* offers a number of special effects based sequences of this kind, the most striking of which are the folding inward of imaginary Paris streets and the crumbling cliffs of buildings at the edge of the world created by Cobb and Mal. More conventional sources of spectacle include a number of standard Hollywood chase and/or fighting scenes. A link between the *Inception*-specific and the more generic action-based forms of spectacle is found on a number of occasions in which dream-constructed edifices are shaken or blown apart by explosions—the fireball explosion being standard currency in action films—when their imaginary foundations are challenged. When Cobb and Ariadne sit together outside a café, for example, she initially being unaware that the location is inside a dream, the world they inhabit begins to fragment in a very particular spectacular fashion (slow-motion air-burst explosions outward of objects ranging from the produce outside shops to the facades of buildings, effects that are marked as more subtle and innovative in character than typical action-movie explosions) that signifies both a particular kind of construct bursting at the seams in a manner that is specific to the narrative framework and a familiar usage of effects to mark a heightened moment of physical impact. A similar combination of distinctive elements and much that is more familiar is found in extended fight sequences featuring Arthur in the hotel in zero-gravity conditions created by the downward plunge from a bridge of the van in which this dream level is rooted, and by a sustained period of inter-cutting between this, the action surrounding the van (attacked by gunfire, overturned in a crash, etc.), and a lengthy series of chases and armed engagements in the snowscape.

It is useful here to consider the different positions occupied by the various components of the film in prevailing cultural-status hierarchies. *Inception* was considered by some critics to demonstrate an unusually ambitious 'quality' approach to the summer blockbuster, with its more complex narrative dimensions (see, for example, Barnes 2010). The same might be said of the elements of spectacle that reflect the 'mind-bending' aspects of the plot, including the manipulations of the Paris cityscape and the crumbling

building-cliffs. The resonances of these with a more 'intellectual' or 'arty' approach are suggested most explicitly in a visual reference to the work of the artist M. C. Escher in the form of an 'impossible' staircase used by Arthur in his induction of Ariadne into some of the tricks of their trade. The more generic action-movie sequences would be associated with a realm 'lower' in established cultural hierarchies, as implied by their use of conventional devices such as mobile camerawork and rapid cutting to evoke the intensity of gun battles and chases (see, for example, the chase sequence set in Mombasa and the gun battle in the streets of New York) and perhaps most clearly in the deployment of the obligatory unspoken truism that 'movie bad guys can't shoot' through which the action heroes typically win against unlikely odds.

In its combination of such elements, *Inception* might be considered to be an 'incoherent' text, an accusation made of some more conventional blockbusters on the basis of their tendency to mix whatever combination of ingredients might maximize their commercial potential (Schatz 1993). What appears most striking, however, is the manner in which the different components seem quite carefully to be integrated, particularly on the occasions in which 'explosive' action material is used in conjunction with the articulation of the connections between different dream levels. In the early sequence of shifts from one to another that begins in the Japanese setting, for example, it is a series of fireball explosions in one level— motivated by what appears to be a street riot—that marks the physical deterioration of the level below, providing a form of spectacle that plays a central role in the explanation to the viewer of how the different levels are connected. The same is true of the articulation of the relative situations in the multiple levels involved in the action climax marked on the uppermost dream level by the much-delayed, slow-motion crash of the van into the water after falling from the bridge. If the action in the snowscape seems somewhat excessively extended (the response of some critics and my own evaluative opinion on first viewing), this is narratively motivated (even if it also provides an opportunity for more 'action movie' material) by the establishment of the fact that time passes more slowly in the lower dream levels. The connection between certain kinds of physical action and the multi-dream structure is also spelled out to the viewer. To break out of a dream level, we are told in the early stages, a 'kick' is required, a 'feeling of falling' that reaches inside the dream state because the drug employed during the process does not impair the function of the inner ear. This is much the same as the vicarious 'kick' offered to the viewer by the contemporary action sequence, the film here seeming to come close to articulating a reflexive explanation of part of its own aesthetic.

Inception offers an interesting case for consideration in debates about the relationship between narrative and spectacle in the contemporary blockbuster. Such films have often been accused of surrendering narrative to

spectacle, a viewpoint against which I have argued at length elsewhere (King 2000, 2002). The typical blockbuster, even in its most maligned form, in examples such as the *Transformers* sequels (2009, 2011), combines its spectacular action and special effects with considerable measures of 'classical'-style narrative, often including more of the latter than might seem necessary for the effective delivery of spectacle (for more on this, see Bordwell 2006). *Inception* is an exception in the relative complexity of its narrative material, but it still mixes the two dimensions in a manner that can fundamentally be seen as part of the core blockbuster recipe in which the two are typically mutually supportive more than one working against the other. It seems highly likely, as suggested above, that the action spectacular dimensions were a key factor in the green-lighting by one of the majors of a film of this kind of budget and prominence that displays the degrees of narrative complexity outlined above. But how else might this be explained?

production context and beyond

If the spectacular dimension, and the presence of a major star such as DiCaprio in the lead, goes a long way to making *Inception* seem less of an exception to the blockbuster norm than would otherwise be the case, further reasons might be found to explain the existence within Hollywood of an example of quite this kind. Why, for example, should one of the studios take the risks that might be associated with the more challenging dimensions of the film when similarly star-led thrilling/spectacular material might elsewhere be generated without any such complications? That the film balances its complexity with more familiar components might help to explain its commercial viability but does not fully account for how it was able to come into being in this particular form. Does the film, then, fit into any broader trends in studio production of the time? Or should we seek more proximate explanations? It is with the latter that this section begins, with an examination of the immediate production context of *Inception,* particularly in relation to the status of its writer-director, Christopher Nolan.

The simplest answer to the question of how *Inception* was able to come into existence as a major summer blockbuster with its puzzling qualities intact is that Nolan appears to have been given the scope to shape the film more or less as he wanted. He enjoyed a degree of 'artistic' freedom that itself requires explanation, so much does it go against the dominant conception of Hollywood as an institution characterized by the interventions of executives and marketing departments expected to focus solely (and thus conservatively) on the commercial bottom line, particularly in productions of this scale and expense. Press accounts of the production process repeatedly emphasized the 'personal' nature of the project—another marker of 'quality'—recounting the story of the film's own inception as

a long-germinated idea that first came to Nolan some ten to fifteen years before being brought to fruition (see, for example, Antrim 2010; Boucher 2010b). In this respect the film is positioned in public discourse in contrast to the more familiar (and critically denigrated) Hollywood process of decision-by-committee or multiple rewriting. Nolan's agent was reported to have negotiated a deal that gave him final cut and that left 'unprecedented control' in his hands and those of his established producer, Emma Thomas (Siegel 2011).

The idea for the film was pitched to Warner in 2001 and was said to have received an enthusiastic response, although the project was set aside for some years as Nolan was given the opportunity by the studio to work on the renewal of the Batman franchise with *Batman Begins* (2005) and *The Dark Knight* (2008). In interviews, Nolan suggests that he would not have been equipped to handle the logistical challenges of a film on the scale of *Inception* without this experience (see, for example, Itzkoff 2010). The script was also said by producer Thomas to require work, a process of particular interest here in that this is defined as having a need to strengthen the 'human element' of the story, in relation to Cobb, to make the film "less of a puzzle and more of a story of a character audiences could relate to" (Antrim 2010), which offers some evidence for the deliberate nature of the process through which the balance of qualities offered by the film was constructed. The Batman factor is clearly central, however, to the freedom Nolan was given on the film.

The ability of any filmmaker to gain the kind of freedom enjoyed by Nolan with *Inception* is strongly reliant on one overriding factor: a strong track record in delivering commercial success, preferably with material of a broadly similar kind, in the recent past. If *Inception* was likely to be seen as in some respects a risky project because of the relative complexity of aspects of its narrative structure and also because, unlike many contemporary summer blockbusters, it had no relation to an existing franchise property with presold name recognition, the best explanation we have for its existence is the commercial clout possessed by Nolan at the time, clout that enabled him to shape it without any apparent executive interference. The primary basis for this was the performance of *The Dark Knight,* the worldwide box office gross of which topped the $1 billion mark, making it the biggest success of its year and giving it a position near the top of the all-time money-earners list at the time. Probably the single most important causal factor for the appearance of *Inception,* then, in its finished form and including some puzzle elements that go beyond the norms of the summer blockbuster, was the enormous success enjoyed by Nolan's previous feature.

The resonances of the director's name might be expected to spread wider than his involvement in the Batman films for some viewers—and, importantly, for critics and other media commentators who supply discourses surrounding the film—including other points of reference that

might be germane to the positioning of *Inception*. After his first feature, *Following* (1998), Nolan made his name with the indie hit *Memento* (2000) before breaking into larger budget films: *Insomnia* (2002), *Batman Begins, The Prestige* (2006), *The Dark Knight, Inception,* and *The Dark Knight Rises* (2012). His films are noted for dark, somber qualities (particularly at the fore, for example, in *Insomnia*) and a penchant for narrative complexity, confusion, or trickery (especially *Memento* and *The Prestige*). A key role here in establishing any distinctive auteur 'brand' is played by *Memento,* noted for the reverse direction of its main narrative thread and for the relative box-office success (a worldwide gross of $39,723,096 that made it one of the indie hits of its year) of a film that initially struggled to achieve theatrical release. As a filmmaker associated with such work, combined with the major success of *The Dark Knight,* itself a darker than usual take on the summer blockbuster, it is hard to imagine anyone better placed than Nolan was at this point to introduce some dimension of the puzzle film into a high-profile summer release.

To a large extent, then, the puzzle that is posed not by the narrative of the film but by its existence as an in some respects unconventional high-cost blockbuster is most easily resolved by recourse to these proximate factors: the particular balance offered at a textual level between more or less usual components of the blockbuster and the specific factors that resulted in a figure with the proclivities of Nolan being able to shape the work without any apparent studio interference. What, though, of any broader contextual factors relating to Hollywood or the wider American film landscape? Should *Inception* best be seen as something of a one-off, an exception explained by a particular conjunction of forces, or can it be seen as part of a wider pattern?

One possible argument here would be to suggest that the puzzle film, as defined in this collection and its predecessor (Buckland 2009), has gained broader currency in recent years, making some of its qualities likely to be familiar to a larger constituency than might have been the case in the past. Some evidence for such a trend might be found in the presence of puzzle qualities in some productions from the Indiewood sector, the region in which Hollywood and the indie sector overlap. Examples here might include *Eternal Sunshine of the Spotless Mind* (2004) and *21 Grams* (2003). Whether or not such a presence would be sufficient really to have an impact on the broader bounds of what is likely to be found in the most mainstream of Hollywood productions is open to question, however. The fact that some other films with reality-manipulation plots were released the year after *Inception* (*The Adjustment Bureau* [2011], *Source Code* [2011]) might be of interest but does not in itself seem to offer any grounds for causal explanation at the level of specific short-term film cycles, insufficient time having elapsed between *Inception* and these films, for example, for the latter to be seen as the initiator of a distinct trend in this period.

It is always easy to oversimplify the relationships among films of broadly similar types that appear more or less together, sometimes perhaps by

chance. It might be that all of these examples are better seen as particular examples of longer-standing generic or subgeneric categories, including in the case of *Inception* that of the 'heist movie.' This is certainly a category to which *Inception* seems to belong in some key dimensions and is one that offers another quite firm point of ground for any viewer who might be confused by any of the particular details: what remains clear throughout much of the action, along with Cobb's quest to return home, is that there is a 'job' to pull that has the usual kinds of technical/logistical complications found in the heist format.

A particular strain of science fiction that involves shifts between dimensions of reality and its replication or falsification provides a more obvious broad generic grounding for the film, particularly a version often associated more or less directly with adaptations of the work of Philip K. Dick. Along with its more immediate successors cited above, *Inception* might be associated here with films such as *Blade Runner* (1982), *Total Recall* (1990), and *The Matrix* (1999). The latter was cited by commentators in connection with the perceived risks associated with *Inception,* as an example of an original/inventive predecessor (and another Warner Bros. production) that proved highly successful in the blockbuster arena and that might be seen as a model for Nolan's film (see, for example, DiOrio 2010; Fritz and Eller 2010). Nolan himself associates the development of the film with the period of *The Matrix* and its contemporaries *Dark City* (1998) and *The Thirteenth Floor* (1999) rather than 'alternative reality' films from closer to its period of production such as *Surrogates* (2009) and *Avatar* (2009) (Boucher 2010a). Genre can itself be a factor that motivates or can be seen to 'contain' certain departures from 'classical'-type Hollywood norms, as might be the case on some occasions with both this brand of science fiction and the heist movie as far as certain kinds of narrative complication or trickery are concerned.

Whether or not all of these films have any broader shared basis on the sociocultural level is, as is usually the case, more difficult to establish with any certainty; often such arguments are subject to oversimplification and overstatement. Garrett Stewart reads such films as expressions of cultural anxiety about the integrity of reality and/or the self and, simultaneously, of 'cinema's own institutional fears' (can a medium/institution have fears?) of the replacement of the indexical status of celluloid with the malleability of the digital (2007, 156, 162). It might be reasonable to speculate that part of the appeal of such work is its broader social resonance with discourses relating to the prevalence in some sectors of various virtual worlds or heavily mediated realities, online or elsewhere. But in Stewart's account such conclusions tend to be asserted or assumed and, for those not convinced by it, somewhat mired in heavy doses of psychoanalytically grounded discourse. The editor of this collection also risks oversimplification in the introduction to its predecessor volume in the statement that "experiences are becoming increasingly ambiguous and fragmented; correspondingly,

the stories that attempt to represent these experiences have become opaque and complex" (Buckland 2009, 1). I would want to add heavy qualification to all of these kinds of claims. *Some* experiences might be thus, and *some* stories might plausibly be seen as a response to this, but what evidence is there to suggest that this is the case in other than a minority of cases? To what extent are Stewart's cultural anxieties at all widely shared among the wider population, as opposed to a relatively small circle?

I find a similar problem in Thomas Elsaesser's account of what he terms "mind-game films," when he bases on what he terms "their often cult status" a suggestion that they might be treated "as symptomatic for wider changes in the culture's way with moving images and virtual worlds" (2009, 39). Cult status implies an intense level of engagement with these films but by a minority rather than the broader audience, one on which it seems questionable to base a claim to wider symptomatic status. Films of this kind are often of greater than usual interest to critics and theorists because they offer particular kinds of grist to the critical or theoretical mill. They are good "to think with," to quote Claude Lévi-Strauss out of context. A substantial gap exists between this, however, and claims that such texts are representative of broad cultural trends. The prevalence of particular narrative or other tropes in a particular period might provide some provisional evidence of the wider resonance of such material, or at least a starting point for such analysis, as might the spread of the puzzle film in some cases into more mainstream or commercial realms. But we should not forget the larger number of films that do not display these characteristics. If the puzzle film represents cultural change or 'crisis' of some kind, what do all the others that outweigh them in numbers, if not attention from such critics, represent? We should also bear in mind the other more proximate industrial factors that help to generate particular cycles of films in particular periods or those specific to individual examples that have been the primary focus in this chapter.

references

Antrim, Taylor. 2010. "Anatomy of a Contender: Making of 'Inception.'" *The Hollywood Reporter,* November 24. www.hollywoodreporter.com/news/anatomy-contender-making-inception-47634.

Barnes, Brooks. 2010. "Hollywood Moves Away from Middlebrow." *New York Times,* December 26. www.nytimes.com/2010/12/27/business/media/27movies.html.

Barthes, Roland. 1974. *S/Z.* New York: Hill and Wang.

Bordwell, David. 2006. *The Way Hollywood Tells It.* Berkeley: University of California Press.

Boucher, Geoff. 2010a. "'Inception' Breaks into Dreams." *Los Angeles Times,* April 4. http://articles.latimes.com/print/2010/apr/04/entertainment/la-ca-inception4–2010apr04.

Boucher, Geoff. 2010b. "Christopher Nolan: All His Altered States." *Los Angeles Times,* December 9. http://articles.latimes.com/2010/dec/09/news/la-en-chris-nolan-20101209.

Buckland, Warren (ed.). 2009. *Puzzle Films: Complex Storytelling in Contemporary Cinema.* Oxford: Wiley-Blackwell.

Chang, Justin. 2010. "Inception: A Fiendishly Intricate Yarn Set in the Labyrinth of the Subconscious." *Variety,* July 5. www.variety.com/review/VE1117943114?refcatid=31&printerfriendly=true.

DiOrio, Carl. 2010. "'Inception' Is No Dream for Marketers." *The Hollywood Reporter,* October 14. www.hollywoodreporter.com/news/inception-no-dream-marketers-25352.

Elsaesser, Thomas. 2009. "The Mind Game Film." In *Puzzle Films: Complex Storytelling in Contemporary Cinema,* ed. Warren Buckland, 13–41. Oxford: Wiley-Blackwell.

Fritz, Ben and Claudia Eller. 2010. "Warner Gambles on an Unproven Commodity." *Los Angeles Times,* July 13. http://articles.latimes.com/2010/jul/13/business/la-fi-ct-inception-20100713.

Hornaday, Ann. 2010. "'Inception''s Dream Team Weaves a Mesmerizing Tale." *The Washington Post,* July 15. www.washingtonpost.com/gog/movies/inception,1158861/critic-review.html#reviewNum1.

Itzkoff, Dave. 2010. "A Man and His Dream: Christopher Nolan and 'Inception.'" *New York Times,* June 30. http://artsbeat.blogs.nytimes.com/2010/06/30/a-man-and-his-dream-christopher-nolan-and-inception/.

King, Geoff. 2000. *Spectacular Narratives: Hollywood in the Age of the Blockbuster.* London: I. B. Tauris.

King, Geoff. 2002. *New Hollywood Cinema: An Introduction.* London: I. B. Tauris.

King, Geoff. 2005. *American Independent Cinema.* London: I. B. Tauris.

Puig, Claudia. 2010. "You Definitely Won't Sleep through Complex Thriller 'Inception.'" *USA Today,* July 16. www.usatoday.com/life/movies/reviews/2010-07-15-inception15_ST_N.htm.

Schatz, Thomas. 1993. "The New Hollywood." In *Film Theory Goes to the Movies,* ed. Jim Collins, Hilary Radner, and Ava Preacher Collins, 8–36. New York and London: Routledge.

Siegel, Tatiana. 2011. "Being Nominated is the Best Revenge." *Variety,* February 15. www.variety.com/article/VR1118031878/.

Stewart, Garrett. 2007. *Framed Time: Toward a Postfilmic Cinema.* Chicago: Chicago University Press.

Turan, Kenneth. 2010. "Movie Review: 'Inception.'" *Los Angeles Times,* July 16. http://articles.latimes.com/2010/jul/16/entertainment/la-et-inception-20100716.

'show, don't tell'

considering the utility of diagrams

four

as a tool for understanding

complex narratives

elliot panek

How do we, as analysts and audiences, untangle the knotty mysteries of complex narratives? Detailed verbal or written descriptions can be quite good at explicating the complexities of an intricate narrative like that of the 2010 film *Inception*. That words, either spoken or written, have been the primary means of describing film narratives, complex or otherwise, is a function of the constraints of the classroom and the medium through which scholarly work has been published. Recent developments in digital communication technologies provide scholars and armchair narrative analysts alike with abilities to create and distribute pictures to convey information, and thus to describe and depict attributes of various kinds of film narratives.

Charts, graphs, and other visual depictions of information have been used widely in the sciences, in policy circles, and in the private sector as ways of conveying characteristics of phenomena as varied as avian migration patterns and trends in homicide. The oft-maligned PowerPoint presentation is perhaps the most widely used means of conveying information graphically in many scholarly and professional contexts. Charts are widely

used in the sciences in the process of making preliminary interpretations of data. Scatter plots, histograms, and other descriptive or diagnostic diagrams help researchers quickly get a sense of what patterns and relationships exist within a large data set that is simply too big to apprehend at once. They are useful as a means of constructing hypotheses.

Understood from the point of view of the narratologist, a film's narrative can be just as complex as a large data set. Each moment of a film is laden with information—about relationships among characters, about the likelihood of possible subsequent events in the plot, about characters' thoughts, feelings, and knowledge of diegetic events relative to those of the audience—and before the viewer has time to reflect upon these characteristics of one moment, it is replaced by another. Closely watching and rewatching films or individual scenes is time consuming. Reading a description of a narrative can be similarly time consuming and inevitably carries with it choices made by the author as to what to leave in and what to leave out.

Pictures, also, by their very nature, must strip away some of the complexity of a large data set in order to facilitate quick comparison and pattern recognition. In this chapter, I use both the traditional written technique of describing an aspect of a complex narrative, and I implement a new tool for visually depicting that aspect. I consider the advantages and disadvantages of both in helping viewers and analysts understand how complex narratives work, using Christopher Nolan's *Inception* (2010) as a test case.

precedents

The translation of a film narrative to visual form often, but not always, necessitates a quantification of the narrative's attributes. If one of the goals of the analyst is precision, then it is important to think of the narrative in this way, comprised of variables, each of which vary in value across time within a narrative and/or between narratives.

Film scholars have used quantitative analyses of certain characteristics of films as a means of identifying particular styles of certain eras or directors. Barry Salt assesses characteristics that are both easily identifiable and are likely to be indicative of the style of one director or era: average shot length (ASL), shot type (e.g., medium shot), and camera movements (e.g., panning) (Salt 1974). Salt uses histograms (i.e., diagrams depicting the frequency distribution of each of these characteristics within a given film) as a means of depicting the frequency of shots of various lengths and types as well as the frequency of camera movements within a single narrative, making it easy to quickly compare the films of one director or era to another. Thus, graphs are used by Salt to get a sense of the patterns in the data, and statistical tests are used to confirm or disconfirm hypotheses.

Salt offers a 'proof of concept' analysis but does not conduct a comprehensive test of any hypotheses that are generalizable beyond his limited sample. Cinemetrics (Tsivian 2009), a technique that involves crowd-sourced coding of certain, easily identifiable characteristics of film style (e.g., shot length), yields a much larger sample, which could allow scholars to generalize beyond smaller samples. This mode of statistical analysis is concerned exclusively with matters of visual style as denoted by types and durations of shots (Cutting, Brunick, and DeLong 2011; Elsaesser and Buckland 2002). It does not tell us much, if anything, about qualities of narration. It is useful to mention in the context of this project because the use of diagrams as *diagnostic aids* in the analytical process is the same as the proposed means of diagramming narratives. It also introduces visual depictions of the quality of a particular characteristic (specifically, shot duration) as it changes over the course of a single film, as a time series, with the passage of time depicted along the x-axis, a technique that is used in this chapter.

variations in the characteristics of narratives, within and across films

Visual depictions of variance in narration, like any kind of statistical analysis of films, require the analyst to identify characteristics of the narrative (i.e., variables) that vary over the course of a single narrative (in which case the unit of analysis would be a shot, a scene, a frame, or a second) and between various film narratives (in which case the unit of analysis would be the film). Variation in these characteristics should tell us something about how the film relays information about the diegetic world to the audience and should correspond to certain predictable reactions in most audience members (e.g., feelings of suspense, relief, fear, happiness, or sadness).

Meir Sternberg (1978) and David Bordwell (1985) (in his use of Sternberg's categories) provide four characteristics of narration that prove to be promising candidates for such variables: knowledge, self-consciousness, communicativeness, and reliability. Within the characteristic of knowledge, film narration possesses depth (that is, the degree to which the viewer is privy to the thoughts and feelings of a character) and range (to which character or characters the viewer's knowledge is restricted or constrained, if it is restricted at all; that is, the amount of knowledge of the state of the diegetic world possessed by an individual character or by the audience relative to other characters or the audience). The approach implemented in this chapter considers one aspect of narration—the range of knowledge.

Range of knowledge is particularly promising for several reasons. Range tends to be less ambiguous than other aspects of narration; it is fairly clear at any given moment in a film how restricted the audience's knowledge is relative to the knowledge of the film's characters, and to which character's knowledge the audience is restricted. Range also tends to vary over the

course of a single film as well as between films. Lastly, variations in the range of knowledge are likely to cue hypotheses formation or revision on the part of the audience as to what will happen next within the diegesis (Bordwell 1985, 58). It is likely that the formation and refining of hypotheses are associated with changes in affect or, more generally, increased brain activity in the viewer. If our aim is to understand how certain ways of telling stories influence audiences' reactions to the stories, range of knowledge is an ideal object of study within the film narrative.[1] Ultimately, it may be the fluctuations in range of knowledge, rather than rapid cutting or an abundance of plot points occurring in quick succession, that account for the extent to which a film or sequence is mentally and emotionally engaging.

It is important to keep in mind that the creation and closure of knowledge gaps (i.e., moments at which an audience lacks knowledge relevant to the plot, or a gap in the audience's knowledge of diegetic events) is distinct from events happening as time unfolds within the diegetic world, what one might call 'and then' moments within a narrative. In such cases, audiences may have formed hypotheses (e.g., the protagonist is strong and clever enough to overcome the physical threat posed by the antagonist) that require revision given new information doled out by the narration (e.g., the protagonist acquires a serious injury); however, neither the audience nor any character experienced a knowledge deficit, either at the time or retrospectively, relative to other characters or the audience.

Charting the range of knowledge over the course of a narrative is a worthwhile enterprise because simply 'taking an average' of the audience's range of knowledge as most analysts do when thinking about a film (for example, when an analyst claims that the narration in a film is 'highly restricted') might efface certain patterns in a film. In *Narration in Fiction Film*, Bordwell describes how detective films restrict audience knowledge to that of the protagonist. Indeed, if one were to conduct in-depth, scene-by-scene analyses of a broad sample of detective stories, it is likely that evidence would confirm Bordwell's assertions. However, when one considers films from other genres, it becomes clear that the restriction of the range of knowledge is not as uniform or as easily characterized as that of most detective stories. For example, a film may have restricted the range of audience's knowledge at the start and then fluctuate between a more restricted and a less restricted range as the film progresses, or it may have restricted the audience to different characters' ranges of knowledge during different points in the narrative. Thus, a depiction of the range of knowledge over the course of a single narrative might help analysts to see similarities between films better than if they had to go on 'averages.'

The approach taken in this chapter is a narrow, in-depth approach, meant more as an exploration of what could be learned by the visual depiction of an aspect of narration in a film. In principle, the technique

outlined in this chapter could be applied to the communicativeness, self-consciousness, or reliability of the narration of a film.

using diagrams to construct and understand narratives

Diagrams have been used by writers as a way of planning or 'scaffolding' story structure for many decades. Even when stories progress in a linear fashion, they are not necessarily constructed in this way. Writers may think of an ending or a climax before thinking of the rest of the story. Diagrams facilitate out-of-sequence writing. Such diagrams are often little more than timelines, depicting the order of events within the diegesis as well as the pace of the story (the pace can be inferred by the proximity of major events in the plot to one another). Other basic plot diagrams, such as Freytag's pyramid, may tell us something about the rise in tension or action (represented by movement along the y-axis) as the narrative progresses (temporal progression is marked by movement along the x-axis), but still do not allow for an analysis of particular attributes of film narratives.

diagramming the range of knowledge of a narrative

Instead of using diagrams merely to facilitate understanding of diegetic event order and story pacing, we can use them to aid understanding of other features of the narrative, such as the range of audience's knowledge of diegetic reality. What's more, these diagrams could be used to depict these characteristics as they change over the course of the narrative. The range of an audience's knowledge of events or the state of affairs within the diegesis can be more or less restricted. They can be restricted to the knowledge of certain characters; typically, to the knowledge that protagonists or antagonists possess.

If we are attempting to quantify and then diagram the range of knowledge as it fluctuates over the course of a narrative, it is easiest to think of range of knowledge as an ordinal scale: the amount of knowledge a film's narration allows an audience to possess can be measured relative to the amount of knowledge it allows characters to possess. At any given moment, the audience may be permitted to have more, less, or the same amount of knowledge of events or states of affairs as the protagonists or antagonists. Flaunted gaps in knowledge make it clear that someone—either the character(s) or the audience—is at a knowledge deficit.

Assuming there are one protagonist and one antagonist, there are seven possible combinations of values for protagonist, antagonist, and audience on the range of knowledge scale at a given moment in a film. These values describe the possible relations the audience, protagonist, and antagonist have to information that is important within the diegesis vis-à-vis the protagonist's goal. For each moment at which important information is

provided, the protagonist, antagonist, and audience are assigned values of either 1 or 0, representing "has knowledge" or "does not have knowledge," respectively. Here are the combinations of values, along with the coding scheme for each set of values:

1. The audience knows information that neither the protagonist nor the antagonist knows: audience = 1; protagonist = 0; antagonist = 0.
2. The audience and the protagonist know information that the antagonist does not: audience = 1; protagonist = 1; antagonist = 0.
3. The audience and the antagonist know information that the protagonist does not: audience = 1; protagonist = 0; antagonist = 1.
4. It is revealed that the protagonist knew information that the audience and the antagonist did not, and the audience and antagonist are just being brought up to speed, *or* a question has been raised, and it is apparent that the protagonist knows the answer to the question while the audience and the antagonist do not: audience = 0; protagonist = 1; antagonist = 0.
5. It is revealed the antagonist knew information that the audience and the protagonist did not, and the audience and the protagonist are just being brought up to speed, *or* a question has been raised, and it is apparent that the antagonist knows the answer to the question while the audience and the protagonist do not: audience = 0; protagonist = 0; antagonist = 1.
6. A question has been raised, and the audience, protagonist, and antagonist do not know the answer to the question: audience = 0; protagonist = 0; antagonist = 0.
7. A question has been raised, and it is apparent that the protagonist and antagonist know the answer to the question while the audience does not: audience = 0; protagonist = 1; antagonist = 1.

It is commonly the case that there are multiple protagonists or antagonists in a film, as is the case in *Inception*. In such cases, many more than seven possible combinations of values may exist. Each character would be assigned either a 0 or a 1 depending on whether or not he or she possessed the relevant information possessed by the other character(s) or the audience at that time. When the audience possesses the same amount of information as a character, it is likely that the audience will experience feelings of identification and sympathy toward that character.

Given this coding scheme, diagrams of narrative range can be constructed in the following manner. First, the viewer watches the movie all the way through, making note of moments at which information comes to light that is important vis-à-vis the protagonist's goals. Specifically, the viewer notes the time (in minutes and seconds) when the moment occurred and considers whether each character knows this information,

whether it is revealed that the character(s) knew more information than the audience and the audience is just being brought up to speed, and whether a gap (either flaunted or suppressed) has been created. This coded information is then used to create a diagram. The x-axis represents the passage of time as it is experienced by the viewer, running from left to right. The y-axis represents the amount of information possessed by the character or the audience, with separate lines representing protagonist(s), antagonist, and the audience.

exploring *inception*

fan attempts to use diagrams to understand inception

The 2010 film *Inception,* like Christopher and Jonathan Nolan's earlier *Memento* (2000), practically begs to have its narrative/narration analyzed. Unlike many other psychological puzzle films (Panek 2006), *Inception*'s narration is rather explicit about how to interpret most of what is real within the world of the diegesis and what the subjective realities of particular characters are. Portions of the story take place within dream worlds that are 'nested' in other dream worlds. Throughout the story, the rules of this diegetic universe are explained via character dialog: some aspects and inhabitants of these worlds are not real in the sense that they do not continue existing after dreamers awaken, while other aspects are real in that they can affect the thoughts and behavior of dreamers after they awaken.

By now, the reader is likely familiar with the basic storyline of the film: Dom Cobb has the ability to infiltrate other people's dreams and steal secrets based in their subconscious or, in some cases, plant ideas in their minds. He has been hired by a wealthy industrialist, Saito, to infiltrate the dreams of a competitor, Fisher, in order to convince Fisher to dissolve his corporate empire. Saito promises to help Cobb clear his criminal record so that Cobb can see his children, from whom he has been estranged. Cobb assembles a team of accomplices—Arthur, Ariadne, Eames, and Yusuf—to help him plant this idea in Fisher's mind. As the film progresses, it becomes clear that Cobb is still mourning the loss of his wife, Mal. This loss threatens to disrupt his ability to achieve the aforementioned goals.

There is one primary protagonist—Dom Cobb—and several lesser protagonists (Ariadne, Eames, Arthur, Yusuf, and Saito) as is standard in a heist movie, the genre to which this film superficially belongs. The antagonists, in a sense, could be considered to be the characters' own subconsciousnesses (as manifest in Cobb's remembrance of Mal and various guards armed with guns). Figments of these subconsciousnesses prevent the protagonists from achieving their goals—convincing Fisher to break up his company; Cobb returning to the United States to see his children—and, in some cases, threaten pain or permanent exile to a kind of purgatory

called 'limbo.' If the film simply included one dream sequence, or several dream sequences over the course of the film, then *Inception* would likely not have inspired anyone to diagram the 'levels' of reality of the film. It is the nested quality of the realities within the film that make it unique and inspire viewers to create diagrams to 'keep things straight' or merely to admire the unique qualities of this film.

In the summer of 2010, the website of the magazine *Fast Company* held a contest for which readers created graphics depicting the narrative of *Inception*. The contest spawned numerous graphics, most of which conveyed the sense of subjective time as it was experienced by the characters as well as the character who was dreaming during each section of the story.[2] The writer/director of *Inception*, Christopher Nolan, has noted the importance of subjective realities in films on multiple occasions, in film noir movies in particular (Mitchell 2010; Stephens 2001), stating, "A big part of my interest in filmmaking is an interest in showing the audience a story through a character's point of view" (Bordwell 2012; Nolan 2010), and "Everything, for me, comes back to the difference between the way we see the world subjectively but we believe there's an objective reality . . . cinema, in particular, is a great medium for exploring subjectivity" (Mitchell 2010). Given Nolan's predilection for using cinema to explore subjectivity, it seems worthwhile to explore the ways in which the narration in *Inception* restricts the viewer to various characters' knowledge of the diegetic world.

an explanation of fluctuations in the range of knowledge

The traditional means of describing elements of a film narrative is via words. Rather than presenting a full-length description of the range of knowledge as it changes throughout the duration of *Inception*'s plot, I present a description of these changes through the first fifteen minutes of the film as a sample of this method to be contrasted with the graphical method.

0:40–2:48 After the opening credits, a character whom the audience comes to know as Dom Cobb, the primary protagonist, is seen washed up on a beach. The audience is as disoriented as Cobb seems to be. However, the audience will later realize that Cobb knows things about his surroundings— the children playing in the sand by him at the beach, the guard who takes him up to see an elderly man, and the identity of the elderly man (whom the audience comes to know as Saito)—that they do not know. So, it is possible to say that in this first scene, the protagonist knows more than the audience does but that this knowledge gap is *suppressed* (i.e., the audience does not know that they are at a knowledge disadvantage relative to the character). At the same time, there seems to be a flaunted gap: the audience might think that Cobb knows who the children are, but they can only speculate. Perhaps Cobb is flashing back to when he was a young boy, playing on the beach. Perhaps the boy and girl he sees are real; perhaps they are

not. As in other movies written or cowritten by Christopher Nolan, the audience starts the film at a knowledge disadvantage.

To some extent, audiences always play catch-up, getting to know aspects of the diegetic world with which protagonists and antagonists are already acquainted. At the start of any film, audiences are being introduced to a world about which they know very little. But Nolan likes to give audiences just enough information for them to form a hypothesis about the state of affairs in this world and then surprise them with some bit of knowledge that the protagonists (in the case of *Inception*) or antagonists (in the cases of *The Dark Knight* [2008] or *The Dark Knight Rises* [2012]) had all along (e.g., what the audience sees is actually a dream, and then, is a dream within a dream). It is unlikely that audiences would think that a subsequent scene in which protestors riot in the streets is directly related to another subsequent scene taking place in a Japanese-style building, and certainly not that the street scene is part of yet another dream. This violation of audience expectations is a good technique for getting the audience's attention.

2:48–4:28 Cobb and Arthur, who appears to be Cobb's ally, pitch the idea of dream espionage (i.e., 'extraction') to a younger version of Saito. This talk of dream espionage serves to set up a subsequent scene in which the Cobb, Arthur, and Saito we now see are revealed to exist only within a dream world. Arthur makes a cryptic remark to Cobb near the end of this scene: "He knows" (the "he" clearly referring to Saito). This creates a flaunted gap in knowledge between the protagonists and the audience (Knows about what? the audience might ask). Presumably, Cobb and Arthur know more than the audience knows about their goals and the threats that may prevent them from reaching those goals. Arthur is also asserting that the person who appears to be an antagonist, Saito, knows more than the audience does as well. This scene, therefore, continues the last scene's knowledge range dynamic: the audience knows less than the protagonists or the (apparent) antagonist.

4:28–5:06 The action switches locations to a city street in which people are rioting, and Cobb, Arthur, and Saito are sleeping in an apartment above. Here, the film uses the norms of continuity editing to fool the audience. Typically, when there is a cut to the same character in a different setting, the audience assumes that the action takes place at a different (that is, noncontinuous) time. Indeed, that is the relationship between the first scene (featuring Cobb and older Saito) and the subsequent scene (featuring Cobb and younger Saito): they involve at least one of the same characters, but they are *not* temporally continuous.

There are two hints suggesting that the action taking place in the Japanese-style building and the action in the street/apartment scenes are temporally continuous—Arthur says, "What's going on up there?" as the lights above him shake; this is followed by an explosion in the other location. At the end of the scene in the street/apartment, there is a cut back to

Cobb and Arthur in the Japanese-style building, and, again, the characters seem to react to the explosions in the other location. The audience finds out, later, that Cobb and Arthur know that they are in a dream within a dream. However, the audience possesses a bit of knowledge that Cobb and Arthur do not: when Arthur asks, "What's going on up there?" the audience knows something he and Cobb do not know—that the rumblings are being caused by rioters running through the streets, blowing up cars. This knowledge might keep the audience from totally giving up on interpreting the scene: being kept disoriented for too long while characters, apparently, know more than you do is likely to feel alienating. The attentive audience might know something that the protagonists don't—the explosions are causing the rumbling—but the protagonists know something that the audience is unlikely to know—that the action in the Japanese-style building takes place inside a dream, and the protagonists also know something that the first-time viewer cannot know: that they are in a dream within a dream. It is thus not easy to say who is at an advantage here in terms of knowledge (the audience or the protagonists), but if one had to decide, one would likely say that the audience is still at a disadvantage, not even knowing the extent to which any of what they see is 'real' within the diegetic universe.

5:06–8:34 Mal (whom we later identify as the primary antagonist) appears with a line of dialog that is, in retrospect, quite poignant: "If I jumped, would I survive?" In retrospect, the audience knows that this must be poignant to Cobb as well. The audience knows later (and Cobb knows at that moment) that Mal killed herself by jumping to her death. This scene plays out more like a standard scene from the first ten minutes of any movie: clearly, the characters know one another, and through their dialog, the audience gets to know a bit more about how they relate to one another. Still, the audience does not have key bits of information to which the protagonist is privy: this is all a dream and Mal is dead and, in some sense, not real. The audience might think that they are learning that Cobb and Mal are divorced (Mal's line "Do the kids miss me?" cues this hypothesis) when, in fact, Cobb is widowed. Cobb proceeds to kill a few guards and then is caught by Mal and Saito while breaking into Saito's safe.

8:34–9:08 Saito speculates that they are in a dream, confirming what the savviest of viewers might have guessed when seeing sleeping Cobb, Saito, and Arthur in the apartment. Mal and Cobb trade knowledge about the nature of Mal's threat to Arthur and the 'rules' of cause and effect as they operate in the dream world. Cobb notes that Mal's threat to shoot Arthur isn't truly threatening: when one dies in a dream, one simply wakes up. Mal counters by pointing out that she can inflict real pain on Arthur and then proceeds to cause him real pain by shooting him in the leg. Cobb shoots Arthur in the head, which for an instant might seem a shocking

development to the audience that is not yet certain that this is a dream. There is a brief insert shot of Arthur's eyes opening (at 9:09). This confirms that the scene that takes place in the old Japanese building is a dream. The (apparently) real Arthur wakes up in the apartment and explains to a nearby partner, Nash, that "the dream is collapsing" and that they have sedated the (apparently) real Saito.

Thanks in part to the earlier planting of information about the existence of extraction (i.e., dream espionage), the audience can quickly grasp that the world of the Japanese-style building is a dream but (equally importantly) that the action in the dream has effects in the (apparently) real world. During the subsequent action scene, the audience seems to know as much as the characters know. The flaunted gap created by the comment "He knows" has been closed: the audience knows that Saito knew that he was in a dream. In a sense, the audience may feel as though they have more knowledge than the 'dream Cobb,' who still cannot see the events in the apparently real world that are causing the world of the Japanese-style building to collapse, and eventually flood, around him. The audience feels as though they are, at least, on equal footing with the protagonist at this point (9:09 for slower viewers; 2:50-ish for sharper viewers).

9:52 As the dream collapses on the Japanese-style building, Saito discovers that he has not kept his secret (in the envelope) hidden from Cobb but that Cobb has switched the envelopes and, for the time being, has the upper hand. This is a moment in which it is revealed that Cobb knew something that the audience and the apparent antagonist did not: that he had time to switch the envelopes. This puts Cobb at an advantage relative to the audience and the protagonist and makes the audience realize his powers and abilities to deceive.

10:50 Cobb discovers, with the audience, that some pieces of information on Saito's secret document have been redacted. This puts the protagonist and the audience in a place of vulnerability. The threat of the antagonist is more formidable than the audience, or Cobb, initially thought.

10:55 In the apparently real street/apartment world, Saito draws a gun on Arthur. The audience learns, along with the protagonists, that Saito had knowledge (specifically, the knowledge that he possessed a gun) that the audience did not have and that the protagonist did not have. Again, this serves as another counterpoint to the moment at 9:52, where Cobb seemed to have the advantage. This (somewhat) rapid back-and-forth between revealing that the protagonist and antagonist had knowledge that the other (and the audience) did not is likely typical of engaging action sequences, prompting the audience to revise their hypotheses as to whether the protagonist will achieve his or her goal.

11:53 Saito asks Cobb how he found him. It is revealed that Cobb knew something that Saito did not know he knew: that Saito had a 'love nest.' Here, Cobb is at an advantage relative to Saito.

12:16 Saito reveals that he was auditioning Cobb and his associates, putting Saito in a position of power again. The rapid back-and-forth continues.

12:34–12:39 We cut from the street/apartment scene in the apparently real love nest of Saito's world to Nash's sleeping face on a train. A similar sequence of shots (action from one setting, a sleeping face from another setting, accompanied by a close-up of a ticking watch) was used before at 4:28. At that time, the audience may not have recognized what it signified: that the action was taking place inside someone's dream. The audience members received information between now and 4:28 that would prompt them to retroactively understand that earlier scene in those terms. That information also helps the audience understand this sequence at 12:34. The audience is being provided with information that the protagonist had all along: the characters in the apartment are in another dream.

13:30 The antagonist realizes that he is in another dream, providing a redundant, explicit cue to the audience. He catches all members of the audience up to the protagonists and the sharper members of the audience, who have already realized this.

14:30 Another twist occurs. It is revealed that the antagonist and audience have been at a knowledge disadvantage: neither Saito nor the audience realized that we were not in Saito's dream but in Nash's dream instead. The protagonists had information that neither we nor the antagonist had, making them seem powerful again.

interpreting the diagram

The diagram (Figure 4.1) succinctly captures fluctuations in the range of knowledge across the entire narrative. Each point on the diagram represents whether or not characters or the audience possess the relevant, new knowledge that is doled out by the narration. To aid comprehension, the points have been 'jittered' or placed at slightly different heights along the y-axis. This slight difference in heights does not signify a difference in values. It is only used as a means of making it easier for the reader to see the points. Any point above the midpoint on the y-axis signifies the character has knowledge while any point below the midpoint signifies the character does not have knowledge. The x-axis, labeled in the middle of the diagram to aid visibility, signifies elapsed time, in minutes.

By examining this diagram, we can see at which points most of the important information is being conveyed to the audience, whether the audience knows more than the protagonist and antagonist in general or at particular points throughout the movie, how many characters are featured in the action, how much time each character is part of the action, and to what extent the audience is experiencing the events in ways similar to each character. This diagram tells us more than just how much of the film features unrestricted narration. This information would more

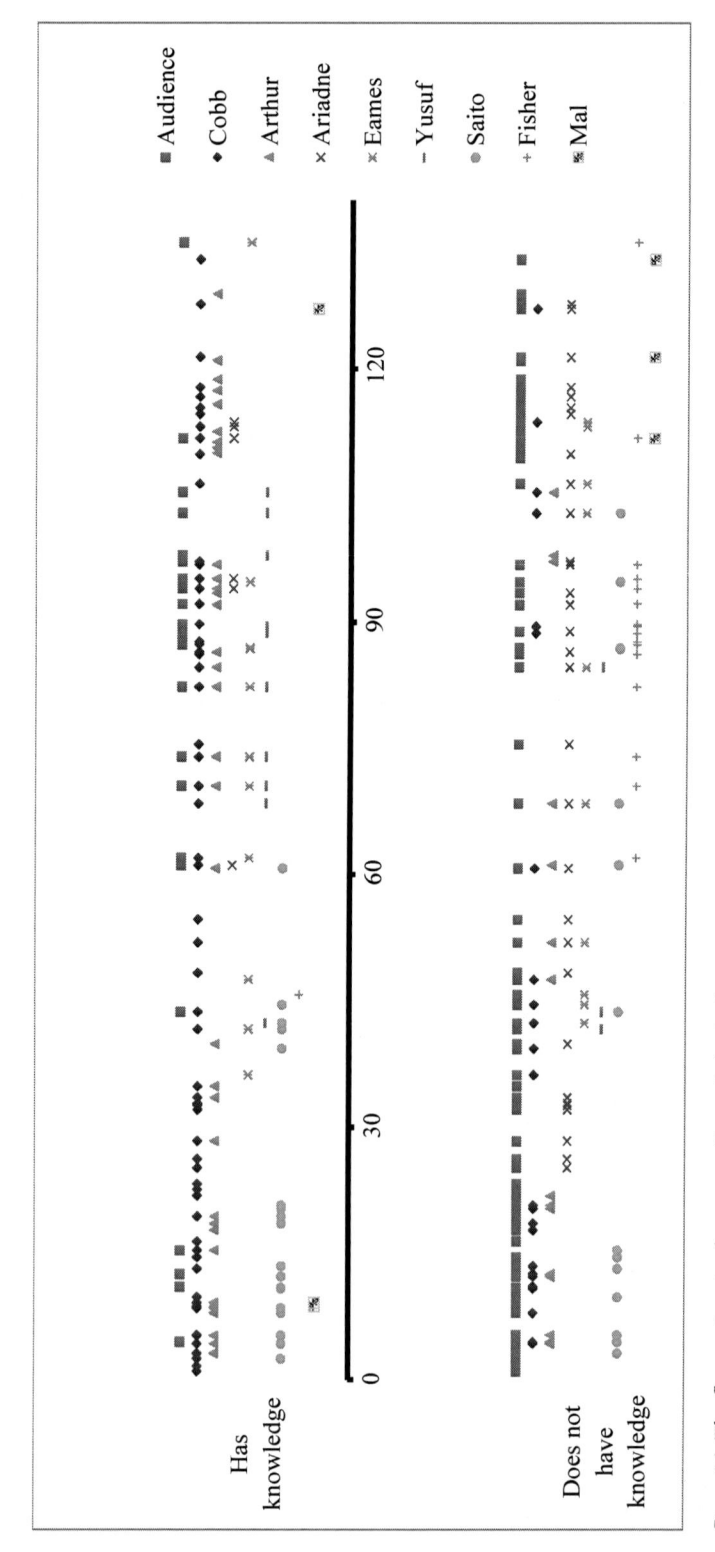

Figure 4.1 The fluctuations in the range of knowledge in *Inception*

efficiently be conveyed via a percentage of screen time that the audience shared the range of knowledge of each character. Instead, the diagram tells us *at what point* in the narrative the narration becomes more or less restricted and to whose point of view the audience's knowledge is restricted.

The diagram suggests what many critics have noted: there is a great deal of exposition via character dialog. Specifically, the primary protagonist, Cobb, has knowledge when the audience does not, frequently dispensing knowledge of the diegetic world to the audience. Nolan is aware of this heavy reliance on exposition and justifies it on generic grounds: heist movies use a lot of explanation of the circumstances through dialog (Bordwell 2012). Particularly in the second half of the film, it is apparent from looking at the diagram that the primary protagonist very rarely operates at a knowledge deficit. It is possible that this detailed and frequent exposition keeps the audience from being confused by a movie that has nontraditional internal norms of causal relationships between events depicted on screen (i.e., many different diegetic realities that contain some elements that affect the other diegetic realities).

It is also apparent from the diagram that Ariadne acts as a proxy for the audience, especially throughout the latter portion of the film. The diagram shows that she is often equal to the audience in terms of her knowledge of the diegetic world. While Arthur and Cobb are mostly at a knowledge advantage to the audience and other characters, Ariadne, like the audience, is most often at a disadvantage, figuring out the world as she goes. Ariadne often articulates the questions the audience is likely to be thinking (e.g., Wait, whose subconscious are we going into exactly?) throughout the film while Cobb acts as a proxy for the narration, quickly answering the questions with an explanation.

The diagram also tells us that Ariadne is a strong female character with whom the audience is meant to sympathize. In fact, it could be argued that she becomes the real protagonist or that she and Cobb are dual protagonists. At first, we spend the most screen time with Cobb, but after the forty-eight-minute mark, Ariadne is just as much a part of the action as Cobb. Initially, we are meant to sympathize with Cobb and his troubles, but as the film progresses, we see that he withholds information (from the audience and from his partners) that might harm his partners, making him seem less reliable or forthcoming. Ariadne, on the other hand, seems incapable of withholding such information. At different times, the narration is restricted to Cobb's or Ariadne's knowledge, making each of them more sympathetic. We see Cobb's painful memories, and he has the most screen time, but as the film progresses, Cobb becomes more like a love interest in many other movies: qualities or characteristics about him are revealed to Ariadne and to the audience. Ariadne never withholds information from the audience, so she does not seem all-powerful but rather sympathetic to the audience.

The diagram clearly shows that the antagonists, Fisher and Mal, are almost always at a knowledge deficit when they are privy to important knowledge at all, particularly in the crucial latter portion of the film. This suggests that whatever drama there is in *Inception* does not originate from the more traditional protagonist/antagonist back-and-forth knowledge dynamic that is typical of Hollywood action-adventure films. Both the dearth of knowledge afforded the antagonists and the absence of this common pattern in knowledge range are instantly recognizable in the diagram, which suggests that most of the drama and conflict takes place via what Cobb relates to the audience and to other characters. The narrative appears, at first glance, to bear more of a resemblance to a psychological thriller than a traditional heist film.

conclusion

Comparisons of the diagram and the text depicting and describing changes in the range of knowledge across *Inception* reveal that the diagram conveys information about the entire narrative in far less time than the text. The technique of diagramming the range of knowledge across a narrative can be used to differentiate any type of film narrative from any other type of film narrative. We might use it to differentiate complex or 'puzzle' narratives from simpler narratives. Given prior research on complex narrative structure (e.g., Buckland 2009), we would expect puzzle narratives to possess greater diversity in terms of range and depth of audience knowledge over the course of their narratives than other films and to be content to leave the audience in the dark for greater portions of the film. The diagram of *Inception*'s narrative shows two potentially unique characteristics that confirm these hunches. The primary protagonist possesses and dispenses knowledge relevant to the plot throughout the film and does not alternate with antagonists. Additionally, the audience is not restricted to the primary protagonist's knowledge of these events. Instead, as the film progresses, the audience is increasingly likely to be restricted to a secondary protagonist's range of knowledge. Finally, the diagram shows quite clearly that the audience spends much of the narrative (particularly the first third of the narrative) at a knowledge deficit.

However, the diagram is unable to convey much of what makes *Inception* unique. In particular, it fails to convey the ways in which the film uses strategic restriction of viewer knowledge to alter the viewer's experience on a scene-by-scene basis. More generally, visual depictions of narratives result in a kind of flattening of the importance of each moment at which the range of knowledge changes. Revelations that occur late in narratives (e.g., in *Fight Club*, when it is revealed that Ed Norton's character is Tyler Durden, or, in *The Sixth Sense*, when it is revealed that Dr. Malcolm Crowe has been dead all along) tend to evoke a greater emotional

reaction on the part of the audience than revelations that occur earlier in narratives. Diagrams like the one used in this chapter do not convey that difference.

It would be ideal to create a diagram that could instantly convey all aspects of how it would feel to watch a particular movie. Would it be suspenseful? Would the second act drag? At which points would it be confusing, poignant, or funny? This exercise in diagramming the range of knowledge as it changes over the course of the narrative in *Inception* is a first step in exploring the potential of diagrams to do just that.

notes

1. There are, of course, many other characteristics of narratives that could be depicted, such as the presence of events that affect the protagonist's likelihood of achieving his or her goal (i.e., plot points). Based on analyses by screenwriting gurus (Field 1979; Nash and Oakley 1978) and film scholars (e.g., Thompson 1999), this particular characteristic does not vary a great deal; most films adhere to the three- or four-act structure. Given this lack of variation between films, such a characteristic would not be well suited to visual depiction unless it were to confirm one's hunch that, indeed, it does not vary a great deal between films.
2. An example of these graphics can be found at http://images.fastcompany.com/upload/InceptionArch_Slusher.jpg.

references

Bordwell, David. 1985. *Narration in the Fiction Film.* Madison: University of Wisconsin Press.

Bordwell, David. 2012. "Nolan vs. Nolan," August 19. www.davidbordwell.net/blog/2012/08/19/nolan-vs-nolan/.

Buckland, Warren. 2009. *Puzzle Films: Complex Storytelling in Contemporary Cinema.* Oxford: Wiley Blackwell.

Cutting, James E., Kaitlin L. Brunick, and Jordan E. DeLong. 2011. "How Act Structure Sculpts Shot Lengths and Shot Transitions in Hollywood Film." *Projections* 5(1): 1–16.

Elsaesser, Thomas and Warren Buckland. 2002. *Studying Contemporary American Film: A Guide to Movie Analysis.* London: Arnold.

Field, S. 1979. *Screenplay: The Foundations of Screenwriting.* New York: Delta.

Mitchell, Elvis. 2010. "The Treatment. Christopher Nolan: Inception." www.kcrw.com/etc/programs/tt/tt100714christopher_nolan.

Nash, Constance and Virginia Oakley. 1978. *The Screenwriters Handbook: Writing for the Movies.* New York: Harper Collins.

Nolan, Christopher and Jonathan Nolan. 2010. "Commentaries." Disc 1. *Insomnia.* Warner Home Video.

Panek, Elliot. 2006. "The Poet and the Detective: Defining the Psychological Puzzle Film." *Film Criticism* 31: 62–88.

Salt, Barry. 1974. "Statistical Style Analysis of Motion Pictures." *Film Quarterly* 28(1): 13–22.

Stephens, Chuck. 2001. "Past Imperfect." *Filmmaker* 9(2): 86–88, 117–119.

Sternberg, Meir. 1978. *Expositional Modes and Temporal Ordering in Fiction.* Baltimore: Johns Hopkins University Press.

Thompson, Kristin. 1999. *Storytelling in the New Hollywood: Understanding Classical Narrative Technique.* Cambridge, MA: Harvard University Press.

Tsivian, Yuri. 2009. "Cinemetrics, Part of the Humanities Infrastructure." In *Digital Tools in Media Studies,* ed. Michael Ross, Manfred Grauer, and Bernd Freisleben, 93–100. Piscataway, NJ: Transaction Publishing.

'pain is in the mind'

dream narrative in *inception*

and *shutter island*

p a o l o r u s s o

The similarities between Christopher Nolan's *Inception* and Martin Scorsese's *Shutter Island* have been pointed out by a few critics; while some attribute them to a supposed lack of creativity (Clover 2011) or to "Hollywood's mental block" (Cox 2010a), others focus on parallels between the two films, albeit largely from a specifically clinical, psychoanalytical perspective (Clarke 2012). Indeed, both films feature very similar backstories—a trauma occurred in the past to the male protagonist (played in both films by Leonardo DiCaprio) concerning the death of his wife following tragic circumstances. In *Inception,* corporate espionage contractor Cobb's actions are motivated by the desire to be reunited with his children from whom he was forced to part following an incriminating letter filed by his wife, Mal, to the authorities; in *Shutter Island,* federal marshal Teddy Daniels (whose real name is Andrew Laeddis) kills his wife, Dolores, because she murdered their three children.[1] In both stories dreams and hallucinations of the wives impact the present lives of the protagonists, which are driven by an obsession with conspiratorial plots leading to ambiguous endings. Furthermore,

the two films share similar visual imagery of dramatically steep cliffs and the recurrent element of water—sea, lake, river, harbor.

The main argument of this chapter moves from the assumption that the elements mentioned above constitute only the basic premise of the two stories. In fact, both films rely heavily on the use of dreams, memories, and hallucinations to emplot quite complex narrative structures that eventually differ substantially from each other. As I will show in the analysis that follows, *Shutter Island* ultimately revolves around specific strategies of unreliable narration as a result of the particular use of focalization techniques; in *Inception,* the representation of dreams achieves levels of complexity that question all perceptual logic of time and space as the result of a singular, linear cognitive process.

nontraditional use of traditional narrative elements in *inception*

Discussion of *Inception* so far has mostly sought possible answers to whether the spinning top topples at the very end and, as a corollary that questions the very status of the supposed reality in the film, whether the whole film is just one long dream (and whose). Whenever any attempt to extricate the complex narrative is made, analyses are mostly limited to the generic principles that govern the dream levels. This chapter seeks to explore the film's complex narrative by looking at its structural elements and salient plot points and by focusing on the unconventional treatment reserved to the screen:plot time ratio in relation to structure, with particular emphasis on dream sequences.[2]

At a macro-narrative level, the film consists of three clearly distinguishable acts, bookended by a short prologue (a two-minute prolepsis from Act 3 when Cobb finally finds Saito) and a coda (Cobb clearing passport control at LAX and finally returning home to his children). However, despite the subdivision into three acts, the narrative paradigm of *Inception* is far from classical. Figure 5.1 below plots out the main narrative segments within each individual act, thus showing their internal structure.

General consensus among both film narratologists and screenwriting gurus predicates a more or less even distribution of screen time per single act. The classical three-act paradigm calls for a 1:2:1 ratio, where 1 stands for a typical twenty-five- to thirty-minute range.[3] In *Inception* the ratio becomes an almost perfect although rather unusual 1:2:4, where 1 is reduced to roughly eighteen minutes of screen time, resulting in a relatively short first act and a much longer third act. This striking imbalance is justified by the narrative function of each act, as discussed below. It is also to be noted that the only fade to black of the whole film occurs at the close of Act 2, ending the sequence when for the first time Ariadne sneaks into Cobb's dream and finds out that he uses it as an addiction to relive his memories of Mal and his children. At 57:50 into any film with a classical

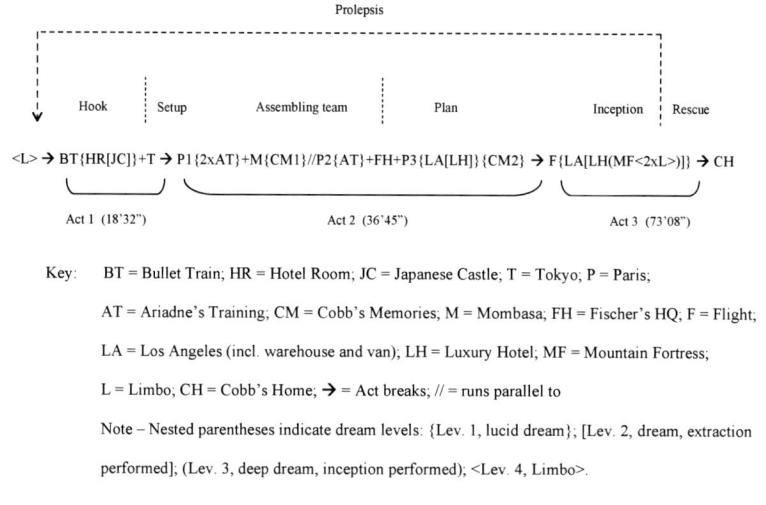

Prolepsis

| Hook | Setup | Assembling team | Plan | Inception | Rescue |

<L> → BT{HR[JC]}+T → P1{2xAT}+M{CM1}//P2{AT}+FH+P3{LA[LH]}{CM2} → F{LA[LH(MF<2xL>)]} → CH

Act 1 (18'32") Act 2 (36'45") Act 3 (73'08")

Key: BT = Bullet Train; HR = Hotel Room; JC = Japanese Castle; T = Tokyo; P = Paris;

AT = Ariadne's Training; CM = Cobb's Memories; M = Mombasa; FH = Fischer's HQ; F = Flight;

LA = Los Angeles (incl. warehouse and van); LH = Luxury Hotel; MF = Mountain Fortress;

L = Limbo; CH = Cobb's Home; → = Act breaks; // = runs parallel to

Note – Nested parentheses indicate dream levels: {Lev. 1, lucid dream}; [Lev. 2, dream, extraction performed]; (Lev. 3, deep dream, inception performed); <Lev. 4, Limbo>.

Figure 5.1 Main plot segments in the three acts of *Inception* (not scaled to time)

three-act structure, this would most likely mark the mid-point of the second act. In *Inception* it announces that Cobb's team is eventually ready to embark on its mission: more specifically, that the main plot concerning the inception of Fischer's mind can finally take off. What usually signals the beginning of the second act, in Nolan's film is pushed to and unfolds almost entirely throughout Act 3. The fade to black thus signposts visually a split into two distinct halves: the first half encompasses Acts 1 and 2; the second coincides with Act 3. As the analysis below seeks to show, this subdivision is in accord to the film's own internal logic based on the specific narrative function of each act—namely, priming (Act 1) and reframing (Act 2) the spectator's affective/cognitive relationship to the complex story elements and plotting strategies, and only afterward, unfolding the main plotline (Act 3) by employing those same strategies.

Act 1 can be further subdivided into two main segments: the first attempted extraction by Cobb (from Saito), and Saito tracking down Cobb and Arthur in Tokyo.[4] The failed extraction takes place in the course of the first complete dream sequence of the film, which interrupts the prologue abruptly. In a typical Hollywood blockbuster, a spectacular, action-ridden sequence such as this would work as an initial hook to establish the mood and genre of the story and, at the same time, captivate the viewers' emotional investment. But while a hook usually lasts only a few minutes, in *Inception* this segment is stretched to twelve minutes, about two-thirds of the whole first act. The longer duration serves the purpose of priming the viewer for the complex perceptual mechanism enacted throughout most of the main plotline. The opening hook plunges us *in media res* in the middle

91

of a dream within the dream, or level 2 dream, thus mirroring the reasoning outlined by Cobb to Ariadne later in the film, according to which whenever one becomes conscious of dreaming one never remembers the actual beginning of that dream. However, no clear frame of reference for the narrative world has been established yet; the events portrayed in the first few minutes look perfectly plausible in the generic context of what we immediately perceive as a heist plot—that is, Cobb trying to steal top secret documents from Saito's safe. Moreover, since all the characters appear to be awake, the most likely hypothesis would be to assume this to be the physical reality of the diegetic world.

The first hint that such a hypothesis is ill-grounded is given in Scene 5 (starting at 4:15), which cuts abruptly to a new character (Nash) supervising the same characters seen previously (Cobb, Arthur, and Saito) and now asleep and all plugged in to a silver briefcase via plastic tubes similar to the type used for intravenous infusions; while we may start to infer some kind of direct causal connection between the lines of action in the two scenes, the profilmic elements (i.e., different locations and costumes) and the narrative situation featured—the breaking of the Aristotelian unity of space, time, and action—make it more likely to perceive this scene as either an analepsis or prolepsis relative to the one in the Japanese castle that encapsulates it. We must wait until Scene 17 (8:51)—when Cobb is forced to kill Arthur, who then vanishes inexplicably from the Japanese castle to immediately wake up in the same hotel room of Scene 5, where Nash still stands—before we begin to understand that the two lines of action are actually linked in some way.

As the lower level in the Japanese castle becomes more and more unstable and begins to crumble, the cutting rate between the two levels intensifies parallel narration until the lower dream eventually collapses completely and the related thread comes to an abrupt close.

By this point we have received enough information to infer some kind of (narratively) logical connection between the two threads/levels; however, although we understand that the device inside the silver briefcase can somehow regulate a dreaming experience shared by several characters, its specific workings remain to be explained. A new situation is established in the decrepit hotel room, with Cobb and his team acknowledging the failure of their dream-induced extraction and trying to beat Saito's secrets out of him. Because dialogue makes it explicit that they were previously in a dream (the one in the Japanese castle), it is now plausible to formulate a new hypothesis: this scene must be portraying the actual diegetic reality. Because our emotional response tends to engage with the protagonist's, we do not realize that our knowledge of and evaluative attitude toward the events so far have been guided through Saito, not Cobb. And because Cobb and his allies are bluffing, thereby withholding relevant information from Saito, that same information is being withheld from us as well. We

realize that this level is just another dream, not reality, only when the narration cuts to yet another line of action, on a bullet train, in Scene 43 (12:10); a new character (Todashi) checks on the same characters from the decrepit hotel room scene (i.e., Cobb, Arthur, Saito, and Nash), who are asleep in their seats, all connected through a silver briefcase identical to the one seen before. As Jacob Lothe points out, the repetition of similar or identical narrative events with even slight pattern variations is a powerful tool to accrue and intensify the meaning being conveyed (2000, 63–64). Similarly, by providing a repetition of the same induced dreaming device already seen twice previously, with the added variation of the character controlling the technology being used, the scene in the bullet train finally allows us to reframe our initial hypotheses about reality and dream levels in the film, and we can now begin to infer a discernible pattern.[5]

The second segment of Act 1 consists of two beats. The first beat opens on Cobb, alone in his hotel suite in Tokyo, fiddling with a small spinning top. He stares intensely at his gun; for a moment we are tempted to think he may be contemplating suicide, until he receives a phone call from his children. This scene provides a breather after the adrenaline-filled opening but also unveils some vital information related to Cobb's backstory: his wife, Mal, may either have left his family or be dead, and for some reason he cannot go back home to his beloved children, which establishes the protagonist's want. This last piece of information pays off in the second beat of this segment, when Saito—so far perceived as Cobb's antagonist—offers Cobb a unique chance to obtain what he wants in exchange for his services to implant in the mind of Saito's main competitor's heir the idea of breaking up the competitor's economic empire. This works as the conventional device that incites the incident—that is, an unexpected event that will eventually trigger the decision to act; as in most goal-oriented stories, the successful completion of the action line (in this specific case, the inception plotline) will enable the protagonist to overcome his main problem in the relationship line.[6] Because Saito can use his powerful connections to solve Cobb's problem as leverage to lure him into accepting his offer, Cobb quickly changes his mind and accepts the call to this dangerous adventure after the initial refusal and despite Arthur's reluctance.

At this point, in a traditional paradigm the main plot would be delayed slightly to allow the protagonist some time to hatch a plan with the aid of mentors and/or helpers, so as to get ready to embark on the assigned mission/journey by the end of the first act, around the thirty-minute mark. This is indeed what happens in *Inception,* too, with Cobb scouting Ariadne in Paris and enrolling Eames and Yusuf in Mombasa; however, this section is expanded substantially into an autonomous act of its own. As a result, Act 1 is squeezed down to a mere eighteen minutes, to include just the opening hook and the setup of the plot; any real development of the latter is then delayed until Act 3.

'pain is in the mind'

The complex nested dream structure of the long hook sequence has thus established a rather unfamiliar framework—that is, our "preferred set of cognitive, evaluative, and emotional responses to the story" (Currie 2010, 86). When challenged with nontraditional schemata, we tend to respond with some resistance. In the specific case of *Inception,* in Act 1 we witness how the whole nested dream device is executed in all its components—dreamers and victim (or subject), the silver briefcase device infusing the yellow liquid, dream levels becoming unstable, dreamers being woken up, the countdown, the kicks—but we still do not know exactly how all this works as a whole. Act 2 provides the opportunity for a reframing: Ariadne's training in Paris explains the architecture of the dreams to be designed—that is, structure, layout, and linkages. Cobb's meetings with Eames and Yusuf in Mombasa provide the scientific and technological explanation for the PASIV device (i.e., the silver briefcase) and the sedative compound used to induce shared dreaming in the participants. In other words, by showing how Cobb's team is trained, Act 2 teaches the viewers the rules of the game, thus setting the very conditions for spectatorship that will favor pattern recognition in the final act. Furthermore, in the latter part of Act 2, the whole team virtually recreates the locations of the first two dream levels designed by Ariadne (i.e., the now empty boulevards of Los Angeles, as well as the luxury hotel) while illustrating the main steps of the plan. As opposed to the rather gap-ridden information provided in Act 1, this excess of narrative intentionality results in a redundancy of information, which compensates for the structural complexity in order to render the framework more stable by correcting the displacement of the spectator's affective positioning, or what Roger Odin calls "dephasage" (1995, 219).[7]

the dream level structure

After the setup, Ariadne replaces incompetent and renegade Nash as the team architect in charge of designing all three levels of dreams required to carry out the inception plan in Act 3.[8] Her training shows her (and us) that each single dream is controlled (cognitively) by one dreamer and shared by the subject (i.e., the designed victim of the extraction or inception) and the dreamer's accomplices. In an interesting article, Graham Clarke suggests a comparison between the dream architecture of *Inception* and Freud's topographic theory of inner reality, which structures dreams on three levels of depth: conscious, preconscious, unconscious (Clarke 2012, 208).[9] If we apply Freud's paradigm to the dream sequences, the first, or conscious, level is that of lucid dreaming: on this level the dreamer is able to maintain sufficient awareness of his or her own cognitive faculties to influence and drive the designed plot forward in order to manipulate the subject's unconscious.[10] Extraction is possible on this level but not easy. This is a

semiconscious state; therefore a particularly alert victim may render the task quite difficult or, as in the case of specifically trained subjects such as Saito and Fischer, nearly impossible. For this reason, the extractors need to descend to the second, preconscious, level, where cognitive defense mechanisms are still not completely absent but are much weakened. In order to accomplish this, a different dreamer is needed, for two reasons. First, one character has to stay behind (or, more appropriately, above) to prepare all the other dreamers and start the musical countdown that will synchronize the kicks used to wake up everybody in the upper level before the effect of the compound wears off or in case of unexpected complications. Second, although only virtually and in relation to the previous dream, according to the logic of the narrative the new level would be the first (conscious) level of active dreaming for the new dreamer but the second down (preconscious) for the first dreamer, who, therefore, would not be able to control it adequately.

Performing inception is even more difficult because in order to plant an idea in the inceptee's mind the inceptors must make sure that the subject cannot trace the origin of that idea back to them. Another, deeper level is therefore required to reach the subject's unconscious, the third according to Freud's topography. As Henry M. Taylor points out, travelling down the vertical axis of penetration can be successful because at the unconscious level the inceptors can access, stimulate, and manipulate the thoughts and emotions of the subject (2012, 4). Leaving aside psychoanalysis, this is the very core of drama: Cobb is moved to take action when Saito touches the sensitive nerve of his affective relations; conversely, anticipating that Fischer would oppose resistance even at the second level, Cobb and his acolytes double-cross him by having Eames be disguised as Browning (a surrogate father figure) to infiltrate and manipulate Fischer's affective troubles (with his real father), thus turning another antagonist into an ally. In a nutshell, when it comes to affects (portrayed through the relationship line) characters become emotionally vulnerable and lose sight of objective reality (apparently tracked through the action line). Conversely, by manipulating our spectatorial affective positioning with the enactment of these very complex narrative strategies, Nolan makes our resistance to such unusual framing vulnerable. Warren Buckland proposes a critique of the disembodied passive spectator assumed by much psychoanalytic film theory that privileges the unconscious mind and vision. He quotes cognitive linguists George Lakoff and Mark Johnson to argue that experience-based perceptual input is structured by image schemata that "are inherently meaningful because they gain their meaning directly from the body's innate sensory-motor capacities" (2000, 27, 40). The dream structure in *Inception* follows a similar logic by staging a state of simultaneous acting/spectatorship whereby mental images (of mentally generated events), although not material, are perceived as cognitively real by the characters because they

are generated by stimulation of their bodies' sensory-motor faculties (via the PASIV device), and are also perceived as motivated because they reach the affective core of their unconscious.

Level 4 is Limbo. In his article, Clarke mentions Lacan to describe this as the deepest level of the "real unconscious . . . where space and time dissolve" (Clarke 2012, 210). In fact, Clarke refers to Lacan's notion of the self-contained mother–child dyad unit to explain Cobb's cathexis for Mal. The analogy, though, is well suited and extends Freud's topographic paradigm to an additional deeper level (Limbo), which Cobb himself describes as a "raw infinite subconscious, unconstructed dream space" where, due to altered perception, time seems to expand indefinitely.

The nested structure thus makes the narrative causation work along the ideal horizontal/chronological time axis on each individual dream level and, at the same time, down the vertical axis of the dream levels synchronically at the points of interaction between levels. Such a complex architecture requires a specific time pattern for the logic of narrative causation to maintain consistency and believability. The required pattern is determined by the chemistry of the compound used with the PASIV device. Yusuf's compound is powerful enough to last up to ten hours and to alter (i.e., slow down) time perception by a 1:20 ratio each level down.[11] Table 5.1 lists the maximum amount of plot time that the characters could spend on each level, should they stay there until the effect of the sedation wears off.

Fortunately, Cobb's team doesn't need that long, and the actual amount of time they are asleep in reality depends on how long it takes them on Level 1 (the Los Angeles designed by Ariadne) to kidnap Fischer, dupe him with the fake Browning impersonated by Eames, and put him and everybody else to sleep to go down one more level. Because screen time narration incorporates conventional ellipses, it is not possible to establish the exact plot time spent on this level. A rough but reliable estimate is possible though: allowing 20 minutes for the car chase, 5 minutes debriefing at the warehouse, 1 hour (as declared twice by the characters) for Fischer's interrogation, 5 minutes for the second gunfight and at least 10 more minutes for the van ride until the bridge, we get to around 100 minutes. Based on the 1:20 ratio, all the characters—with the exclusion of Cobb and Saito, who remain trapped in Limbo—wake up on the plane after no more than five minutes (of the ten hours available) in reality.[12]

Table 5.1 Maximum plot time on each level, based on Yusuf's compound

Level	Time
0—Reality	10 hours
1—Lucid dream	8 days, 8 hours
2—Extraction	5 months, 16 days, 16 hours
3—Inception	9 years, 3 months, 3 days, 8 hours

The actual plot duration of Level 2—which takes place entirely in the luxury hotel—is determined by the moment Yusuf plugs in the PASIV device before driving the van across Los Angeles; ostensibly, this segment corresponds to the last ten minutes (plot time) of Level 1, amounting to three hours and twenty minutes available to Arthur (the second dreamer) inside the hotel. Even more importantly, accurate parallel editing becomes crucial from the minute the dreamer in the next level up starts the musical countdown to synchronize the action in the lower levels between the two kicks. The double kick allows the dreamer in the next level down to make fairly accurate calculations of the time remaining to complete his or her task.[13] As declared through dialogue, Yusuf's van's freefall off the bridge will last ten seconds (Level 1 plot time), which, theoretically, would give Arthur three minutes and twenty seconds down on Level 2. Unfortunately, despite being alerted by the musical countdown, Arthur wastes much of his kick time having to fight the projections of Fischer's security men, which causes him to miss the first kick from above and saves him about only two minutes (Level 2 plot time) to tie up his mates, push the human bundle inside the elevator, place the charges in the shaft, and press the detonator remote control—that is, his first kick. By this time, however, the new group of dreamers who enter Level 3 (on the snowy mountains) have already been asleep for about forty minutes (Level 2 plot time). This estimate is made possible once again by parallel editing, as the dreamers in Level 2 are put to sleep roughly when Yusuf's van rolls down the embankment, corresponding to at least the last two minutes on Level 1. This equals to more than thirteen hours (Level 3 plot time) available to Cobb's squad to rappel down the rocky escarpment, ski down the white slopes, and assault the fortress/hospital. When Arthur hits the detonator, thus initiating the first kick on Level 2, Yusuf's van is only one second (Level 1 plot time) away from hitting the river surface; as a result, the elevator's freefall through the shaft will last twenty seconds, which gives Eames and Fischer about six-and-a-half minutes in the strong room to finally perform inception, which takes place in the climactic moment of Act 3.

When he eventually faces the projection of his dying father, Fischer has just been revived by Eames in sync with his return from Limbo (Level 4), where he falls after Mal shoots him inside the fortress on Level 3. When, on Ariadne's suggestion, Cobb decides to take his chance and go down one more level to try and rescue Fischer, it takes Eames around two minutes (Level 3 plot time) before he can power up the defibrillator and shock Fischer. This gives Ariadne and Cobb around forty minutes in Level 4 to locate Mal and Fischer, which they do shortly before hearing Eames's kick (another denotation) from Level 3. Ariadne jumps off the skyscraper, thus waking up and riding up level after level right before each one of them collapses, until she is finally able to swim out of the river in Level 1 and gasp for air. Level 1 can be considered a master dream level, since everybody needs to wake up on this

level in order to be able to wake up in reality. Cobb stays down because he needs to find and rescue Saito, or he will not be able to achieve his goal: to be reunited with his children. Because he misses Eames's kick, Cobb does not wake up in any of the upper levels, which means that he dies in the explosion that destroys the fortress; he dies in the violent impact and subsequent explosion of the elevator at the bottom of the shaft; and he dies one last time by drowning inside the van that sinks into the river. The result of Cobb's multiple deaths in the upper dream levels while under such heavy sedation means that he falls back down to Limbo again and, like Saito, will not be able to wake up in reality. As we learn from the flashes that show Cobb's memories of the time he and Mal spent there, there are only two ways to exit Limbo. In the easiest instance, one simply wakes up once the sedation wears off. However, that option is no longer viable when one dies in a dream when too sedated and, as a consequence of that, subsequently falls into Limbo; in any such case, one has to kill oneself. The problem with this, as Cobb explains to his team in the warehouse when Saito is wounded, is that in Limbo dreamers reach a state of "raw infinite subconscious," meaning that those who end up down there do not know or realize they are dreaming. Ironically, the symbolic totem that caused Mal's suicide and originated Cobb's inner conflict, the spinning top, now comes to Cobb and Saito's aid. Seeing it triggers the memory of a "half-remembered dream" in Saito as anticipated as early as in the prologue; although their cognitive capacities are reduced to the extent that they cannot suspect that they are dreaming, it is enough for Cobb and Saito to postulate that "this world is not real" and to take a "leap of faith." The scene cuts before we can be shown whether they actually kill themselves, but Saito grabbing the gun when Cobb asks him to "come back with me" in order "to honor our arrangement" is enough audiovisual information to hypothesize that they do.[14] When they wake up, the flight attendant announces that they will land in about 20 minutes, which means that they overslept the 10 hours of the compound sedation effect and have in fact been under for about 12 hours, minus the 5-minute dream (Level 0 plot time), or 220 years (Level 4/Limbo plot time) (Table 5.2).[15]

Since our perception of time is linked to the physical world, our perception of narrative time is determined by what we perceive as the physical world in the film diegesis. Therefore, once Level 0 is established as the

Table 5.2 Actual plot time spent on each level while dreaming

Level	Time
0—Reality	5 minutes (Cobb and Saito: 12 hours)
1—Lucid dream	1 hour, 40 minutes
2—Extraction	3 hours, 20 minutes
3—Inception	13 hours, 20 minutes
4—Limbo	220 years, 8 months, 4 days (only Cobb and Saito)

baseline reality, our narrative schemata formulate the expectation to find the characters as specifically located finite agents: "Finite agents have locations in space and time, with consequently limited access to other such locations" (Currie 2010, 89). The nested structure of the dream sections destabilizes this assumption, at least in the first segment of Act 1 and throughout Act 3.[16] The real challenge presented by *Inception* lies in its complex use of the represented/representational time ratio (or plot/screen time ratio).[17] Along the ideal horizontal time axis within each individual dream level, Nolan employs several types of duration: scene (1:1), ellipsis (1:n), expansion (n:1)—all of which are quite traditional narrative devices. Even the external analepses of Cobb's memories of his wife or the implicit, internal prolepsis that bookends most of the film, as disorienting as they may be in fragmenting and reshuffling the chronological order of events, are quite conventional. Structural complexity becomes evident when we explore the tentacular matrix that combines the horizontal with the vertical axes because the main assumption of the narrative is that the same characters are involved in the causally linked but clearly distinct lines of action of multiple threads that run simultaneously, thus seemingly contradicting the finiteness of their agency and the limited accessibility of different spatiotemporal locations. The fact that when a new line of action starts on a deeper dream level the dreaming characters are asleep in the upper level does not mean that these characters are passive and just inert since the outcome of one line of action will impact the other. The same device is then further repeated in more nested levels and thus shapes a systematic pattern. The key to reading this pattern is provided by the added complication of altered time perception that follows the same 1:20 rule (or 1:12 in earlier acts of the film), which results in the seeming paradox of simultaneous lines of action that, however, can be neither zeugmatic nor codiegetic.[18] The complex dream structure of *Inception* must instead be seen as eso-diegetic because each level down is nested within and originated from the previous one, and the related lines of action interfere with and threaten each other, as analyzed above.

spectatorial aesthetic defense in *shutter island*

Much critical literature has focused on the symptomatology of the protagonist from a psychoanalytical perspective as in the case of *Shutter Island*'s Teddy Daniels/Andrew Laeddis, especially with a recurrent preoccupation of verifying how the film portrays mental disorders (Clarke 2010; Cox 2010a). Frances Pheasant-Kelly relies on Julia Kristeva's notion of the abject to offer a different reading, which links the protagonist's PTSD and denial to flashbacks and hallucinations in the film narrative (Pheasant-Kelly 2012). More interestingly, Jeremy Clyman suggests that Daniels suffers from a mixed type of DD (delusional disorder) and points out that, according to the *DSM-IV*, subjects affected by this kind of disorder are cognitively,

socially, and emotionally high functioning and experience their delusional state "without clear mental hiccups" (Clyman 2010). This is a fundamental aspect to consider in order to understand *Shutter Island* correctly as a mind-game film, of which it features all the elements as expounded by Thomas Elsaesser (2009). The protagonist suffers from a delusional state caused by excessive grief following traumatic events that occurred to his family; in order to maintain the delusion, he sets out to unveil a conspiracy, which will be revealed to be another fabrication of his mind. Most important, this type of film enacts the very condition that affects the protagonist as its main narrative device, without marking off which segments or acts narrate a fabrication and which ones the supposed diegetic reality of the story (Bordwell 2006, 80–81; Elsaesser 2009, 18–20). In *Shutter Island* this is made even more complex by the role play therapy that Daniels is subjected to, which adds a second layer of simulation to Daniels's own fabrications. The main challenge when analyzing the film narrative is identifying the reality status of each segment in the various lines of action.[19]

A cursory reading of the plot points advancing the main action line shows that *Shutter Island* apparently adheres to a fairly linear three-act paradigm and follows the 1:2:1 rule of screen time distribution, although it is slightly imbalanced by a longer second act, as is evident in the summary below.

Act 1 (29:02): Daniels and Aule arrive at Shutter Island. Investigation on disappearance of Rachel Solando begins.

Act 2 (67:05; breaks at 96:07): Daniels and Aule are stranded on the island. Solando is found. Daniels suspects conspiracy and parts from Aule.

Act 3 (29:08; ends at 125:15, sans credits): Daniels breaks into the lighthouse determined to expose the conspiracy, only to be confronted by Doctor Cawley.

Looking more specifically at the internal segments within each of the three acts, the initial setup establishes the time setting of the diegetic present (i.e., 1954), the protagonists, and the one-location space setting of the story—that is, the ominous Ashecliffe Hospital for the Criminally Insane, which is on the top of the almost inaccessible Shutter Island, off the Boston Harbor. Doctor Cawley's recount of the mysterious disappearance of one dangerous patient (Rachel Solando) functions as the incident (at 10:40) that incites the main action/plotline—that is, Teddy's investigation to find Solando. Realizing that neither the hospital staff nor the senior members of the board of overseers are keen on collaborating, Teddy resolves to end the investigation and report back. However, a huge storm prevents him from leaving; at 29:09 into the film, this unexpected complication is the first major turning point as it foils Teddy's plan and traps him on the island, thus marking the start of Act 2. In the first part of the second act, Teddy introduces a subplot, exposing to Chuck the real reason why he asked to be assigned to this case: while

investigating the case of a former patient (a socialist named Noyce), he discovered that Ashecliffe is funded by the HUAC to conduct experiments on the human mind. Although revealed completely through dialogue, this constitutes a major revelation because it triggers a second plotline, which revolves around a potential conspiracy Teddy was supposedly aware of all along. Given that this piece of information had been withheld from us thus far, we need to reframe our expectations and reformulate hypotheses. Teddy's double agenda also eventually establishes Ashecliffe's personnel, particularly Cawley, Naehring, and the wardens, as his clear and dangerous antagonists, who, as active players in the conspiracy, and with the added complication of physical isolation in a hostile environment, may put his life at risk. The need for such a rephasage is reinforced in the next segment when Solando is found, thus leading what we assumed to be the main plotline to an abrupt close via an anticlimactic mid-point (from 49:19 to 61:32).

In a classical narrative, a subplot is usually thematically linked to the emotional investment of the protagonist; often started in the second half of the first act, the subplot is then regularly interwoven with the main action line throughout the second act until it is played out as a consequence of significant events that impact the protagonist's life. In *Shutter Island,* the addition of a subplot (the conspiracy plot) is delayed until Act 2, but after the midpoint it replaces the line of action that was established in Act 1 as the main plotline (the Solando investigation plot) altogether. As a result, what initially seemed a straightforwardly linear narrative organization begins to fragment into two separate, although connected, lines of action. The forward progress of the new line of action is ensured by a number of discreet segments throughout the rest of Act 2: Teddy meeting Noyce in Ward C of the hospital; Teddy becoming suspicious and deciding to part from Chuck; Teddy meeting in the cave with the 'real' Rachel Solando, whose recount seems to confirm his suspicions about the inhumane experiments conducted in the lighthouse; Teddy eventually returning to the hospital. While Teddy's confrontation with Naehring provides the climax that leads into Act 3, it is his final confrontation with doctors Cawley and Sheehan (the latter being Chuck Aule's true identity) that causes the next real narrative break. Their exposition of Daniels/Laeddis's backstory and of the therapeutic role game they involved him in does not simply gradually but quickly dismantle Teddy's delusions piece by piece until he finally breaks down; it also exhausts (at 118:52) the conspiracy plot started in Act 2, thus calling for an even more radical reframing of our perception of the whole story, which we realize so late into the film to have been just a simulation. This is made possible, once again, by a persistent and consistent use of unreliable narration through what we initially assumed to be internal focalization guided through Teddy's disturbed character, when, in fact, the narration was externally focalized—that is, we know less than what the characters know, despite assuming the opposite. Having to reclassify both lines of action developed thus far as a product of Teddy's mental state, what we can

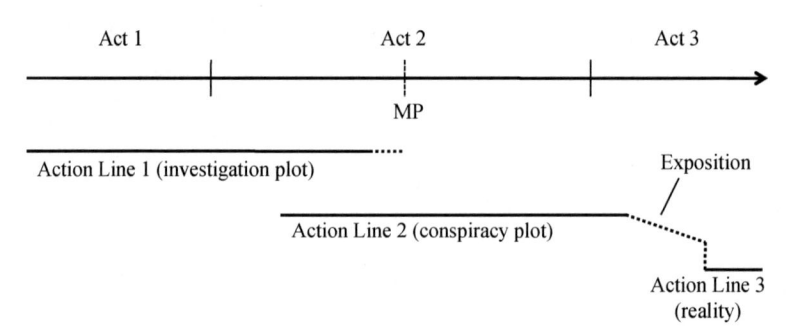

Figure 5.2 Three action lines in *Shutter Island*

finally perceive as objective reality of the diegetic world of the film is limited to the last 6:23. The supposed linearity of Scorsese's film thus presents a three-layer fragmentation that is best represented by the diagram in Figure 5.2.

In her thorough analysis of *Shutter Island*, Pheasant-Kelly identifies three narrative strands that differ from the three lines of action illustrated above (Pheasant-Kelly 2012, 219). Pheasant-Kelly distinguishes between two strands that refer to Teddy's backstory as presented in the flashbacks that visualize his traumatic experiences on the day of the liberation of Dachau and following the death of his family, and a third strand referring to the action line that unfolds in the diegetic present on the island. As shown above, this third strand is in fact itself split into three distinct action lines. The resulting structure is therefore determined by how and when the analepses that illustrate Teddy's traumatic past experiences interrupt these three action lines. The narrative content of these analepses originates from Teddy's memories, dreams, and hallucinations and can be summed up as follows.

action line 1 (investigation plot)

- Flashback 1 (F1: few frames; begins at 2:43): brief memory flashes of Teddy's wife, happy. Triggered by Aule's question about wife while on ferry.
- Flashback 2 (F2: :04 at 11:32): memory flashes in fast montage of four shots of dead bodies and a little girl at Dachau's concentration camp. Triggered by picture of fake Rachel Solando shown to Teddy by Cawley.
- Flashback 3 (F3: :05 at 20:18, and 1:35 at 22:09): illustrative flashback of Teddy kicking away gun from agonizing Nazi commandant, thus condemning him to a slow death; alternates with Jewish prisoners in camp. Triggered by Mahler's record playing and by Naehring's presence in Cawley's quarters.
- Dream 1 (D1: 2:40 at 26:28): asleep (drugged) Teddy dreams of his troubled life with wife Dolores. She exhorts him to face the fact that she is dead before she crumbles to ashes.

action line 2 (conspiracy plot)

- Dream 2 (D2: 4:45 at 55:17): Teddy asleep (drugged). Images of Dolores and her dead children at the lake mix up with images of the woman and the little girl from the concentration camp and of Laeddis and Aule in Cawley's studio. Teddy wakes up within the dream (thus revealing that the above was a dream within the dream) and is approached by Dolores who exhorts him to kill Laeddis.
- Hallucination 1 (H1: :16 at 71:55): Teddy's wife materializes in Ward C. Triggered by Noyce's warning, "She's fucking with your head."
- Hallucination 2 (H2: 1:23 at 96:03): Dolores and the little girl from Dachau try to dissuade Teddy from going to the lighthouse.
- Hallucination 3 (H3: :09 at 102:53): Dolores warns Teddy once more.
- Hallucination 4 plus Flashback 4 (H4+F4: 6:20 at 102:53): Dolores and the little girl appear one last time in the lighthouse before the scene cuts to Teddy's recollection of his family's tragedy at the lake. Triggered by Cawley's recount; eventually triggers Action Line 3 (reality).

The sequence of analepses outlined above follows a discernable pattern, moving from memories to dreams, and from dreams to hallucinations as the action shifts from one plotline to the next. The initial memory flashes (F1 and F2) expand into a longer flashback proper (F3) and provide background information regarding Teddy's past that still seemingly retains a certain internal and external coherence. Such coherence is soon lost in the subsequent dreams (D1 and D2), even though the oneiric state would justify the lack thereof in these instances. However, it is to be noted how the two backstory lines (Dachau and the family's tragedy) conflate in the last dream (D2), thus signaling Teddy's fast deteriorating state of mind. Not randomly, all memories occur during the role play therapy action wherein most events still appear to be verisimilar; dreams instead lead to hallucinations as the conspiracy plotline progresses. From D2 on, all logical coherence gives way to glaring hallucinations until Cawley's reconstruction of past events reinstates it forcibly, causing Teddy's eventual breakdown, the end of all simulations, and the traumatic return to reality. Furthermore, as soon as we mentally process Cawley's exposition and validate his account, we need to retrospectively reconsider Teddy's meetings with Noyce (in Ward C) and the 'real' Rachel Solando (in the cave)—both occurred within the conspiracy plotline—as further hallucinations [H(N) and H(RS)].

If we then update the diagram from Figure 5.2 based on this analysis by adding all the occurrences when the various analepses caused by dreams, memory flashes, and hallucinations interrupt the forward progress of the three action lines, we obtain a rather complex overall structure that, as shown in the new diagram in Figure 5.3, cannot be easily dismissed as just "an old-fashioned noirish thriller that ends with a massive twist" (Cox 2010b).[20]

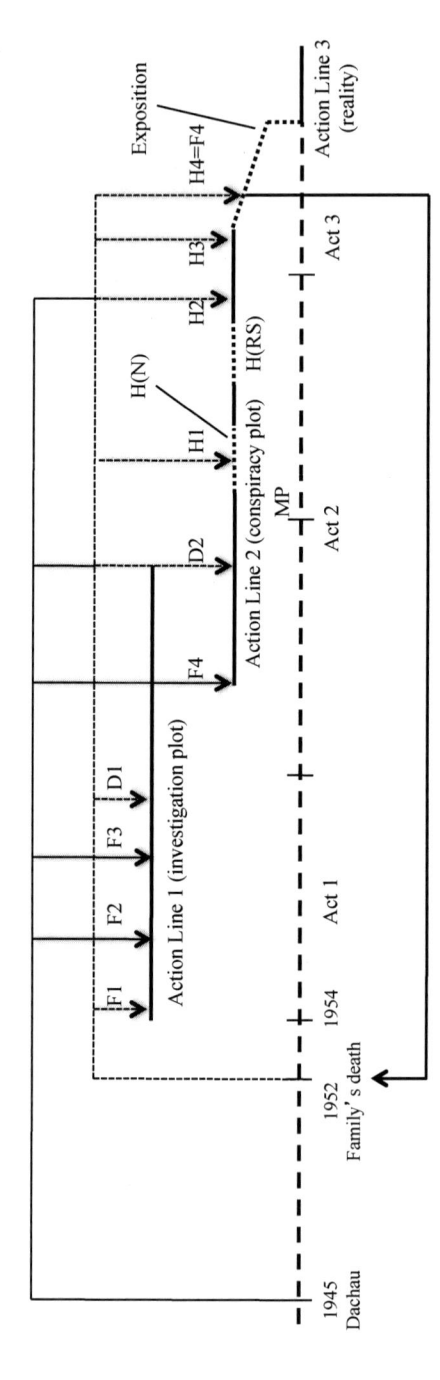

Figure 5.3 The complex narrative structure of *Shutter Island*

Clarke proposes the intriguing notion of "moral defense" as the unifying theme between *Inception* and *Shutter Island*.[21] By applying Ronald Fairbairn's theory of object relations, he argues that both Cobb and Daniels/Laeddis have internalized their respective wives as bad objects; since their libidinal cathexis for them prevents both protagonists to part from these bad objects, they make them acceptable to themselves thus opposing powerful resistance to cure (Clarke 2012, 203–209). As both *Inception* and *Shutter Island* enact this very dynamic as their own strategic justification for narrative complexity, our cognitive activity as spectator opposes a similar defense mechanism to the multiple reframing enacted, mostly due to misleading focalization; it is therefore necessary to be ready to give up this aesthetic defense in order to fully comprehend the complexity of the two films.

notes

1. In the flashbacks set in Dachau, Daniels/Laeddis letting a Nazi commandant agonize and, along with the rest of his platoon, executing all the German soldiers can also be seen as an emotional reaction to the shock of seeing so many dead bodies piled up and a dying little girl. Note: this analysis assumes the reader's familiarity with the story and characters of both films.
2. Scope and focus of this study therefore exclude any commentaries on possible plot holes, goofs, and incongruities; riddles and enigmas; philosophical ambiguities or scientific validity.
3. In fact, third acts are often shorter than first acts. Advocates of four-act models, such as Kristin Thompson, adopt a 1:1:1:1 ratio.
4. On the bullet train, before Saito wakes up, Cobb announces he is getting off at Kyoto. However, the shooting script indicates Tokyo in all the scene headings for this segment; the helicopter sequence was shot on and off the rooftop heliport of ARK Hills in central Tokyo.
5. Significantly, Scene 43 in the bullet train was Scene 7 in the shooting script, immediately after the first presentation of the line of action in the decrepit hotel room with Nash (Nolan 2010, 27). By delaying it by about seven more minutes in the final edit, Nolan does not give away the pattern of his nested dream narrative too soon and allows the spectators enough time to process the information and constantly reframe hypotheses. Scene numbering adopted in this chapter follows scriptwriting conventions (i.e., new scene at every change of location) and refers to the final cut of the film, not the published shooting script.
6. In order to do so, though, Cobb will also have to solve his inner conflict caused by his sense of guilt for Mal's death.
7. An alternative reading of the main plot points that applied Joseph Campbell's (2004) and Christopher Vogler's (1998) hero's journey model would identify the crossing of the so-called first threshold at the beginning of the main dream/inception plot aboard the flight to Los Angeles, which marks the beginning of both the physical and the emotional journey (i.e., the action and the relationship lines) of the protagonist. However, the threshold also stands for the entrance into the second act. This

means that what I have identified as Act 1 and Act 2 so far would have to be considered as a very long Act 1. In fact, in it we could trace all the steps included by Vogler in the first act of his model structure—the ordinary world, the call to and initial refusal of the adventure, the meeting with the mentor (Miles), and the preparation to cross the threshold—with the significant addition of "allies, enemies and tests," which constitutes the first part of the second act in Vogler's model but that in *Inception* would be subsumed into the long Act 1 according to this breakdown. The main dream/inception plot (Act 3 in my analysis) then becomes Act 2: the first part, up until all three dream levels are set up, provides the rising action or, quite appropriately in the case of Nolan's film, the approach to the inmost cave; whereas the subsequent crescendo of set-backs and near death moments build up the complicating action leading to the climactic ordeal, the actual inception of the idea in Fischer's mind in the strong room/hospital scene. When all characters ride up all the collapsing levels through the synchronized kicks, they actually cross the second threshold to safely return to their ordinary world; all but Cobb, who remains in Limbo to rescue Saito. The second threshold signposts the beginning of Act 3, wherein Cobb must literally face death one more time since he and Saito have to kill themselves in order to "return with the elixir"—that is, Cobb's finally being able to reunite with his children. While this shows that *Inception* makes use of Campbell/Vogler's mythic structure, a quick check of the screen time reveals that it does so in quite an unconventional way: with Act 1 running for around 56:10 and Act 2 for 71:00, the whole of Act 3 is squeezed to just 5:10. Still following Campbell's model, one could identify archetypal characters (Mal as the queen goddess/temptress, Miles as the mystagogue, albeit in a quite marginal role) and motifs (the mystical marriage with the goddess/Mal, which gives Cobb mastery of their dream world; Ariadne's initiation to the dream techniques; the atonement with the father, although surrogated through Fischer).

8. This is true with the notable exception of a few changes made by Eames at the lowermost level, the revelation of which to Cobb provides the narrative device for one last, almost fatal complication when it unleashes his unconscious in the shape of Mal's vengeful projection. Initially, Ariadne is not supposed to take part in the operation but decides to join Cobb's team when she finds out about his addiction to dreaming memories of his dead wife. While she is never the dreamer of any level, being the architect Ariadne knows well the maze-like structure of all levels and is eventually able to save Cobb from Mal.

9. Although he praises some aspects of the film, Clarke brands it "a caricature of psychoanalysis" (2012, 208), missing the all important point that genre films work by narrative necessity, by condensation.

10. The characters in the film use the lay term *subconscious*.

11. In order to render this altered perception of time in *Inception*, slow-motion is used in an upper dream level whenever a kick penetrates one level down—and extreme slow-motion when the kick reaches the second level down.

12. This easily explains why all other characters are already awake (they have been for hours) when Cobb and Saito eventually wake up. Fischer would most likely wake up later than Cobb's team since, as shown twice earlier in Act 1, the victim of the extraction/inception is kept under heavier sedation

to give time to the extractors to unplug everybody and hide the silver briefcase so as not to arouse suspicion.

13. The first kick—caused by the van hurting a barrier on Level 1 and by a detonation in an elevator shaft on Level 2—sets a vehicle carrying all the dreaming characters (the van and the elevator, respectively) in freefall vertical motion until it impacts a surface—that is, the second kick.

14. It is irrelevant to know who kills the other first and then commits suicide, or whether they take turns in shooting themselves.

15. In fact, this is the time Saito spends in Limbo, as he dies before Cobb. I will not try to explain here why Saito has aged in Limbo whereas Cobb does not.

16. The shorter dream sequences in Act 2 feature some of the protagonists going down only one level, mainly with the sole purpose of training Ariadne or planning Fischer's inception. Because the characters that are asleep in these scenes are not tasked with any other particular plot, these sequences do not differ from usual representations of dreams in film—that is, a dreamer shown asleep before the scene cuts to a visual representation of the dream.

17. Taylor hints briefly at this but does not explore the issue further (2012, 12).

18. A zeugmatic pattern (e.g., Yusuf dreams Dream 1, then Arthur dreams Dream 2, etc.) would establish the action of dreaming as the governing principle of the parallelism between the various levels but would not explicate the unusual temporal relations instated by such parallelism. A pattern defined as codiegetic would explain simultaneity of action (e.g., Eames dreams Dream 3 while Arthur dreams Dream 2 while Yusuf dreams Dream 1) but neither the fact that each dream level down matches only the last temporal segment of the previous upper level, and therefore a limited portion of it, nor the mentioned apparent paradox of a shorter screen time (in the lower level) nonetheless perceived as considerably longer in terms of plot time, which defies, at least in part, the very notion of simultaneity.

19. As with *Inception,* I do not set forth to providing any specific interpretation of the ambiguous ending of *Shutter Island.*

20. Cox's remark also fails to acknowledge that Hollywood's classic films noir of the 1940s in particular were highly innovative in their use of countless and often intricately complex variations of flashback structures.

21. Clarke's comparison includes Nolan's *Memento* as well.

references

Bordwell, David. 2006. *The Way Hollywood Tells It: Story and Style in Modern Movies.* Berkeley: California University Press.

Buckland, Warren. 2000. *The Cognitive Semiotics of Film.* Cambridge: Cambridge University Press.

Campbell, Joseph. 2004. *The Hero With a Thousand Faces.* Princeton, NJ: Princeton University Press [first published in 1949].

Clarke, Graham. 2012. "Failures of the 'Moral Defence' in the Films *Shutter Island, Inception* and *Memento:* Narcissism or Schizoid Personality Disorder?" *The International Journal of Psychoanalysis* 93: 213–218.

Clover, Joshua. 2011. "The Looking Glass." *Film Quarterly* 64(3): 7–9.

Clyman, Jeremy. 2010. "Shutter Island: Separating Fact from Fiction." *Psychology Today.* www.psychologytoday.com/blog/reel-therapy/201002/shutter-island-separating-fact-fiction.

Cox, David. 2010a. "Hollywood's Mental Block." *The Guardian,* July 22. www.theguardian.com/film/2010/jul/22/hollywood-mental-block.

Cox, David. 2010b. "*Shutter Island*'s Ending Explained." *The Guardian,* July 29. www.theguardian.com/film/filmblog/2010/jul/29/shutter-island-ending.

Currie, Gregory. 2010. *Narratives & Narrators: A Philosophy of Stories.* Oxford: Oxford University Press.

Elsaesser, Thomas. 2009. "The Mind-Game Film." In *Puzzle Films: Complex Storytelling in Contemporary Cinema,* ed. Warren Buckland, 13–41. Oxford: Wiley-Blackwell.

Lothe, Jakob. 2000. *Narrative in Fiction Film: An Introduction.* Oxford: Oxford University Press.

Nolan, Christopher. 2010. *Inception: The Shooting Script.* San Rafael, CA: Insight.

Odin, Roger. 1995. "For a Semio-Pragmatics of Film." In *The Film Spectator: From Sign to Mind,* ed. Warren Buckland, 213–226. Amsterdam: Amsterdam University Press.

Pheasant-Kelly, Frances E. 2012. "Institutions, Identity and Insanity: Abject Spaces in *Shutter Island.*" *New Review of Film and Television Studies* 10(2): 212–229.

Taylor, Henry M. 2012. "The Junkies of Plato's Cave: *Inception,* Mindbending, and Complex Narration in the Shadow of Philip K. Dick." *CineAction* 86: 4–13.

Vogler, Christopher. 1998. *The Writer's Journey: Mythic Structure for Storytellers and Screenwriters.* London: Pan.

modular spacetime in the 'intelligent' blockbuster

inception and *source code*

allan cameron and richard misek

Following the popular success of narratively complex films over the past two decades, there has been a recent tendency for overt temporal tricks, puzzles, and formal twists to appear in films aimed directly at mass audiences. A prominent example is Christopher Nolan's blockbuster *Inception* (2010), in which a team of corporate spies led by Dominick Cobb (Leonardo DiCaprio) is hired to infiltrate a business magnate's dreams and implant an idea that will alter his (and his company's) future. In its labyrinthine plotting and temporal convolutions, *Inception* is paralleled by the minor hit *Source Code* (Duncan Jones, 2011), in which soldier Colter Stevens (Jake Gyllenhaal) is projected into the mind of Sean Fentress, a passenger aboard a train that is about to suffer (or rather, has already suffered) a terrorist attack. Reliving Fentress's final eight minutes repeatedly, Stevens must find the bomber who destroyed the train. Suggesting both linear progression and configurable modularity, these complex narratives produce distinctive articulations of cinematic time and space.

Both *Inception* and *Source Code* comprise multiple sequences or narrative 'modules,' occupying self-contained spaces and temporalities. David

Bordwell has suggested that the spectator's progress through a film's narrative can be seen as a metaphorical journey through "architectural volume" and asks, "What, then, is the spectator's itinerary? Is it string-straight, or is it more like the baffling 'crooked corridors' that Henry James prided himself upon designing?" (Bordwell et al. 1985, 37). The answer, in these two films, is neither. Eschewing spatiotemporal continuity, the narrative structures of *Inception* and *Source Code* are too complex to be illustrated through the metaphor of a single through-line. At the same time, both films are nonetheless intrinsically architectural: they not only feature intricately designed narratives but also foreground and thematize the architectural processes involved in their own narrative construction; they feature characters who are programmers, designers, and architects; and they deploy a range of spatial metaphors—including lines, layers, and circles—that evoke the activities of a design studio rather than a film studio. These metaphors appear throughout the films' scenography, mise-en-scène, and dialogue, translating narrative relations into visual form.[1] In this chapter, we explore the spatiotemporality of these films and investigate the role that graphic metaphors play within them. Ultimately, we argue that the films' metaphors can be oriented around two competing logics: speed and memory.

modular spacetime and modular narratives

Cinematic 'modular narratives' foreground and segment narrative time through processes of reordering, repetition, and recursion. They tend to present an analytic perspective on time, exploring the ways in which rearrangements of narrative temporality trigger epistemological and ontological shifts for characters and viewers alike (Cameron 2008). Both *Inception* and *Source Code* can be classified as modular narratives. *Inception* offers a variation on the 'anachronic' narrative. Anachronic narratives disturb the temporal hierarchy of classical cinema, in which there is a narrative 'present' from which any temporal shifts (notably flashbacks) depart and to which they return. They interleave past and present to the point that it becomes unclear what the 'main' narrative timeline is, or whether there even is one. *Inception* achieves its anachronic effect by having characters move between different dream worlds in which temporal disjunction is always accompanied by spatial disjunction. *Source Code,* meanwhile, exemplifies the 'forking-path' narrative, in which we see multiple iterations of the same scene; each is set in the same space (and replays the same stretch of time) but, due to minor but crucial variations, follows a different narrative trajectory.

Despite destabilizing temporal relationships, both *Inception* and *Source Code* simultaneously supply viewers with ways of making them legible. For example, they both provide narrative clarification through various expository mechanisms. In *Inception,* characters often pause to explain the rules of

the procedure that allow them to enter, move through, and manipulate people's dreams; indeed, the first hour of the film forms an extended lesson in how the dream narratives in the second part of the film will function. By contrast, *Source Code* selectively withholds information (for example, about where Stevens is and why he was chosen to participate in the US military's 'source code' project) in order to engineer a climactic revelation. Nonetheless, it also explains many of the rules underlying its looping narrative early on—notably, the fact that the 'source code' is a technology that allows characters to 'replay' the experiences of other characters, as if in an immersive videogame.

Both films' attempts to clarify their unstable temporalities often involve spatial metaphors. In *Inception*, virtual movement through each dream is figured as movement through a different architectural space (for example, the gridded streets of a city, the corridors of a high-rise hotel, a concrete ice base). The overall duration of each dream experience is, in turn, indexed to a spatial journey undertaken by the slumbering bodies of the dreamers (for example, a journey on a bullet train, a long-haul flight, a car chase). Characters also repeatedly discuss their movement between the 'levels' and 'layers' of the film's multiple realities. Such graphical metaphors map the characters' convoluted journeys onto spatial coordinates. In this way, they allow viewers to visualize the connections between the films' various narrative modules and to make sense of the characters' movement within and between them.[2] As we discuss later, *Inception* features more elaborate and sometimes more ambiguous spatial metaphors.

In *Source Code*, Stevens's repeated immersion in the same eight-minute memory is mapped onto the train's journey along a commuter line into Chicago. The film features a less complex narrative, so it does not require quite as extensive a verbal and visual lexicon of metaphor as *Inception*. One dominant metaphor is enough: 'tracks.' Stevens's return to the film's main narrative 'track' is always ironically accompanied by the same question from his travelling companion, Christina (Michelle Monaghan): "Am I on the right track?" When Stevens loses motivation later in the film, he is played an audio track of his father talking about him after he died, which inspires him to 'get back on track.' This metaphor is also used by Dr. Rutledge (Jeffrey Wright), designer of the 'source code' software/hardware and so the film's main supplier of narrative exposition. To clarify Stevens's situation, he explains that his invention exploits the fact that the brain has a "short-term memory track that's approximately eight minutes long. Like a convenience store's security camera that only records the last portion of the day's activity on its hard drive." Meanwhile, the train tracks approaching Chicago offer a more direct and practical means of clarification, providing Stevens with spatiotemporal signaling by which he can orient himself. For example, noticing that the bomb is timed to engulf both his train and a passing freight train, Stevens deduces that the bomber must

111

have been nearby, watching both. The spatial alignment of the trains thus helps Stevens locate the bomber. Through the metaphor of 'tracks,' *Source Code* explicitly maps physical transport, mental transport, and media transport onto each other.

Indeed, both films exist at the interstices of these different modes of transport, involving their protagonists (or rather, their protagonists' virtual avatars) in relentless motion, searching for a way out of their virtual environments. Stevens finds himself stuck on a train that continually approaches but never arrives at its destination. Cobb and his team become trapped in the dreams of business heir Robert Fischer (Cillian Murphy), their bodies too heavily sedated for them to wake themselves from within. As a result, though their physical bodies are recumbent, within the films' virtual environments, sitting tight is not an option. In the case of *Inception,* characters' motion comprises complex trajectories through three-dimensional urban grids, as well as the Escher-like space of the ice base. At the same time, these labyrinthine trajectories are bounded by vehicular movement. Even when sleeping, their physical bodies are in constant linear motion: along train lines, on flight paths, or through city streets. In the case of *Source Code,* Stevens's movement is more bounded, involving running 'up and down' the enclosed space of a train compartment. It is, however, equally unrelenting, as are the repeated Steadicam tracking shots that follow him through the train—stylistic metonyms for the repeating linear journey of the train itself and his journey through Fentress's memory.

Both films spatialize time. They do so through setting, creating an environment within each narrative module that is conducive to the reassuring repetition of generic movement (notably, the high-speed chase). They also do so through metaphor, mapping characters' disorienting movement between narrative modules onto stable spatial forms, helping (or pretending to help) characters and/or viewers visualize the temporal relations between these modules. One might therefore suggest that these films epitomize a drift toward spatialization that is already embedded in the modular narrative's analytical orientation. This might be linked in turn to broader notions of spatialization, from Henri Bergson's concern that modern technologies misrepresented time by projecting it spatially (1910) to Fredric Jameson's account of postmodern culture's "spatial turn," characterized by "the will to use and to subject time to the service of space" (1991, 154).[3] More recently, Todd McGowan has argued that contemporary complex narratives can be linked to the spatialization caused by digital technologies and are, in their emphasis on traumatic experience, fundamentally atemporal (2011, 3).

We wish to suggest, however, that this grand theoretical notion of time subsuming itself to space is too simple and aphoristic an approach to the complex spatiotemporal dynamics of these films. Though they make

temporal experience legible as spatial inscription, they also enact a temporalization of space. For example, though Cobb employs an architecture student to design three different dream worlds and so underlines the spatial aspect of the virtual environments that subtend *Inception,* the film places overt temporal constraints on this design process. Testing the abilities of Ariadne (Ellen Page), Cobb gives her two minutes to design a maze; the 'drawing' that results is both a graphic object and a high-speed process. A temporalization of space is also evident when Cobb takes Ariadne on a tour through his dream of Paris and shows her how to reconfigure it. Her changes involve spatial convolutions, such as a gigantic mirrored door that bends space and forms the threshold of a new street. Observing the result of her on-the-fly design process, Ariadne comments that a particular building "feels like it's creating itself" and notes that her "mind functions more quickly" inside dreams, further emphasizing the high-speed processual operations through which these virtual spaces are created. An analogous process occurs in *Source Code:* the space of the train, presented repeatedly as the location of Stevens's mission, is in fact a projection of time past, looped and altered with each iteration. The train, and the mission itself, are artifacts of psychological and technological processes unfolding in time.

The characters in these films inhabit dynamic rather than static modules of spacetime, each moving at different speeds and in different trajectories. This is represented most strikingly through vehicular movement. In *Source Code,* the train provides the spatiotemporal vehicle for the narrative, while in *Inception,* voyages into dream states are predominantly undertaken from within speeding vehicles (via air, rail, and road). Similarly, the trajectories of the vehicles within which Cobb and his team sleep form spatialized countdowns, ticking off the units of a finite period of time within which they need to complete a set of tasks. Blending spatialized time and temporalized space, these films thus articulate and overlay a range of spatiotemporal models. Both, however, make use of one illustrative metaphor in particular: the timeline.

lines, layers, and loops

The opening images of *Source Code* initially suggest a freedom of movement through all three dimensions, as a series of aerial shots takes us over, around, and through the cityscape of Chicago. Quickly, however, the film settles on the line as its key visual motif and the dominant trajectory of its motion: the camera follows railway tracks from above, as the ill-fated train approaches downtown Chicago.[4] Sean Cubitt argues that *Source Code* can be interpreted as a rendition of digital time, likening the film's combination of temporal rigidity (its eight-minute sections) and fluidity (high-speed movement, slow motion effects, etc.) to the computational processes of the various cameras used to shoot it—notably, the varispeed Phantom HD

(2013). We wish to suggest that the film also evokes the digital processes associated with image playback. In light of the location of the action on a train line, and the temporal countdown that restarts with each return to the train, could Stevens perhaps be regarded as occupying the metaphoric spacetime of a particular mode of media transport: the digital timeline? Each time Stevens relives the memory of the train's last eight minutes, he moves along an eight-minute video track that plays within his head. Indeed, Stevens himself could perhaps be regarded as a metaphoric playhead, moving forward and backward along the passageways of the train's compartments, trapped within a sequence that he is himself generating. When Stevens's physical body is finally unplugged at the end of the film, his heart monitor flatlines, assuming the appearance of an audio track with no media left on it.

Inception also involves movement along various timelines, paralleled by the linearity and horizontality of the lateral vehicular movements that form the basis of the characters' spatiotemporal journeys: the high-speed train at the start of the film, the flight from Sydney to Los Angeles, and the car chase in New York City. In addition, based on the assumption that "in dreams, the mind functions fast, so time moves slow," *Inception* posits the idea that time in each layer of dream extends exponentially (one minute in reality = seven minutes in the first dream = forty-nine minutes in the dream within the first dream, etc.). This relation sets up the notion of layers of timeline nested within each other.

The narrative metaphors most commonly expressed by characters in *Inception* are those of 'levels' and 'layers.' Both are apt. The metaphor of 'levels,' like the 'replaying' metaphor in *Source Code,* evokes the architectural form of a video game; the metaphor of 'layers' evokes the interface of popular media production applications including Photoshop, After Effects, and Final Cut Pro. Such metaphors imply a vertical relation between the films' different narrative modules. *Inception* comprises multiple layers of reality and dream: notably, the top layer of reality and Fischer's three-layered dream, which Cobb and crew access by sedating themselves to sleep ('going under'). As well as moving horizontally within specific spatiotemporal layers, characters move vertically, to ever-lower layers of Fischer's dream. The film also intermittently moves through the layers of Cobb's own unconscious, accessed initially via an elevator, at the bottom of which (in the basement) he tries to entrap his traumatic memory of the suicide of his wife, Mal (Marion Cotillard); the deeper Cobb goes, the more narrative backstory the viewer acquires. Narratively, in *Inception,* downward is the only way forward. By implication, reality is what exists at the surface, at ground level, thus constituting the film's horizon line. Paradoxically, in order to go up a layer (toward reality), characters have to fall (for example, off a chair, down a liftshaft, or off a bridge) in order to experience the 'kick' that jolts them back to consciousness.

Source Code is less emphatic in terms of verticality. The connections that link the horizontal movement of the train, Stevens's capsule, and his supervisors' control room are kept deliberately unclear. Within the train itself, however, there are two levels. Yet, though Stevens repeatedly ascends to the upper level (for example, to retrieve a gun from the conductors' car), the only time he stays there for an extended period is when he calls his father. These crucial few minutes lift him out of his relentless quest to find the bomber, which involves constant movement back and forth along the train compartment, and connect him with his own past. Beyond the space of the train, there is also a notional verticality in the film, which corresponds to the paradigmatic axis. In structural terms, the film's syntagm (the horizontal arrangement of sentences, narratives, or time-lines) intersects with its paradigm (the vertical menu of semantic, generic, or ontological models that might be inserted into it). Each iteration of the narrative represents a different paradigm, determined by Stevens's motivation and strategic thinking. Drawing upon his experience and knowledge of the previous iterations, the narrative creates a layering effect, in which each linear trajectory 'builds on' the memory of the previous eight minutes.

The vertical connections between the different 'layers' in *Inception* are altogether more precipitous: from the fall off the skyscraper that takes Cobb and Ariadne to the meticulously constructed dream world that he lived in with his wife, Mal, to the fall of the elevator in the hotel and the fall of the van into the river.[5] It should be emphasized that the guiding metaphor here is not just that of a vertical line; it is that of a vertical timeline. The van's fall off the bridge constitutes a timeline for all the events that take place in the two deeper layers of dream: when the van hits the water, the characters asleep in the van will wake, whether or not they have completed their mission. Because the van drives off the bridge a few seconds too early, the time available in the lower dream levels reduces exponentially. Cobb's solution to this problem is simple: "Move fast!" Subsequently, repeated shots of the van in mid-air provide a spatial marker of how 'long' the characters have left. As if this is not a sufficient temporal constraint, the characters also need to wake simultaneously in each dream layer in order to feel the cumulative force of gravity associated with three kicks so they can move all the way back up to reality. Each kick thus needs to be timed to coincide with the others. This is not an easy task, considering that time moves at different speeds on each dream level; careful timekeeping is required to prevent both characters and viewers from being left behind. Unsurprisingly, *Inception* is full of verbal time markers.[6] Characters repeatedly provide summaries of how much time is left on each of the three dream levels. Both the van's spatially vertical trajectory and the film's narratively vertical trajectory between layers are thus precisely measurable, and repeatedly measured, using clock-time. Ultimately, the kicks occur at

the moment the van hits the water, in a perfect alignment of the three different dream timelines, which also serves as the film's climactic resolution and provides its characters with a final 'out point.'

Verticality also forms the basis of a particularly intriguing narrative complication just before this climactic moment, in which up and down are superimposed. As the van drives off the bridge, the hotel dream one layer down suddenly moves into zero gravity, and Arthur (Joseph Gordon-Levitt) finds himself crawling along walls and ceilings. Unfortunately, the zero gravity also means that he cannot give his colleagues their wake-up kick by pushing them off their chairs because they are already experiencing the free fall of the van in the next dream up. Paradoxically, Arthur has to load them into an elevator and sabotage it so that it free falls, in the hope that when it hits the bottom of the lift shaft and *stops* falling, it will create the same surge of gravity as that felt when falling off a chair. The ambiguity about what is up and down within the dream worlds extends to the film's camerawork. As Arthur crawls along the ceiling of a hotel corridor, one can only assume that the camera, not the actor, is upside down. Elsewhere, the camera's shifting axis is even more overt. For example, various shots of characters falling asleep and waking up involve the camera tilted at ninety degrees to the horizontal. When Cobb and Mal decide to escape their dream limbo by committing suicide, they lie down on railway tracks; the verticality of the tracks within the frame provides the promise of an express line back up to reality.

The cumulative effect of such shots is to produce a spacetime with a center of gravity that is continually shifting, like that of a rotating disc within a gyroscope, mounted on an axis that is itself in motion. Horizontality and verticality become interchangeable, each one turning on the other and, in turn, contributing to a loss of gravity for the characters. In *Source Code,* this loss of gravity is exemplified by Stevens's experience within the 'capsule,' where he finds himself between iterations of the train's fatal journey. Our introduction to this spatiotemporal module comes in the form of a close-up of his face, framed almost upside down. We hear what we shall soon know to be his controller's voice, asking if he is OK. "Where am I?" he asks in turn. "I'm dizzy." "Adjusting your rotation," she replies. A motor whirrs, and the shot rotates through 320 degrees, until his face is upright. Over the course of the film, Stevens is framed within the capsule at various angles. When he finally discovers the truth about his physical condition, a series of arcing camera moves place his body at one moment on a vertical axis, and at the next on a horizontal axis. It is not clear if what we are witnessing is a series of expressive camera moves (reflecting Stevens's disorientation) or a realignment of the capsule within the film's diegesis, but it barely matters, as the capsule itself, of course, is just a 'manifestation' of Stevens's mind.

Both the zero gravity hotel and the gyroscope capsule reflect the fact that horizontality and verticality in *Inception* and *Source Code* are nested

within a top-level spatiotemporal metaphor: that of circularity. In *Source Code,* circularity manifests itself in the form of a narrational loop in which a single timeline is metaphorically bent so that its ending becomes the antecedent to its beginning. In addition to this temporal loop, Stevens's mission also involves an iterative loop: each time his controller sends him back onto the train, she inputs a command line that presumably causes the 'source code' program to start again from its first line of code. In *Inception,* the metaphor of circularity takes on a physical form, in the shape of the spinning top that serves as Cobb's 'totem.' The top is an aide-mémoire, which signals to Cobb whether he is dreaming or awake. If it stops spinning after a while and succumbs to the downward pull of gravity, he is in the film's top layer—reality. If it continues spinning, it demonstrates that gravity is exerting a gentle upward force and that he is below ground level—in a dream. Again, the motion of the top can be likened to the spinning of a disc within a gyroscope, a circle within a circle. At the end of the film, Cobb returns home, reunited with his children, and spins the top one last time. The final shot cuts to black before the question of whether it falls is answered. The film teases us with the possibility that its entire two-and-half hour narrative has in fact been spun on its axis, that we have been watching the film the wrong way up, and that Mal was right all along: down is up and up is down.

spacetime, speed, and memory

The progress of characters through the narratives of both *Source Code* and *Inception* involves movement within and between spacetimes with shifting axes. Characters find themselves variously fighting, testing, or succumbing to forces pulling them in different directions. Are these forces technological or psychological? Both films play upon the confusion between the two; their narratives revolve around a notion of transport that brings together psychology, movement, and mediation. The characters are transported psychologically, entering into other minds, bodies, and worlds; they are transported physically, through the motif of constant vehicular movement; and they are advanced along various timelines (layered, nested, looped, and parallel), embodying the concept of a media 'transport.'

In this section, we suggest that various forces that operate on the films' characters can usefully be framed with reference to speed and memory. While speed links space and time through physical coordinates, memory does so through order, association, and repetition. Both are integral to the narratives of *Inception* and *Source Code.* In each case, temporal deadlines structure the action: characters must move quickly through space in order to achieve their goals. These spatiotemporal itineraries are graphed along notional timelines. The films' insistence on speed applies both to the timelines within each module and to the relations between modules, which are

defined by the fact that the characters are located within an immediate environment (a train, an airplane, a van) that is traveling at high speed. These parallel velocities produce relational effects, which include the experience not only of acceleration but also of deceleration and inertia. Paul Virilio suggests that the sensation of inertia can be seen as a byproduct of speed; he uses as an example of "the moment when two trains seem immobile to travelers while they are really launched at top speed one beside the other" (1991, 108). The slowness of the van falling from the bridge (signified by the use of slow motion) is a relational effect, produced by the fact that the dreamers inside are moving more quickly through time in the next 'layer' down. So too is the effect of hitting the bottom of the elevator shaft: immobility within one dream makes it possible to feel the acceleration within another.

Memory, in the form of associative links, mnemonic ordering, and traumatic recollection, also structures the relationships within and between narrational 'modules.' Both Cobb and Stevens are heavily affected by trauma. Cobb is haunted by the recollection of Mal's death, which is signaled by the way in which her image returns to him in dreams, repetitively and insistently. Meanwhile, Stevens's body is itself an emblem of trauma. Preserved on the edge of death after being injured in Afghanistan, Stevens does not realize that half his body is missing and that he is being kept in an incubator. As in Cathy Caruth's influential account of trauma theory, the truth of what has happened returns to him belatedly, "fully evident only in connection with another place, and in another time" (1995, 8). According to Todd McGowan (2011), the preponderance of trauma-based plots in contemporary complex narratives (including *21 Grams* and *Eternal Sunshine of the Spotless Mind*) signals a philosophical commitment to atemporality. Characters in these films, argues McGowan, come to terms with trauma, giving up on future-oriented desire. McGowan praises them for the way that they depart from an instrumental orientation toward the future, relinquishing desire in favor of the atemporal (Lacanian) 'drive.' Yet as Thomas Elsaesser points out, trauma theory is only one way to approach such complex "mind-game" narratives (2009, 29). Indeed, the traumas suffered by characters in many such films can be seen as "productive pathologies," which endow the characters with special faculties (31). In *Source Code,* it is Stevens's traumatic estrangement from his own body that allows him to find the bomber, preserving the city's future. In *Inception,* Mal's posttraumatic visitations seem to go hand-in-hand with Cobb's inventiveness and resourcefulness within this world of layers and mazes. Furthermore, rather than closing down time and desire, these productive pathologies can become the basis for new temporal affirmations, indicating "that 'trauma' is not only something that connects a character to his or her past, but also opens up to a future" (Elsaesser 2009, 31).

An overinsistence on trauma as the films' structuring principle can also obscure the significance of other types of memory. In both films, the

characters move through spaces generated from others' memories, while approaching their missions as a kind of mnemonic challenge. In *Source Code,* Stevens's repeated movement through the train comes to resemble the ancient art of memory, in which orators remembered their speeches by imaginatively projecting key images into virtual spaces and then retrieving these images as they moved through their speech (Yates 1966, 3). For Stevens, small details—a drop of coffee on his shoe, a character quirk, a throwaway comment—become mnemonic resources that help him orient himself. For example, whenever Christina says, "Everything's going to be all right," the train erupts into a fireball; through repetition, this cue quickly becomes not only a source of dark humor for Stevens but also a tool enabling him to advance his quest. Cobb and his team also treat memory as a resource to be exploited. By using prior knowledge to place an emotionally charged object in Fischer's safe, they project an image into the space of his dream, which he will remember when he awakes and which will in turn change his future behavior. Both Stevens's and Cobb's repurposing of the art of memory can thus be seen as fundamentally instrumental. Furthermore, it suggests that the logics of memory and speed are not entirely contradictory: in a certain sense, memory enables speed, since foreknowledge of territory and resources enables rapid action, and thus control over the future.

Is it perhaps this relationship between speed and memory that underpins the popular designation of these films as 'intelligent'? Intelligence (of characters and of viewers trying to keep up with the narrative) involves achieving command over narrative details (a memory of what has passed) as well as a certain cognitive speed (Are we fast enough to keep up?). Of course, though viewers may have the luxury of a pause button, the films' characters do not: their only hope is to move fast enough to allow more time for present action. The intelligence of modular narratives thus parallels military intelligence, which brings together foreknowledge and adaptability, and computer intelligence, which leverages stored data in the execution of high-speed processes. Though *Source Code* involves many implausibilities, the militarization of its technology is not one of them.

At the same time, just as it is too simple to subsume time to space in these films, so is it too simple to subsume memory to speed. As Wendy Chun observes, our contemporary digital moment is defined by the "enduring ephemeral." Images and texts do not disappear as a result of digital media's erasability; rather, they are constantly recycled (2008, 167). Memory in *Inception* and *Source Code* operates according to a similar logic. It is not a solid, storage-oriented memory but a memory produced through repetition; so too, digital memory is defined both by its "impermanence and volatility" (164) and by its tendency to endure as a virtue of repetition.[7] In *Source Code,* the execution of Stevens's quest involves a repetition of memory by means of digital technology; however, his own memories also

begin to creep in, necessitating a telephone conversation with his father that is separate from the instrumental quest of the main narrative. In *Inception,* the speed-oriented thrust of Cobb's mission is also overtaken by memory. "Never recreate places from your memories," Cobb warns Ariadne. Ignoring his own injunction, he dreams about his wife and children every night; he uses an elevator as a mnemonic device, moving vertically between memories, each mapped onto a different floor. At the same time, he tries to lock away the traumatic memory of Mal's death in the basement. Of course, he fails. Rising up from his deepest unconscious, she refuses to be contained; her presence seeps up through the layers of Fischer's dreams. In addition, *Inception* also includes flashbacks: additional narrative layers that provide us with backstory about Cobb's relationship with Mal, scenes that themselves also seep into Fischer's dream and so complicate his horizontal momentum.

At the same time, though Cobb is himself a prisoner of memory, he discusses his aspirations in terms of spatial navigation and architecture: he thinks he has "found a way home," while relishing having "a chance to build things . . . that never existed." In order to be reunited with his (and Mal's) children, he embarks on the most complex world-building job of his career. Cobb wants to return to his past family life, yet also, in his excitement at creating the new, bristles with modernist zeal. This dual pull of memory and speed is epitomized by his totem. The spinning top not only tells him if he is dreaming but also triggers memories of his children—and of Mal, who previously owned it. At the same time, it communicates this information through speed—not as space traversed but as cycling and repetition; the top turns on its axis, a visual metaphor of the film's spinning narrative axis. Memory and space turn upon each other.[8] The image of the spinning top evokes the instrumental project that has animated the film, as well as the possibility of a loss of control triggered by the return of the past.

rewriting spacetime

Tying together physical, technical, and psychological movement, *Inception* and *Source Code* link speed and memory via a complex interplay among linearity, repetition, and recursion. In the first instance, each film displays an architectonic logic based on lines, planes, and layers aligned along horizontal and vertical axes. However, these axes also fit within a broader dynamic of circularity. Our metaphor of the multidirectional spinning of a gyroscope emphasizes the fact that both the nature of characters' movement within the films' narrative modules and the alignment of their narrative modules with each other are relational and dynamic.

Early in *Inception,* when introducing Ariadne to his dream, Cobb draws two semicircular arrows pointing at each other: one signifies creation and the other experience. He uses them to explain that dreamers create their

environment as they experience it. *Inception* narrates both its characters' movement through an environment and their shaping of that environment; its main characters are architects and user experience designers, and the film's narrative focuses on how they design and navigate Fischer's dreams. In *Source Code,* by contrast, Stevens himself is merely a player, as if in an immersive military simulation whose rules are only gradually explained by his superiors on a need-to-know basis; designing credit is shared by Rutledge (the inventor of 'source code') and Fentress (the man whose perceptions Stevens is projected into).[9] Consequently, the narrative focus of *Source Code* is different from that of *Inception.* As Sean Cubitt notes, "The film is an inquiry into how to live in a world where decision making is not only remote but automated (and that goes for the mass transit system where most of the action takes place, as well as the Beleaguered Castle laboratory where Colter's body is held)" (2013, 496). Yet Stevens repeatedly resists this automation. At the end of a particularly unsuccessful iteration of the train journey, he asks Christina to say "Everything's going to be all right," so as to expedite the explosion that will return him to the capsule. Indeed, Stevens ultimately achieves such mastery over his seemingly preconfigured environment (at least, within the eight-minute track of his mediated train journey) that even the bomber can only look on dumbfounded.[10]

The environments in which both films' narratives unfold are thus themselves shaped and reshaped by the characters' actions within them. Seemingly static spaces are revealed to be in a constant state of transformation, shifting in relation to temporal processes.[11] In both films, spacetime must be understood as a real-time process of creation and/or computation. In terms of the spacetime that both we and the main characters perceive, we/they are effectively in a computer-generated sphere—as in Google Street View, or rather, as in a computer game, which appears to present us with a Cartesian space but actually just involves real-time rendering of the space immediately around us. Each film addresses a contemporary experience of spacetime that is inflected by data flows, not geometric coordinates. Rather than acting as stable spaces within which narrative motion takes place, these CG spheres become interfaces for both registering and responding to the dual pull of speed and memory, manifested via invisible forces that include digital technology, trauma, military power, terrorism, and capital flows. Together, these forces keep the spatiotemporal axes of *Inception* and *Source Code* in constant motion. They thus entail a drastically different narrative architecture than that describable by Henry James's metaphor of a 'crooked corridor' or even that of a (nonlinear but still static) 'database narrative.' Both films point toward a new conception of narrative, in which spatiotemporal relations are dynamic, and can only be apprehended by analyzing spacetime as the cause and effect of a series of processes. The metaphoric brilliance of Cobb's circle is that it encapsulates the narrative head-spin of 'mind-game' films, as well as illustrating how

the dizzying spatiotemporal relations of *Inception* and *Source Code* are generated. By doing so, paradoxically, it also points to the limits of narrative visualization and of these two films' own graphic metaphors. It simultaneously redeems spacetime and undermines it.

notes

1. The centrality of metaphor needs to be acknowledged when considering complex narratives. In recent writing on the subject, a whole range of new metaphors has come to be used to describe such films: for example, database narrative (Kinder 2002), forking-path narrative (Bordwell 2002, 2006), multiple-draft film (Branigan 2002), puzzle film (Buckland 2009), and mind-game film (Elsaesser 2009).

2. The films thus invite readings that draw upon what Garrett Stewart terms "narratography," which involves "the reading of an image and its transitions for their own plot charge" (2007, 7).

3. Literary critic Joseph Frank argued that the multiperspectival, urban-set novels of Joyce and Woolf were examples of "spatial form" (1991 [1963]). Recent software that allows the user to visualize screenplays in different ways—as charts, flow diagrams, tag clouds, and so on—provides further evidence of the contemporary urge to approach narrative via both metaphoric and graphic spatialization. For an overview of the different ways that screenwriting programs can and could visualize screenplays, see McKie 2008.

4. Of course, *Source Code* takes places on two separate narrative tracks: the looping eight-minute track of the train journey and the nonlooping temporality of the film's physical reality, in which the characters are 'running against the clock' to prevent the detonation of a nuclear bomb in Chicago.

5. Garrett Stewart has noted the tendency for contemporary films to present time shifts via "a precipitous optic plunge through space itself as if it were time's own inroad" (2007, 134).

6. *Source Code* also features numerous temporal markers, such as the comment by a commuter that the train is running ten minutes late. However, given the film's more straightforward narrative trajectory, these references usually provide an ironic commentary on the narrative rather than clarifying it.

7. "If our machines' memories are more important," writes Chun, "if they enable a permanence that we seem to lack, it is because they are constantly refreshed so that their ephemerality endures, so that they may store the programs that seem to drive our machines" (2008, 167).

8. This neither/nor both/and logic is captured by Garrett Stewart when he writes that the sense of duration particular to the "timespace image" in many contemporary films is "neither a thrust or vector of motion nor a layered 'sheet' of time but rather the glimpsed relativity of each to the other in the immanent technology of the digital array" (2007, 127). In other words, the logic of these films involves a dialectic between speed and memory.

9. There is a secondary distinction to be made here too. *Inception* downplays the technology by which characters can enter and shape dreams. Its creators remain unknown, and the technology itself remains discreetly

packed away inside leather briefcases. In addition, when Cobb teaches Ariadne how to reshape dream worlds, he does so from within a dream; we never see the process by which the film's 'media production' technology functions in the real world. *Source Code,* by contrast, places far greater emphasis on its technology: Rutledge's control room is full of monitors, wires, and flashing lights, and Stevens's physical body exists in an incubator surrounded by a room full of wires and monitors. At the same time, of course, *Source Code* also sidesteps the question of precisely how its technology interacts with its users' brains.

10. Conversely, the designers in *Inception* sometimes lose control of their own creations. When a freight train barrels down the middle of a New York street, one might be forgiven for wondering if one is witnessing a spatio-temporal glitch whereby a narrative module from *Inception* has become scrambled with one from *Source Code.*

11. Wolfgang Ernst suggests that, in the context of digital media, the static spatiality of the archive "is being replaced by dynamic temporal storage, the time-based archive as a topological place of permanent data transfer" (2004, 49–50). As Wendy Chun puts it, "Digital media is truly a time-based medium, which, given a screen's refresh cycle and the dynamic flow of information in cyberspace, turns images, sounds, and text into discrete moments in time" (2008, 166–167).

references

Bergson, Henri. 1910. *Time and Free Will: An Essay on the Immediate Data of Consciousness,* trans. F. L. Pogson. London: S. Sonnenschein and Company.

Bordwell, David. 2002. "Film Futures." *SubStance* 31(1): 88–104.

Bordwell, David. 2006. *The Way Hollywood Tells It: Story and Style in Modern Movies.* Berkeley: University of California Press.

Bordwell, David, Janet Staiger, and Kristin Thompson. 1985. *Classical Hollywood Cinema: Film Style and Mode of Production to 1960.* London: Routledge.

Branigan, Edward. 2002. "Nearly True: Forking Plots, Forking Interpretations." *SubStance* 31(1): 105–114.

Buckland, Warren. 2009. "Introduction: Puzzle Plots." In *Puzzle Films: Complex Storytelling in Contemporary Cinema,* ed. Warren Buckland, 1–12. Oxford: Wiley-Blackwell.

Cameron, Allan. 2008. *Modular Narratives in Contemporary Cinema.* Basingstoke: Palgrave Macmillan.

Caruth, Cathy. 1995. "Introduction." In *Trauma: Explorations in Memory,* ed. Cathy Caruth, 3–12. Baltimore: Johns Hopkins University Press.

Chun, Wendy Hui Kyong. 2008. "The Enduring Ephemeral, or the Future is a Memory." *Critical Inquiry* 35: 148–171.

Cubitt, Sean. 2013. "*Source Code:* Eco-criticism and Subjectivity." In *The Oxford Handbook of Sound and Image in Digital Media,* edited by Carol Vernallis, John Richardson, and Amy Herzog, 483–501. New York: Oxford University Press.

Elsaesser, Thomas. 2009. "The Mind-Game Film." In *Puzzle Films: Complex Storytelling in Contemporary Cinema,* ed. Warren Buckland, 13–41. Malden, MA: Wiley-Blackwell.

Ernst, Wolfgang. 2004. "The Archive as Metaphor: From Archival Space to Archival Time." *Open* 7: 46–53.

Frank, Joseph. 1991. *The Idea of Spatial Form.* New Brunswick: Rutgers University Press.

Jameson, Fredric. 1991. *Postmodernism, or, The Cultural Logic of Late Capitalism.* London and New York: Verso.

Kinder, Marsha. 2002. "Hotspots, Avatars, and Narrative Fields Forever—Buñuel's Legacy for New Digital Media and Interactive Database Narrative." *Film Quarterly* 55(4): 2–15.

McGowan, Todd. 2011. *Out of Time: Desire in Atemporal Cinema.* Minneapolis: University of Minnesota Press.

McKie, Stewart. 2008. "Screenplay Visualization: Concepts and Practice." *Reconstruction* 8(3). http://reconstruction.eserver.org/083/intro.shtml.

Stewart, Garrett. 2007. *Framed Time: Toward a Postfilmic Cinema.* Chicago: University of Chicago Press.

Virilio, Paul. 1991. *The Aesthetics of Disappearance,* trans. Philip Beitchman. New York: Semiotext(e).

Yates, Frances A. 1966. *The Art of Memory.* Chicago: University of Chicago Press.

complexity and

simplicity in *inception*

and *five dedicated to ozu*

w i l l i a m b r o w n

In this chapter, I am going to undertake an unusual step: using the concepts of complexity and simplicity as my basis, I am going to offer comparative analyses of a Hollywood blockbuster, *Inception* (Christopher Nolan, USA/UK, 2010), and an Iranian art house film, *Five Dedicated to Ozu* (Abbas Kiarostami, Iran/Japan/France, 2003). Stranger bedfellows one is unlikely to meet outside of the kind of free-wheeling works written by Slavoj Žižek, who, in *The Fright of Real Tears* (2001), for example, puts films by Krzysztof Kieślowski to work alongside various mainstream (and other art house) films, as well as pornography. However, while *Inception* and *Five* make an unusual pairing, in analyzing them together, I hope to achieve a number of things.

First, I hope to complicate what constitutes a 'complex' or 'puzzle' film. *Inception* is a contemporary mainstream film replete with CGI, rapid cutting, and beautiful stars, and it involves characters penetrating into the minds of other characters in order to plant ideas there. *Five,* meanwhile, consists of five long takes of natural-seeming scenes, each shot with a static camera, and features barely any human figures at all. In comparison to

Inception, 'nothing' happens in *Five,* and there is no plot to speak of. And yet for all of the complexity in and of *Inception,* I shall argue that the film is relatively 'simple,' while for all of the apparent simplicity in and of *Five,* it is a deeply complex film.

In complicating the definition of 'complexity,' particularly in relation to the 'puzzle' film, I hope secondly to suggest that all films, from the mainstream to the art house, coexist within a cinematic 'ecology' that is finely balanced, which itself is complex in nature, and the totality of which is important to bear in mind (even if we can never 'see' the whole because no one can physically watch all films ever made, although various critics and scholars, from Leslie Halliwell onward, seem to have lived and died trying).

This effort to remember the 'whole' or totality of cinema or the cinematic ecology is related to a third, 'political' motivation for pairing *Inception* with *Five*: to offer a 'corrective' of sorts to the increasing specialization of film exhibition and reception, a specialization reflected also in film studies as an academic discipline. As is indicated by the progression from a book on puzzle films in contemporary global cinema (see Buckland 2009) to this volume, which concentrates on puzzle films specifically in contemporary Hollywood, there is a tendency for research into film to take on ever-more specialized areas. In the face of the sheer volume of material produced globally, this process is understandable: no one could watch and read all of the relevant material in order to stay on top of even quite a specialized area of film studies (say, French cinema). Nonetheless, this specialization potentially demarcates boundaries and erects barriers in an ecology that does not necessarily have any.

If scholars of cinema are pushed into ever-greater levels of specialization at the expense of 'holistic' or 'ecological' considerations, then the concomitant erection of boundaries between cinema types among audiences can be seen in the ghettoization of art house cinema in art house chains, art galleries, and film festivals (which themselves are increasingly forced in an era of obligatory economic competition to show mainstream films, to rely on works by canonical *auteurs,* and to have star-based events in order to maintain their bread and butter).

If this chapter is something of a 'corrective' to this dual tendency—the tendency not to mix considerations of the mainstream with considerations of the art house, both among audiences and among film scholars—I should make clear that I do not wish to propose simply that mainstream or Hollywood cinema is bad and that art house cinema is good. Such a reductive formula is counterproductive, since it does not move beyond but in fact replicates the very system of reductive formulae that oversimplifies the complexity of our reality and of the cinematic ecology that exists within it. It is precisely this reductionism, rather, that I wish here to challenge.

That said, it would be naïve simply to suggest that mainstream and art house cinema are the same or equal. Given the size of its production

budgets, Hollywood can and does produce enormous spectacles that many viewers will deem more cinematic (i.e., better) than low budget, mimimalist art house fare. An art house director from Iran, meanwhile, works on a much smaller economy of scale. Now, it may well be that Abbas Kiarostami does 'in miniature' what Christopher Nolan does on the grandest of scales: each director works with the material that he has in order to produce works for specific audiences, no matter how small or large in size that material and those audiences are. However, it is unsurprising that *Inception* does bigger business than *Five* when one considers the way in which a Hollywood studio can create much larger-scale promotional materials, negotiate a worldwide release, offer up high-end crowd-pleasing special effects, and include big name stars like Leonardo DiCaprio (as well as relatively/ increasingly familiar names like Tom Hardy, Joseph Gordon-Levitt, Ellen Page, Marion Cotillard, Cillian Murphy, Ken Watanabe, Tom Berenger, Michael Caine, Dileep Rao, and Lukas Haas). It is possible/likely that *Five* does not want to compete with *Inception* in this kind of way, but on another, pragmatic and economic level, it simply cannot compete. And the upshot of this imbalance of economy is that, broadly speaking, cinema's 'rich' get richer, while its 'poor' get poorer—with the art house withdrawing into ever smaller circles as the mega-movies become bigger and bigger.

However, while these economic imbalances exist, the concept of complexity provides a terrain on which *Inception* and *Five* can have an equal footing or at the very least can compete legitimately. It is from the perspective of complexity, then, that I wish to contend that the 'poor' art house has as much to offer as the 'rich' mainstream. That is, the 'poverty' of the conditions in which a film like *Five* (perhaps willfully) gets made does not overcome the film's richness. Meanwhile, the glamorous opulence on display in *Inception* cannot cover over all of its 'poor' elements (particularly its logical shortcomings). In some senses, then, this chapter does offer a critique of *Inception* and a defense of *Five,* but this is not because *Inception* is a bad film (whatever that may be); it is because *Five* is an excellent and complex film that, like many art house movies, will likely be overlooked by all but the most specialized of audiences, both because the film is formally challenging (read 'slow') and because the money is not there to bring it to wider attention. My goal, then, is not to encourage viewers to watch *Five* at the expense of *Inception* but to watch and to think about *Five* and films like it *in addition to* films like *Inception*—because if complexity is indeed grounds to enjoy a film, as this book implicitly posits, then *Five* is as enjoyable as *Inception,* in spite of its relative slowness and lack of plot.

If this essay encourages people to 'enjoy' *Five* as much as *Inception,* it is not because I am saying that there is a preset way of 'getting' the film that I can magically pass on to readers. For many viewers, *Five*'s lack of an identifiable plot and its slowness will be frustrating and they therefore might feel alienated—and in many respects there is little that this essay can do

to change that. However, rather than suggesting how to 'get' *Five*, I simply want to encourage viewers to embrace the film's slowness and lack of an identifiable plot and to use them as an opportunity to ponder, to think about, and to engage with the film's images—in the same way that *Inception* also invites us to think (for example, about the nature of reality). In this sense, it is not about 'getting' *Five* (since in many respects I feel that there is nothing to 'get'), but it is about 'getting *into*' *Five*. Admittedly, *Five* is harder to 'get into' than *Inception*, but if one does get into it, its rewards can be great—greater perhaps even than *Inception*'s, the rewards of which are real, but that are arguably slight given the size and scale of its production.

Before we can continue by using complexity as a means for leveling the playing field between mainstream Hollywood and global art house cinema, we need first to define what exactly I mean by complexity. This is what I hope to explain in the section that follows.

what is complex cinema? what is complexity?

In addition to Warren Buckland's previous edited collection on global puzzle films (Buckland 2009), there have been various attempts to describe the development of increasingly complex narratives in cinema, as well as in television (Johnson 2005; Mittell 2006) and in DVD culture (Harper 2005). Furthermore, Thomas Elsaesser has identified the puzzle film's literary precursors (Elsaesser 2009, 20). *Puzzle film,* seemingly first coined as a term by Elliot Panek (2006), seems to be the increasingly accepted nomenclature for movies that present worlds that often look just like ours, but: where multiple timelines coexist, where the narrative engenders its own loops or Möbius strips, and where there may well be a beginning, a middle, and an end, but they are certainly not presented in that order, and thus the spectator's own meaning-making activity involves constant retroactive revision; new reality checks, displacements, and reorganization not only of temporal sequence but of mental space; and the presumption of a possible switch in cause and effect (Elsaesser 2009, 21).

However, other terms have been used to describe such films, including: "forking-path" and "multiple-draft" narratives (Bordwell 2002; Branigan 2002); mindfuck films (Eig 2003); fractal films (Everett 2005); twist films (Wilson 2006); complex narratives (Harper 2007; Ramírez Berg 2006; Staiger 2006); modular narratives (Cameron 2006); and Elsaesser's own preferred term, "mind-game films" (Elsaesser 2009).

While these different and perhaps competing terms are in circulation, they do describe films that bear striking resemblances to the mind-game film defined above by Elsaesser, even if they come from a range of different national, transnational, and technological contexts. With its nonlinear presentation of various levels of reality, all of which, ultimately, may not be real (the top keeps on spinning in the film's final shot, suggesting that

all of the events that we have seen might well be the dream of Cobb, who is played by DiCaprio), *Inception* seems no exception. It is a puzzle film, a mind-game film, a twist film, a modular narrative, a mindfuck film, a complex film. However, the salient point to draw out here is that across all of these terms, it is the concept of complexity that seems most often to be evoked in order to explain them.

Nonetheless, if the complex film is one in which we are unsure of the reality status of events, in which we cross time in a nonlinear fashion, and/or in which characters realize in some twist moment that they are dead or in a simulation or dreaming, then this does not necessarily explain what complexity itself is. As Janet Staiger has said, "Complexity needs careful definition" (Staiger 2006, 3). In order to provide such a definition, then, let us look at how complexity has been defined in physics. We shall do this by looking first at chaos theory and then at complexity theory.

The butterfly effect is the most famous example of chaos theory in action: "A butterfly stirring the air today in Peking [sic.] can transform storm systems next month in New York" (Gleick 1998, 8). However, while the example is well known, it still merits careful explanation. For chaos theory, as per the puzzle film, involves as a starting point a rejection of classical cause and effect. Gleick's example is good because the minute nature of the butterfly in comparison to the planetary scale of the Earth's meteorological systems does help to convey the way in which, according to chaos theory, it is impossible to pin down a single, precise cause for events that take place. Nonetheless, Gleick's example is potentially misleading, too, because it seems to suggest that, with enough information, one could pinpoint the cause of the storm in New York to the butterfly beating its wings in Beijing. This is strictly not the case. For what Gleick does not mention, but which is important to bear in mind, is that equally contributing to that storm in New York is the fly beating its wings in Santiago, the daddy long legs flapping about in Greenland, and the cockroach taking flight in Sydney. In other words, it is not that this butterfly alone caused that storm in New York but that both butterfly and storm (and fly and daddy long legs and cockroach) are part of a system so vast, complex, and integrated (it includes everything, the totality of things) that we cannot attribute a single cause at all. Instead, as Brian Massumi has noted, there are only "quasi-causes" (Massumi 2002, 225): no one thing contributes the cause, but everything plays a causal role. In some senses, then, everything is interlinked.

As Michael Wedel (2009) has discussed, a film like *Run, Lola, Run* (Tom Tykwer, Germany, 1998), in which we see the same story played out three times, but with variations, embodies this notion relatively well: the slightest changes in initial conditions can lead to wildly disparate outcomes for Lola (Franka Potente) as she tries to raise enough money to free her boyfriend, Manni (Mauritz Bleibtreu), from the mob (in one version he dies,

in another she dies, and in another they both raise the money via different means). However, in order to push this point further, I would like to progress beyond chaos theory and toward a related term, *complexity theory*.

Complexity theory is the emergence of order out of chaos. The storm in New York can equally serve as an example of this: from the unthinkable chaos of butterflies, flies, daddy long legs, and cockroaches all over the world beating their wings (which is not to mention humans and other animals breathing and plants photosynthesizing, and perhaps all other motion in the entire universe that contributes in a quasi-causal fashion to the storm in New York), there emerges something identifiable and relatively simple—namely, a storm in New York.

Biologist Jack Cohen and mathematician Ian Stewart have summarized the theories of chaos and complexity thus: "Chaos theory tells us that simple laws can have very complicated—indeed, unpredictable—consequences. Simple causes can produce complex effects. Complexity theory tells us the opposite: Complex causes can produce simple effects" (Cohen and Stewart 1994, 2). Or, as Gleick puts it, "Simple systems give rise to complex behavior. Complex systems give rise to simple behavior. And most important, the laws of complexity hold universally, caring not at all for the details of a system's constituent atoms" (Gleick 1998, 304). Something very simple, a fly beating its wings, can contribute in a quasi-causal fashion to something complex, a storm in New York. At the same time, the storm in New York is the relatively simple result of the vastly complex arrangement of the universe at a given moment in time. In some respects, then, complexity and simplicity seem two sides of the same coin: the storm is massively complex from the perspective of the fly but is relatively simple from the perspective of the universe.

In this way, we can begin to define the relationship between complexity and simplicity as something of a fractal. Discovered in nature by mathematician Benoît Mandelbrot (1967; see also Gleick 1998, 96–103), fractals are objects or systems whose structure is self-similar at all scales. That is, no matter how much we zoom into or out of a fractal system, it will always appear the same. The storm in New York functions as a fractal because while the universe is a seething chaos of moving parts, a storm in a specific location seems very simple; however, a storm seems very complex from the perspective of a fly beating its wings, but the fly itself would seem relatively simple if we were to understand it as being dependent upon a whole, complex body of microscopic, interlinked parts—cells, cell walls, gas molecules, water, and more. And perhaps even a cell, complex as it is, can seem a simple, emergent product if we consider it from the perspective of a soup of quanta and quarks frothing around in the most microscopic reaches of space and time. In other words, the fractal nature of the relationship between chaos and complexity—the same things are simple or complex depending where you wish to view them from—allows us to complicate

the relationship between simplicity and complexity. Instead of there being 'simply' simplicity and complexity, the two are interlinked in the physical universe in such a fashion that we might better use a term like *simplexity* or *complicity* to describe the intertwined relationship of the two—which is what Cohen and Stewart do in their description of how chaos 'collapses' into order (Cohen and Stewart 1994, 396–445).

In this way, I have complicated the definition of complexity, such that we can begin to modify our understanding of complex cinema, particularly in relation to *Inception* and *Five*.

the *inception* complicity

Having called for a careful definition of complexity, Staiger goes on to suggest that "complexity in one area does not necessarily produce overall textual difficulty or sophistication" (Staiger 2006, 3). In some respects, this is the case with *Inception*. In the film, we see Cobb and his team move from carrying out operations in which they enter the dreams of other people in order to obtain personal and/or corporate secrets from them, to carrying out an inception. That is, their task is to plant into the mind of Robert Fischer (Cillian Murphy) the idea that he wants to sell off his father's global energy business when he inherits it. Cobb is paid to do this by Saito (Ken Watanabe)—and he assembles a team of various experts who can infiltrate certain levels of Fischer's mind and/or create dreamscapes that he will think are his own but which are in fact controlled by Cobb and his crew.

So far, so complex. Indeed, the film spends a long time explaining to us various of the provisos that go with entering someone else's mind: there are five layers to the human psyche, each deeper and more mysterious than the last, with the fifth level being the unconscious or Limbo level—a chaotic mass in which decades can seemingly pass for the inhabitant, even though in the 'real' world only minutes or seconds have gone by (indeed, the further one goes into the person's mind, the 'faster' time passes, such that hours on the lower mind levels are instants in the waking world). Now, one cannot simply plant an idea in the first level of someone else's mind; Fischer is trained to detect invaders in his psyche, and also, this would be too shallow for him to believe that the idea came from himself. As a result, Cobb and company must work their way deep into Fischer's mind, to the fourth level, where he keeps his deepest secrets. There they can place the idea of selling off his father's business so that Fischer feels as though it truly is/was his idea.

There are various subplot elements and points of procedure that perhaps also merit elaboration. Cobb is haunted by the memory of Mal (Marion Cotillard), his former wife, who supposedly killed herself when she could not distinguish her own reality from a dream (dying in a dream—as well as receiving a large jolt—means that one 'wakes up' in the next dream

level up; convinced that she was still inhabiting a dream, Mal believed that her death would simply cause her to wake up in reality). Indeed, confusion between whether what is happening is real or in someone else's mind is commonplace in the film; as a result, characters have a totem, the behavior of which only they can determine/interpret. Cobb's is a spinning top; if the top stops spinning and falls over, he is awake. If not, he is still in the dream world. As it is, Mal's memory continually sabotages Cobb's missions, while missions are also susceptible to attack from various anonymous (but for some reason always aggressive, always armed, and always male) projections of the host's mind. Cobb's motivation for undertaking the inception mission is that it will allow him to reenter the US, where he can continue his life with his children, whom he chose to abandon after Mal's suicide, which Mal made to seem like murder (Cobb would have gone to prison had he not fled).

Now, what is a relatively complex plot is only made more complex by the way in which the film is shot. For a start, there are various specific trompe l'oeil shots, including one of an M. C. Escher–style staircase that descends only to join back on to itself, and another featuring the infinite regression of characters stood between mirrors facing each other. The total surface of the Escher-style staircase (it has no depth because the staircase connects back on to itself) and the infinite depth of the double mirror shot (there are Cobbs as far as the eye can see) suggest an awareness on the film's part of the play between simplicity and complexity that perhaps is core to complex cinema as I am trying to define it here. Nonetheless, the film is also complex for its sophisticated use of parallel editing: in accordance with classical Hollywood cinema, the protagonists have a deadline (they must plant the idea in Fischer's head before the airplane that they are all traveling in lands), but here this deadline becomes five separate deadlines as each character must penetrate and then subdue a different layer of Fischer's psyche.

What is more, what happens on one level directly affects what happens on the other levels. For example, when Yusuf (Dileep Rao) drives a van over the edge of a bridge on the first dream level, this means that there is no gravity for Cobb's main associate Arthur (Joseph Gordon-Levitt) on the next level down. This in turn means that there is an avalanche on the next level down where Eames (Tom Hardy) struggles to fight with more of Fischer's projected protectors. In other words, audiences are invited to carry out much cognitive work when watching the film in order to keep on top of what is going on. For these reasons, *Inception* is a complex film.

Nonetheless, *Inception* also does not add up in many ways, and these make the film somewhat 'simple' in various respects. This is not a case of writer-director Christopher Nolan creating a story in which the science is wrong. Or rather, while the film probably does present to us a set of events that from the scientific point of view are impossible, this is not the

charge that I wish to level at *Inception.* Rather, there are one or two elements of *Inception* that seem unexplained and that would undermine the whole premise of the film.

The first and most simple of these is that the film culminates with Saito, Cobb, and his team joining Fischer on the flight from Sydney to Los Angeles during which the inception will take place. As Rod on the parody script website The Editing Room has implied, it is strange that even though Fischer has been trained to repel intruders into his brain/mind/dreams, he does not recognize Saito, the head of the largest rival energy company in the world (Rod 2010). Furthermore, while Yusuf's falling van causes gravity to cease on Arthur's level of Fischer's mind/dreams, it does not on Eames's level (or any of the subsequent ones), even though it does cause an avalanche there (Rod 2010).

However, most problematic (for me) with regard to *Inception* is the very notion of inception itself. It is not, as Rod points out, that it might just have been easier to kill Fischer than to go through with a convoluted brain implant (Rod 2010). Rather it is that the film insists that inception must take place on such a profound level at all. Humans are influenced by the thoughts and ideas of others all the time. For example, I know full well that my belief that we live in a world in which good and evil are not essential truths but moral constructs was first introduced to me while reading *Beyond Good and Evil* (Nietzsche 1998)—but I still believe the idea for myself, and I do not believe that Nietzsche's presence in this inception somehow invalidates it or makes me any less my own person. In fact, I believe that we only exist in relation to each other (for a more complete treatment of this idea, see Brown 2013)—and that we would not have ideas at all were it not for our interactions with other people. Why Cobb is not an expert in befriending people and of suggesting ideas to them, much like a hypnotist, say, seems nonsensical to me. Indeed, provocatively speaking, evidence for this much more commonplace take on inception as a process is the fact that the film *Inception* seems to have planted in so many people's heads the idea that it is a good, maybe even a great, film. If inception were so difficult, surely the film would have failed to convince so many people of its excellence.

There are other questions not answered in *Inception* (How does Saito have the power to have murder charges dropped against Cobb?; Why does Eames insist upon impersonating a particular person when, given that this is a dream world, he could become a wall or a chair in order to spy with less likelihood of detection?). However, the point here is not to make a list of shortcomings with the film. That is the task of reviewers and fans. Rather, I wish to use these logical shortcomings as instances of how *Inception* has a (surprisingly?) simple and simplistic logic when one views it from a more distanced perspective: the whole film is a storm in a teacup—even if that storm is still real enough while one is in that teacup.

The question of how the film is made here becomes important. For, as mentioned, *Inception* is a film that makes serious cognitive demands of its viewer: it is hard to keep up with all that is going on and how each of the film's levels fit together. Furthermore, *Inception* is a film made by and largely using the stylist tropes associated with what David Bordwell (2006, 121–138) has termed "intensified continuity": rapid cutting, extreme focal lengths, a camera that is always moving. Drawing upon contemporary understandings of attention, I have argued elsewhere that the intensified continuity style might appeal 'naturally' to viewers but that the demands made upon us as a result of the film's rapidity might make it hard for us to 'see through' (to get into?) the film, such that we think about such logical inconsistencies as those outlined above (Brown 2011). In effect, *Inception* is such a rapid (which is not to mention bright and good-looking) film that our attention is drawn away from the inconsistencies, the 'poverty' of the film's story, and the 'simple' core that the movie seems ultimately to have.

Some might say that looking for and finding holes in a film like *Inception* 'takes away from the fun' of the film. Suddenly I am taking too seriously something that should not be taken seriously—even though nowhere in the promotional material have I read that the film is *not* to be taken seriously. In some respects, to say one should not take *Inception* seriously is legitimate, but I raise it here because it points to an important aspect of film-going. If, implicitly, viewers have a contract with *Inception* such that they are not to take it too seriously, and if I look for and find holes in the film's plot and conceptual framework, then supposedly I have violated my contract with the film because I have taken it too seriously. And yet, as Will Brooker (2012, 1–43) points out, *Inception* is a film that marks Christopher Nolan's emergence proper as an auteur in Hollywood—a filmmaker whose work is precisely to be taken seriously, even if the characterization of *Inception* as a Christopher Nolan film has an economic as well as an artistic prerogative.

In other words, *Inception* wants to eat its cake and have it, too: it presents itself as a serious work by a serious artist, and yet one has not taken the film in the intended spirit if one points out its logical shortcomings. Abbas Kiarostami's *Five*, on the other hand, seems to suffer from almost the polar opposite problem, as I shall now discuss.

the *five* simplex

If *Inception* is marketed as the work of an auteur, then Abbas Kiarostami is perhaps one of the most recognized auteurs in contemporary world cinema—as the various monographs dedicated to his work suggest (see Elena 2005; Nancy 2001; Saeed-Vafa and Rosenbaum 2003). Nonetheless, even though his status as an award-winning auteur might lead us to believe

william brown

134

that he creates deeply complex films, in some respects nothing could be further from the truth.

As mentioned, *Five Dedicated to Ozu* comprises five static shots, each lasting for up to fifteen minutes, and yet very little happens—at least in terms of conventional plot. The first shot sees a piece of driftwood caught on waves on a beach; the second shows us a seaside pier and various passersby; the third and fourth also show us different angles of a (the same) beach, the fourth involving a badling of ducks that walks across the screen first from left to right and then from right to left; and the final shot involves an almost entirely dark screen that turns out to be of a pond at night.

Ostensibly, nothing could be more simple. Furthermore, nothing could be more slow for the unhabituated viewer—*Five's* seventy-four-minute duration seeming an eternity to some of the students to whom I have shown the film. Nonetheless, I find few films as profound as *Five*—but perhaps also few as joyful. The joyfulness of the film is important because if others argue that to pick holes in *Inception* is somehow to take the film too seriously, then so is viewing *Five* as a dull, eventless movie also to take it too seriously.

Earlier I mentioned how the split between mainstream and art house cinema, both by audiences and by film scholars, runs the risk of erecting boundaries where in fact there are none. In her consideration of art works that endeavor to break down the boundaries between illusion and reality, Maggie Nelson suggests that boundaries are not always bad but that, in the spirit of Ludwig Wittgenstein, they can sometimes help to delineate the rules of the game (Nelson 2011, 47). That is, boundaries help us to understand and to reach responses appropriate to that which we are considering. I might modify Nelson's argument in relation to the mainstream art house 'boundary,' however, and say that the distinction between the two remains illusory but that we should perhaps consider many films to be playful. This is not to consider films as games, although this can be a productive approach to cinema, as Jan Simons has shown in relation to the cinema of Lars von Trier (Simons 2007). Rather, if I take *Inception* 'too seriously' as a result of its trying to position itself as the work of an auteur, then perhaps many viewers take *Five* too seriously, even though it is also the work of an ostensible auteur (who goes so far as to reference another 'serious' auteur, Yasujiro Ozu, in the title of his film).

Instead of taking *Five* too seriously, then, and considering it a waste of time (I'm never going to get those seventy-four minutes back—as if one got back any of the time one were on Earth), a more 'joyful' approach might help bring its complexity to the fore. For *Five* is patently *not* a film in which 'nothing happens.' Watching the film, I find myself absorbed by the piece of driftwood: Will it rest on the shore? Will it float off? Will it split? Will it sink? Not only does the film fill me with suspense, but it also allows me to think. As opposed to the onslaught of information that is *Inception*,

which does not stand up to much scrutiny, *Five* appears to show us not much of interest—until we realize that the screen is alive with happenings and that the least movement of the ocean is worth contemplation, since it, like the butterfly beating its wings, is part of the world around us, playing a quasi-causal role in all that happens.

Five's slowness and lack of camera movement are key here: it is the film's slowness, perhaps off-putting at first but ultimately hypnotic, that invites us to reflect and to think. A cognitive approach to the film would seem to suggest as much:

> When multiple viewers attend to the same static scene, they do not necessarily look in the same places at the same time . . . It might be expected that an increase in complexity of a dynamic scene would also increase differences among viewers. However, the opposite is true. The gaze of viewers is highly coordinated in dynamic scenes, a phenomenon called *attentional synchrony.*
>
> (Smith, Levin, and Cutting 2012, 109)

In other words, a visually complex film like *Inception* leads to a simple/poor variety of responses, while a visually simple film like *Five* leads to a complex variety of responses. In *Five,* there is no right or wrong place to look (there is nothing to 'get' here). But by getting into the film, by allowing its complexity to emerge slowly as one takes a complex pleasure in seemingly the most simple things, this is what the film's slow pace and static camera allow audience members to do. By the time we see the ducks walking one way and then the other, we can only marvel at the organized (if staged) behavior of these animals: such complex movements for such supposedly simple creatures. The scene is comic and, as mentioned, joyful: from so simple a shot, such a complexity of thoughts and emotions can emerge that truly we do have a complexification of simplicity and the simplification of complexity when we compare a film like *Inception* to a film like *Five.*

the black whole

I should like to conclude this essay by returning to the issue of why I have put *Inception* alongside *Five.* In her contribution to the first *Puzzle Films* volume, Eleftheria Thanouli (2009) identifies the worldwide reach of complex cinema, an idea that she also explores in a second article from the year before (Thanouli 2008). Physicist Max Tegmark (2007), meanwhile, has come up with an "ultimate ensemble theory of everything" that draws upon possible worlds theories to describe a free-floating universe in which the whole emerges as more simple than the detailed analysis of any of its

complex parts. The important thing to take away from this is that the whole can sometimes be more easily grasped than the parts, with Tegmark's theory significantly echoing the 'fractal' nature of chaos/complexity and simplicity/complexity—in that the universe is a simple entity that emerges from a chaotic and complex mass of parts.

With regard to film studies, perhaps we are also moving to a stage where analysis of the whole (global trends in a global cinema industry in an era of globalization) is easier (or at least more urgent) than the painstaking analysis of cinema's multiple, complex, and dynamic parts. The problem is that it is impossible to see the whole of cinema, since it is too great: there are far too many films, particularly in an expanded 'new' media environment in which the number of films has virtually exploded. And yet, I would propose that we strive to do this, since it may be that by putting unlikely films alongside each other, we find that they have commonalities that give us a better sense of the whole than simply moving into ever more specialized areas of research that never interact or find common ground with other areas of research.

Recent quantitative analysis of films over a seventy-five-year period has revealed that (mainstream) films have become quicker, faster, and, most significantly, darker (Cutting et al. 2011). There are more cuts, and there is more motion on screen, but there has also been a general darkening of cinema. Smith, Levin, and Cutting suggest that "darker images give viewers fewer options of where to look" (Smith, Levin, and Cutting 2012, 109). That is, darker images control viewers' responses with greater accuracy, since viewers' attention is drawn only to the part of the screen that is clearly lit, rather than to the other parts of the screen that the darkness otherwise hides. While this interpretation seems logical, it is not the only plausible one. For example, we could also see the darkening of mainstream cinema as the 'noirification' of cinema, with *Inception* as a key example of the ongoing presence of noir elements in mainstream film. If we accept that the search for answers that the puzzle film typically entails means that the puzzle film has its roots in film noir, centered as classical noir films often also were on an investigation, then the 'noirification' of cinema is global, in that the trend for the emergence of puzzle films is, as Thanouli (2008) suggests, also global.

Globalization, which sees the removal of boundaries where previously there were fixed borders, itself plays a role in this process of noirification: globally now, we search for something like a coherent identity—a search mapped out on our cinema screens, most ostensibly in puzzle films. Paradoxically, however, the darkening of the screen also suggests a narrowing of vision, in that we concentrate on the elements of the screen that are lit, rather than the dark majority. If the globalized era offers to us a time period in which we feel lost and without identity, and if we are in search of that identity, then perhaps the key to finding it is in trying to see as

holistically as possible, to include the dark elements of the screen in our understanding of the image. While *Inception* does have an ambiguous ending, meaning that the whole film might have been a dream, *Five* is ambiguous from start to finish through the way in which the viewer is invited to contemplate the whole of the screen. Indeed, when there is darkness on Kiarostami's screen—as in the final shot of *Five*—it is a near complete, almost impenetrable darkness. In the context of global puzzle films and the noirification of cinema, Kiarostami here offers us not the guided and simplified solutions of the partially lit, supposedly complex film like *Inception*. Instead, Kiarostami goes to the logical extreme and offers us the black (w)hole: a seemingly uniform visual field of darkness, but it does not offer us simple answers; it instead encourages us to think, which leads us toward the complexity of autonomous thought.

references

Bordwell, D. 2002. "Film Futures." *SubStance* 31(1): 88–104.

Bordwell, D. 2006. *The Way Hollywood Tells It: Story and Style in Modern Movies.* Berkeley: University of California Press.

Branigan, E. 2002. "Nearly True: Forking Plots, Forking Interpretations—A Response to David Bordwell's 'Film Futures.'" *SubStance* 31(1): 105–114.

Brooker, W. 2012. *Hunting the Dark Knight: Twenty-First Century Batman.* London: I. B. Tauris.

Brown, W. 2011. "Rejecting the Psycho-Logic of Intensified Continuity." *Projections: The Journal for Movies and Mind* 5(1): 69–86.

Brown, W. 2013. *Supercinema: Film-Philosophy for the Digital Age.* Oxford: Berghahn.

Buckland, W. (ed.). 2009. *Puzzle Films: Complex Storytelling in Contemporary Cinema.* London: Wiley-Blackwell.

Cameron, A. 2006. "Contingency, Order, and the Modular Narrative: *21 Grams* and *Irreversible.*" *The Velvet Light Trap* 58: 65–78.

Cohen, J. and I. Stewart. 1994. *The Collapse of Chaos: Discovering Simplicity in a Complex World.* London: Viking.

Cutting, J. E., K. L. Brunick, J. E. DeLong, C. Iricinschi, and A. Candan. 2011. "Quicker, Faster, Darker: Changes in Hollywood Film over 75 Years." *i-Perception* 2: 569–576.

Eig, J. 2003. "A Beautiful Mind(fuck): Hollywood Structures of Identity." *Jump Cut: A Review of Contemporary Media* 46. www.ejumpcut.org/archive/jc46.2003/eig.mindfilms/index.html.

Elena, A. 2005. *The Cinema of Abbas Kiarostami,* trans. B. Coombes. London: SAQI/Iran Heritage Foundation.

Elsaesser, T. 2009. "The Mind-Game Film." In *Puzzle Films: Complex Storytelling in Contemporary Cinema,* ed. W. Buckland, 13–41. London: Wiley-Blackwell.

Everett, W. 2005. "Fractal Films and the Architecture of Complexity." *Studies in European Cinema* 2(3): 159–171.

Gleick, J. 1998. *Chaos: Making a New Science.* London: Vintage.

Harper, G. 2005. "DVD and the New Cinema of Complexity." In *New Punk Cinema,* ed. N. Rombes, 89–101. Edinburgh: Edinburgh University Press.

Harper, G. 2007. "Emobility and the New Cinema of Complexity." *Journal of Contemporary European Studies* 15(1): 15–22.

Johnson, S. 2005. *Everything Bad is Good for You: How Popular Culture is Making Us Smarter.* London: Penguin.

Mandelbrot, B. 1967. "How Long is the Coast of Britain? Statistical Self-Similarity and Fractal Dimensions." *Science* 156(3775): 636–638.

Massumi, B. 2002. *Parables for the Virtual: Movement, Affect, Sensation.* Durham, NC: Duke University Press.

Mittell, J. 2006. "Narrative Complexity in Contemporary American Television." *The Velvet Light Trap* 58: 29–40.

Nancy, J.-L. 2001. *Abbas Kiarostami: The Evidence of Film.* Paris: Yves Gevaert.

Nelson, M. 2011. *The Art of Cruelty: A Reckoning.* New York: W. W. Norton.

Nietzsche, F. 1998. *Beyond Good and Evil: Prelude to a Philosophy of the Future,* trans. M. Faber. Oxford: Oxford University Press.

Panek, E. 2006. "The Poet and the Detective: Defining the Psychological Puzzle Film." *Film Criticism* 31(1–2): 62–88.

Ramírez Berg, C. 2006. "A Taxonomy of Alternative Plots in Recent Films: Classifying the 'Tarantino Effect.'" *Film Criticism* 31(1–2): 5–61.

Rod. 2010. "*Inception:* The Abridged Script." www.the-editing-room.com/inception.html.

Saeed-Vafa, M. and J. Rosenbaum. 2003. *Abbas Kiarostami.* Chicago: University of Illinois Press.

Simons, J. 2007. *Playing the Waves: Lars von Trier's Game Cinema.* Amsterdam: Amsterdam University Press.

Smith, T. J., D. Levin, and J. E. Cutting. 2012. "A Window on Reality: Perceiving Edited and Moving Images." *Current Directions in Psychological Science* 21(2): 107–113.

Staiger, J. 2006. "Complex Narratives: An Introduction." *Film Criticism* 31(1–2): 2–4.

Tegmark, M. 2007. "The Mathematical Universe." *arXiv.org.* http://arxiv.org/PS_cache/arxiv/pdf/0704/0704.0646v2.pdf.

Thanouli, E. 2008. "Narration in World Cinema: Mapping the Flows of Formal Exchange in the Era of Globalisation." *New Cinemas: Journal of Contemporary Film* 6(1): 5–15.

Thanouli, E. 2009. "Looking for Access in Narrative Complexity: The New and the Old in *Oldboy.*" In *Puzzle Films: Complex Storytelling in Contemporary Cinema,* ed. W. Buckland, 217–231. London: Wiley-Blackwell.

Wedel, M. 2009. "Backbeat and Overlap: Time, Place, and Character Subjectivity in *Run, Lola, Run.*" In *Puzzle Films: Complex Storytelling in Contemporary Cinema,* ed. W. Buckland, 129–150. London: Wiley-Blackwell.

Wilson, G. 2006. "Transparency and Twist in Narrative Fiction Film." *Journal of Aesthetics and Art Criticism* 64(1): 81–95.

Žižek, S. 2001. *The Fright of Real Tears: Between Theory and Post-Theory.* London: British Film Institute.

the science fiction
hollywood puzzle film

section three

philip k. dick, the mind-game film, and retroactive causality

t h o m a s e l s a e s s e r

the power of the posthumous

It seems the family resemblance among so many of the films we label mind-games or puzzle films is no accident.[1] Insofar as they have one common father, his name is unquestionably Philip K. Dick (PKD). Not only are some of the most absorbing cult films of the past three decades adaptations of Dick's fiction (predominately short stories)—for example, *Blade Runner* (1982), *Total Recall* (1990), *Minority Report* (2002), *A Scanner Darkly* (2006)[2]— several other films revealing to their heroes that they are in fact living fake or manipulated lives, such as *The Matrix* (1999) or *The Truman Show* (1998),[3] are like PKD clones, just as *The Sixth Sense* (1999), *Vanilla Sky* (2001), *The Others* (2001), *Inception* (2010), *Dark City* (1998), *eXistenZ* (1999), *Eternal Sunshine of the Spotless Mind* (2004), and *Looper* (2012), to name a few, also have distinct PKD DNA: they all share his 'what if' thought experiment premises, are variations on his obsessions, or play riffs on his themes and motifs, such as "repressed memories, false pasts, strange doubles and simulated realities" (Lambie 2012).

Such major direct and indirect influence on mainstream cinema seems particularly perplexing, given PKD's outsider status during his lifetime and his late recognition even as an exceptional sci-fi author:

> American author Philip Kindred Dick died in 1982 [at age 54], leaving behind an astonishing 41 novels and around 120 short stories. But despite his prolific output, and the success of the adaptations of his work—most famously *Blade Runner, Total Recall* and *Minority Report*—Dick passed away in relative obscurity. Celebrated though he was in sci-fi circles, it was only in the 30 years after his death that his fame gradually grew—as of 2009, adaptations of his novels and short stories grossed an estimated total of $1bn at the box office.
>
> (Lambie 2012)

As this passage implies, Hollywood was late in calling on his work, and only toward the very end of his life was Dick making anything like an income from selling his work. For "We Can Remember It for You Wholesale"—the story that became *Total Recall* and in its original version (1990) grossed over $260 million—Dick was paid a derisory $1,000 in 1974. Though he negotiated a somewhat better deal over *Do Androids Dream of Electric Sheep?*, which became *Blade Runner* (1982), Dick had little time to enjoy these financial rewards: he died before the film opened. The enormous impact that *Blade Runner* and *Total Recall* would have on creating a special New Hollywood genre, the *sci-fi noir* thriller, raises the question in what particular sense PKD's stories put him way ahead of his time and, in a manner of speaking, made him a "pre-cog" (as the predictors are called in *Minority Report*), who, in the original story are "babbling idiots." For what strikes one is that both his reputation as a writer and his cinematic emulation, already during his lifetime, belonged to a special kind of afterlife: comparable to a 'serious' writer like Franz Kafka, also specializing in ontologically precarious, liminal experiences, also virtually unknown during his lifetime and now instantly recognizable, Dick's brand-name fame (his followers refer to each other as "Dickheads") makes his a typical case of the *posthumous*.

The condition of the posthumous, briefly described, implies a relation of the past to the present that no longer follows the direct linearity of cause and effect or the genealogy of generational succession. Instead, it forms what can be called 'a loop of belatedness,' where the present rediscovers a certain past, to which it then attributes the power to shape aspects of the future that are now our present. I take my cue about the posthumous in part from Jeremy Tambling, who, referring to Walter Benjamin's messianic conception of Jetztzeit or Now-Time, explains the condition as follows: "The past is formed in the present, posthumously. It comes into

discourse *analeptically* in relation to a present, and since it is read from the standpoint of the present, it is *proleptic* as well, in that it forms 'the time of the now'" (2001, 117). In other words, we are in the temporality of the posthumous whenever we retroactively discover the past to have been (possibly unknown to itself) prescient and prophetic, as seen from the point of view of some special problem or urgent concern in the here and now.

My argument in what follows will be that not only Philip K. Dick's fame and influence fall under the peculiar temporality of the posthumous: his whole work is an extended meditation on such loops of belatedness and retroactivity. To understand his work's presence in contemporary cinema, therefore, it pays to analyze more closely the function of time and temporality in his work, not in order to add yet more words to the already enormous literature on PKD but to try and understand this retroactive causality as symptomatic of our own situation, and as a clue to the nature of mind-game films and of their particular fascination for filmmakers and audiences. If I am right that such films embrace complex narratives and multiple temporalities in response to challenges arising from the cinema's altered status in the digital world of the actual and the virtual, then the mind-game film as the brainchild or retroactively fathered bastard of PKD can be considered an especially creative solution, since flip-over switches from *psyche* into *physis* and *physics* into *metaphysics* are embedded in PKD's literary genes, as well as his lived life and speculative spirituality. He thus touched on something typical of our present (but in truth, perennial) predicament—namely, the growing discrepancy between the belief in our central role (beneficial or nefarious) in the future of the planet, and our marginality to this future, in the face of the universe's indifference to our species. Such awareness allows us to retroactively assign the gift of prophetic vision to Dick's marginality, and explains why this lonely and by all accounts deeply troubled figure from the past now speaks to us in such a present (and prescient) way.

pkd in hollywood

In "How Philip K. Dick Transformed Hollywood" (2012), Ryan Lambie recapitulates the first halting stages of Dick's encounter with the movie industry, which actually began in a very un-Hollywood way, when Jean Pierre Gorin—one part of the Dziga Vertov group, whose other half was Jean-Luc Godard—contacted Dick in 1974 to turn his 1969 novel *Ubik* into a screenplay. The finished script was never produced, although it was eventually published as a book in 1985. In the words of Lambie, the plot involves the "protagonist, Joe Chip, . . . in a terrorist attack that appears to tear a hole in reality itself; everything is decaying at an accelerated rate, and time appears to be going backwards . . . *Ubik* deals with the subjects of dream-states and malleable perceptions of reality uncannily like Christopher Nolan's *Inception*" (Lambie 2012).

Besides repressed memories, false pasts, and strange doubles, the idea of malleable perceptions encountering holes in reality itself describes well the abiding preoccupations of Dick's fiction, and fairly itemizes the ontological tremors that reverberate from his imaginative world into the mind-game genre. One should also note how different the directors—spanning the spectrum from mainstream to independent and from maverick to art house—that Dick's offbeat conceits, oddball characters, and postapocalyptic worlds have inspired and appealed to. If it needed the combined talents of Ridley Scott, David Peoples, and Douglas Trumbull to bring Dick's universe to lugubrious life and give *Blade Runner* the wasted feel and run-down texture that has become the Dickean stock-in-trade in movie iconography, it should not be forgotten that *Blade Runner,* too, suffered its own belatedness and became only retroactively the touchstone and benchmark of *sci-fi noir* that its cult status now confirms.

Yet Hollywood's enthusiasm for Dick was not only tardy but also selective. None of the major novels has so far made it onto the screen (except *Do Androids Dream of Electric Sheep?*), and the stories when adapted often underwent decisive changes, showing the limits of what was deemed acceptable to audiences, as well as pointing up even more fundamental differences in what these stories were thought to be about. In *Do Androids Dream of Electric Sheep?,* the novel that became *Blade Runner,* Dick leaves no doubt that Decker is himself a replicant or android, and it is this knowledge that gives his inner life its poignancy and his actions and emotions their desperate air of futility. *Total Recall* takes from its source "We Can Remember It for You Wholesale" only the first third and then various motifs, jazzing up the rest with chase scenes and weird locations.

Dick's story "The Minority Report" was also significantly modified from story to script to Hollywood blockbuster:

> The movie [*Minority Report*] departed significantly from the short story, which was a paranoia-soaked potboiler in which the police commander in charge of "pre-crime" is framed by his new deputy, or his wife, or an ex-general, or all or none of the above. "I don't think Phil was all that interested in the morality of pre-crime," says Goldman, an executive producer of the film. But Spielberg was, and the movie ends with a ringing endorsement of the American justice system. "It's very difficult to be true to Phil Dick and make a Hollywood movie," Goldman observes. "His thinking was subversive. He questioned everything Hollywood wanted to affirm." No matter. With the release of *Minority Report,* Dick became an A-list Hollywood scribe, a player, a member of the club.

(Rose 2003)

I will return to the differences between Dick's story and its Hollywood adaptation at the end of this chapter, but with *Paycheck,* too, Hollywood held back: notably in the way it cast the relationship between the company the hero works for and the US government. The film modifies the original story's allegiances: in Dick's telling, Jennings is eventually aligned with the company that is trying to overthrow the (fascist, police state) government, but in the film, he is on his own against the company; the FBI tries to help him, since both are working to expose the company. In other words, the enemy in Dick's story is the government; in the film, it is the private company. For fans of Dick's stories, the film adaptations of his works are thus a mixed blessing, with some sensing that the writer's ideas have been betrayed or simply ignored and others picking favorites (typically *Blade Runner, Total Recall,* and *A Scanner Darkly*) and dismissing the rest.

pkd themes and their topical appeal

Yet such picking and choosing should ideally be based on a reasoned assessment of what are Dick's ideas and themes in the first place and why they might be worth being faithful to. Fortunately, ever since Stanislaw Lem's famous defense "Philip K. Dick, a Visionary among the Charlatans" (1975), there have been many thoughtful and perceptive studies of his themes— for instance Carl Freedman's summary: "The defining characteristics of Dick's fictional worlds are commodities and conspiracies: for Dick, virtually everything in the socio-economic field is grotesquely (if sometimes humorously) commodified, while almost everything in the socio-political field is (most often terrifyingly) conspiratorial" (1988, 123). Put as tersely as this, Dick's double-edged critique makes him a writer of interest to a Marxist scholar like Fredric Jameson, whom Freedman follows when arguing that Dick provides—in the vernacular idiom of pulp and sci-fi—a Californian version of Frankfurt School critical theory of late capitalism's relentless reification of human relations.

If consumer capitalism takes the final remnants of bourgeois interiority, including the emotions and conscience, into the realms of quantifiable value and monetary exchange, Dick's brand of paranoia, as we shall see, can also flip over into its apparent opposite, a sullen acceptance of or total indifference to self-alienation (while still constituting a critique). For however paranoid they become, Dick's heroes keep their own *cool conduct,*[4] as semicollusive culprits in their own zombified (android) existence. Besides their ambitions and aspirations seducing them into Faustian bargains, as Jennings is in *Paycheck,* people in Dick's world are willing to sell their dreams and their memories, and even future options on their own life. Alternatively (and this would be another flip-over), they have them stolen by government agencies or implanted (and erased) by ambitious high-tech companies.

Such relentless reverse engineering of the human psyche make Dick's stories ring true to a later, Deleuze-Guattari-attracted and Foucault-fed generation, which is attuned to the shifts from disciplinary regimes to control societies, practicing their own post-Fordist performance-enhancing self-optimization, while fully cognizant of governmental and corporate data-mining, wire-tapping, and intrusive surveillance techniques beyond even the wildest dreams of Dick's drug-induced bouts of clairvoyant paranoia. To this post 9/11 generation, Dick's cool is attributable less to his considerable predictive powers about the ubiquitous surveillance state and derives more from the stoicism his heroes display in the face of all such enormities, and their resourceful matter-of-factness: they do not set out to change the world or rescue civilization but simply try to stay alive, survive, and see another day.

is science fiction (our only) history?

Fredric Jameson has a double interest in sci-fi: as a Marxist, he has an investment in bringing about a better world and therefore looks to science fiction as a genre that speculates about possible futures. But Marxists on the whole do not set much store by sci-fi, regarding it as fantasy rather than as a reliable prediction of how we might, with our present actions, enable society to shape that better future.

By contrast, Jameson has a greater faith in utopias, as demonstrated in *Archaeologies of the Future: The Desire Called Utopia and Other Science Fictions* (2005), which contains three excellent chapters on Dick, where Jameson discovers in Dick, among others, a successor to novelists like Walter Scott, Manzoni, Stendhal and Balzac, creators of the nineteenth century historical novel (2005, 281–295). For Jameson, PKD's brand of sci-fi presents the future as that vantage point from which we can understand and grasp our present as history—an effect that previously I associated with the posthumous but now placed in the future rather than the past, in order to critically envisage the present. As Jameson puts it, "SF has concealed another, far more complex temporal structure: not to give us 'images' of the future . . . but rather to defamiliarize [the] experience of our own present, and to do so in specific ways distinct from all other forms of defamiliarization" (2005, 286). If the future is essentially a literary conceit, a thought experiment on the present, so to speak, then Dick defamiliarizes the present mainly by making the future uncannily familiar:[5] "The conapts, autofabs, or psycho-suitcases of the universe of Philip K. Dick, all such apparently full representations function in a process of distraction and displacement, repression and lateral perceptual renewal, which has its analogies in other forms of contemporary culture" (Jameson 2005, 286). Two assumptions come together: explicitly, Dick perspectivizes the present as the (pre)history of a future that is already with us. Implicitly, Dick also shows up the systemic contradictions of what Jameson elsewhere refers to as the "untranscendable horizon"

(of capitalism).[6] These contradictions in turn fire up Jameson's dialectic imagination because they allow him to reveal an internal logic that both explains the structural constants of Dick's fiction and goes beyond them, making the fiction itself an analytical tool of our no-future/utopia predicament, which besides the deadlocks, also signposts the escape route, thus extracting even from Dick's generally dystopic stories a utopian kernel or a Deleuzian "line of flight."

In other words, Dick's fiction confirms for Jameson that the world we inhabit is incomprehensible unless it is presented through (literary) means of indirection, subtraction, and displacements. These often take the form of "retrospective" rewritings of experiences as "memories," making Marcel Proust the high modernist past master of such estrangement through memory (see Jameson 2005, 287). What Jameson calls "posthumous actuality" aligns Dick with Proust, drawing attention in both writers to a temporality that shapes itself into a loop, whose repetitions and rewritings are humanized in Proust when given the name of "memory," and posthumanized in Dick as implants or hallucinations. The value of Jameson's approach to Dick as the designer of such loops, slung into the future, in order for us to see ourselves both "in the present" ("which is all we have," in Jameson's words) and "historically" (which is to say, relationally and in context, and therefore enabled to act meaningfully), is that he can abstract from Dick's asocial behavior, his psychological hang-ups, his private demons, and his public denunciations.[7]

pkd and the mind-game film

Jameson's undoubted achievement in his writings about Dick is that he reveals many of the structural constants and creative constraints that give the stories both internal coherence and polemical force as critical statements about society. However, it takes a mind as dialectically nimble as Jameson's to see in Philip K. Dick a writer whose fiction supports one's trust in purposive human action or that the course of history is set in the direction of progress. When Dick casts a character who can see into the future, can see all possible outcomes of actions in the future, as he does in the short stories "Paycheck" and "The Golden Man," the consequences are dire, for both the protagonist and for the world.

Even his very personal blend of Gnostic Christianity and Buddhism is more Manichean than Messianic and devoid of the promise of redemption. As Dick once drily put it: "Probably everything in the universe serves a good end—I mean, serves the universe's goals" (Dick 1975). In fact, PKD's bleakly parodic pessimism and Martian posthumanism is what contributes most directly to his affinity for the mind-game film (or the mind-game film's affinity for Philip K. Dick: their relation of mutual influence, in the mode of the posthumous, is strictly reversible).

By framing the general argument as the productive tension between history and utopia, with the past serving as a perspective for the future, while the future provides a perspective on the present, Jameson is, however, an attentive reader of Dick's peculiar looping effects that presuppose a complex causality and reversible temporalities, recognizing that they raise ethical questions about agency and accountability, along with the perennial philosophical conundrums of free will and determinism.

The latter is usually at the center of time travel films, which have, in recent decades, become once more a major feature of mainstream Hollywood, with a predilection either of returning to the past (e.g., *Back to the Future* [1985]) rather than travelling to the future, or switching back and forth between past, present, and future (as in the Terminator franchise).[8] But films like *12 Monkeys* (1995), *Donnie Darko* (2001), *The Butterfly Effect* (2004), *Source Code, Looper, About Time* (2013), and others tend to use time travel as a shorthand for returning to the past in order to repeat. This is a constant of mind-game films which often differ as to the motivations that make such repetition necessary: some repeat until the hero gets it right (self-improvement, self-reflexivity, a learning curve, as in *Groundhog Day* [1993]); others repeat in order to repair (retroactive rearrangement as in *Source Code;* Oedipal guilt, trauma, and loss, as in *12 Monkeys* and *About Time*); some repeat to indicate the contingency of our choices and the fragility of our actions (more European than Hollywood: *Blind Chance* [1987], *Run Lola Run* [1998], *Sliding Doors* [1998]); and yet others repeat as a repetition compulsion indicative of an unresolved inner conflict that returns to the past in the form of acting out, as in *Back to the Future*.[9]

While none of the films just named is a Dick adaptation, several bear the marks of his imagination, most typically perhaps *Source Code* and *Looper.* Yet the question that Dick's stories raise are both more general and more specific than those usually addressed by time travel. The more general one is, What if time does not exist?—not just in Aristotle's sense of the present not existing because as soon as we can name it, it is already the past but in the sense that while we mortals are subject to time's irreversibility, the universe is not. The more specific question has to do with the micro-level of our moral being, where time is the medium of change and of our actions but where the distribution of cause and effect, and thus the meaning of our agency, seems far from unequivocal. It is this latter issue, which goes under the name of retroactive causality, that I want to probe further with respect to Dick's filmed fictions, and especially *Minority Report.*

retroactive causality

While time travel returns to the past and time warp self-encounters have become such sci-fi clichés that they scarcely receive a (pseudo-)scientific explanation, more intellectually stimulating temporal loops involve what

is variously known as retrocausality, reverse time causality, retroaction, deferred action, *Nachträglichkeit,* and après-coup. At its most basic, these terms refer to the possibility of the future influencing the past, with effects preceding causes. Rather than accepting time's arrow pointing in one direction only, retroactive causality allows for causal movement to occur in two directions, and not only from past to future. Common sense says that this is impossible, and most scientists agree, unless some stringent special conditions are put in place. But there seems room for debate:

> Retrocausality is primarily a thought experiment in philosophy of science based on elements of physics, addressing the question: Can the future affect the present, and can the present affect the past? Philosophical considerations of time travel often address the same issues as retrocausality, as do treatments of the subject in fiction, although [time travel and retrocausality] are not universally synonymous.
> ("Retrocausality," Wikipedia, 2013)

Clearly there is a significant difference whether the term is used in the context of a scientific experiment, a philosophical "what if" scenario, or as a literary device of making strange in a novel, short story, or film script. But, then again, both Dick's stories and several mind-game films might best be regarded as subcategories or special cases of thought experiments, which would bring philosophical speculation and fictional thought experiments closer together. Dick himself has a very precise notion of how scientific and experiential notions of time can coexist while, as he puts it, standing in right angles to each other:

> I wish to add that Paul [the apostle] was probably saying one thing more than Plato in the celebrated metaphor of the cave: Paul was saying that we may well be seeing the universe backwards. The extraordinary thrust of this thought just simply cannot be taken in, even if we intellectually grasp it. "To see the universe backwards?" What would that mean? Well, let me give you one possibility: that we experience time backwards; or more precisely, that our inner subjective category of experience of time (in the sense which Kant spoke of, a way by which we arrange experience), our time experience is orthogonal to the flow of time itself—at right angles. There are two times: the time which is our experience or perception or construct of ontological matrix, an extensiveness into another area—this is real, but the outer time-flow of the universe moves in a different direction. Both are real, but by experiencing time as we do,

orthogonally to its actual direction, we get a totally wrong idea of the sequence of events, of causality, of what is past and what is future, where the universe is going.

(Dick 1975)

Yet the concept of retroactive causality that Dick refers to in all but name entered the field of literary studies and film theory via another route. More specifically, retroactive causality came into the discussion of cinema and mind-game films in the first instance through Freud's theory of *Nachträglichkeit* and its popularization through Slavoj Žižek, who not only invokes time loops but regards retroaction as one of the fundamental aspects in the identity formation of the subject: we are never fully present to ourselves, other than through the deferred actions where effects, in seeking their causes, actually generate them.

Žižek, for instance, uses both time travel and a Lynch film to illustrate this broader point about psychoanalysis, as in the following passage where he highlights the mutually exclusive but interdependent dynamics of drive and desire in human subjectivity:

[That drive and desire presuppose one another can be compared to] the time-loop in science fiction (the subject travels into the past—or the future—where he encounters a certain mysterious entity that eludes his gaze again and again, until it occurs to him that this 'impossible' entity is the subject himself, or—the opposite case—the subject travels into the past with the express purpose of engendering himself, or into the future to witness his own death . . .). In order to avoid standard examples like *Back to the Future* [and *La Jetée*], let us recall David Lynch's *Lost Highway*. A crucial ingredient of Lynch's universe is a phrase, a signifying chain, which resonates as a Real that persists and always returns—a kind of basic formula that suspends and cuts across the linear flow of time: . . . in *Lost Highway*, [it is] the phrase which contains the first and the last spoken words in the film, "Dick Laurent is dead," announcing the death of the obscene paternal figure (Mr Eddy): the entire narrative of the film takes place in the suspension of time between these two moments. At the beginning, Fred, the hero, hears these words on the interphone in his house; at the end, just before running away, he himself speaks them into the interphone—so we have a circular situation—first a message which is heard but not understood by the hero, then the hero himself pronouncing this message. In short, the whole film is based on the impossibility of the hero

> encountering himself, as in the famous time-warp scene
> in science-fiction novels where the hero, travelling back in
> time, encounters himself in an earlier time.
>
> (2000, 299)

Retroactive causality also has its application and credibility in several other contexts. Philosophers presuppose retroactive causality when playing through "what if" scenarios intended to distinguish among different kinds of impossibility: physical (the laws of physics do not allow it), conceptual (we may be able to imagine it, but we cannot specify the conditions of its possibility), or temporary (it is impossible now, but who knows if it is so at some point in the future). Many of the classical thought experiments, such as Schrödinger's cat or Einstein's elevator, imply nonlinear causal connections. It indicates that retroactive causality is a logical consequence of certain versions of quantum physics, notably in the way light is defined as either wave or particle, a definition that can be taken retroactively.[10]

However, since for much contemporary physics, the very concepts of cause and effect are inapplicable, retroactive causality, while theoretically possible, would not figure as a viable or useful concept. In cosmology and astrophysics, for instance, theories of the Big Bang and its (ultimate) reversibility would seem to imply retroactive causality: "Physicists like Stephen Hawking and Thomas Hertog [propose] a 'top down cosmology' that views the universe as having begun in every possible way, with the most probable pasts being determined right now" (Larson 2006). But this challenges the very concepts of time and thus also of cause and effect, suggesting that not only time but retroactive causality, too, have only a brief history in the minds of astrophysicists. Finally, retroactive causality makes its appearance in certain versions of Christianity, where the fall of man retroactively made it necessary to introduce evil into creation—that is, it was the fall of man that created the Devil in the first place (see Hinlicky 2011).

free will and determinism

Many, if not all of these different versions of retroactive causality have some bearing on the central preoccupations of Dick's work, while one of his prime philosophical themes is the nature of *free will,* its fragility, its hubris, and its self-delusions, thereby pointing to the limits of human beings as autonomous agents. Within the broader picture, it suggests that, in the Darwinian struggle for survival, human beings may not be the 'fittest' in the long run, superseded by forms of life and types of intelligence they themselves have helped to bring into existence—whether 'beneficial' or 'catastrophic' to humans themselves.

A consequence of these thoughts about species survival and the limits of free will is the possibility that human beings are mere means to ends,

rather than (as Christianity and European humanism would have it) ends in themselves. Instead of each man, woman, and child being God's individual creatures, the human race may actually form part of a different 'intelligent design' for whom people are transporters and transmitters—that is, the 'useful idiots' whose desires, dreams, and ambitions, along with their actions, are the subjective effects of being unwitting tools: fulfilling someone else's plan, in which humans may or may not have the star turn. In one sense, this is a dissident, skeptical riff on the Protestant (and in this form deeply American) belief in Providence—that is, that God has a special, benevolent plan for his 'chosen people,' even if 'ye of little faith' cannot see the contours and therefore have to act 'as if' they did.[11] In another sense, however, the same structure and dynamics apply, if the plan is malevolent rather than benign and providential, and instead of God, it is the government and its myriad agencies, both overt and covert, that manipulate the people in the name of duty and patriotism, or it is corporations adept at using these same exalted values and sentiments to further their own ends.[12] Films such as *Pelican Brief* (1993), *Enemy of the State* (1998), *Syriana* (2005), *Edge of Darkness* (2010), and *The Ghost Writer* (2010), not to mention countless television series, provide ample evidence that Hollywood is familiar—indeed comfortable—with such conspiratorial narratives: a genre to which, as Freedman implies, Dick is no stranger, given *Minority Report* and *The Adjustment Bureau,* with the latter especially alert to the traps that can be sprung on free will, when it no longer spontaneously falls in line with societal norms and consensual conformism.

Beyond conspiracy theories and paranoia thrillers, the 'means to other ends' view of the human race is a staple of science fiction and as such almost a given of the genre. One can cite the novels of Kurt Vonnegut (especially *The Sirens of Titan*) or Arthur C. Clarke's *Childhood's End.* In Dick, however, the notion is enriched with various forms of religious transcendentalism ("Mercerism") and heretic dissent, such as Gnosticism. It means that the critical (or merely cynical) version of human beings instrumentalized by multinational corporations or governmental agencies is both endorsed by Dick and placed within a more cosmic framework that in turn makes capitalism itself merely the instrument within another kind of "design"—"benign for the universe," even more than for the capitalists themselves.

Free will, however, is not only in jeopardy at the macro level by forms of instrumentalization, whether the external manipulator is some form of "divinity that shapes our ends" (*Hamlet,* 5, 2) and imposes an invisible design or whether human beings deploy their capacity for using others for their own ends. Free will is also challenged internally by certain inherent contradictions, which, however, only become apparent when mapped onto temporal sequentiality. It is at this juncture that retroactive causality takes on a moral significance, or rather, that its different meanings and uses prove to be relevant for understanding the paradoxes of free will in

relation to human agency and autonomy, on the one hand, and a state we might call posthuman 'distributed' subjectivity, on the other.

What is at stake can be clarified by considering the difference between classical narrative causality and causality in mind-game films. Classical narrative usually works according to an explicit or implicit logic of linear causality, where unintended consequences are signaled but then pre-empted by actions that eliminate their purported causes. Yet such linear narrative is, of course, itself constructed retroactively, with eventual closure for the audience effectively being the starting point for the maker, plotting backwards from effects to causes.

Mind-game films often highlight these paradoxical features of linear narratives, but they may also involve *multi-strand narratives,* where several distinct narrative lines are woven together, run in parallel, or become mutually entangled. These types of stories have been extensively itemized, analyzed, and subdivided.[13] Yet, unlike multi-strand narratives, where the different strands indicate merely alternative paths or trajectories, each with its own consequences, but all within the same time-space continuum, in mind-game films narrative strands can, in addition, have their own reality-status or 'ontology.' That is, representations are not merely divided between dream or reality, direct perception or hallucination, memory or déjà vu, but can be ontologically distinct and even incompatible. Examples such as *Source Code* and *Inception* come to mind, as well as the films of David Lynch, already mentioned.

An underlying premise of such mutually embedded narrative strands with different reality status is that there is no unambiguous position outside and that any observer is part of the observed. This is an insight shared by Albert Einstein, Werner Heisenberg, and Heinz von Foerster as well as Niklas Luhmann, whose system theory is based on both "auto-poesis" (self-creation, self-reference—i.e., loops) and on "second-order observation" (see Luhmann 1993). For Luhmann, too, time does not exist and is merely our human way of mapping repetition and difference, to which we add causality, in order to avoid having to experience our lived reality as contingent. It is second-order observation that binds us back into the world. Certain mind-game or time travel films make the gap apparent: while presenting diegetic reality as 'objective' and 'out there,' they may include the protagonist twice over, as observer and part of the observed (as in *Back to the Future*), which explains why such protagonists tend to meet their doubles.

With the observer position becoming part of the observed, mind-game films raise epistemological issues about the reliability of knowledge, as well as the knowability of reality, which can either lead to a form of constructivism (the world is 'objectively' unknowable, and all perceptual and sensory representations are mental constructs) or to a critique of constructivism (there are some hard realities out there that we ignore at our peril—that is, they return to us as 'unintended consequences'). If mind-game films

are, from an epistemological perspective, generally 'constructivist,' they can opt for a 'paranoid' version, where everything connects, and someone is out to get you, or for a 'hysterical' version, where you fuse with the world and abandon yourself to the forces you cannot master or control. In either case, 'objectivity' would be "a subject's delusion that observing can be done without him."[14]

a scanner darkly

Such layered and entangled versions of reality as both constructed/delusional and resistant/consequential are straight out of Dick's imaginative arsenal, and one finds both the paranoid and the hysterical type, each of which I want to examine with a film adaptation, beginning with *A Scanner Darkly*, which would be an example of the hysterical version, followed by *Minority Report*, which fits the paranoid version.

A Scanner Darkly is a detective story in the J. L. Borges tradition, which is to say that the detective eventually discovers that he is himself the person being sought. With variations, this closed loop in which external goal and internal target are shown to be continuous also forms the matrix both of *Total Recall* and *Blade Runner*, as well as several other Dick stories. As a narrative conundrum it is, of course, even older, given its resemblance to the story of Oedipus, with all its Freudian resonances. In *A Scanner Darkly*, Dick complicates his Möbius strip storyline by introducing a postworld in which much of the US population is addicted to a powerful hallucinogenic drug, produced and distributed by a shadowy antigovernment agency that Bob Arctor, the detective and undercover agent, is assigned to infiltrate, by living with a hippie group of addicts and dealers. When reporting back to his superiors, Arctor is Detective Fred, and like his senior officer Hank and all other undercover officers, he wears a 'scramble suit' that constantly changes his appearance. Becoming himself addicted and romantically involved with Donna, a cocaine addict who is his supplier, Arctor finds himself under suspicion by both the hippies and the police. As Detective Fred he is ordered to spy on Arctor, and as Arctor he is denounced to Detective Fred by Barris, one of his housemates, who fails to recognize him in his scramble suit. In a further turn of the paranoia screw, Hank is revealed to be Donna, and Arctor is merely the bait to get Barris to incriminate himself. Partly due to these manipulations and partly as an effect of the drugs, Arctor has a breakdown, which leads to him being sent to New Path, supposedly a rehab institution but in actual fact a drug lab, using addicts to tend and harvest its crops. Arctor's mental breakdown and brain damage was part of the police plan to infiltrate New Path. By the end, Arctor, now calling himself Bruce, battles to regain his sanity and smuggle out the 'blue flower' used to produce the addictive drug. However, it is unclear whom he reports to and whether there is still someone he can trust or turn to.

At one level, thus, the story as told by Dick is a case study of severe addiction, of beatific and terrifying hallucinations, of split personalities, of delusions of power and paranoiac persecution fantasies. At another level, and especially as filmed by Richard Linklater, *A Scanner Darkly* is a multidimensional, multi-level 'thought experiment' about the limits of identity, when under pressure from internal and external forces, which turn out to be versions of each other, when rehab and drug lab are the recto and verso, or the police are licensed crime syndicates mostly running undercover sting operations. Furthermore, Linklater's Rotoscope animation-live-action technique (in which animators trace over live-action footage, frame by frame) gives both the metaphor of scanning (as a particularly intense or invasive surveillance technique) and the scramble suits a vivid visual presence. It makes the audience part of the surveillance apparatus, since we constantly have to guess who is who in what guise, what role, and to what purpose.

At yet another level, *A Scanner Darkly* is a meditation on post-Cartesian notions of the self, where 'drugs' stand for the voiding of any interiority in the subject, replaced by media images and pop culture fantasies. Arctor is merely the point of intersection of different networks, working in tandem or at cross-purposes, generating intensities that produce bodily effects and affects but play on a sensory surface, for which 'scanning' is the appropriate form of contact and interaction. Arctor and Fred are 'scramble suits' even before they put on any disguise, making the paranoid fantasies of control and manipulation seem almost nostalgic reminiscences of days when one could point to a central controlling intelligence or agency, manipulating us for their ends. Unlike Tyrell of the Tyrell Corporation in *Blade Runner*, Rethrick of Allcom in *Paycheck*, and Lamar Burgess in *Minority Report* (film), there is no 'enjoying super-ego' father figure in *A Scanner Darkly* on whom to project rebellion, resistance, or revenge. Scramble suit characters would be the prototype for the distributed subjectivity, lacking the interiority of the bourgeois individual and lacking even the 'lack' of Oedipal identity (i.e., symbolic castration).

minority report: self-fulfilling prophecy and self-cancelling causality loop

On this reading, *A Scanner Darkly* is Dick's most far-reaching exploration of the collapse of boundaries, while nonetheless maintaining his dual perspective of reality and subjectivity, or as Jameson would have it, "both history and psychology in scandalous concurrence" (2005, 351). By the same token, Linklater's film would count as the most successful adaptation—a view shared, for instance, by several commentators, including Dick's daughter Isa.

The work, however, that most deeply probes the question of retroactive causality in relation to free will and determinism, as well as politics and

ethics, across closed loops of conspiracy and the open loops of paranoia, is *Minority Report,* especially when taking into account its two versions, Dick's short story and Spielberg's film. These are best considered not so much as the literary source and its filmic adaptation but as two distinct variations on a set of common themes, among which the most important would be free will and determinism; self-fulfilling prophecy; and the self-cancelling causal loop, with—in Spielberg's film—a fourth one added: namely, that of personal trauma as a psychic phenomenon typically associated with deferred action and unpredictable 'returns,' reviving feelings of guilt and leading to actions that try to undo what cannot be undone, seek out the source that caused the original trauma, or reconstruct a past scenario that might explain and justify present suffering.

With regard to free will and determinism, *Minority Report* initially represents an ideal state of balance, since the purported full knowledge of the future perfectly aligns the protagonist and his actions. The underlying premise of (the thought experiment that is) *Minority Report* is that preemptive action can create a virtuous circle: we are in a society where prophecies are so reliable that they can be used and acted upon by the police in order to eliminate crime. This is dramatically orchestrated by Spielberg in the opening scenes with John Anderton (Tom Cruise) in front of his magic screens and then successfully preventing the jealous husband from killing his wife's lover. The curved screens and sweeping hand motions, as well as repeated circular motifs (the circular terrace houses, the children's merry-go-round) reinforce the idea of a virtuous circle but also that of closure, repetition, and the loop.

None of this is in Dick's story, where our attention is quickly drawn to another kind of loop. However successful the Pre-Crime program, it is too perfect, since anticipating an offence means that the crime was not committed. The (unintended but unavoidable) consequence is that society creates (and incarcerates) criminals who are innocent, thus acting immorally if not criminally. Here the loop, based on preemption and deterrence, represents a moral deadlock, with the vicious part cancelling the virtuous part—yet the system as a whole is 'in equilibrium' as any initial situation demands.[15]

In the film version, the disturbance occurs when Anderton, the officer in charge of the prevention program, discovers that he himself is the named suspect, about to murder, within the next thirty-six hours, a man who is to him a complete stranger. Knowing himself innocent of such intent but also believing the system to be infallible, Anderton goes into hiding in order to investigate this apparent inconsistency, suspecting foul play by a government agency that wants to discredit the program, but he is also on the run, since the program, knowing that he knows, is doubly intent on eliminating him. Eventually locating his supposed target, Anderton nearly fulfills the prophecy when he discovers evidence that

points to the man who kidnapped (and probably killed) his seven-year-old son years before.

What is he to do? Shoot the man and thus prove the pre-cogs retrospectively right, by giving himself a motive he did not know he had? Spare the man and thus let the source of his deepest personal tragedy go unpunished? Kill him, to 'save' the reputation of the Pre-Crime program in which he has invested his professional pride, even if it means going to prison? Or let him go, because the 'evidence' that points to him being his son's murder may be fabricated and thus a trap into which Anderton's enemies want him to step? If we accept that the Pre-Crime system is a closed loop, then Anderton's dilemma is that of another closed loop, in which motivation, causation, and agency block each other, as each layer of possible explanation of the nature of this face-to-face encounter merely creates a denser web of hypothetical premises and unproven presuppositions, and thus the downward spiral of the vicious circle.

Spielberg's film finds several ways out. The man to be killed wants to be killed for motives of his own and commits suicide with Anderton's gun, thus fulfilling the prophecy. Full agency is restored to the hero, however, by a typical *sci-fi noir* conspiracy, headed by Lamar Burgess, a powerful political operator, Anderton's boss, and an über–father figure, who frames Anderton for another murder but whom Anderton eventually unmasks as the killer of Agatha's mother, where Burgess used a discarded pre-cog vision as a cover-up and decoy. Faced with the same dilemma of either saving himself or saving the system, Burgess opts to kill himself rather than Anderton. While these neat repetitions and symmetries somewhat muddy the question of free will versus determinism, they set up the terms for a happy ending, where Anderton's successful go-it-alone investigation not only leads to the shutting down of the Pre-Crime program (now seen as flawed) but retroactively compensates for not having protected his son, thus clearing the way also for reconciliation with his estranged wife.

In Dick's short story, the disturbance is of a different kind. Here, too, Anderton finds himself named by the pre-cogs as a future murderer but is first kidnapped by Kaplan, the very man he is supposed to kill, thus introducing a politically motivated rival to the Pre-Crime program with the same foreknowledge, intent on manipulating Anderton for his own ends. A forcibly retired army general keen to reestablish military rule, Kaplan is quick to point out the moral flaws of the Pre-Crime program as an agency that imprisons the innocent. However, a paranoid Anderton has already convinced himself that both his wife and a younger man—his professional rival—are plotting against him, which is why he agrees to go undercover, on behalf of Kaplan, and to reinfiltrate his old unit. Working both for himself (to rescue his life's work and restore his reputation) and for Kaplan (determined to discredit the Pre-Crime program in order to bring down the government), Dick's Anderton is in a different loop and double bind

from his Spielberg namesake. Without detailing the convoluted turns in Dick's story that lead to Anderton actually killing Kaplan in plain public view, the point to make is that the moves and counter-moves that prove the Pre-Crime program prediction accurate after all, follow the peculiar, successively self-cancelling logic of the minority report, which gives the story its title but which in the film version is used mainly to introduce the Agatha pre-cog backstory, only to conclude that there was no minority report from Agatha on the Anderton prediction.

The logic of temporal looping of the minority reports is, however, relevant for understanding how retroactive causality can take different forms: one tending toward recursiveness, the other to deadlock, each either self-fulfilling or self-cancelling. Whereas Spielberg's version humanizes the formal-logical paradoxes of the system's minority reports, by adding the personal traumata of Anderton, his wife and the pre-cog Agatha, and thereby opts for the deadlocks that necessitate the appearance of Burgess as the all-powerful super-villain (and deus ex machina), in Dick's version the equivalent of the super-villain is both a good guy (he thinks the Pre-Crime system is morally flawed) and the bad guy (he wants a military take-over of government), which refocuses the story on the logic of prediction as such and serves to highlight the recursiveness of the minority reports, which tends toward infinite regress rather than deadlock.

More specifically, the logic of the minority reports is such that any 'leakage' in the system—that is, prior knowledge—or the interception of the pre-cogs reports, cancels the prediction, which generates by necessity another minority report, incorporating this cancellation, a process that potentially continues ad infinitum, if the subject has access to these reports and thereby invalidates them in the very act of reading them. One way to characterize the differences between Dick's version and Spielberg's version would be to make a distinction between a 'self-fulfilling prophecy' and a 'self-cancelling causality loop': two versions of the same conundrum, in that both problematize the status and efficacy of human agency, but looked at from complementary perspectives. A definition of the former would be that a "self-fulfilling prophecy is a prediction that directly or indirectly causes itself to become true, by the very terms of the prophecy itself, due to positive feedback between belief and behavior" ("Self-Fulfilling Prophecy," Wikipedia, 2014). By constantly introducing extraneous information (Burgess, the various backstories, the trauma of the dead son), Spielberg maintains a regulatory gap (i.e., negative feedback) between belief and behavior, whereas Dick's paranoid Anderton fully fits the positive feedback model. But through the minority reports (and Kaplan's machinations) he is also part of self-cancelling causality loops, where the anticipated consequences of an action may preempt one kind of event but where the action taken instead sets in train another series of events, even more undesirable than the ones initially preempted, thereby effectively creating the vicious circle that leads to the totalitarian political takeover. In

contrast to the deadlocks in the film, staged in the successive encounters with the victims and resolved through the backstories that act as 'negative feedback'—that is, the outside interventions self-regulate the system—the successive minority reports in Dick's short story are the consequence of 'positive feedback,' with the system's own output (the minority reports) being constantly fed back as input, thus creating a permanent destabilization of both the hero's identity and of the system's power relations.

In Spielberg, the introduction of Burgess, and of the backstory of Agatha—the pre-cog, in other words—puts a stop to the inherent recursiveness and reestablishes the symbolic order, with Anderton initially the tragic Oedipal subject, in the sense of being a detective forced to investigate himself within the self-fulfilling prophecy frame of such classic tragedies as Sophocles's *Oedipus,* Shakespeare's *Macbeth,* or Kafka's parable "Before the Law." A figure also found in Borges ("The Garden of the Forking Paths"), it is the mind-game variant on the Hollywood stereotype of the hunter hunted, and of the wanted man, pursued by the police and by the villains, as we know him from Hitchcock, Lang, and, more recently, the Coen brothers and Ridley Scott, adapting Corman McCarthy's rather than PKD's stories. Spielberg toys with the mind-game version of the dilemma but opts for a more classical happy ending, with Anderton reintegrated into society under the law, a law now purged of its super-ego/super-villain 'excess.'

Dick's story leaves the outcomes of its various loops more open. Even though it also ends with the reformation of the husband-and-wife couple, headed for some Dickean planetary 'outer world,' there is no doubt about the criminality and immorality of both the Pre-Crime system and of the proto-Fascist order that overthrows and replaces it. As so often in Dick, the world has become ungovernable due to the runaway consequences of actions taken in the past, and the self-replicating systems in the present, which justify the hero turning his back on society and making a run for it.

conclusion

What can we deduce from the two films (and the different versions of *Minority Report*) regarding the questions with which I started—namely, Dick's influence as 'posthumous' and thus as an example of retroactive causality, now applied to his own person and work—while arguing that this work is itself a sustained analysis of retroactive causality? And what does Dick's affinity for the mind-game film tell us about the mind-game film's retroactive influence on the reputation and critical reception of PKD? One answer, I hope, is the one given in this chapter: both Dick and the mind-game film require us to think in terms of closed and open loops, with the possibility of either negative or positive feedback regulating the input and output. In this context, 'input' can be Dick's writings, when adapted for the screen,

with the films as 'output'—yet these writings are also 'output' (with the films as 'input'), given how the films have spawned both serious academic and equally serious fan writing about Dick the writer and visionary. The films have thus acted as 'positive feedback' for his reputation, even where they were bad adaptations, carrying Dick's reputation into the virtuous circle of a 'win-win' loop.

Similarly, if the mind-game film is a loose and possibly amorphous category of films that may involve time travel, chance encounters with unforeseen consequences, postmortem characters, and 'productive pathologies' such as schizophrenia, amnesia, autism, paranoia, and hysteria (not to mention the criminal intelligence of sociopaths and serial killers), then looping the mind-game film back to Dick's Möbius strips that entwine present with future and vice versa usefully identifies the genre less with these extreme characters and more with the complex relations of narrative to temporality, as the medium of change and human agency we call 'history.' History is, according to Jameson, the untranscendable horizon of our thinking even in Dick, but as contemporary experience also tells us—with Dick's stories as especially topical testimony—this history is regularly being rewritten, in light of the exigencies of the present, anxiously trying to calculate the risks awaiting us in the future, as the unintended consequences of human actions in the past are taking ominous shape. The paradox of an untranscendable horizon constantly being redrawn is as good a definition as any of Dick's physical metaphysics and the reality effects of mind-game films. Their multiple time schemes and time-frames—most of which run backwards and forwards—would therefore confirm these underlying anxieties, to which Dick's stories give a brightly colored but coolly composed sheen, as if to reassure readers that even if the catastrophe has already happened, there still survives a mind to register and to describe it. This mind has migrated from Dick's stories into the mind-game films, where its reflection is strong enough to illuminate a writer who, had he not existed, would have to be invented: to focus the energies that still emanate from him.

notes

1. Here and in what follows, I retain the term *mind-game film*. For definition and specification, see my chapter of that title in Buckland 2009, 13–41.
2. One could add the less successful adaptations, such as *Screamers* (1995), *Paycheck* (2003), *Next* (2007), and *The Adjustment Bureau* (2011), as well as the 2012 version of *Total Recall.*
3. "*The Truman Show* (1998) and *The Matrix* (1999) are both about relatively ordinary people discovering that the world around them is an immaculately-constructed lie" (Lambie 2012).
4. This is the title of the English translation of Helmuth Lethen's *Verhältnislehre der Kälte,* a subtle analysis of the inner distance (and thus covert

complicity) kept by many writers and thinkers during the Weimar Republic in the face of the rise of fascism.

5. Jameson, on his own admission, is indebted to Darko Suvin's definition of *SF* (Suvin 1979) as "the literature of cognitive estrangement," and *utopia* as "the verbal construction of a particular quasi-human community where sociopolitical institutions, norms and individual relationships are organized according to a more perfect principle than in the author's community, this construction being based on estrangement arising out of an alternative historical hypothesis."

6. Jameson's famous phrase is, of course, "history, as ground and untranscendable horizon" (1981, 102), but I am here conflating it with another famous Jameson saying—namely, that humans seem to find it easier to imagine the end of the universe than the end of capitalism.

7. Dick's paranoid and frankly perfidious behavior toward friends, fans, and benefactors is described in sometimes hilarious detail by several writers (see especially Herr 2001).

8. Arguably, the convoluted *Terminator* plot is inspired by two of Dick's stories: "Second Variety" and "Jon's World."

9. For an extended reading of *Back to the Future,* see Elsaesser and Buckland 2002, 220–248.

10. On Schrödinger's cat, thought experiments, and quantum physics, see www.informationphilosopher.com/solutions/experiments/schrodingerscat/.

11. Retroactive causality is also known as the *predestination paradox,* a term often used when discussing time travel in popular culture, and referring to Protestant doctrine (see Calvin 1998).

12. On this kind of antigovernment paranoia as a permanent feature of US political life, see Hofstadter 1965.

13. Several chapters in Buckland 2009 discuss multi-strand narratives, variously known as complex narratives, network narratives, fractal narratives, forking-path narratives, ensemble films, and so on. See also Berg 2006, which lists some twelve different subcategories.

14. "Objectivity is a subject's delusion that observing can be done without him. Involving objectivity is abrogating responsibility—hence its popularity" (von Foerster, in Poerksen 2004, 3).

15. The Bush administration's creation of extraterritorial preemptive detention at Guantanamo Bay is for its detainees a 'pre-crime program,' a Dickean thought experiment become political reality—and justified as a political necessity—some fifty years after the story was first published.

references

Berg, Charles Ramirez. 2006. "A Taxonomy of Alternative Plots in Recent Films: Classifying the Tarantino Effect." *Film Criticism* 31(1–2): 5–61.

Buckland, Warren (ed.). 2009. *Puzzle Films: Complex Storytelling in Contemporary Cinema.* Oxford: Wiley-Blackwell.

Calvin, John. 1998 [1559]. "On Predestination." www.fordham.edu/halsall/mod/calvin-predest.asp.

Dick, Philip K. 1975. "Man, Android and Machine." www.philipkdickfans.com/mirror/websites/pkdweb/Man,%20Android%20and%20Machine.htm.

Elsaesser, Thomas and Warren Buckland. 2002. *Studying Contemporary American Film.* London: Arnold.

Freedman, Carl. 1988. "Introduction." *Science Fiction Studies* 15(2): 121–130.

Herr, Jeet. 2001. "Philip K. Dick Versus the Literary Critics." *Lingua Franca* (May/June). www.jeetheer.com/culture/dick.htm.

Hinlicky, Paul R. 2011. *Divine Complexity: The Rise of Creedal Christianity.* Minneapolis, MN: Fortress Press.

Hofstadter, Richard. 1965. *The Paranoid Style in American Politics.* New York: Knopf.

Jameson, Fredric. 1981. *The Political Unconscious. Narrative as a Socially Symbolic Act.* Ithaca, NY: Cornell University Press.

Jameson, Fredric. 2005. *Archaeologies of the Future: The Desire Called Utopia and Other Science Fiction Stories.* London: Verso.

Lambie, Ryan. 2012. "How Philip K. Dick Transformed Hollywood." denofgeek, September 28. www.denofgeek.com/movies/2766/how-philip-k-dick-transformed-hollywood.

Larson, Cynthia Sue. 2006. "Retrocausal Reality Shifting: Adventures in the Fine Art of Changing the Past." http://realityshifters.com/pages/articles/retrocausalrs.html.

Lem, Stanislaw. 1975. "Philip K. Dick: A Visionary among the Charlatans." *Science Fiction Studies* 5 2(March). www.depauw.edu/sfs/backissues/5/lem5art.htm.

Luhmann, Niklas. 1993. "Deconstruction as Second-Order Observing." *New Literary History* 24(4): 763–782.

Poerksen, B. 2004. *The Certainty of Uncertainty: Dialogues Introducing Constructivism.* Exeter: Imprint Academic.

"Retrocausality." Wikipedia. 2013. http://en.wikipedia.org/w/index.php?title=Retrocausality&oldid=579958783.

Rose, Frank. 2003. "The Second Coming of Philip K. Dick." *Wired* (December). www.wired.com/wired/archive/11.12/philip.html.

"Self-Fulfilling Prophecy." Wikipedia. 2014. http://en.wikipedia.org/wiki/Self-fulfilling_prophecy.

Suvin, Darko. 1979. *Metamorphoses of Science Fiction: On the Poetics and History of a Literary Genre.* New Haven, CT: Yale University Press.

Tambling, Jeremy. 2001. *Becoming Posthumous.* Edinburgh: Edinburgh University Press.

Žižek, Slavoj. 2000. *The Ticklish Subject.* London: Verso.

fourth dimensions,

seventh senses

n i n e

the work of mind-gaming in the

age of electronic reproduction

g a r r e t t s t e w a r t

One puzzle about puzzle films is their longevity over the last quarter of a century. Are they mostly escapist in their hermetic (and hermeneutic) satisfactions? Do they exhaust all interest in their internal working out, or are they sometimes more telling than their stories? Self-consuming artifacts, or paranoid symptoms of an increasingly unstable sense of grounding in the global present? Answers can only come provisionally—and by example—since the films keep coming. With two of the latest in this cycle of "mind-game films" (Elsaesser 2009), and these in the increasingly sci-fi mode of the "instrumental marvelous" (Todorov 1975), the presence of topical anxieties—however they may get folded under in the unraveling of the trick plots—is hard to miss.[1] In this sense *Source Code* (Duncan Jones, 2011) is *Déjà Vu* (Tony Scott, 2006) all over again: recycling both its computer supernaturalism and its global subtext of terrorist vulnerability and surveillance overkill. Puzzle films may solve nothing beyond themselves, but as modes of the fantastic, it is important to notice what they are fantasies *of.* In these sci-fi cases, both markedly post-9/11, their fictional science of time travel is aimed, via wish-fulfillment, not just at a preternaturally

empowered search and seizure but at the wholesale magic of retroactive prevention. Yet as soon as the force of epistemology in each film (the surveillance thriller plot) turns ontological (the alternate reality fable), they tip over from forensics into equipmental fantasies of a new computer sublime, whether positive or most often negative.

There is at least a certain tech candor in the latest new phase of the Hollywood puzzle plot. Previously, the computer was thematically (and often suspiciously) unplugged. One strain of the time-warp puzzle narratives I previously examined in *Framed Time* (2006) offered 'mind-game films' in the specific sense—peculiar and symptomatic both—that the game being played was to displace gaming itself, as electronic obsession, onto psychosis instead, so that teen heroes lost in the throes of virtual images and alternative timelines emerged as more biologically dysfunctional than prosthetically adept, schizoid more than android, manic rather than electromagnetic in both their angst and their emotional escape routes. That pattern, characteristic of Generation Xbox, has been reversed lately—for the War on Terror epoch and its home (security) front—by tech-heavy sci-fi versions of time-travel narratives in the same trick-ending cycle. Before this, the eponymous Donnie Darko (Richard Kelly, 2001) and the hero of *The Butterfly Effect* (Eric Bress, J. Mackye Gruber, 2004) were troubled youths with no apparent vent in computer-game surrogacy, yet whose malleable reality and its special-effects rendering spoke indirectly to the digital climate of new Hollywood production—including the big screen's growing competition from (in these cases, narratively repressed) computer video.[2]

The earlier salience of such teen heroes—anomalous even then within an audience demographic of keyboard addiction—has been supplanted in the next round of Hollywood fantasy by adult paramilitary operatives in the grips of extravagant digital technology. Such an updated heroic testing ground—with, yet again, lethal and even posthumous consequences— draws its analogies more openly now from the escalating challenges of on-screen avatars and first-person graphics in the video playing field. Where desktop virtuality was once an unspoken trope for emotional transport and psychotic break, electronic imaging has more recently become the literalized vehicle for either reparative or escapist time travel. And in another technological feedback loop, it's all the more obvious in the closely paired films by Scott and Jones that Hollywood plotting is borrowing part of its twist-finish syndrome, as I explored with earlier examples in *Framed Time* (2006), from the 'alternate ending' supplements on the DVD menu, mass-marketed versions of their narratives' own 'parallel universe' logic.

One master plot for any such time travel, in its sentimental and romantic forms, and even when lightly disguised, is of course the dream of transcending mortality, whether preceding birth or surviving death, in order to set things finally right: in *The Butterfly Effect*, to prevent the damage your presence has done to your girlfriend and, before that, for the psychiatrist

in *The Sixth Sense,* to make amends to your wife, among others, by saying a more proper farewell. Premised as so often, almost psycho-neurologically, on the dilated moment of death itself—as a compressed scenario of its own deferral (the *Occurrence at Owl Creek Bridge* archetype)—the hero of *The Sixth Sense,* fatally shot in the opening episode, realizes, accepts, and gives in to that death only (along with our realization of it) at the very end—as if in closing off one prolonged moment of emotional release. In *Source Code*'s more recent sci-fi version of a related time-loop puzzle, however, the synapses that might once have flared up in a distended instant of consolation get 'remapped' elsewhere onto an alternate-world doppelgänger, not flickering out on the instant but given full computer-boosted dilation into a parallel universe. The remedial split-second before extinction, inhabited by a plot-long fantasy, has been replaced (or allegorized) by time's own digitized remediation.

But—come to think of it, as we tend to do somewhere en route through these plots—what is film to begin with but a parallel universe? A rhetorical question like this underwrites the whole subgenre. Puzzled out before our eyes are the conditions and limits of its medium. This, even when no technology get mentioned. And this, all the more in *Déjà Vu* and *Source Code,* when the futurist science portrayed by the films is that of a new computer-driven audiovisual regime. Two examples from earlier puzzle narratives—in which 'mediumistic' plots are covertly articulated, in their irony, by the cinematographic medium itself—should clarify the latest developments. Before its disclosed mind-game blindsides the film's apparent gothic fantasy, *The Sixth Sense* has been about a boy's ability to see ghosts, including the spectral incarnation (we belatedly realize) of the long-dead hero we had been tricked into thinking had survived his opening gunshot wound. Comparably, though turning instead on a prenarrative suicide recovered only in deferred memory (and flashback), *The Others* has, until just before the end, been about a woman fearing for her children and herself in a haunted house but who must come to accept that she and her children themselves are the ghosts of an unexpunged guilt, victims of her own desperate murder-suicide.

It is just here, at these wrenching peripeties, that form brings content up to the speed of recognition. Intercutting in *The Sixth Sense,* jump-cutting in *The Others,* work to figure the fatal evacuation of heroic agency within inhabited diegetic space. Which is to say that cinematic convention is denaturalized, turned perverse and supernatural. In the former, as reviewed in rapid flashback, the rules of shot–reverse shot have been maintained to expose the blank stares of the dead hero's manifestly unfeeling wife as if he were actually there in interchanges with her, to be seen and potentially sympathized with. The 'absent one' of apparatus theory has suffered a macabre literalization. In *The Others,* a séance held by the supposed ghosts to exorcise their newly occupied house cuts between the heroine's aggressive rage at

their tableside and the fact of her absence from the recurrent 'establishing shot': the virtual self-image versus the 'real' view of a mysterious disincarnate fury. Suture and the two-shot are alike tampered with by an out-of-body haunting that, in the films to which we now turn, is manifested instead as a computerized cyberpresence.

In the tech contortions of these more recent sci-fi puzzles, exposure of the medium in its digitally enhanced and manipulated form, though more immediate in its way, is all the more readily masked by futurist electronic technology. Embedded computer wonders are thus easy to miss at first, if not for long, as either the implicit telos or undoing—asymptote or parody—of the commercial medium we're watching. Certainly Christian Metz's (1977) dictum—to the effect that all montage is *trucage* (i.e., trick, 'special effect')—continues to find new narrative deployment in the time-travel mode.[3] Such puzzle films often extrude their own filmic (or postfilmic) conditions as a pertinent inflection of their paradoxical central tricks. Why? One thing for sure—just when the representational credibility that sustains the arc of mystery and detection is swept away by an existential game changer, the film's whole diegetic construct is put in doubt within the disclosure of a reconfigured and wholly virtual real.

déjà views: "a single trailing moment of now"

To begin (where *Source Code* in its own turn later does) with *Déjà Vu,* a straightforward summary of the plot is indistinguishable from a litany of its metafilmic ironies. A terrorist car-bomber has found the perfect venue: a New Orleans car ferry bringing returning soldiers back to their families. And in the eventual disclosure of his motives, a further violence is being brought home. The mass murderer has been rejected for Mideast service because he was deemed too gung-ho and bloodthirsty for the American ranks. The will-to-carnage summoned and thereby unleashed by overseas aggression comes back to haunt us stateside. But that's only the beginning of the militarist subtext. Long before the killer's apprehension, street-smart ATF detective Doug Carlin (Denzel Washington) is brought in on a secret high-tech operation called the 'surveillance window.' What the technicians have been able to do—in a composite program using standard closed-circuit urban video and the image feeds from seven orbiting satellites—is generate computer-simulated 360-degree access (at precisely the scale of widescreen theatrical projection) to private urban space, beginning in its demonstration scene with predictable cosmic zoom. Yet the all but holographic restaging of a crime site requires so much storage that the projected image, and its capacity for rotation and enlargement, lag four days behind the real time in which the electronic traces are first laid down. Explained as "a single trailing moment of now—in the past," it amounts to the braiding together of several separate data streams, 'trailing' time in the sense of tracking it down.

That's the set-up: the first-level explanation. The era of instantaneous transmission has become so overloaded in its detail (more like Hollywood production than everyday domestic web use, especially in the age of CGI 'rendering time') that it reverts ironically to the lag time of traditional film, which must also wait for its technical processing before it can be screened and edited. An early hint from the awed and baffled detective is dropped by his throwaway line, as if realizing the all-too-cinematic (that is, all-too-realist) nature of the equipment: "I won't even ask you how you got the audio." And the remaining two twists in this time-loop plot in fact render the idea more cinematically reflexive—even while less credible. It turns out that the composite rotational image is so powerful that it does not just reconfigure the past, reconstructed from microsecond to microsecond, but has energized the field of view, entirely to the surprise of the scientists, into an immanent duplicate of the past: a warp in time, "a fold," in their jargon, a "wormhole." Optical technology has outplayed its own hand and produced the first time machine. At this midpoint 'switch' of its trick plot, long before the forking and recursive timelines upon which bloggers dote, *Déjà Vu* has closed the distance between surveillance and spectacle, document and immersive environment. It has done so precisely by debuting its 'window' function, in its widescreen expanse, as a movie come true: a movie that, like all cinema, seems as we watch to—and this time truly does—function less as a record of some elapsed action than as an unfolding in the now of present events in their very becoming.

But it's only when the eventual murder victim on screen, four days ago, acts as if she feels spied upon that either we or the hero begin to suspect the truth. In following her around the inner corners of her reinscribed space, he comes upon an inscription in her diary that speaks not only of a metafilmic sense of voyeurism but to the nation's collective unease about unwarranted surveillance: "I've got that weird feeling I'm being watched." The point is further italicized by a pun when male technicians justify ogling her in the shower to "see if she's clean." At just this level of surveillance apprehension, a crucial plot turn in *Déjà Vu* lies coiled in wait. This time the hero must actually track down the past in the space of its former traces. All the techno-babble of the preparatory sequences, we realize, has been built up to grease the wheels of a metafilmic car chase—in one of several revisitations to the elapsed timeline accounted for, by one of the technicians, through "branching universe theory," where every return in time, altering the past, precipitates an independent and parallel graft of new reality.

For this most spectacular of the hero's forays into the past, the very logic of Hollywood editing is submitted to reconception as electronic magic, where medium has become something more fully telepathic, mediumistic. In this climactic sequence, the hero at the speeding wheel of a souped-up Hummer, wearing a headset connected to the surveillance 'window,'

tails the villain at night on a rainy freeway, his efforts further remediated in the surveillance control room. The results are a veritable laboratory of edited filmic sequence. The enemy is kept in sight in one eye (through the optical feed of the digital transmission device) while, with the aid of the other eye, the hero is trying to dodge oncoming rush hour traffic in broad daylight—and four days later. Finally, the time-tunneling detective comes face-to-face—but in an optical one-way street—with the killer, who stares blankly through him (across the gap of time itself) into an unnerving sense of his destiny, but with no present nemesis to anchor the eyeline match. From the point of view (in both senses) of industrial production, the very condition of traditional cinema—its inscription of separate shots within an articulated (and fabricated) composite space—is parsed into inoperability from within this sci-fi upgrade. Far more openly than in *The Sixth Sense,* the foundational suture of narrative cinema has itself become what it always invisibly is, only more so here: a time-lapse effect.

An added topical wrinkle only tucks further into this logic. Recalling Friedrich Kittler's claims (1999) for military invention as the recurrent harbinger of media advance, an overt military link in *Déjà Vu* comes bearing a metafilmic irony about the disappearing fourth wall of cinema's quasi-theatrical mise-en-scène. As one of the surveillance engineers puts it, the "window" is "able to see through walls" precisely because of access, not just to Hummers, but to the "same infrared heat-sensitive stuff they've been using in Iraq." The technological feedback loop is complete and, one guesses, supposedly consoling: The so-called War on Terror is fought at home as it is abroad, with the same vanguard electronics—but, in the present case, by way of well-intentioned individual surveillance rather than mass targeting. If Vietnam was the TV war, our Mideast incursions have become a more literal war of mediation, since the technologies of surveillance and targeting, and in turn prosecution and broadcast, have grown nearly identical.[4] We have satellite imaging to thank or blame both for what we are able to do there and for what we see of it on the evening news. The only way out of this double bind, according to Hollywood genre formats—the only way to transcend the invasive video surveillance that can at any moment turn violent, the imaging technology that can store and obliterate at once—is the route into sci-fi fantasy, where in *Déjà Vu* the continuous networked present is overtaken (paradoxically, preter-naturally) by the inscribed trail of a suddenly immanent past. And can it be an accident that this happens exactly in connection with a scheme of ex post facto prevention—the ultimate fantasy in this epoch of 9/11 hindsight? Typical in being strictly implicit, buried in a single allusion to Iraq-war technology, here is the unthought wish that, if we could actually turn back the clock, there would be no War on Terror, nor terror's war on us.

Instead, in *Déjà Vu* as well as in *Source Code* after it, we have the nightmare of further sacrifice, even death, at the hands of terrorism—before the

quantum leap (cinematographically figured) into a happy ending. In *Déjà Vu*, this technique of restitution (matched to classic film technology) follows from those multiple timelines where the hero must die in one to save the girl, while returning in another temporal stream to claim her. Long after a proleptic first sequence in which the (already dead) detective is first seen in slow motion as he hears his own cell phone ringing from the body bag of his corpse, we see the explanation for this, in a parallel time line, as he is done in by the bomb. But this does not prevent him from ending up, in another "trailing moment of now"—and after a recursive image of that same slowed motion at the start—reuniting with the girl and driving her off in(to) an especially nondramatic stop-action frame (equivalent to the crop-box freeze functions deployed earlier in scanning the surveillance window). This closing and particularly 'dated' photomechanical (and now digitally trivial) device offers the filmic frameline's material equivalent of an arrested timeline. And it does so just in the way that slow motion—another 'time-image' like the freeze-frame in Gilles Deleuze's sense (an *opsign* rather than a mere visual image)—has already figured, early and late, the temporal manipulation of the (intervening) intervention plot.

But not merely these familiar cinematic tropes (slow motion and stop-action) are requisitioned by Scott's plot, almost nostalgically, to throw into relief the cutting-edge technology it depicts. Everyday digital tech—in the case of the cell phone and its normal affordances, especially texting—operates as a subtext to explain the instrumental melodrama of temporal transport. Before the scientist lets the hero risk his own body in disintegrated transit through the 'surveillance window,' a handwritten message—as an inorganic guinea pig, so to speak—is sent back into the past in an incidentally motivated effort to alert the hero's partner to a surveillance opportunity. Before the hero himself climbs into the electronic teleportation chamber, that is, it has already been naturalized as a kind of glorified text-messaging machine—but this next time about to turn a human being all told into the electronic data of a communication circuit. This passing and minor episode in *Déjà Vu* could almost be the source of *Source Code*'s most muted contemporaneous irony—associated precisely, and twice over, with a disembodied text message as figure for the trauma of radical cyberpresence. This, too, will require summarizing a plot whose puzzling deferrals couldn't begin to camouflage their metafilmic dimensions. For *Source Code* is a film, like all films, in which the projected afterlife of a hero—no longer bearing any indexical resemblance to his origin and model—operates, and in this regard more like a screen actor than a person, through an assuming of character by proxy; in this case becoming a surveillance agent in a world not his own.

As I've argued before with earlier and considerable evidence (1999, 189–224), science fiction film repeatedly turns on, turns into, the fantasy of visual culture's own future, from René Clair's 1922 *The Crazy Ray*, where

a mad scientist doesn't just freeze the world but fast-forwards it, to *Avatar* (James Cameron, 2009), where a chair-borne war veteran can be plugged in by proxy to a fleet-footed virtual double in—What else is new?—a whole world apart, a world that is in fact logged in (though in this anomalous case *after* rather than before each visit) on a computer screen back at his base of operations. Even video games need their big-screen mythologies. Yet again, though usually with a more cautionary diagnosis, sci-fi stages a recycling of the media-saturated present as an allegorical prognosis (to borrow the title of a 1930s film drenched in video futurism) of 'things to come': things, machines, whose ingenuities are devoted to the far reaches of perceptual transmission and virtual presence.

don't ask, don't tell: 'am i dead?'

Avatars are one kind of 'second life.' But what if the maimed but electronically enabled war veteran were not just, as in Cameron's film, a paraplegic but a quadriplegic—and in fact a disemboweled—pilot downed in Afghanistan, yet still undischarged as a corpse, kept instead on military counterterrorist assignment stateside? And, further, what if the futurist media tech brought to bear prosthetically on his condition were no less than a parable of current surveillance video all but magically recreated in its physical absence, the proverbial spy-cam retroactively installed through the soldier's own mental circuitry in remote activation? Such is the premise of *Source Code,* where the victim of a third and fatal Mideast posting is denied a standard body bag and, after fake ashes are presented to his grieving father, secretly installed in a life-support tank as a wired torso jacked in to a top-secret paramilitary computer designed for 'time reassignment' in the interception of terrorist plots. Again, in the aftermath of 9/11, it offers a story of reverse castration, both for a veteran's severed body and for Homeland Security itself.

The director, Duncan Jones, began his career with a mordant short film about long-distance satellite surveillance called *Whistle* (2002) in which a high-tech transnational hit man is taken out—a switch ending in itself—by his own technology behind a final blank screen. In *Source Code* the premise involves a victimized protagonist who has become the involuntary subject rather than object of surveillance, or not so much the subject as the apparatus. Beyond this, the film's techno-futurism is quite clearly extrapolated from contemporary concerns about the psychic tolls of repeated military deployment from a diminished volunteer army under stop-loss protocols, crossed with life-support and euthanasia debates. With no living will in either sense, the film's hero, involuntarily sent back into an antiterrorist if civilian theater of war as indeed a mediated and disembodied specter as spectator, suffers—across one bomb blast after another—from an extreme form of posthumous traumatic stress disorder. The plot thus resembles a

2005 film called *The Jacket* (John Maybery), where a Gulf veteran in a coffin fantasizes his sci-fi teleportation back into the world of the living, a post-mortem mirage undermined by another whiplash surprise finish. In *Source Code,* in an attempted redemptive gesture, the trick ending tries rescuing the dead-end of a paramilitary thriller by a heavier dose yet of sheer sci-fi.

But the film can also be seen against the backdrop of Jones's previous feature *Moon,* where the hero, working for Lunar Industries, oversees the harvesting of a new and nonpolluting world fuel source, Helium 3, only to discover that, in the interest of energy efficiency, he himself is recyclable, if not biodegradable: one of an endless series of clones under constant computer surveillance after being retrieved, one by one, several years apart, from cryogenic storage. *Moon's* revelation scene comes when the present incarnation of the hero clicks through a series of data-banked images of himself just before, time and again, his vaporization and replacement. In the genre terms of Todorov's (1975) theory of "the fantastic," the previous tease of an uncanny explanation—that cabin fever had driven him psychotic, and he was seeing double in the supposed company of his accidentally discovered clone—is trumped by the delayed fuse of the sci-fi explanation in actual biometric replication. *Moon* displays the structure of a puzzle film only up to this approximate halfway point, from which it then levels out into an action thriller. In contrast, though also dependent of the hero's pivotal discovery of his own simulacral status, the cultural nervousness leveraged by *Source Code* goes beyond the stem cell controversy to something like the technogothic of brain stem research: the human body repurposed as neurocognitive antenna. In the process, this bringing home of the so-called wired war isn't so much unmanned in its sorties as it is demanned, everything below the hero's waist to be facilitated only by a surrogate persona in computer-generated displacement.

In *Source Code's* first scene, the hero, Colter Stevens (Jake Gyllenhaal), finds himself mentally catapulted into the body of a male passenger on a commuter train bound to Chicago, his new involuntary mission to detect and identify a domestic terrorist whose next threatened move, after blowing up the train, will be to detonate a dirty bomb in midtown. At first the suspicious hero thinks he's belted into a virtual reality capsule, a combat "sim" as he calls it, but he's finally convinced by his tech handlers that he has been undergoing "time reassignment" as the optical flashpoint of a computerized second sight. The slowly arriving sci-fi explanation certainly takes its prototype, baldly enough, from everyday spy cams. The hero's remote-control projection into the 'synaptic map' of some (other) now-dead man is possible, we're told, because the mind retains the electronic traces of its last eight minutes of cognition—Who knew?—"like a surveillance camera in a convenience store at closing time." In the pointed absence of any such CCTV hookups on that fatal suburban train, so-called human intelligence must be recruited in disembodied form. Yet it is not

disembodied for long, since the retooled warrior as human projectile must suffer all the agonies of incineration in a borrowed body before being yanked back into the zone of the undead. One sees why a certain blogger took *Source Code,* despite its Chicago setting, to be the "first Surge movie" (Thorne 2011). Throw more manpower at the problem, keep pumping in the troops, even if it's the same soldier over and over again, and terrorism will be quelled. With the already doomed hero being blown to bits again and again on the train, if only digital bits within his new simulated being, the film in this way also indulges the counterterrorist fantasy of a suicide anti-bomber, surrendering his body again and again to the cause of detection and disposal.

But there's a further catch, an emotive hook. Each time the hero is rebooted (by digital breakup of his on-screen image) into the world of his doomed double so as to scavenge more information, he grows more and more smitten with the girl he's just (and just again) struck up a conversation with. The 'rom com' ingredient of 'meeting cute' gets stretched, by time loop, half-a-dozen times over, to the length of the entire plot. This is a plot whose last phase is possible only when the pilot/hero's female operator, Goodwin, back at air force headquarters—where all airborne force is now stratospheric, both computerized and telekinetic—agrees to euthanize Colter rather than keep him in his electronic straitjacket. She allows him, that is, against her superior's orders, one last time-lap to catch the (now located) terrorist and thus alter the girl's fate, after which he will be switched off.

The trick of the eventual trick ending is to turn this exploitation of an overseas casualty—his drastic disembodiment—somehow celebratory, and then to normalize and ingratiate the idea of out-of-body transmit in the familiar form of a supposedly liberated cell phone link, when Colter informs Goodwin that he has in fact been able to alter rather than just scan the past and thus reroute his future. How strained and thematically contradictory this feels depends upon a full sense of the delayed disclosures whose mounting logic it sells out. Yet for that dubious last move of cyber-transcendence there has been a digressive set-up in smart-ass dialogue early on. The repatriated but out-of-step war hero asks the girl on the train at one point if her mobile phone can connect to the Internet, and she mocks him for his anachronistic innocence by saying that no, alas, it's only connected by a long string to her office. Little does she realize that her networked interlocutor is, as digital figment, a kind of biological walkytalky rendered-up-to-date with a paramilitary vengeance.

Yet from the hero's own perspective in this iterated electronic transference into a dead man's embodied sensorium, it is as if, sent repeatedly into the breach, he is passing each time through the escalating levels of his challenge like a video-gamer enhancing his skills. So that in his practiced time travel, like the hero of *Déjà Vu* as well, he is at last empowered—at the

very moment when, in parallel montage, the button is pressed to release him from life support—to make a last effort of will (in the final eight-minute loop he has been granted) and, seizing the moment for a kiss, to seize up his whole world in a bravura digital freeze. What is achieved at this moment is a wholesale arrest of diegetic space, with the time-trapped commuters, himself, and the girl included, converted to digital equivalents of trompe l'oeil mannequins as the camera floats past them, figuring the apparent release of the couple's own Liebestod.

As the ensuing sentimental coda begins to unroll, we have every reason to suspect this as yet another cruelly postponed but finally alleviating death-moment fantasy for the electronically resuscitated hero in his last resting tank—this, rather than some unaccountable triumph over a surveillance tech in which instant replay has been upgraded to brutal time loop. The hero's traumatized subordination to electronics has been too complete for that. And we would be encouraged in this familiar interpretive direction by the way the final shots of his torso, in the countdown toward his pending release, are intercut several times over—in a prolonged alternating montage—with the emotional amends (filial here, rather than marital, as in *The Sixth Sense*) that the interval allows: a long call home from the train to his estranged father, in the voice of his co-opted double, making up, as otherwise in *The Sixth Sense,* for what he died too soon to set straight. Over against this episode are interspliced images of Colter's mutilated body in wait for its imminent deactivation. And so it is that his preservation tank passes as if from coffin to incubator precisely as his father's acceptance of his death—through an acceptance of the other's voice within him—marks a symbolic second birth into the digitally induced virtuality of a parallel world.

Until then, the whole plot could be seen shaped around the hero's acquiescence to the fact of his *own* death. Though the former pilot, strapped into his time machine as if it were a downed cockpit, is told early on that it, like his body, is merely a digital 'manifestation' designed to orient him in his VR task, it has been almost as hard for us as for him to avoid imagining his face and voice actually there at the source of Skype-like communications—on more than one mounted screen—with his computer operators. In the climactic scene immediately preceding that digital freeze, full disclosure comes just before the mission controller, as if in immediate confirmation, looks away from her bank of electronic consoles toward a high-security glass mausoleum within which we see for the first time, like an armored coffin, the hero's wired steel crypt: the last resting (or holding) place; a subsequent scene will reveal his cut-away brain pan and eviscerated but still breathing cadaver strung up by computer feeds like the horizontal puppet that he is. As the camera returns to her array of monitors, none containing his image, we are shocked to realize that the spindly camera into which she has been peering, alongside the separately

fed mike, has been not so much transmitting her image (to what we soon see are the mercifully, even ritually, closed eyes of his near-corpse) as transcoding an optic signal, paired with an audial track, intended for strictly neural recognition at what's left of his receiving end.

In this same jolting moment we also realize that, reciprocally, Colter's surveillance reports have been coming through to her not in audited speech at all, let alone in the presumed sutured visuals that editing has offered us in the very dramaturgy of the genre. He's been present only in something more like closed-captioned subtitles for his computer-activated brain waves—nothing other than text-messages from the virtually dead, here manifest at last when eked out in dot-matrix array: "Just send me back in" (five words, sixteen ciphers one at a time)—back "in" there, into the program not the world, before the scheduled "memory wipe" that will ready him for yet another telepathic ordeal.

Upping the stakes of the puzzling features still in wait, the in-joke on suture played by *Déjà Vu* has been, in effect, complemented and trumped by *Source Code:* the car chase disjoin in Scott's film is blatantly temporal rather than spatial. In Jones's *Source Code,* the 'real time' intercutting in the capsule between gaze and monitor has until now been instead an unabashedly spatial artifice, since neither soldier nor inset screen occupy any space—over the entire course of their transaction—but the virtual. So that his image (or his imaging) has been no more 'real' at his immobilized base of operations, for himself or us, than it is when 'projected' (the inescapable cinematic irony) by way of vicarious cognition into the train car episode(s). Yet once cut loose from his computerized life-support system, the plug mercifully pulled, the electronically freed hero, hand-in-hand with his retrieved dream girl, comes out the other side of that digital freeze, the onboard arrest of all motor action, released to an embodied second life in the person of the former unsuspecting stranger on the train. Right from the start, the "brain-world" conflation that so often characterizes the modernist "time-image" in cinema (Deleuze 1989, 210) appears here in travesty, the philosophical instigations of the virtual turned to digital contrivance.[5]

With the hero having been never more to the agents in the control room, at least during their surveillance relays and debriefings, than an intermittent flow of electronic signals, not a comatose face but a mere coerced interface, he announces his triumph now in more of the same. He does so using a cell phone text to let Goodwin know that her prosecution of the top secret code has in fact sourced, despite its intended use as sheer reconnaissance, a 'whole new world'—which is to say another digital myth, where the dystopian plot has its own ESC button, dodging the consequences of its well-earned technophobia. Even when the status of *homo electronicus* has been fiercely and explicitly abused, the human form snared by cyber circuits, technology may still, we're to think, help us *out*: service our desire, make emancipatory connections—in this case transmute a

macabre allegorical disembodiment into its more standard-issue version in remote messaging. This can happen only, that is, when the nightmare of disembodied, voiceless texting is converted in the end to the convenient wireless proof of a computer-triggered afterlife rather than a hybrid cybernetic limbo.

Reversing the more common negative turn of the puzzle film's trick ending, here the narrative noose has become a loophole. From an invisible site off-screen, the hero's mobile signal reaches his supervisor at her computer post next to the high-security chamber of horrors in which his effectual corpse still lies unreleased, still undead. But Goodwin is now part of the same parallel reality or 'branching universe' (in the more explicit terms of *Déjà Vu*) into whose private distance his digital projection has beaten a clean retreat—yet where his corpse remains still artificially animated and in line for new brutalities. Colter's humane discharge from the reloaded ordeal of one mission after another must in itself be repeated again and again, it would seem, sprouting a new virtual branch of reality each time. This is what the text message from beyond the grave implies, and seeks to meliorate, however many redeployments are to come: "Promise me you'll help him and, when you do, do me a favor, tell him everything's gonna be okay"—each violent death rewarded, that is, with an erotic afterlife, the secular correlative of a jihadist's harem in the sky.

In the tandem logic of Scott's and Duncan's films—unlike their clear-cut military prototypes from *Jacob's Ladder* (Adrian Lyne, 1990) to *The Jacket*, or less directly *The Sixth Sense* and *The Others*—the final puzzle turns not on a death we hadn't guessed or recognized but on a rebirth we hadn't foreseen. In one respect the alternate universes that come to the rescue of fatality in these later sci-fi thrillers are like lucid dreams—a simile taken to the limit in the blockbuster mind-games of *Inception* (Christopher Nolan, 2010), yet where, in that later film, the very technology that might conceivably generate these virtual alternatives is supplanted by uncanny rather than electronic explanation. One doesn't die in such dreams, lucid or otherwise; one dies out of them—into another time frame. But in *Déjà Vu* and *Source Code*, rather than being awakened at the last minute, the hero is digitally reconfigured. In the latter film, given Colter's final recourse to the quotidian wonder of remote messaging—even after his own exploitation as an immaterial data stream—suddenly this disembodied alphabetic communication offers, just in time, the kind of everyday miracle (as in the experimental text-transmit in *Déjà Vu* as well) from which the astonishments, and monstrosities, of dystopian science are derived by exaggeration, and indexed by technique.

In both of Jones's features, in fact, it is the surveilled clone and the living surveillance drone—the replicant and the cyborgian brain scanner—that submit to their own exposed artifice from within the denaturalized logic of montage as it is pressed back to the discontinuities of the track itself. In

Moon, a prolonged barrage of New Wave–style micro jump cuts punctuates the clone's manic search for proof positive of his derivative status as serial duplicate, reminding us in the process that all continuity of screen character, too, is a reduplication of the image from frame to frame: not just a cloning of the original by photomechanics but an imprinted repetition with minimal difference in the time-based frameline. And in *Source Code,* the repeated explosion of the train from different angles, eight minutes apart and many times over, paced by the hero's forensic reentry into that detonated past, serves to lay bare the ordinary montage of such a showpiece explosion, with its gestalt of separate camera angles. By these respective fractures and decompactions of the track in *Moon* and *Source Code,* the technical constructedness of cinema itself, undergirds even while unraveling the simulated reality of its dystopian protagonists. The genre signature of sci-fi once again: images of the near or far future about the future of human imaging, where so-called life, under conditions of total surveillance, may devolve into the madness of permanent replay.

And montage is there as well, in *Source Code,* to turn the final trick in the mind-game logic. This happens when that closural text message enters a space we associate with a past actuality that has actually been remade as present reality—but only in a parallel universe electronically triggered (though not continuously generated) by the source code computer program. This happens when the familiar control room scene to which we cut back in the last toggle of montage is accompanied by the voiceover of the hero speaking through the body he has self-savingly snatched. Via a standard screen convention of sound bridging that is here upended by ontological irony, the result is the virtual recitation of his own text. The forced ligature between separate and incompatible sites within Colter's new virtual reality is marked by this aberrant form of 'vertical montage,' where the mise-en-scène is superimposed upon by a voice that has always—as we've so tardily discovered—been in its own right eerily nondiegetic. Achieved by this closing moment of intercut spatial counterpoint is a final spin on what we've noted as the film's most unnerving turn: the revealed voicelessness of a hero transcribed rather than heard in his own native tongue. Metz again (1977):

> montage is at base *trucage.* More particularly, what we sense being narratively exploited by *Source Code* is a realization that all temporal montage amounts to the sign of parallel universes brought coterminously together in one imagined (extended) diegetic space: a confusion, a ruse, a preternatural gambit. Again we encounter the sci-fi extrusion of technique as theme. The implied read-out is as follows: if life were really like a movie, it might also be like a digitally driven alternate universe.

At which point of closure we look back on other ways in which the cinematic constitution of this puzzle narrative has so completely prepared the trick ending that the latter seems to have done little more than refigure the screen's own routine devices. To sense as much in considering films of this stripe is to move beyond the obvious thematization of CGI as virtual reality. Again and again such narratives leech from the specific affordances of their own technical premises, as medium, to fuel their technophobic plots. In *Moon*, say, what's the difference whether an actor is playing a character 'himself' or his identical twin, his clone? In *Source Code*, how soon we forget that human figures never enter their plots, daredevil or otherwise, in propria persona. It's only natural that we suspend our disbelief, along with the pod-bound hero, in assuming that he is really there in bodily form in the encapsulated space on which we spy unseen. Thus does this one protagonist, like any other screen actor—giving us the visual image of a character he only provisionally embodies and then getting put through his paces via multiple takes of the same action—underscore the condition of cinema's own optical as well as narrative performance.

the infrastructures of montage: from 'synaptic map' to bitmap

In thinking through plot to medium in *Source Code*—or, rather, in thinking plot through at the level of its mediation—we find suggestive points of comparison both with digitally executed fantasy and with a whole range of electronic sci-fi. In that earlier cycle of temporal recursion in the puzzle film mode, teen heroes escape their troubled present by one fantastic form or another of digital whoosh or cosmic zoom, letting framed space and its textures figure time under distress—en route to temporal restitution. In *Source Code*, when the order comes to "charge the computer drivers," the military hero is vacuumed out from time present in much the same electronically disintegrated way, via a similar digital chute, though more explicitly technological in this case: his whole bodily mass fracturing into gridded digital bits along the cross-veined fissures of its tessellated form— and then instantaneously reconstituted as human image on the speeding vehicle of the counterplot. Like the time travelers before him, albeit in a sci-fi rather than fantasy mode now, he is cybernetically disintegrated by the same screen technique that has become, this time, explicitly incorporated as a diegetic technology. In the cross-mapping of the 'synaptic' network from Colter's brain to that of his alter self, visual form and machinic function are so inextricable that we readily read the raster graphics of his bitmap image, obliterated and rezoned, as the very medium of temporal transit. In the micro-triangular webwork that 'nets' him each time for transmit, the shivering wrench of his image is not exactly like the pixel checkerboard underlying this digital F/X (of the sort we might see in an

accidental DVD break-up of the same shot)—but close enough to figure it in passing.

But there is a further narrative irony in this, as we know, one also delivered by the medium itself—and emerging most clearly by contrast with the later tour de force of the digital freeze. There the stop-action (rather than stop-motion) effect, with the camera still seemingly in play, no sooner signifies an abrogated life support than it also serves to figure—with no pixel static this time—the hero's gateway to a branching reality. That mobile but actionless shot is the CGI upgrade of photomechanical cinema's classic punctuation in the freeze frame, familiar to us most recently from the last 'dated' shot of *Déjà Vu:* the iteration of the single frameline cell that flattens out diegesis into photographic fixity.[6] At the climax of *Source Code,* however, the diegetic space remains negotiable in depth by the camera, though frozen in its own ontology. The result operates somewhere between a metaphorical gesture and a neurological rupture. So, too, with those earlier computerized decimations of Colter's image in teleportation rather than arrest. They are no mere metaphors either.

Nor are they strictly narrational transitions. Operating there, over and over, is not just a case of digital breakdown as scene change—as if we were seeing for a few split, splintered seconds into the bowels of the medium's own pixilated generation. That's only the half of it. Any such potential for a self-reflexive recuperation of the F/X involves its own ontological relapse for the hero—which, one may say, *changes the picture* of this digital transit entirely. Given that Colter is as much a heuristic 'manifestation' to himself as he is, on screen, to us, it is therefore his virtual presence rather than just his image that is all but instantaneously decomposed and recomposited: as if it, as if 'he' (in propria persona) were no more than the digital effect that in fact, even inside the plot, he is. Certainly the notion that all montage is *trucage*—Metz's (1977) resonant dictum one last time—anticipates perfectly, by way of hypertrophic special effects, the digital morphing of the image plane in the several variants of this shot (and its many familiar predecessors from digitally edited fantasy over the last couple decades). But the sci-fi premise runs deeper this time, however manifestly shallow in the planar effects of its raster dispersion. *Source Code's* dismembered and now dispelled hero is disintegrated across a montage gap that shatters to a vanishing electronic collage. With human agency constituted in this way, beyond its mortal remains, as pure code, with no fully incarnate source left, the result is stylistically overdetermined. All screen presence is manufactured, digitized, virtual. All personage has become trucage.

And, in just such moments of spectral transition and technical disclosure, the montage of *Source Code* deposits certain further inlaid fragments that end up traversing the whole vector of plot in reverse, future to present. So deeply ingrained, that is, does the mind-game logic seem that an independent motif in this vein—Or is it so separate after all?—can be run

alongside (in fact jumping the gun) of the main parallel-universe plotting. When the railroad bomb first goes off, propelling Colter back to his virtual cockpit—and then at various points in his later ejection from present to past, lab to train—there's an unaccountable overload of image. Besides pixel breakdown, the temporal malleability of the montage interspace involves flash-forwards to shots of the chrome sculpture by Anish Kapoor visible in 'real time' (scare quotes indeed) only at the end, when the hero walks toward it in Millennium Park with the girl he's retrieved from death—so that its gleaming anamorphic surface is visible at that final point (for Colter, too, not just for us) with a glint of recognition. What we also see is that the man holding her hand before the sculpture's warped mirror is his dead double from the train, whose snatched body is all that is now available to our hero in this new parallel life.

Two puzzle pieces seem to be falling into place within the same mirror shot—having to do, inextricably, with somatic and temporal displacements alike. Yet questions nag. The flash-forwards to this moment do seem rounded out here in something more than a mere formal symmetry; they appear part of the fable, an inbuilt déjà vu. But engineered for what purpose? And by any mechanism, perhaps, other than cinema's own? Under the immediate spell of the scene's double take, a quizzical Colter asks the saved girl: "Do you believe in fate?" In the same mood he had previously asked Goodwin if she ever fantasized about her life taking a different path—of the sort he was at the moment hoping for according to 'branching universe' possibilities. No, neither woman is the dreamer he is, which may seem designed in the end to humanize his technological breakthrough as mental disposition (at the expense, nonetheless, of his predecessor's dead body).

But there is another reading of the flash inserts in their intermittent clairvoyance—yielding a different sense of the twist ending or inducing another level of trick altogether. For the prefigurations could well insinuate that the happy-ever-after finale was programmed by the source code all along, leaking through with the split-second hints of destiny rather than confessed machination. Programmed, precoded: this so that each of the soldier's uploadings onto the scene of terror would be laced with appeasing free-associations of potential escape, some glimpsed indeterminate space beyond pod or doomed passenger car. These would then be anodyne images (u-topic, place-less) generated electronically in each sequential reality and offered up there as the unconscious warrant, traumatic time and again, for yet another branching bypass of his death.

Dramatic tone at the end, however, along with orchestral uplift, does strongly suggest the former upbeat assumption. It is as if Colter's foreseen if unrecognized dream has come true, an unconscious scene of desire (almost subliminal in its fragmentation) getting realized by dint of heroic faith and persistence. Yet it is typical of such computer fables that anything seemingly beyond the cyborgian horizons of the machine may be

delusional, may be programmed in its matrix rather than released from the virtual into some autonomous real, a vision implanted rather than liberating. In this case, How can we know? A libidinal sixth sense or an electronically instilled seventh? Extraneous and implausible, merely that, such premonitions in *Source Code* may well be. Or are they motivated and psychological: more like figures of desire than fateful prefigurations? Or, again, they could instead be genre determined as the recurrent switch-point (computer-generated) between a puzzle film premise and the slowly disclosed no-exit rationale of a dystopian and entrapping sci-fi plot.

In any case, within the rushed blur of such transtemporal shifts, we've seen how the digital virtuality of the hero's image, confirmed by bitmap disintegration at the very seams of montage, is continuous with the third (and fourth) dimension of the film's branching reality plot. At which point the metafilmic turns inescapably monitory. With every antiterror combatant, not just every actor, pressed into service more as a role than a person, technique verges again on critique through that belatedly divulged 'reading' (rather than actual seeing) of the slain soldier 'reenlisted' as a sheer apparatus of retroactive deterrence. As always in the so-called war machine—that machine increasingly identified with the computer—the soldier is systemically faceless and entirely at the disposal (in either sense of the word) of his dispatchers.

But this is where a trick ending so arcane in its final double cross that one barely notices it can still bite its own tail. The fact that the utopian alter-world to which Colter flees doesn't in fact alter the mortal trauma, the morbid half-life, of his artificially sustained heart, lungs, and brain—vestigial organs not finally shut down after all—is a quirk of the storyline that can scarcely squirm free from the broader aura of biopolitical paranoia that rims the film. There's no escaping the death of one's body. And as soon as we warm to the contrived fantasy of the ravaged soldier's doing so, we're back in the lab with his version of an immobilized rat on the computer treadmill, jerked back there by the double helix of plot itself. Tonally, the film dodges this recognition in the attempted uplift of its final download, its message from the ever after. But ethically, the narrative is caught up in its own time-loop paradox.

Hardly without precedent, the genres of sci-fi and puzzle film hereby implode on each other. In the eight minutes left to, and of, our hero, it is only a recent catastrophic past, fled to after averted disaster, that his exploit of surveillance and interception has redeemed. The present still awaits his continued, his recursive, vigilance—or let's say that of his inert somatic platform. By heroic *convention,* the doomed war hero on screen routinely stands in for a host of other soldiers lost in battle. Here instead, by high-tech *invention,* only one death would ever be necessary, at least given just the right recyclable scapegoat, whose wired crypt would become an unforgiving altar for this new military-industrial science of human sacrifice.

At this convergence point of technique, genre, and political irony, one can venture a generalization about the reflexive status of mediation in such screen narratives. Whether classically fantastic or electro-savvy, puzzle films are most interesting as films (which is to say, these days, as hybrid photochemical and digital objects) when their riddling uncertainties are more than just structural but in fact medial. What the two movies we've examined have demonstrated, alongside their predecessors of similar format, amounts to a subgeneric specification of David Bordwell's (1985) formula for narrative cognition at large.[7] If, according to Bordwell, sequential structure plus style collaborate in guiding our normal formulation of a storyline, in puzzle films the deliberately withholding work of structure is abetted by style, sequence by technique, in sustaining for as long as possible the plot's battery of conceptual enigmas and false leads—until in the end, style itself, audiovisual execution, becomes a metaphor for the uncanny narrative solution. And in the process, beyond anything narrowly metafilmic, it becomes further symptomatic in a more enmeshed cultural sense as well. It is at this level that cinema's latest computer-boosted mixed-media technique taps in its own right into a widening vein of technological marvel and anxiety—for which media fix or addiction in its dystopian forms, and despite a last-ditch fantasy communicated at the end of *Source Code* via an everyday text message, there is, in the other sense, no quick fix. In this way the medial dimension of sci-fi puzzlers like *Source Code* and *Déjà Vu* goes straight to the vanishing border between spectacle and inspection in the new digital circuits of civil as well as military surveillance—their wizardry, their excesses, and their hazards.

notes

1. Under this rubric, Elsaesser's essay takes up many of the films I had previously discussed in *Framed Time* (2006) according to Tzvetan Todorov's model (1975) for narrative puzzles in the genre he designates "the fantastic." These are narrative conundra resolved by recourse either to uncanny or, alternately, to supernatural paradigms, the latter including the 'instrumental marvelous' of magic machines—to which, in my latest example here, the time-bending supercomputer is heir. The method of approach is again what, in the procedures of *Framed Time,* I term *narratographic:* attending to medium-determined inflections of the storytelling apparatus that in these cases do not just contribute to the puzzle but constitute (and then refigure) its often delusory execution.
2. This is a more recent development from the first wave or two of interplatform rivalry narrated by Hollywood films in address to mass computerization, the Internet, and video-gaming—as discussed by Paul Young with examples down through David Cronenberg's 1999 *eXistenZ.* A decade and more later, the films taken up in this essay have a similar "media unconscious" (Young 2006, 146) in respect both to their "informatic voyeurism" (203) and, more generally, to the digital technology drawn on to implement their halfhearted critiques of computer surveillance as a new optic mode, critiques often buffered or muzzled by their puzzle tricks. To the

extent that *Source Code,* especially, may be seen as 'cyberphobic,' at least until its computerized happy ending, it fits Young's model, whereby films of computer recoil "subtly recast the cinema in the very terms set by the new media and the discourses that collect around them" (206).

3. Metz (1977): "Montage itself, at the base of all cinema, is already a perpetual *trucage,* without being reduced to the false in usual cases" (672). Yet it is the 'falsity' of the shot exchanges at the center of *Source Code* that, we are to see, has 'tricked' the very premise of montage in its limning of the diegesis.

4. See Stewart, "Digital Fatigue" (2009) for a fuller discussion of the scopic ironies surrounding military surveillance and its globallistics.

5. *Source Code* thus takes its place on the roster of sci-fi narratives that address Deleuze's curiosity at the end of his second cinema volume (writing in the early 1980s) about whether the "electronic image," alternatively called the "tele and video image" and the "numerical image," is destined to "transform cinema or to replace it" (265), which means for the "time-image" in particular whether electronics "spoils it or, in contrast, relaunches it" (267). The 'temportation' plots examined in *Framed Time* tend, I argue, more to simplify and instrumentalize—almost to parody, rather than productively explore—Deleuze's sense of temporal imaging on screen. The computerization of collective urban memory, as it were, in *Déjà Vu,* followed by the electro-parthenogenesis of parallel realities in *Source Code,* offers similar conceptual reductions of cinema-as-brain to the prosthetic engineering of lived time.

6. Discussed at length in my *Between Film and Screen,* Chapter 3, "Frame of Reference" (1999, 117–150).

7. Bordwell's definition (1985) is given in italics. Narration is understood as *"the process whereby the film's syuzhet and style interact in the course of cueing and channeling the spectator's construction of the fabula"* (53).

references

Bordwell, David. 1985. *Narration in the Fiction Film.* Madison: University of Wisconsin Press.

Deleuze, Gilles. 1989. *Cinema 2: The Time-Image,* trans. Hugh Tomlinson and Robert Galeta. Minneapolis: University of Minnesota University Press.

Elsaesser, Thomas. 2009. "The Mind-Game Film." In *Puzzle Films: Complex Storytelling in Contemporary Cinema,* ed. Warren Buckland, 13–41. Oxford: Wiley-Blackwell.

Kittler, Friedrich. 1999. *Film, Gramophone, Typewriter,* trans. Geoffrey Winthrop-Young and Michael Wutz. Stanford: Stanford University Press.

Metz, Christian. 1977. "Trucage and the Film." *Critical Inquiry* 3(4): 657–675.

Stewart, Garrett. 1999. *Between Film and Screen: Modernism's Photo Synthesis.* Chicago: University of Chicago Press.

Stewart, Garrett. 2006. *Framed Time: Toward a Postfilmic Cinema.* Chicago: University of Chicago Press.

Stewart, Garrett. 2009. "Digital Fatigue: Imaging War in Recent American Film." *Film Quarterly* 63(2): 45–55.

Thorne, Christian. 2011. "The New Way Forward in the Middle West." http://sites.williams.edu/cthorne/tag/source-code/.

Todorov, Tzvetan. 1975. *The Fantastic: A Structural Approach to a Literary Genre,* trans. Richard Howard. Ithaca, NY: Cornell University Press.

Young, Paul. 2006. *The Cinema Dreams its Rivals: Media Fantasy Films from Radio to the Internet.* Minneapolis: University of Minnesota Press.

source code's

video game logic

w a r r e n b u c k l a n d

Source Code (Duncan Jones, 2011) can be viewed through two 'grids' of concepts: conventional narrative logic and video game rules, each of which highlights certain structural aspects of the film while ignoring others. The premise of this chapter is that the structure of a few contemporary narrative films, such as *The Fifth Element* (Besson, 1997) (see Buckland 2000, 2002) and *Inception* (Nolan, 2010), as well as *Source Code,* are in part structured using the abstract rules of video games. These films are shaped by both narrative and video game logics, creating unusual structures—a complex structure, in the case of *Source Code* (and, to some extent, *Inception*). Each theory simply highlights one aspect of *Source Code,* rather than trying to account for everything in it. In this chapter I do not adopt a hermeneutical perspective to determine the film's wider philosophical meanings or cultural production (see Garrett Stewart's insightful analysis of the film in "fourth dimensions, seventh senses: the work of mind-gaming in the age of electronic reproduction," in this volume); instead I explore how both theories study the formal construction of *Source Code.*

Video games are a major form of new media, "texts that have become computable" in Lev Manovich's definition (2001, 20).[1] Manovich begins his 2001 book *The Language of New Media* by studying new media's immanent structure. He identifies five principles that constitute its computability: numerical representation, modularity, automation, variability, and cultural transcoding (2001, 27–48). Numerical representation is the key to new media texts because it transforms media into computer data that can be manipulated algorithmically. Analogue data is digitized—that is, coded into numerical values, which involves reducing a continuous data stream into discrete units with clear boundaries. Anthony Wilden has examined the analogue/digital communication in depth. He concludes, "A digital system is of a higher level of organization and therefore of a lower logical type than an analog system. The digital system has greater 'semiotic freedom'" (1980, 188). A digital system has a higher level of organization and greater semiotic freedom because its discrete digital bits of information make it immensely flexible, whereas an analogue system consists of one continuous stream of information. A direct consequence of numerical representation is modularity, in which new media texts are composed of discrete independent parts (modules), which are themselves composed of smaller discrete independent parts. The first two principles allow many operations to be automated and text duplicated without human intervention, and characterize new media as variable. New media texts are not singular, fixed objects but can easily be manipulated, modified, and duplicated.

Finally, new media's specific structure, its organization of data, creates a computer layer, "the computer's own cosmogony" (Manovich, 2001, 46), which is distinct from the cultural layer, the human way of processing and understanding data (via stories, myths, encyclopedias, visual representations, etc.). Manovich argues that the computer layer is profoundly transforming communication, much more so than the printing press in the fourteenth century or photography in the nineteenth century. The result is "a blend of human and computer meanings, of traditional ways in which human culture modeled the world and the computer's own means of representing it" (2001, 46). The cultural layer has been transcoded into the computer layer. The influence of video game logic on Hollywood storytelling is a manifestation of this transcoding process. This is evident in the way storytelling has been computerized, or digitized, turning storytelling into a more flexible semiotic system.

186

The flexible, variable, and modular nature of digital media is exploited in *Source Code,* as Pepita Hesselberth and Maria Poulaki point out:

> Events are continually re-wound, re-lived, fast forwarded, altered, or frozen, while characters break up into pixel-like glitches, produce uncanny mirror images, or die a dozen deaths.
>
> (Hesselberth 2012)

In contemporary complex films that now also proliferate in Hollywood, the diegesis is internally "multiplied" into several pieces—through scenes and shots that are repeated with variation like in forking-path films, introducing an alternative path of the story or adding new perspectives upon the same event (from *Run Lola Run* to *Source Code*).

<div align="right">(Poulaki, "puzzled hollywood and the return of complex films," in this volume)</div>

In short, *Source Code* is an instance, in Garrett Stewart's terms, of "what the digital has already done to cinema" (2007, 1). In the following sections I develop these observations by analyzing *Source Code* in terms of video game logic.[2] Before analyzing the film, though, I examine the rules that constitute the video game as a computable, new media text. These rules are not contingent on (video) games but constitute their very core: "Every game *is* its rules" (Parlett 2005).

video game rules

Video games possess "an excess of visual and aural stimuli" but also "the promise of reliable rules" (Gottschalk 1995, 13). These rules, which are reliable in that they are systematic and unambiguous (for they are unencumbered by morality or compassion), constitute the video game's environment, or location, which is not restrained by the laws of the physical world. The game user can experience video pleasure primarily by attempting to master these rules—that is, decipher the game's logic. Moreover, the desire to attain mastery makes video games addictive, which at times can lead to the user's total absorption into the game's rules and environment. This absorption in turn may alter the user's state of consciousness and lead to a momentary loss of self (see Fiske 1989, chapter 2).

Here I outline a number of the general structures used to construct these rules.[3] Individually, they do not define a narrative as digital; only when combined together do they begin to dominate a film's narrative structure. Some of the most common rules to be found in video games include the following:

- serialized repetition of actions (to accumulate points and master the rules)
- multiple levels of adventure
- spacetime warps
- magical transformations and disguises
- immediate rewards and punishment (which act as feedback loops)
- pace
- interactivity.

Video games are organized around the serialized repetition of actions for several reasons, including the accumulation of points and the opportunity to master the rules of the game. "Once players have learned a set of skills," writes Nicholas Luppa, "they want to apply them in new situations. Elevating a game to other levels has long been a secret of good game design" (Luppa 1998, 32). In other words, users are keen to refine their newly acquired competence in game play by applying and testing it in similar but more difficult environments (which keeps the game in balance, as I describe ahead).

Spacetime warps represent an alternative way to reach another level. They are the video game's equivalent of the hypertext link, for they enable the player to be immediately transported to an alternative space (and time), leading to a sense of multiple fragmented spaces, with immediate transportation between them.

The user's accumulation of points acts as a feedback loop in the process of mastering the rules, since it represents a reward for good game play and confers upon the user the sense that his or her competence is improving and the game is progressing. In similar fashion, the loss of points or a life acts as an immediate punishment for failing to master the rules. A repetition of this punishment leads to the user's premature death and an early end to the game, or a return to its beginning. Serialized repetition therefore involves repeating the same stages of the game—usually at a faster pace or moving up to another similar (but more difficult) level. According to Nicholas Luppa, pace is one of the most important features of video games: "[Video games] require pacing and the beats that are being counted in that pacing are the beats between interactions" (Luppa 1998, 34). The important point here is that the player controls the beats via interaction, which confers upon the player the feeling of control—the manipulation of a character in a usually hostile digital environment. Moreover, the interactions need to be immersive—that is, must focus the user's concentration and must be multiple and varied. Interaction is also dependent on the interface design, which must be detailed but also easy to use.

Video pleasure, created by a user's addiction to and immersion in a game, is therefore not simply a matter of a heightened stimulation generated by high quality graphics, audio, and animation but is also—and, I would argue, primarily—a function of these rules, of the user's success at mastering these rules. Of course, in discussing the popularity and pleasure of video games, we should not leave out their content and themes, which can in fact be summarized in one word—violence: "The central organizing assumption of videology is unarguably that of violence . . . The only relevant question posed by videology is not whether a particular situation calls for negotiation or violence but how efficiently can violence be administered" (Gottschalk 1995, 7).

I devised the above list of rules after watching *The Fifth Element*. After watching *Source Code*, I realized it is structured according to a number of these rules but that, at the same time, it appeared to be significantly more complex than *The Fifth Element*. This warranted the identification of additional video game rules to explain this complex structure. A select number of concepts from *Fundamentals of Game Design* by game developers Ernest Adams and Andrew Rollings (2007) provided names and descriptions of a rich array of rules, including the following:

- The game's environment can be open or closed, linear or nonlinear.
- The game needs to remain balanced.
- Some games consist of a foldback story structure.
- In role-playing games, players can usually choose or customize their avatar.
- The avatar possesses a series of resources and entities.
- Typical gaming skills a player needs are strategy and tactics.
- Most games (unintentionally) have an exploit.
- Many games include a sandbox mode.

Adams and Rollings (2007, 405–410) map out the various environments or layouts a game designer can adopt, from open layouts that allow for a player's unconstrained movement within a game to closed layouts (usually a set of interior spaces). The open layout has little linear structure, while closed spaces have single or multiple paths the player needs to follow.

One of the key concepts in game design for Adams and Rollings is balance (2007, chapter 11). As the game progresses, the player feels it is becoming easier because he or she gains game experience. To keep the game in balance, tasks must progressively become more difficult.

In the foldback story structure, "the plot branches a number of times but eventually *folds back* to a single, inevitable event" (Adams and Rollings 2007, 200). In other words, several ways exist for reaching the same unavoidable endpoint. This story structure is usually combined with serialized repetition of actions, for a player within each repetition takes a different path to reach the same endpoint. The foldback plot structure (in combination with the serialized repetition of action) is a clear instance of what Manovich calls *variability*. I will show below that, every time the film's main protagonist (Colter) returns to the train (the film's equivalent of the game environment), he creates a different version of it, but he always ends or folds back to the same ultimate point, which is his main aim (locating the bomb and bomber).

Game designers enable players to construct or modify their avatar and also confer on it a series of resources, "objects or materials the player can move or exchange, which the game handles as numeric quantities" (Adams and Rollings 2007, 323). An entity then names an avatar's possession of a particular amount of a resource.

The distinction between strategy and tactics derives from military theory, although Michel de Certeau also developed it to analyze the routines and habits of everyday life, including resistance to everyday forms of control (1984). In studying video games, the terms can be used to cover both sets of meanings. A strategy involves constructing a game plan on the available knowledge of the rules and the opponents in the game. Because information is usually concealed in a game, the player relies on probability and skill in succeeding (Adams and Rollings 2007, 298). A strategy is implemented through tactics, the carrying out of a strategy through a variety of actions. Both strategy and tactics need a clear, measurable outcome, although tactics can try to subvert and find shortcuts to the strategy, ultimately leading to exploits (and here we switch to de Certeau's meaning of tactics as a form of resistance to the established rules embedded in the strategy).

An exploit is an unexpected action the player uses to gain advantage within a game. The player usually exploits a weakness, glitch, or bug in the game's design. Adams and Rollings give an example:

> In an old side-scrolling space-shooter game on the Super Nintendo Entertainment System . . . the player could, after upgrading her weapons to a certain level, make her way through the rest of the game without ever losing a life by traveling as low on the screen as possible and keeping her finger on the fire button. Although clearly unintended, this position made her invulnerable to enemy attacks.
>
> (2007, 366)

Finally, the sandbox mode allows free play, or the player to explore the game without constraints. The player can experiment with using the game without devising a strategy or achieving a goal.

conventional narrative analysis

Source Code can be subjected to a conventional narrative analysis, which will highlight some of its structure.[4] The opening shots of the film are primarily descriptive, portraying the city of Chicago and its environs. It switches to narrative when Colter Stevens (Jake Gyllenhaal) wakes up feeling confused, as he finds himself on the train travelling to Chicago. He is quickly singled out as the film's main protagonist, with the cause-effect logic focused around his psychology and actions. (For the first few seconds he is on screen, we also hear meta-diegetic sounds—that is, sounds coming from inside his head—that resemble a battle.) In typical puzzle film mode, his psychology is not coherent but is afflicted. For the first few minutes, the film begins in a state of equilibrium; it is thrown into disequilibrium and a state of liminality by a series of actions: (1) Christina (Michelle

Monaghan), a fellow train passenger sitting opposite him, addresses him as Sean (a history schoolteacher), while he tries to explain that he is not Sean but Captain Colter Stevens, a helicopter pilot in Afghanistan; (2) he enters the restroom and sees someone else's reflection in the mirror; and, more radically, (3) the film is thrown into disequilibrium when a bomb explodes on the train. This latter action is a major turning point, as we see the film's main protagonist die within the first ten minutes and also see the screen go black, followed by a montage sequence. The disequilibrium continues in the next scene when we see the main protagonist, Colter, still alive but isolated in a dark capsule. The cause-effect link with the previous scene on the train is tenuous and uncertain.

The film begins with the use of restricted narration, severely limiting what both Colter and the film audience know. Exposition is designed to fill in the backstory. In her debriefings with Colter, Air Force Captain Colleen Goodwin (Colter's main point of contact outside the train environment, played by Vera Farmiga) gradually provides this exposition. In her first debriefing she sets up the narrative goal and timeline: "Who bombed the train? . . . You will have eight minutes, same as last time . . . Find the bomb, and you will find the bomber." In the second debriefing she explains that the explosion on the train is an actual event that has already taken place and is the first of possibly many that will take place in Chicago, which is why he needs to find the bomber. Dr. Rutledge (Jeffrey Wright) provides more exposition thirty minutes into the film—mainly in the form of a quasi-scientific explanation of how it is possible to send Colter to a train in the past that no longer exists: he is in fact sent back into a parallel or alternative possible world, not to the past of the actual world. Rutledge designed the technology (called source code) that carries out this seemingly impossible task.

Because he is sent back to the train several times, the same deadline is repeated. Colter soon finds the bomb but does not diffuse it (he does not have the skill, but he does discover it is detonated by mobile phone). He cannot find the bomber either because too many people on the train are using mobile phones (an obstacle to him succeeding). After one hour of screen time, through coincidence and luck, he manages to identify the bomber and the location of the second bomb. Once Colter has identified the bomber, the film shifts to Colter's needs and demands (the film follows the typical dual-focused narrative, the genre plot and romance plot). Identification of the bomber places the genre plot in the background, enabling the more personal plot, involving romance, and also Colter's relation to his father, to develop. More specifically, he plans to save Christina on the train (by disarming the bomb) and talk to his father on the phone (by pretending to be a friend of Colter). Goodwin tells him this is impossible because the world on the train no longer exists and because he is simply occupying an alternate world. But Colter insists, and he returns

191

to the train one last time. He asks Colleen to terminate his life support after the eight minutes are up. She does this, but Colter's life (as Sean) continues to exist within the alternate reality on the train. He sends a text message to Colleen, explaining how the bomb plot was foiled. He gets off the train with Christina and walks around Chicago with her. The film ends by going back to the beginning of the day, with a series of unusual events: Colter is still attached to the source code technology; Colleen reads Colter's text message; and Rutledge watches a new report of the bomber being arrested in Chicago, saying that his source code technology will one day have its moment. Equilibrium is reestablished in this final scene, and a major series of narrative transformations have taken place involving the creation of parallel universes, as Brad Brevet explains:

> The text Colter sends is received in the final alternate reality and received by an alternate Colleen. It tells her the "Source Code" works and a crisis was averted. Shortly thereafter you hear Rutledge in his office say, "One day a crisis will come and the 'Source Code' will have its day in the sun." He says this because in this reality—the parallel reality where Colter stopped the first bomb from going off—the "Source Code" was never used. It is here Colter's consciousness exists in two places. His consciousness resides in the body of [Sean] Fentress as well as in his body in the lab, waiting until a crisis comes along and the "Source Code" program can be used for the "first" time.
>
> (2011)

The film's alternative realities, plus several major events, challenge and disrupt its classical narrative logic. Rather than simply characterize this disruption in negative terms, I will try to specify it more positively in terms of video game logic.

source code's video game logic

A conventional narrative analysis misses some of the film's structure, particularly those aspects that make it distinct. Those aspects can be characterized in terms of video game logic, the two sets of rules outlined above, extracted from academic studies of video games, as well as design manuals. But why these rules, specifically? In outlining the Russian Formalist method, Boris Eichenbaum wrote: "We posit specific principles and adhere to them insofar as the material justifies them. If the material demands their refinements or change, we change or refine them" (1965, 103). I have supplemented the first set of rules (which I applied to *The Fifth Element*) with additional rules because of the added complexity of *Source Code*. In other

words, the rules are employed from the ground up, are dictated by the complexity of films under analysis.

The relation between a game player and the world of the video game is replicated within the film, setting up two radical spaces: Colter is the game player in his capsule; his avatar is the schoolteacher Sean Fentress on the train. The film requires Colter (via Sean) to exercise typical gaming skills—strategy and tactics—on the train in order to identify the bomber. The film therefore replicates a role-playing game—it uses an avatar to represent the player (in this instance, Colter) within the game world. The avatar is a form of what Manovich calls telepresence: "Telepresence encompasses two different situations—being 'present' in a synthetic computer-generated environment . . . and being 'present' in a real remote physical location via a live video image" (2001, 165). This term can only partly be applied to video games, since the game player is linked to the synthetic environment via a graphics user interface, rather than a live video image. (Manovich discusses the interface in chapter 2 of *The Language of New Media* [2001].) Also, telepresence only applies in part to *Source Code,* since the link between Colter in his capsule and his avatar on the train is indirect and mediated (involving a connection between his and Sean's brain cells). Nonetheless, both video games (the relation between player and synthetic environment) and *Source Code* (the relation between Colter and the train) maintain the structural relation between two spaces, both occupied by the same person, linked by an interface. More specifically, *Source Code* consists of three ontological spaces, or realities:

1) the train and its environment;
2) Colter in his capsule; and
3) the actual world.

Pepita Hesselberth (2012) argues that *Source Code*'s story concerns Colter's dematerialized body and its multiple locations in these three different places. Colter's fundamental points of reference to his being in the world are not fixed and stable but alternate across these three worlds, as he tries to discover where he is in space and time and, more fundamentally, who he is or has become.

The train carriage can be read as a game environment to the extent that Colter enters it on eight occasions via an avatar, and he needs to perform in there a series of tasks. It is a closed space with limited freedom of movement. Interactivity is also replicated in the film, as we see Colter moving around the game space and interacting with it via his avatar. He can manipulate the environment (Goodwin encourages him to be aggressive) in order to complete his task because it is not part of the actual world.

In terms of video game rules, the whole film is based on the serialized repetition of action, with variation (in the form of progression) from one

repetition to another. With each repetition, a form of replay, Colter (as Sean) learns the rules of the game and becomes more proficient. He receives punishment when he fails (the bomb explodes) but also rewards (once he has identified the bomber, he can phone his father and also save Christina). The transition from capsule to train is not smooth, but it is dramatic and involves a spacetime warp (or, at least, a space warp), since he travels between two radically different locations—the actual world and possible worlds. These transition shots show Colter's digital transformation—that is, computerization—as he is manipulated algorithmically, rendered or compiled by the source code technology into digital bits and sent to an alternate universe. The pace increases from one repetition to the next— the editing is more elliptical, and Colter becomes more frantic because he is working against a deadline.

Colter is not only disguised as schoolteacher Sean Fentress, his avatar. While in this disguise, he takes on other disguises: on one serialized repetition, he pretends to be a transport security officer in order to try to persuade everyone to switch off their phones and, when phoning his father, he pretends to be a friend of Colter. Although these changes are minor, Colter has at least some scope to customize his avatar.

The environment in which most of the game is played out is designed as a closed space (the train, although the more open space of the train station also plays a role). The initial condition (the beginning of the game) is always the same, and the termination condition (end) is clear and unambiguous. Furthermore, Colter needs to follow a strict set of rules in order to succeed. In terms of game design, the game-play challenges and actions are few and linear, and the game space is closed and limited. It is clearly marked off from a parallel space, the capsule that Colter occupies.

Colter's capsule is an imaginary space, creating in his head the illusion he is still able-bodied, can talk and see. He exists in the actual world as a corpse with a limited amount of brain power kept artificially alive via a life-support machine. Once Colter becomes aware of his real existence in the third realm of reality, he asks for his life to be terminated, but he thinks he will be able to remain alive in the first realm.

As with video games, he has several attempts at winning, and he dies in the game, which simply takes him back to the beginning. At the same time, he accumulates in-game experience and chooses different options that the game opens up to him. But he has few options and few tasks: his strategy is to find the bomb and identify the bomber. Goodwin spells out this strategy to him in clear, unambiguous terms and also offers a few tactical suggestions (retrieve the guard's loaded gun; search passengers who are using mobile phones). This skews the game toward storytelling, for it does not allow the player to freely explore the space and characters in the game.

Colter learns to play the game by dying, which, according to Adams and Rollings (2007, 372), is an old method of learning in the video game

environment. The bomb kills him several times, but at least this helps him locate it (since he remembers the direction of the blast). After the blast, he is thrown out of the game; when he returns, he goes back to his initial or default position—sitting opposite Christina. He follows different 'paths' each time to reach the final endpoint—locating the bomb and identifying the bomber. The film therefore has a foldback structure. Colter perceives that the game becomes a little easier on subsequent attempts because he is building up knowledge of in-game play (the game's perceived difficulty is reduced). That is, Colter becomes more successful at implementing the strategy—his tactics improve as the game progresses. To keep the game in balance (a key concept for Adams and Rollings), the tasks must become harder. In *Source Code,* tasks are made more difficult as the film progresses (finding the bomb was quite easy, identifying the bomber much harder). The bomber is identifiable because she or he is using her or his phone. This obviously applies to a lot of characters and is therefore more difficult to solve. But when Colter eventually achieves this task, he comes to understand his real mission—to locate the bomber's second more deadly bomb. (Whereas the first bomb, on the train, has already exploded, the second bomb has not yet been detonated.) To ensure the game does not reach a stalemate, Goodwin gradually feeds Colter more information about the bomb, about the importance of his mission, and about what tactics to use to successfully carry out the strategy—before he reenters the game.

However, Colter then sets himself two additional goals, which are not part of the game's strategy—to contact his father and to save the people on the train. Both of these self-imposed goals go against the rules of the game, and he is told that they are impossible to achieve because the world of reality one (on the train) is in the past and therefore no longer exists: the train has already been destroyed, and the source code technology is simply sending Colter to an alternate reality in order to identify the bomber. Colter subverts the game's strategy with his own tactics in order to map out his own trajectory within the game.

What resources does Colter have when he begins the game? He has very few resources and therefore few entities. He has multiple lives, the ability to reenter the game once he is killed, but the film does not quantify this resource (although there is a strict deadline, since the bomber needs to be identified so that his second bomb can be halted). Colter relies on his skills and tactics rather than specific resources.

Once Colter's life support is switched off in world three, he continues to exist beyond the eight minutes in world one. He has achieved what Goodwin and Rutledge (the latter is the 'game' designer) said is impossible. In terms of game design, Colter has found and used an exploit, a glitch resulting in an unexpected action that shifts the game from a limited rule-following activity to a free play sandbox mode, where he can explore the world of the game without remaining confined in its closed space or

without following any specific rules or game plan. The way the exploit works is obscure, although it involves a series of actions: Goodwin switching off Colter's life support (in reality three) after eight minutes (just before he returns from reality one, on the train), and Colter disarming the bomb on the train and, at the eight-minute mark, kissing Christina. These events pause the game at the eight-minute mark, freezing everyone on the train in what appears to be an eternal moment. But a few moments afterward, the train and the lives of its passengers inexplicably continue unhindered, as action enters the free play of the sandbox mode. This exploit and move into the free play game mode enables Colter to save everyone on the train from the terrorist attack, at least in an alternate, parallel universe, and to construct a stable future for himself and Christina.

*

In the final chapter of *The Language of New Media,* Manovich asks, "How does computerization affect our very concept of moving images? Does it offer new possibilities for film language? Has it led to totally new forms of cinema?" (2001, 287). After placing the digital cinema within the history of the moving image (2001, 293–308), Manovich explores these questions via "digital films, net.films, self-contained hypermedia, and Web sites" (2001, 292). Earlier, he briefly mentioned filmmakers' reactions to new media, citing "conventions of game narratives" (2001, 288) and referring to *Run, Lola, Run* (Tykwer, 1999) and *Sliding Doors* (Howitt, 1998). *Source Code* is a more recent film that belongs to this category, blending the cultural layer (traditional storytelling) and the computer layer (in the form of new media's video game logic), which has created a complex, hybrid form of storytelling.

notes

1. This is not to say that Manovich's use of the term *new media* is unproblematic (see Rodowick 2007, section III). Nonetheless, for the purposes of this chapter I will be working within the framework of Manovich's definition, for I find it instrumental in conceptualizing the relation between narrative and video game logics in films such as *Source Code.*

2. The film's title is therefore apt, because 'source code' names a system of instructions written in a programming language:

> When programmers create software programs, they first write the program in source code, which is written in a specific programming language, such as C or Java. These source code files are saved in a text-based, human-readable format, which can be opened and edited by programmers. However, the source code cannot be run directly by the computer. In order for the code to be recognized by the computer's CPU, it must be converted from source code (a high-level language) into machine code (a low-level language). This process is referred to as "compiling" the code. ("Compile," TechTerms.com, 2008)

3. The following outline of the first seven rules derives from Buckland 2000 and 2002.
4. This conventional narrative analysis of *Source Code* is carried out using the following basic concepts: description; cause-effect logic; character motivation; shifts from equilibrium to disequilibrium (and back again); turning point; transformation; liminality; dual-focused narrative (genre narrative/love story); exposition; obstacles; deadlines; and coincidence.

references

Adams, Ernest and Andrew Rollings. 2007. *Fundamentals of Game Design.* Upper Saddle River, New Jersey: Pearson.

Brevet, Brad. 2011. "Spoiler Talk: Is the Ending of 'Source Code' Open to Interpretation?" www.ropeofsilicon.com/spoiler-talk-is-the-ending-of-source-code-open-to-interpretation/.

Buckland, Warren. 2000. "Video Pleasure and Narrative Cinema: Luc Besson's *The Fifth Element* and Video Game Logic." In *Moving Images,* ed. J. Fullerton and A. Söderbergh, 159–164. London: John Libbey.

Buckland, Warren. 2002. "S/Z, the 'Readerly' Film, and Video Game Logic (*The Fifth Element*)." In *Studying Contemporary American Film: A Guide to Movie Analysis,* ed. Thomas Elsaesser and Warren Buckland, 146–167. London: Arnold.

"Compile." 2008. Techterms.com. www.techterms.com/definition/compile.

De Certeau, Michel. 1984. *The Practices of Everyday Life,* trans. Steven Rendall. Berkeley: University of California Press.

Eichenbaum, Boris. 1965. "The Theory of the 'Formal Method.'" In *Russian Formalist Criticism: Four Essays,* ed. Lee T. Lemon and Marion J. Reis, 99–139. Lincoln: University of Nebraska Press.

Fiske, John. 1989. *Reading the Popular.* London: Routledge.

Gottschalk, Simon. 1995. "Videology: Video-Games as Postmodern Sites/Sights of Ideological Reproduction." *Symbolic Interaction* 18(1): 1–18.

Hesselberth, Pepita. 2012. "From Subject-Effect to Presence-Effect: A Deictic Approach to the Cinematic." *NECSUS: European Journal of Media Studies* 2(autumn). www.necsus-ejms.org/from-subject-effect-to-presence-effect-a-deictic-approach-to-the-cinematic/.

Luppa, Nicholas V. 1998. *Designing Interactive Digital Media.* Boston: Focal Press.

Manovich, Lev. 2001. *The Language of New Media.* Cambridge, MA: MIT Press.

Parlett, David. 2005. "Rules OK, *or* Hoyle on Troubled Waters." www.davpar.com/gamester/rulesOK.html.

Rodowick, D. N. 2007. *The Virtual Life of Film.* Cambridge, MA: Harvard University Press.

Stewart, Garrett. 2007. *Framed Time: Toward a Postfilmic Cinema.* Chicago: University of Chicago Press.

Wilden, Anthony. 1980. *System and Structure: Essays in Communication and Exchange,* second ed. London: Tavistock.

the image of time in

post-classical hollywood

donnie darko and *southland tales*

b r u c e i s a a c s

on cinematic time

Everything in cinema is, in some sense, a matter of time. Cinema is a temporal medium in ways in which other image art forms are not. According to Todd McGowan, the medium has, "from its inception, privileged time. The essence and the appeal of the cinematic art are inextricable from the experience of temporality that it offers spectators" (2011, 4). A photograph displays an image that signifies 'a time,' 'this time' as opposed to 'that time,' the time of a special moment captured through light and photochemical processes. The still image calls to mind a time and place, but it remains in stasis, reflecting back upon the past as a discrete moment cut off from the present. This is why André Bazin referred to the image in the photograph as time embalmed, or change mummified (1967, 8). Mummification entraps time, holding it to unnatural form for eternal preservation. The photographic image has an uncanny quality derived purely from its ephemerality, its sense of 'having passed.'

On the other hand, cinema, a still image in contrived progression (at the conventional twenty-four frames per second), displays an image

of time through *movement*. Cinema gives time its constant movement, or flow. The spectator feels the presence of time in cinema in conscious and unconscious ways. Lumière's train arriving at a station in 1895 carries the weight of its temporal movement, animating not only the space it opens up but also the time imbued though its animated form. We could say that cinema displays time through projection, animating time's passing with the passage of film through the projector. Granted, each frame is a section of time, cut off from the next. But in constant movement, this projection is no longer the discreet 'moment' of the photograph, mummified in print, but time in constant flow. In this sense, all of cinema's material properties—objects within the frame (the constitution of mise-en-scène), the relationship between cuts (Will the image display continuous, progressive movement through montage, or discontinuous movement?), the sonic material internal to the image—serve time's inexorable progression through the apparatus.

This chapter presents an analysis of two of Richard Kelly's films—*Donnie Darko* (2001) and *Southland Tales* (2006)—as 'post-classical' images of cinematic time. But in a broader sense, I attempt to assess the capacity of contemporary Hollywood cinema to reflect a transformation in the image of cinematic time. Booth is correct to suggest that *Donnie Darko* reveals a "disturbance in our understanding of narrative form itself" (2008, 399). But this disturbance is not merely contained within the overarching temporality of story but in how time *renders* experience: the relationship between moments in time, or instants, and ultimately what Bergson calls 'duration.' In *Donnie Darko,* Kelly seems to ask, What, precisely, is time? What is the special relationship between time and the subjects that encounter it? This is less a question of narrative progression than an inquiry into the basic ontology of narrative form itself. Kelly's negotiation of a classical temporality in *Donnie Darko* explodes in *Southland Tales* into a kaleidoscopic time that "surveys and maps—and mirrors back to us in fictive form—the excessive, overgrown, post-cinematic mediasphere" (Shaviro 2010, 67). Like Shaviro, I argue that Kelly is a filmmaker operating on the fringe of a contemporary Hollywood that seeks to display an American time "out of joint" (2010, 64).

time as space: hollywood's spatial metaphor

If, as McGowan suggests, time is internal to the moving image, I wish to examine the nature of this temporal image in a contemporary industrial context—Hollywood—that remains a hegemonic force in cinema production. I ostensibly agree with the influential position of Bordwell in *The Classical Hollywood Cinema* (Bordwell, Staiger, and Thompson 1985) and more recently in *The Way Hollywood Tells It* (2006) that the Hollywood aesthetic is, in significant part, coherent. This aesthetic, at least from the late 1920s and the industrial formalization of the studio system, displays a convergence of

technological, industrial, commercial, and aesthetic imperatives. If we take Robert Ray's position, the aesthetic tendency is toward cinema's 'invisible style' that displays temporal continuity (1985, 93–104). For Ray, style incorporates narrative structure, ideological subtext, even montage, which is necessarily 'matched,' and causally motivated; the match cut provides the uninterrupted flow of movement. At the level of story, plot points stitch a fabric encompassing the whole such that conflict is mastered by the invisibility of narrational devices—for example, the flashback that sutures past to present in films like *Double Indemnity* (1944) and *Sunset Boulevard* (1950). The cut on action is the treasured tool of the invisible style simply because it obfuscates any potential discontinuity between shots that is especially vivid in images of inaction. This is why the duration of the long take emphasizes time's unruly presence within the shot.

Classical imperatives give rise to a kind of filmmaking that continues to dominate the contemporary studio system. Bordwell's long-maintained position can be summarized as follows: "In formal design, today's Hollywood cinema is largely continuous with yesterday's. There's no doubt that some changes are worth highlighting . . . But those changes stand out against a backdrop of conventions that are as powerful today as they were in 1960, or 1940, or 1920" (2006, 35). This "backdrop of conventions"—the classical aesthetic—is founded upon a temporal determinism. Bordwell doesn't mention time explicitly, yet time is internal to every facet of his study. Cinema's time is internal to the formation of a narrational system, or continuity editing, or an image soundscape that augments visuality (Bordwell and Thompson 1985). The close-up on the visage of a star—a soft-focus shift into Ingrid Bergman's face in the classical montage of *Casablanca* (1942)—enacts a kind of temporality. We pause (a temporal beat) in the presence of this image in close-up. The time internal to the contemplation of the attraction of Bergman is strategically distended through the medium's capacity to 'shape' time.

Marginally tilting classical Hollywood's aesthetic *toward time,* I would argue that Bordwell's temporality infers cinematic time as a deterministic set of shot relations external to the presence of narration; time is subject to story rather than internal to its development in narrative form. Classical storytelling's impulse to resolve conflict (Thompson 1999, 10) is, when broken down to its elementary form, a particular configuration of time. Time takes the spectator to the end of the story, in spite of the narrative digressions along the way. Time is external to classical montage's relationship between shots, which merely cut duration into temporal segments that carry forward the story to its natural and preordained end. In the great majority of Hollywood's classical films, time is ordered, rigidly thematized, and deterministic.

We could say then that in Bordwell's model, time is confined to the process of mapping movement; time is *spatialized.* This is not in any way

to reject this model of spatialized temporality. On the contrary, it is to concur that the majority of classical films animate a form of narrative in which time is subjected to external properties; time is mapped, measured, collated, and imaged as a series of discrete segments in progression that "[blind] us to time's absolute heterogeneity, to the newness inherent in the continuum of time" (McGowan 2011, 23). These are classical Hollywood's requirements of story (time that moves in 'three acts,' or time that must engage its spectator with a hook by the tenth minute, and so on) and character (the temporality of psychological/existential conflict and resolution), and perceptual realism founded upon spatial recognition and temporal continuity.

The debate over classicism is not so much a question of whether cinema still maintains a classical formalism. Of course it does. Rather, Elsaesser (2009), Buckland (2009), and Campora (2009) challenge what they perceive to be Bordwell's reductive, perhaps even simplistic paradigm, in which all variations speak to, rather than extend, an elemental aesthetic system. Can Bordwell's classical narration encompass what appear to be striking departures from the itinerary toward narrative, image, and thematic closure? Buckland's "irresolvable ambiguities" in *Lost Highway* (2009, 55) speak to Elsaesser's reading of a post-classical narration that represents a fundamental "'crisis' in spectator-film relation" (2009, 16). But for Bordwell, such narrative and image oddities are tangential to a basic deterministic narrative model. Kaufman's narrative kinetics or De Palma's neo-baroque spatiality (Cubitt 2005, 221–222) build upon without significantly altering what is already there. Greengrass's hyperkinetic montage in *The Bourne Ultimatum* (2007) (Bordwell 2007) or Gaeta's bullet-time in *The Matrix* (1999) are less a radical form of digital montage than "intensified continuity" (Bordwell 2006, 121–138). The "metaleptic" narrative of *Eternal Sunshine of the Spotless Mind* (2004) (Campora 2009) is an "off-beat story," no less classical in its bankability than its earlier romantic comedy counterparts (Bordwell 2006, 86).

While I agree with Trifonova that the majority of "multiple discourse" films exemplify a tendency toward resolution and the affirmation of agency (2010, 167–169), yet, following Elsaesser, I acknowledge that the allure of the puzzle film is in its affect of "disorientation" (2009, 39). Audiences are increasingly willing to accept a lack of information that might destabilize narrative sense-making. We forge some kind of meaningful relationship to Diane/Betty (Naomi Watts) in Lynch's *Mulholland Drive* (2001), who is split, both within and outside of the diegesis. We accept on some level the capacity of cinema to *not make sense.* Such films display a basic lack in the constitution of the epistemological and ontological fabric of experience.

But the real potential of what Elsaesser (2009, 39) calls a "certain tendency" against cinema's overarching classicism is not toward the affective engagement with a puzzle than toward a radically different image of temporal experience. For Elsaesser, the potential of the 'mind-game' film is to

"show how the cinema itself has mutated." He suggests that such films "refer to . . . 'the rules of the game'" (2009, 39). But this approach returns the crisis of disorientation to a basic question of narrative form. Puzzles disorient the spectator; the curious affect of the puzzle film is founded merely upon *puzzlement,* upon the convoluted and often playful entanglement of narrative progression. These are cinematic mind-games in which meaning extends from the interior of the narrative to cinema's proliferating "meta-contact[s]" (Elsaesser 2009, 37).

If reduced to an engagement with form, cinema's image potentiality is always already a function of classicism's spatialized time. It is merely a variation on classical causality, on a means-end temporality. Constrained to this approach, Elsaesser concludes that "it may be true that many, if not all [mind-game films], can—in due course and given sufficient determination—be disambiguated by narratological means, forcing the analyst to refine his tools, and in the process, forcing the films to yield their secrets" (2009, 39). But the process of disambiguating *Memento* (2000), or *Mulholland Drive* (2001), or *Donnie Darko* and *Southland Tales,* imposes a limit on the experiential capacity of the film. The desire to disambiguate the 'puzzle' assumes a foundational point of closure at which the narrative must rest. This resting point presents the comprehensive, conclusive reading—a predetermined outcome that, in the fullness of deterministic time, will materialize. The tougher the secret is to uncover, to be mastered by the discerning and determined spectator and/or spectator community, the more elegant and accomplished the puzzle film.

The most interesting post-classical films, or puzzle films, or 'multiform' narratives that display a conflicted ontology, present, in image-form, "new life experience" (Žižek 2000, 39). The post-classical effect is not contingent on, nor should it be subjugated to, the engagement with *form.* Form can only in the end reduce the image to a spatialized abstraction external to experience. Taking a very different approach, McGowan suggests that films such as *Pulp Fiction* (1994), *The Butterfly Effect* (2004), *Eternal Sunshine of the Spotless Mind, 21 Grams* (2003), *2046* (2004), *Irréversible* (2002), and *Memento* (2000) "permit the spectator an authentic experience of time" (2011, 6), "time as malleable rather than constant" (2011, 31). But this is not to reduce time to a formal spatiality. It is to project time as intrinsic to experience rather than its deterministic map. In a basic sense, one might ask, What can cinema do for time? What can cinema do for how we engage time, how we map ourselves *within* it, rather than *to* it, how we constitute ourselves as temporal subjects? For McGowan, cinema's internal movement has the capacity to *display* rather than describe time, to reimagine (and reimage) it, to potentially even "[reverse] the relationship between means and ends" (2011, 16).

The following analyses attempt to 'read' the way in which time is opened to complex, creative, paradoxical forms of subjective experience.

This is not to map the narrative machinations of Kelly's films, which, in their proliferation across extra-diegetic spaces of meaning, remain in the process of 'being read.' In the various iterations of *Donnie Darko* and *Southland Tales,* the spectator remains unsettled by the text's capacity to signify outwardly rather than inwardly, projecting beyond the subject's capacity to hold the text to a defined shape. One might see the operation of such narratives as a textual stream of consciousness that cannot be contained by either diegetic form or a singular interpretation. This incapacity of the text to be contained is one of the formative elements of the contemporary ontological puzzle film; the puzzle film unsettles the textual boundaries of the film itself, collapsing inside and outside into a fluid significatory space. Such texts are not merely changeable but in the constant process of meaning-deferment. Basic questions—How does Donnie save the universe? Why does he sacrifice his life when he is clearly aware of his imminent death? What mysterious force of the universe sets Donnie on his path?—not only defy simple explanation but strategically open onto a plethora of interpretations in preceding texts, interactive websites, and formal and informal fan communities (King 2007, 23). In *Southland Tales,* Kelly encodes narrative through the logic of the comic book in a series of 'parts' that lead up to, integrate with but also animate the logic, formal style, and aesthetic sensibility of the film; one element of what Shaviro (2010) calls the film's "post-cinematic effect" is, literally, its incarnation as a comic book, a textual platform subject to graphic rather than photographic affect, hyperbolic rather than realistic (or naturalistic) style. The richness of experience in *Southland Tales* is thus not commensurate with pure interpretation but something nearer to what Barthes calls textual "play" (Barthes 1996, 162).

In this chapter, I engage both films less as a matter of narrative *form*—less the elegance of entanglement—than as the image-expression of cinematic time.

haunted by time in *donnie darko*

I saw *Donnie Darko* twice upon its theatrical release in 2001. On an initial viewing, I was intrigued (though I confess perplexed) by what appeared to be a very simple though elegant paradox. In the first narrative 'movement,' Donnie returns from a strange absence (Where is Donnie?) to discover his bedroom destroyed by an enormous jet engine. Fast-forward to the final sequence of the film, and now Donnie, through a circuitous narrative pathway, is again present at the moment at which the jet engine falls into his bedroom. Contrary to the first event, Donnie is now in bed and is killed by the jet engine. The sequence is thus *replayed* in the narrative, with a dramatic change. But further, Donnie, around whom this strange transformation has taken place, is aware of the change and is resigned to his own death. A particularly vigilant spectator might even conclude that

Donnie has, in some way, engineered this narrative transformation. On my early viewings of the film, I wondered, How could Donnie be both present and absent at the instant of his own death? And what was the relationship between the first iteration of the 'event' and its reiteration in the penultimate sequence of the film?

The cult status of *Donnie Darko* initially derived from its apparent incomprehensibility. As King argues, "In its original incarnation, *Donnie Darko* leaves plenty of questions unanswered and many issues at best partly resolved" (2007, 23). The 2001 theatrical release offers very little in the way of making sense of a convoluted story. Is Donnie schizophrenic, as is implied by Dr. Thurman (Katharine Ross), or is he granted special access to time, perhaps even moving through time in the final act of the film? If schizophrenic, the spectator contains the strange time travel plot within the all-encompassing delusion of a troubled teenager. If not, the spectator engages the film as a hybrid genre, incorporating a teen coming-of-age story and speculative science fiction. Even a determined viewer must settle for an incomplete and imminently changeable reading of the film. Repeated viewings only enrich the film's radical openness; Kelly seems especially attuned to postmodern cinema's capacity for reiteration. The incomprehensibility of the original iteration was augmented by the *Donnie Darko* website, which filtered a series of backstories into the diegetic narrative, additional information on characters and key plot points, and even excerpts from Roberta Sparrow's *The Philosophy of Time Travel.* The director's cut of the film, released in 2004, was again a reiteration rather than a definitive text. This iteration incorporates the substantive narrative elements from the website into the story of the film. Excerpts from *The Philosophy of Time Travel,* displayed onscreen in the director's cut, explain a great deal about Donnie's troubles, differentiate between a 'primary' and 'tangent' universe, and allude to Donnie's special quest to save the world. On a viewing of the first iteration of the film, the spectator might be forgiven for thinking that Donnie is a conventional Christian figure: he must learn the value of sacrifice, giving his own life so that Gretchen, his mother, and sister can be saved from a certain death. (Donnie's mother and sister will die in the plane crash after its jet engine is propelled through a hole in time, twenty-eight days into the past.) If assembling material from the website and director's cut into the whole, it becomes apparent that Frank's warning about the world ending in twenty-eight days is to be taken literally. Donnie is a troubled teenager, but he is also something of a classical superhero.

I will avoid attempting a comprehensive textual disentanglement of *Donnie Darko.* For a careful and insightful reading of the meaning of the film (though the designation of 'the film' in an age of media reiteration is problematic), see King (2007, 63–74) and the materials on the *Donnie Darko* website. On the one hand, I simply cannot see the value in 'making sense' of a text that willfully disperses its meanings in proliferating iterations. This

dispersal of narrative content is perhaps what Garrett Stewart perceives as contemporary cinema's multiple spatialities in the era of digital remediation (2007, 130–137). But more importantly, the desire to lock the film into a final reading imposes a limit on how we might engage such a text and, indeed, how we might engage a text that deliberately seeks to unsettle the interpretive faculties of the spectator. Rather than settle *Donnie Darko's* ontological disturbance (which manifests temporally *and* textually), I wish to confront the temporal paradox upon which the narrative is fashioned. How are we to read Donnie's movement through time? This is more than a question of time *travel,* but of time itself. What must cinematic time *be* for Donnie to encounter it?

Classical narrative cinema (which I have argued subdues time to a spatial correlate) has always been fascinated with the object of time. Occasionally a film is produced within the studio system that seeks to displace time from its naturalized spatiality. Such films often formulate narrational fields based upon temporal paradoxes. Perhaps the most well known, and a clear intertextual reference in *Donnie Darko,* is Zemeckis's *Back to the Future* (1985). In that film, the protagonist travels to the past, encounters his future parents, and potentially causes a temporal paradox, "the results of which," to quote a line from the dialogue of *Back to the Future Part II* (1989), "could cause a chain reaction that would unravel the very fabric of the spacetime continuum, and destroy the entire universe." In *The Terminator* (1984), Kyle Reese (Michael Biehn) fathers the child who will ultimately select him in the future to travel back in time to prevent his mother's (Sarah Connor) death; in a spatialized temporality, Reese's presence in John Connor's time prevents him from being, simultaneously, John Connor's father (they are roughly the same age). Perhaps Terry Gilliam's *12 Monkeys* (1995) is the most interesting studio film examination of time's inherent nonspatiality. James Cole (Bruce Willis) is sent back in time to inhabit a temporal moment that is both present and past (in his memory). A childhood memory (the image of his own death) maintains the past within the present; at the point of the climax of the film, Cole inhabits a temporality in which past and present are no longer clearly distinct.

Yet, as I have suggested, the imperative of the classical aesthetic is toward time as a spatial measure; time is merely the accompaniment to spatial progression within an ontological (textual), epistemological (narrative), and affective (experiential) framework of the film. For this reason, the temporal paradoxes indicated in each of the studio films above are necessarily resolved through the agency of the protagonist. Marty McFly (Michael J. Fox) ensures that his parents will fall in love, that the idyllic America of the 1950s maintains in perpetuity, and that the future is not only intact but is improved through changing the past to what it should *always have been.* John Connor will presumably age in accordance with his deterministic (if not fated) temporality, resulting in his selection of Kyle Reese as the protector of Sarah Connor. The image of Cole's splintered self—inhabiting both the

figure of the child and man simultaneously (Who is Cole at the moment he is shot: the man who dies in contemplation of the child looking on or the child that looks on?)—is a peripheral (and contained) narrative disturbance within the overarching question of whether the world will be saved. In Cole's failure to save the world, *12 Monkeys* enacts a post-classical narrative modality in which the protagonist's primary goal remains unfulfilled, while the secondary goal (the discovery of the meaning of the image that has haunted him his entire life) is fulfilled.

In each of these films in which time is bent out of shape, the protagonist works to reinstate a predetermined temporal pathway, the shape time (or history, or the projection of the future) was always meant to take. Such films ultimately seek to resolve the temporal paradox in the subject's detachment *from time*. These protagonists cannot confront time as complex experience, instead resolving time into its spatial metaphor, or what Umberto Eco refers to as Western civilization's "arrow of time" (1999, 184–185). This spatial metaphor is conventionally visualized as a line, seen, for example, in the spacetime continuum Doc Brown (Christopher Lloyd) displays on a chalkboard in *Back to the Future Part II*. One might contrast the spatialized image of time in *12 Monkeys* with the image of complex temporality in Chris Marker's *La Jetée* (1962), from which *12 Monkeys* was loosely adapted. If Gilliam's time is subject to travel *through*—which ultimately inscribes a spatial objectivity of time itself—Marker's time is internal to the subject's consciousness. In *La Jetée,* time is a field representing something like McGowan's stream of consciousness temporality. The mechanism of time travel is not an object that travels (a spatial metaphor) but an uncontainable image in the protagonist's consciousness. The image spills over from present to past, animating time's flow as internal to the mind of the subject. Gilliam's vague temporal paradox that is sublimated by the classical orientation of the narrative is left like an open wound in Marker's film. The spectator of *La Jetée* senses the inescapable burden of time. For Marker—unlike Gilliam, or Zemeckis, or Cameron, who inhabit Hollywood's classical industrial complex—time is that fundamental part of human experience that cannot be escaped, that haunts the consciousness through an uncontainable image.

Donnie Darko, a film ostensibly about the experience of time, negotiates the classical imperative toward spatialized time while presenting a temporal paradox that cannot be contained within the diegesis. Contrary to a great deal of commentary on the film, I argue that Kelly maintains a complex image of time in the *co-existence* of a primary and tangential universe. I would further argue that the film's reiteration as the permanent deferral of meaning (the director's cut, according to Kelly, is an "extended remix," not a textual completion [cited in King 2007, 70]) works in conjunction with the paradoxical nature of its temporality. I accept that Donnie's quest, according to Kelly (2010), is to collapse the tangent universe and,

in so doing, to restore the authorial primacy of the "primary universe" (Kelly's terminology invariably results in a semantic muddle). But in my reading the tangent universe is not 'tangential'; rather, its capacity to materialize spontaneously, to unsettle the original (primary) universe with its presence, and ultimately to contest the primacy of a single, deterministic image of time, establishes a splinter in time. This is the schism in a temporal experience that enables Donnie to experience his own death before it occurs. This splinter is not contained within the ontological insularity of the tangent universe but materializes as a temporal complexity in which both 'realities' converge as experience. The tangent universe enables Donnie to detach from a predetermined path ("God's path") and in so doing, to contemplate more than one temporal experience. Donnie encounters a radically different image of time that is both alluring and deeply unsettling, enabling the subject to think outside the conventions of spatialized selfhood, collapsing the determinacy of the primary 'present' into the openness of time itself. Donnie's hysterical laughter in the moment before his death displays a subject in communion with its own reflection, its *other* that materializes in a tangential space and time. In the experience of time's multiplicity, Donnie appreciates the finitude of this moment, its inevitable passing. And yet at the same time, he projects outward to a future that is filled with temporal possibilities: "I hope that when the world ends, I can breathe a sigh of relief because there will be so much to look forward to." Of course, Donnie's statement in the moment before death is an affirmation of the accomplishment of the classical protagonist's goal. But equally, the spectator (and Donnie) is cognizant of a radical otherness in which the temporal paradox at the core of the film remains unresolved.

What then are we to make of the film's final sequence, in which history is rewritten and in which *Donnie Darko*'s complex temporality seems to have been erased from the diegesis? What are we to make of Kelly's contention that Donnie completes his quest in *collapsing* the tangent universe, in restoring the primary universe of experience that now again dutifully follows "God's [or whatever force ordained this intervention] path"?

The final sequence of *Donnie Darko* is played to Gary Jules's "Mad World," a melancholy cover of the 1980s Tears For Fears song: "All around me are familiar faces/ Worn out places, worn out faces/ Bright and early for the daily races/ Going nowhere, going nowhere." As the song plays, the image moves into a montage captured in a series of high-angled shots: characters that had been strategically 'operated' in the tangent universe are isolated in the slow track of the camera's movement. Dr. Thurman awakes, haunted by a dream she cannot comprehend, or fully recover; Cunningham (Patrick Swayze), whose pedophilic behavior will not be discovered in the primary universe (this discovery is prompted by Frank in the tangent universe), is racked by his own guilt; Frank (James Duval) touches his right eye in what appears to be a sensory connection to his embodiment within

the tangent universe. The continuity of the camera movement belies the fact that separate sequences have been cut together to form the semblance of continuity or, at least, connectedness; these characters, once joined in the tangent universe in an alternate existence, share the enormity of that experience.

The montage concludes on a shot of the jet engine lifted by crane. Gretchen (Jena Malone) peddles her bicycle up to the Darko house; restored to the primary universe, she has no knowledge of Donnie or of the sacrifice that has enabled her to live. The gesture that concludes the film—a tentative wave exchanged between Gretchen and Rose Darko (Mary McDonnell) that is meaningless as literal signification but speaks of inexplicable loss—implies that the characters who inhabit the primary universe remain haunted by their experiences as 'other selves,' as the embodiment of other, uncontainable experiences. *Donnie Darko* is thus ultimately about the uncertainty of subjective experience opened up to its radical temporal indeterminacy. This is an experience that plays over the final montage as the existential burden of time that is essentially unmapped, and unpredictable. This is a time that cannot measure, or correlate to, a progressive utopian ideal (what McGowan [2011, 77] calls the "politics of the good") but submits to the shortcomings—the elemental indeterminacy—of human experience.

proliferating images: graphic temporality in *southland tales*

> He is a pimp. And pimps don't commit suicide.
> —Pilot Abilene (Justin Timberlake),
> *Southland Tales*

The temporal paradox persists in *Donnie Darko* as a subconscious image of time. Time's materiality remains imprinted in the minds of those characters that once inhabited a tangent universe—a tangent temporality—as 'other selves.' But the film's semblance of a final act resolution implies the beginning of a process of healing in which the nuclear family is restored (minus a son), the all-American suburban setting maintains as Hollywood's perpetual present, and the future (from the vantage point of a retrospective 1980s) remains intact. Kelly's story, characters, and thematic subtext affirm the classical cinematic experience as trauma mastered through heroism and sacrifice. This affirmation of a classical being seems to resonate in *Donnie Darko* in spite of each character's felt perception of its radical alternative—the (temporal) experience of the apocalypse.

Southland Tales, Kelly's subsequent film, in production during the creation of the director's cut of *Donnie Darko,* continues what appears to be Kelly's overarching thematic: the disturbing nature of temporal experience. But whereas *Donnie Darko* must strategically negotiate the imperatives of a

classical ethos, suturing present to past to evacuate the tangent universe from existence (though it maintains in image form as memory), *Southland Tales* reimagines time as intrinsic to *all* experience, all aspects of being. If *Donnie Darko* collapses the tangent universe to affirm the teleological trajectory of the primary universe, the ontological universe of *Southland Tales* is infected with multiple temporalities, with infinitely proliferating images of the past, present, and future. If Donnie's 'other self' maintains as an unsettling image of a repressed subjectivity, the characters in *Southland Tales* are always already a multiplicity, inhabiting more than one temporality simultaneously. Ronald Taverner (Seann William Scott) confronts the image of himself in a mirror, yet he is dislocated from that image *in time;* the movements of his reflected image lag behind his own by several seconds. Ronald/Roland (his temporally divided 'other self'), as well as Boxer Santaros (Dwayne Johnson) and his 'other self'—burned in the explosion in the desert—inhabit both the present and past *simultaneously.* The temporal paradox that is sublimated in the narrative closure of *Back to the Future* and *12 Monkeys* materializes and, indeed, animates the image of time in *Southland Tales.* The capacity for temporal disjunction, or conflicted temporal experience, rather than a means to a narrative end, is construed as an experiential end in itself. Of course, Ronald's confrontation with his temporally deferred image is unsettling, but it is precisely this image of the subject *in time* that is for Kelly the poignant image of an American subjectivity 'out of joint.'

In *Southland Tales,* temporal indeterminacy is matched by a radical textual indeterminacy. Kelly in fact conceived the film as a form of expression Abbas describes as "a possible future form of narrative . . . supported, officially and otherwise, by online interactive narrative experiences" (2009, 60). Like *Donnie Darko, Southland Tales* is dispersed across a number of textual iterations; it also similarly traverses media platforms that express a textual or media diegesis rather than a cinematic diegesis confined to the screen. It utilizes a series of interactive 'tie-in' websites to disperse content across a range of participatory media platforms. In so doing, I agree with Shaviro that *Southland Tales* "does not exempt itself from the frenzied media economy that it depicts" (Shaviro 2010, 69). However, while the online interactive, participatory possibilities of *Southland Tales* clearly partakes of this 'transmediality,' online movements within and between mediated structures is only one mode of transmediation. The most striking transmedial resonance of *Southland Tales* derives from a series of three comic books authored by Kelly during the production of the film. These comic books, providing a wealth of narrative material as backstory, were not conceived as a narrative accompaniment but as part of the integrity of *Southland Tales* as a textual/media object; indeed, the film constitutes merely a continuation of the narrative of the comic books.

While this intertextual tapestry is nothing new in cinema, and certainly nothing new as contemporary textuality goes (King 2007, 22–24), what

209

seems especially significant is Kelly's unusual choice of the comic book as a textual modality through which to anchor the film's diegesis. While the narrative maintains across film and comic books, the material form that contains this narrative is transformed from the comic book's essential *graphic* mediation to cinema's essential *photographic* mediation. The comic is not a form of animation per se (the comic book is composed of images without movement), but its essential graphism displays the capacity for movement without an indexical relationship to actual movement (as there would be in live-action cinema). In contrast to live-action's "base deposits of reality" (Manovich 2001, 294), the comic book demonstrates multiple, and varied, capacities for movement. Atkinson argues that "the [comic book] panel is not an instant in time but the contraction of a period of movement that is informed not only by the shape and size of the panel but by the gestural arc of a character's body" (2009, 268). Movement here is intrinsic to the animation within and between panels. But furthermore, movement is not *internal* to the image (as it would be in live-action's twenty-four frames per second, or 'constant movement') but *animated by* the reader's intervention into the flow of images across discrete panels. In locating the film as the continuation of the comic books, *Southland Tales* demonstrates an overarching imperative toward graphic movement that implicates not only the content (*fabula*) but the form (*syuzhet*) in which this content is contained.

I therefore wish to distinguish between the comic as a form of graphic *interpolation* within and across panels (Atkinson 2009, 266–267) and the cinematic image as a form of photographic *reproduction* bearing the indexical trace of the real. *Southland Tales* (film) displays the aesthetic (narrative and image) signature of a comic book: emphasis on graphic spatiality and movement, spatial collage rather than temporal montage, spatial montage (in which a single graphic panel contains discrete temporal frames), narrative as a series of discrete panels in potentially arbitrary relation, hyperbolic aesthetic mannerism, image in potential 'excess' of the frame (crossing the panel spatially rather than temporally), and so on. Whereas the comic's capacity for movement is amplified through its graphic spatiality—"Movement in the comic book can be understood in relation to the graphic quality of the line" (Atkinson 2009, 270)—cinema's photographic image materializes as an index of temporality (duration).

Southland Tales begins with a Fourth of July neighborhood celebration—Kelly's coda to the idyllic suburbia of *Donnie Darko*. A couple of kids run around with a digital video camera shooting the celebration. Appropriately the opening is shot in amateurish handheld style to emphasize cinema's naturalistic depiction of reality: the ordinariness of the Fourth of July gathering is matched by the ordinariness of the image-capture. After the camera captures the mushroom cloud of the first nuclear attack in Texas, the image cuts to a simulated satellite shot of the United States captured in what is implied is real-time, accompanied by voice-over commentary.

The camera (though the virtual image here is not reliant on the cinematic 'camera-eye') then zooms out and is intruded upon by a second image-frame emblazoned with the insignia of DSI: Doomsday Scenario Interface. This image within an image closes off with a mechanical clanking sound and is replaced with a series of separate image-frames representing what Manovich calls "spatial montage": "a number of images, potentially of different sizes and proportions, appearing on the screen at the same time" (2001, 322). But rather than the image partaking of the spatiality of a database system, Kelly's image is rendered *as a database*—a series of frames that open up various pathways through an infinitely proliferating stream of images and narrative trajectories. Images, voices, and sound effects are mixed in a simulated collage in which each image presents as a discrete signifying object, each a signifying 'panel' within the whole across which the spectator might interpolate a continuous movement.

My point in this brief scene analysis is that the cinematic image in *Southland Tales* is, in a literal sense, animated by the graphic imperative of the comic book. Kelly's transmedial object inscribes an image as interpolation (rather than traditional cinema's image-index of the real) in which the image is *always already* in a process of compositional change. This process of interpolation is part of a wider image-itinerary Garrett Stewart describes as "framed time" (2007). In the case of *Southland Tales,* the image is interpolated through a digital (graphic) simulation rather than an analogue (indexical/photographic) reproduction. Southland (a Baudrillardian simulacrum of Los Angeles's infinitely dispersed geographic networks [Baudrillard 1998]) inheres within a cultural matrix, "a contemporary culture of electronic interface" (Stewart 2007, 124).

Could we not say that in *Southland Tales,* time itself—cinema's image of time—is an interpolated image-form? That it is animated precisely by this process of graphic (digital) interpolation? Could we not say that time is cut off from the indexical real (traditional cinema's duration) and opens onto a plethora of new (graphically animated) time-image possibilities? I'm reluctant to accept Shaviro's notion of the "exhaustion of temporality itself" (2010, 87), though his argument about a post-cinematic temporality is provocative. Clearly the graphic (digital) image displays temporal capacities far removed from cinema's century-long images of time *as duration.* But in what sense could the spectator be affected by an image in which there was *no time,* in which time's basic connection to experience was remodeled as a "new sort of audiovisual and multimedia image" (Shaviro 2010, 87)? Of course, for Shaviro, this is what makes *Southland Tales post*-cinematic: "Its audio-visual flow is entirely post-cinematic, and of a piece with the video-based and digital media that play such a role within it" (70). I would suggest that to avoid the determination of 'time's exhaustion,' we might entertain an 'audiovisual and multimedia image' that construes time in new ways, according to new temporal experiences informed by—but not exclusively

animated through—digital technologies, media systems, and modes of image affect.

Ronald/Roland's Taverner's doubling 'in time' is not a subjective splintering from deterministic time (the mirror phase reenactment we see in Neo's subject-formation in *The Matrix*) but the capacity of the interpolated image to render a double ontologically dislocated from its original. Taverner's doubling is not a psychical reproduction but a graphic doubling of the infinitely divisible (or reproducible) subject-image. Unlike *Donnie Darko*'s negotiated ending, confronting the fullness of time in *Southland Tales* is not to disengage one's own ending but to confront the image of all endings—the apocalypse of the Book of Revelations. Kelly offers the fleeting possibility of restoring time's spatial determinism—like Donnie, Ronald, in killing himself, will collapse temporal indeterminacy into the primacy of an original time, a spatially *replete* temporality that affirms a primary universe. But in the final sequence of the film, Kelly embraces temporality's multiplicity. He allows the world of experience to confront the image of its own oblivion. As Pilot Abilene declares, "He [Taverner, Santaros] is a pimp, and pimps don't commit suicide." In *Southland Tales,* the confrontation with the temporality that materializes at the point of the apocalypse is an experience of *excess,* a 'pimped' subjectivity that converges the hedonistic absurdity of temporal experience with the uncertainty of not knowing what will succeed it. The absurdity of such a confrontation with one's 'other self' is, as Shaviro suggests, "almost sublime" (2010, 92).

references

Abbas, Tom. 2009. "Hybrid Stories: Examining the Future of Transmedia Narrative." *Science Fiction Film and Television* 2(1): 59–75.

Atkinson, Paul. 2009. "Movements within Movements: Following the Line in Animation and Comic Books." *Animation: An Interdisciplinary Journal* 4(23): 265–281.

Barthes, Roland. 1996. "From Work to Text." In *Image Music Text,* ed. Marcia R. Pointon and Paul Binski, 155–164. Oxford: Blackwell.

Baudrillard, Jean. 1988. *America,* trans. Chris Turner. London: Verso.

Bazin, André. 1967. "The Ontology of the Photographic Image." In *What is Cinema? Volume 1,* trans. Hugh Gray, 9–16. Berkeley: University of California Press.

Booth, Paul. 2008. "Intermediality in Film and Internet: *Donnie Darko* and Issues of Narrative Substantiality." *Journal of Narrative Theory* 38(3): 398–415.

Bordwell, David. 2006. *The Way Hollywood Tells It: Story and Style in Modern Movies.* Berkeley: University of California Press.

Bordwell, David. 2007. "Unsteadicam Chronicles." *David Bordwell's Website on Cinema.* www.davidbordwell.net/blog/2007/08/17/unsteadicam-chronicles/.

Bordwell, David, Janet Staiger, and Kristin Thompson. 1985. *The Classical Hollywood Cinema: Film Style and Mode of Production to 1960.* New York: Columbia University Press.

Bordwell, David and Kristin Thompson. 1985. "Fundamental Aesthetics of Sound in the Cinema." In *Film Sound: Theory and Practice,* ed. Elizabeth Weis and John Belton, 181–199. New York: Columbia University Press.

Buckland, Warren. 2009. "Making Sense of *Lost Highway.*" In *Puzzle Films: Complex Storytelling in Contemporary Cinema,* ed. Warren Buckland, 42–61. Oxford: Wiley-Blackwell.

Campora, Matthew. 2009. "Art Cinema and New Hollywood: Multiform Narrative and Sonic Metalepsis in *Eternal Sunshine of the Spotless Mind.*" *New Review of Film and Television Studies* 7(2): 119–131.

Cubitt, Sean. 2005. *The Cinema Effect.* Cambridge, MA: MIT Press.

Eco, Umberto. 1999. "Signs of the Times." In *Conversations about the End of Time,* ed. Catherine David, Frédéric Lenoir, and Jean-Philippe de Tonnac, trans. Ian Maclean and Roger Pearson, 165–178. London: Penguin.

Elsaesser, Thomas. 2009. "The Mind-Game Film." In *Puzzle Films: Complex Storytelling in Contemporary Cinema,* ed. Warren Buckland, 13–41. Oxford: Wiley-Blackwell.

Kelly, Richard. 2010. "Director's Commentary." *Donnie Darko* Blu-Ray: Ultimate 2-Disc Edition. Metronome Video.

King, Geoff. 2007. *Donnie Darko.* London and New York: Wallflower Press.

Manovich, Lev. 2001. *The Language of New Media.* Cambridge, MA: MIT Press.

McGowan, Todd. 2011. *Out of Time: Desire in Atemporal Cinema.* Minneapolis: University of Minnesota Press.

Ray, Robert. 1985. *A Certain Tendency of the Hollywood Cinema: 1930–1980.* Princeton, NJ: Princeton University Press.

Shaviro, Steven. 2010. *Post-Cinematic Affect.* Winchester, UK: Zero Books.

Stewart, Garrett. 2007. *Framed Time: Toward a Postfilmic Cinema.* Chicago: University of Chicago Press.

Thompson, Kristin. 1999. *Storytelling in the New Hollywood: Understanding Classical Narrative Technique.* Cambridge, MA: Harvard University Press.

Trifonova, Temenuga. 2010. "Multiple Personality and the Discourse of the Multiple in Hollywood Cinema." *European Journal of American Culture* 29(2): 145–170.

Žižek, Slavoj. 2000. *Art of the Ridiculous Sublime: On David Lynch's* Lost Highway. Seattle, WA: Walter Chapin Simpson Center for the Humanities.

the drama hollywood puzzle film

re-viewing *vantage point*

twelve

paul cobley

The consensus on *Vantage Point* seems to be that it is a two-star movie. Reviewers at the time that the film was released, plus subsequently for TV listings magazines and elsewhere, generally consider *Vantage Point* to be a failed film undeserving of a five-, four-, or even three-star accolade according to the demotic calibration of cinematic quality. Making an observation on this apparent consensus, however, might seem a strange way to open an essay where the task in hand is to consider this puzzle film's narrative and the way that it exemplifies complex storytelling. Nevertheless, there is good reason in what follows for making a note about the film's reputation. First, the demotic rating—though widespread, appearing in the assessments of professional reviewers for publications as well as the legions of bloggers—is rather unjust. Arguably, the narrative is expertly constructed and innovative. Second, the film contributes to more than one corpus or cycle of contemporary narratives with common purposes—not just the puzzle or complex film but also the overlapping category of films devoted to replaying or negotiating the trauma of 9/11. Third, one key component of the film's narrative betrays its ultimately conservative political project, although it is

not mentioned in reviews of the film. Fourth, the issue of the complexity of the narration is at the heart of the discourses that have thus far established the film's reputation, offering up a potentially dominant way of apprehending the narrative. Finally, and perhaps most importantly, the approach in the current essay necessitates consideration of the film's reputation in assessing the nature of the narrative's complexity. A cognitivist approach to the complexity of a narrative in a film tends to stress how a film is "incomplete" until the spectator implements "schemata" to render the film as a coherent mental representation (Buckland 2009a, 7). A semiotic approach, while allied to a cognitive perspective in focusing on how a spectator is likely to read a narrative, is concerned with the semiotic resources that are brought to bear on reading. As such, it considers a narrative, complex or otherwise, to consist of a multi-ply tissue of readings (Lotman 1974, 1982) implying certain audiences, certain probable readings, as well as the possibility of aporia in readings, but without imagining that there is always a 'text itself' which awaits liberation from the webs of relations in which it is suspended.

complex storytelling

Complex storytelling, of course, is not new, in the same way that the narrative devices often manifest in postmodern fiction have their own, centuries-old precursors (Cobley 2013, chapter 6). Likewise, puzzle narratives and convoluted plots are not necessarily phenomena indigenous to the present. Nor is it true to say that complexity and convoluted plots are both marked only by their movement into the mainstream in recent years. In one of the canonical inaugural texts of cultural studies, Hall and Whannel (1964, 125–127) note that what marks hugely popular contemporary detective narratives on television is the almost unmanageable density of their plots, suggesting that their audiences are made up of viewers who are not only competent in the genre but also not unintelligent. In the thriller genre in particular, some key mainstream films of the last forty years have experimented with such staples of complex storytelling as unreliable narrators, specific focalizations, prolepses, and analepses. *Blow Up* (1966), *The Conversation* (1974), and *Blow Out* (1981) have provided inspiration in this respect. These kinds of movies embody, significantly, narratives of *witnessing* and points of view. One precursor of such 'witnessing narratives' that acts like a brand leader is, of course, *Rear Window* (1954). Sometimes these thrillers have close relatives in relatively uncomplex narratives in paranoid surveillance thrillers, the benchmark for which was set over the last decade by *Enemy of the State* (1998) (see Cobley 2010). In other film genres, complex staples have served other specific generic purposes—for example, the constant problematizing of what is real in the horror *syuzhet* as opposed to what is imagination or dream (*Nightmare on Elm Street 3: Dream Warriors* [1987] is a well-known example) or what is memory and what is an artificial implant for science fiction characters (*Total Recall* [1990] is an obvious exemplar).

These are important points to take into account in relation to *Vantage Point*. First, the filmmakers state that they conceived the film with reference to 1970s paranoid thrillers such as *The Parallax View* (1974) and *Three Days of the Condor* (1975) as well as *The French Connection* (1971) and have clearly extended the problematization of viewpoints in those films (see Travis 2009). Second, one of the central questions elicited by *Vantage Point* regards the moment when the devices of complex storytelling are found to be stale, conventional, and merely 'generic.' For critics, audiences, and theorists alike, complexity of narration is not 'enough' to guarantee attention. Nor is it sufficient in ensuring a film's vision or political project. The critical response to *Vantage Point* demonstrates this quite clearly. The complexity of the narration in this film was fairly obvious to audiences, to the extent that many reviewers simply labeled the movie's core narrative device a 'gimmick.' Nevertheless, before discussing that, some exposition—along with spoilers—is required here.

In *Vantage Point*, the plot—or what, after Ricoeur and St. Augustine, one might more theoretically call the "chain of causality" in narrative (Cobley 2013)—concerns an international summit held in Salamanca, Spain (actually filmed in Mexico), and attended by the president of the United States (William Hurt). Members of a 'local group' of Moroccan- and/or 'Mujahideen'-connected terrorists—according to belligerent presidential aide McCullough [Bruce McGill]—led by Suarez (Saïd Taghmaoui), along with collaborators, have a daring plan that will be carried out at the summit. At the plaza event where President Ashton is due to speak, along with the town's mayor, to the press and the assembled crowd, the terrorists intend to have the president shot by a 'sniper' and then create chaos by exploding a bomb. The bomb is to be carried into the plaza by the jealous boyfriend of one of the conspirators, a Spanish undercover cop, Enrique (Eduardo Noriega), who does not suspect that his girlfriend, Veronica (Ayelet Zurer), is a terrorist. The 'sniper' is a remote-controlled rifle pointing out of a window above the plaza. In fact, the man ascending the podium to represent the United States who then gets shot is not the president but an actor who stands in as his double. As the 'president' is shot in the plaza, there is also an explosion on the lower floors of the president's hotel, in a different part of the town. This causes chaos for the security services but also allows the kidnapping of the real president (also William Hurt), who is drugged and bundled into an ambulance, even as his double is making a journey to hospital in a similar vehicle.

Thus far, this account of what goes on in *Vantage Point* has been deliberately bare. Indeed, it is so bereft of causality and motivation as to be a set of story events of the kind that are isolated in analysis and sometimes, after the Russian formalists, given the name of *fabula*. However, in all narratives, complex or otherwise, story events are inseparable from principles of organization that constitute fabula's partner, *syuzhet*, or, if the phenomenon is being stated more strongly with reference to causality, *plot*. In *Vantage Point*, motivation is partly provided by the characters and offstage events.

The terrorists' plan is supposedly motivated in retaliation for a US special forces operation in Morocco that uncovered a dirty bomb plot and took the plotters prisoner. The hawks in the administration want the president to authorize an air strike on the terrorist *leaders*, who are together in Morocco, rather than the local cell involved in the current attack. This is an action that the president is unwilling to take because Morocco is a friend of the US, and he is also suspicious of his hawkish advisers. In turn, though, the hawks imagine that they can have the air strike ordered while the real president is in the sticky position of having his double incapacitated in an ambulance, rendering the real president unable to assume the commander-in-chief role.

As regards the other characters, motivation is also strong. The local terrorist plan is activated by Javier (Edgar Ramirez), a Spanish special forces agent who was blackmailed into carrying out the kidnap of the (real) president because his brother is being held by gunpoint by Suarez's group. Javier is set on his mission by Veronica, who is seen in conversation with Javier by the jealous cop Enrique. As the president's double is shot, the US Secret Service operatives jump into action. One of these, Barnes (Dennis Quaid), had already taken a bullet for the president in an assassination twelve months prior to the summit and is on his first day back on duty in Salamanca. A second secret service agent, Taylor (Matthew Fox), is, in fact, a double-agent who is working for the Moroccan terrorists. Once the (real) president has been kidnapped, Barnes takes center stage in his pursuit (partly by car chase) of the terrorists and his attempt to rescue the (real) president. The other chase that is central to the film, but seems to be a mere adjunct to the plot, concerns an American tourist, Howard Lewis (Forest Whitaker), who, in between calling his estranged wife and children, captures some of the plaza events on the camcorder he has taken on his holiday. Lewis had spoken briefly with a six- or seven-year-old child, Anna (Alicia Zapien), before the terrorist attack and then seeks to rescue her when she is separated from her mother during the melee that ensues from the explosions.

For anyone who has seen *Vantage Point,* the summary above, even with the motivation of the characters signaled, will verge upon the unrecognizable. This is not because the summary is inaccurate—indeed, it presents the events in chronological order rather than impressionistically—but because the plot and the story are, as with all narratives, dependent on the specific devices used in their narration. It is clear in *Vantage Point* that the already complex plot makes more sense in terms of its narration as a series of different viewpoints. So, the first part of the movie consists of the immediate build-up and the shooting of the 'president' in the plaza narrated from five different vantage points: a position close to that of television news anchor Rex Brooks (Sigourney Weaver), another one close to that of Barnes, another close to Enrique, one near to Lewis, and a final one near to the (real) president. At the moment of the assassination in each of

the first four vantage points, the action 'rewinds' with the key events in that vantage point briefly played backwards before a digital clock appears onscreen (almost in the style of the television series *24*) to reveal the same time moving slowly forward again, a few seconds toward 12:00 in each case, as the next vantage point is played out. The poster for the film announces, "Eight strangers. Eight points of view. One truth." But, strictly, this is not accurate, since three of the viewpoints in the narration are broader than those focused on the moment of the assassination and they sometimes involve more than one character. Rather, the final three character positions provide an additional set of vantage points on events *following* the attack: the kidnap (Javier); the coordination of the attack and the flight in the ambulance (Suarez—and, partly, Veronica, but actually beginning close to the innocent child, Anna); Taylor and Javier's escape attempt and the shooting of Enrique (Javier and Taylor and, earlier, Lewis and, later, Barnes)—plus an anomalous brief fourth, which is mentioned below.

genres and cycles

So far, what has been stated, despite laying bare some of the mechanisms of the narration, has been description rather than analysis. This is because it is necessary to unravel the plot and narration and to be clear in analysis about what the narrative of the puzzle actually does. Some readings of the film, in rushing to judgment, fail to do this. Moreover, the status of the film in relation to complex storytelling depends on whether the narrative devices are viewed as meaningful or merely 'tricksy.' The distinction of tricksy/meaningful, of course, entails comparison of *Vantage Point* to other cycles and genres, particularly where it stands in relation to such beacons of the contemporary complex film as *Memento* (2000) or *Minority Report* (2002). *Vantage Point,* for all its paraphernalia of complex narration, can also be appreciated in the same ways as other, straightforwardly narrated paranoid thrillers as adumbrated earlier. The obvious conspiracy emerges with the plan of Suarez and his blackmailing of Javier to act as his agent, but there is also the paranoia-inducing conspiracy in which Taylor has used the seemingly fragile Barnes as a sap during the plaza attack, as well as the hawkish agenda behind the guidance of the liberal President Ashton by his aides. To recognize and expose each of these requires a specific 'vantage point' that, in 'conventional' thrillers, is usually revealed toward the end of the movie by the central character from whom information has previously been withheld in the narration. In *Vantage Point,* there is a telling difference: information is withheld from various characters rather than just the 'hero' or central consciousness, and it is withheld, especially, from the audience.

Withholding information from the audience is a common trope in the complexly narrated puzzle film and is associated with the audience's questioning of events as they are filtered through protagonists'

consciousness(es). In this way, it follows that withheld information constitutes a further demand on the spectator to construct a film's *syuzhet*. However, in terms of genre—and, especially, the contemporary thriller—the act of withholding information in the narration has a further dimension. There can be little coincidence in the release of two films in close temporal proximity to *Vantage Point*, which represent a cycle of contemporary movies devoted to the problems of witnessing. Both *Déjà Vu* (2006) and *Passengers* (2008) dramatize the dilemma of remembering and working through (and, to a certain extent, completing the Freudian triad, *repeating*) a major public trauma. Although not directly about the 9/11 attacks—and, in the case of the terrorist attack in *Déjà Vu*, echoing also the natural disaster of Hurricane Katrina—it is clear that these films replay the sheer shock of the aircraft crashing into the Twin Towers and the Pentagon, as well as the dilemmas of memory and rational reconstruction involved in comprehension before it is possible to begin to come to terms with what happened. *Vantage Point*, in this respect, shares a great deal with these two films and, by extension, such narratives as *World Trade Center* (2006), *United 93* (2006), and even *Cloverfield* (2008) through the way that it figures the assault on the plaza as initially chaotic and almost unfathomable until a deeper truth can be discerned beyond the web of witness accounts. If one was to extend the connection beyond 9/11 to other traumas, then one would have to mention *Vantage Point* director Pete Travis's *Omagh* (2004) as well as *United 93* director Paul Greengrass's *Bloody Sunday* (2002) and even the comical *Four Lions* (2007). The main way in which *Vantage Point* differs from *Déjà Vu* and *Passengers*, though, is generically—*Vantage Point*'s 'rewinds' adhere to the puzzle as it features in the regime of verisimilitude that characterizes the thriller. That is, the film eschews 'otherworldly' events in favor of 'realism' and a commitment to that which is broadly probable in the known world. It uses complex narration to dramatize quotidian psychological experiences of memory and perception rather than in the service of complementing the fantastic (time travel in *Déjà Vu*) or the supernatural (dead people coming to terms with the fact that they did not survive a trauma in *Passengers*). Moreover, this seems to be of a piece with *Vantage Point*'s relatively pessimistic complex narrative. Whereas narratives such as *Source Code* (2010) and *Déjà Vu* embody a dystopian/utopian apparition of surveillance technology, a "widening vein of technological marvel and anxiety" as Stewart (this volume) attests, *Vantage Point*, for all its plot resolution, concludes with sociocultural anxiety about the so-called War on Terror.

when complexity is not enough

Vantage Point, as a puzzle film, therefore, lies between or overlaps with the cycle of films devoted to replaying or negotiating the trauma of 9/11, the genre of the paranoid thriller, and, in particular, the narrative theme of

'witnessing,' which is the core of the former and has sometimes been the seat of narrative innovation in the latter. Yet, it seems that the liminal existence of this film is the dominant contributor to its failure for the majority of commentators. Analysis of the storytelling, then, requires some assessment, using whatever valuable information is available, of whether the film's narrative techniques were judged to be successful or not and what the foundations for this judgment might have been. As has been noted, comment on the film at the time of its release was dominated by negative judgments: the website *Rotten Tomatoes* contains links to a seemingly endless array of professional, semiprofessional, and nonprofessional voices expressing discontent with the film. The complexity of the narration is actually the crux of the matter, even when the complaints are about character and political motivations. For critics, the film is a "triumph of form over content" (Mackie 2008), "making so many impossible demands on us to suspend disbelief that the audience should demand combat pay" (Travers 2008).

Typically, *Vantage Point* was compared to other films, particularly on the issue of the complexity of its narrative. Some of these were contemporary movies such as those of Quentin Tarantino and Sidney Lumet's *Before the Devil Knows You're Dead* (2007) (see Grierson 2008); some saw the film as akin to *Groundhog Day* (1993) (see, for example, Gilchrist 2008); but, above all, the key reference point was the "grandaddy of multi-viewpoint cinema" (Robey 2008, 18) *Rashomon* (1950). Judgments such as "Rashomon through a sniper scope" (*Total Film* 2008) come as no surprise, although the only sniper in the film is actually an electronic one. What is important is that the Kurosawa 'masterpiece' is generally used as a club to beat *Vantage Point* for the latter's supposedly unblurred vision of reality. "[T]here's no real ambiguity (so stop with the careless comparisons to Kurosawa's *Rashomon*)" says the review of the DVD on Amazon.co.uk (Jameson n.d.). The *Daily Telegraph* expands by stating that *Rashomon* has

> a story obfuscated by unreliable narrators and this [*Vantage Point*] is one whose characters just miss things. No one's fabricating a false version. No one has much of an agenda, or leaves their lens cap on at a crucial moment. The movie hands witness status solely to the obliging.
>
> (Robey 2008, 18)

The irreverent blog *The Daily Raider* raises similar issues in a more demotic strain:

> Every fucking review of *Vantage Point* invariably mentions the Kurosawa classic, either by saying 'influenced by *Rashomon*' (if the review is positive [apart from French (2008), no positive review doing this has been found for the current

essay]) or by saying 'ripped off from *Rashomon*' (if the review is negative). It's not really the case. Sure, there are superficial similarities, but the key component of each differs. In *Rashomon,* there is no objective reality. We only rely on accounts provided by various people. It's up for the viewer to decide. *Vantage Point,* contrastingly, has an objective reality. Though the viewer is led astray with red herrings and 'everything you know is wrong' twists, eventually we learn the truth. There's no ambiguity in what happened; the entire plot unravels. Whereas Kurosawa's picture uses the unconventional method with purpose, *Vantage Point*'s usage is a mere gimmick. Simply a 'how do we make a completely boring, stupid film somewhat memorable' thing. So stop comparing it to *Rashomon.* They're not the same.
(Doom and Malice n.d.)

The *New York Times* was more specific still: it claimed *Rashomon* offers its version of the same incident "brilliantly," whereas with *Vantage Point* "we get so many versions and viewpoints that a preview audience started to complain audibly each time the clock was reset, though this probably had less to do with the fractured storytelling than its lack of brilliance" (Dargis 2008). The review also adds that in *Rashomon* there are far fewer versions of events: just five, including that of the filmmaker, "a vantage point that's missing from this newer work" (Dargis 2008; cf. Gilchrist 2008). Clearly, this comparison rests on insufficient attention to *Vantage Point* and is naïve in respect of cinematic narration, but it still results in a self-confident judgment on when complex narration is 'good' and when it is 'bad.'

What is apparent is that some audiences seem to have responded with irritation to *Vantage Point*'s rewinds, viewpoints, and cliff-hangers: "a three-steps-forward-two-steps-back feel that eventually becomes rather annoying" (Arendt 2008) or "annoyingly constrictive" (*Total Film* 2008). The film's editor, Stuart Baird, an experienced and distinguished craftsman, makes it clear that he repeatedly used a staple of conventional cinematic narration—the cliff-hanger—in his work on the film (*An Inside Perspective* 2009). Yet this cuts no ice for some audiences: "*Vantage Point* is ridiculous because it wants to keep us in the dark like children, concealing a conspiracy plot that's batty anyway," complains the *Daily Telegraph* (Robey 2008, 18), while IGN suggests that the *New York Times*'s point about the preview audience is more widespread because "each time the film 'rewinds' to the beginning, audiences will likely be less interested in learning 'the truth' than in leaving the theatre" (Gilchrist 2008). *Variety* suggests that tedium sets in after thirty minutes of the film "not because the instant-replay structure couldn't work in theory, but because its audience-baiting tactics are so transparent (having a character whisper 'Oh my god' when

something shocking transpires offscreen loses its punch the third or fourth time)" (Chang 2008). One problem for audiences might be that there are too many characters for the complex narration to work. In *Memento,* for example, which is also rife with cliff-hangers and repetition (if not rewindings of the same event), the audience's response can be stabilized by the fact that the film's focalization involves just one character. In respect of *Vantage Point,* there is negative feeling about the proliferation of characters and, certainly, what is perceived as insubstantial motivation. The central character of Barnes is repeatedly seen as a Secret Service agent modeled on Clint Eastwood's *In The Line of Fire* (1993) character (Grierson 2008) "minus the complexity" (Travers 2008). Unsurprisingly, in a low-level analysis of the politics of representation, the terrorists and the 'foreign' characters are repeatedly seen as mere cyphers who undermine the complex narration. The character of Howard Lewis is also criticized for being a simple plot device and, in one of the most sympathetic of commentaries, is summed up as no more than a "sad-faced everyman" (Jeffries 2008, 7). The irritation with the rewinds and the discontent with the drawing of the characters is an indication of where the audience's tolerance threshold for complex narration meets the demand of realist verisimilitude, the latter of which, as has been indicated, tends to arise in particular from the thriller genre. An instructive contrast, here, is the enthusiasm with which reviewers and audiences greeted similar narrative devices in the much less peopled and significantly more optimistically romantic *Source Code.* Nevertheless, this is not to say that the threshold of complexity and the demand for verisimilitude are not open to contestation.

beyond realism

Positive assessments of *Vantage Point* are rather thin on the ground. Yet, they are as important as negative ones in analyzing why the complex narration of this film did not work for many audiences. They come not only from reviews but also from the comments—often for public relations purposes but sometimes illuminating—of those who worked on the film. These comments appear in the customary DVD 'extras' or narrative 'supplements' that are an extension of some features of narrative itself, serving to broaden the definition of the cinematic text (see Cobley and Haeffner 2011). The DVD extras and positive reviews predictably see the construction and viewpoints in the film as pivotal. Unintentionally countering those reviews that evinced a feeling that the audience was shortchanged by the same event being filmed a number of different times, the director reveals that filming was scheduled for a few days around each character to produce a perspective as close to that character as possible rather than filming one event with a plethora of cameras (Travis 2009). None of the reviews sees fit to even mention the handheld steadicam fast-cut mode of the film,

so naturalized has that mode become in action movies—although *Rolling Stone* does say of Travis's style, "The guy knows how to pump the action pedal—hell, he floors it" (Travers 2008). As regards the viewpoints and cliff-hangers, Travis (2009) does insist that the film was trying to emphasize "different ways of seeing." The rewinds were all planned to end on the face of each character to reflect the individuality of their view (Travis 2009), and, in an intention that appears to have backfired in many cases, editor Baird states that he deliberately edited the initial four sequences in order that the rewind took place when audiences did not want to leave the story that was being narrated (*An Inside Perspective* 2009). One reason why this tactic might have had only limited success is indicated in a (positive) review by the literate critic Philip French of the *Observer*:

> The movie can be seen as going back to the earliest days of the cinema when, before cross-cutting was developed, parallel events were shown consecutively rather than concurrently. It also employs a narrative device that can be found as early as the Gospels of the New Testament, where a series of events is seen from different, often conflicting, points of view.
>
> (French 2008, 9)

In this assessment the film is not complex but unsettlingly simple. More telling, perhaps, is the implication that the dissatisfied audiences continued to read films largely in the way that Griffith intended. Indeed, in relation to the film's narration, French quotes Fitzgerald on the ability to hold two opposed ideas in the mind at the same time and still retain the ability to function, comparing the viewer's task as akin to being "on a jury where the evidence is being presented by Oliver Stone and Jerry Bruckheimer" (French 2008, 9).

One reason why the narrative is complex in this way is put forward by the director, who expresses his contention that the story is "more complicated than news." The stated directorial intent was to frame the story as a whole with an opening sequence in the newsroom and, following some interspersing of news reports in the story such as the president watching his double on TV, conclude with the simplified news bulletin (Travis 2009). The news account of events, of course, is not just simplified but also complicit with the official US government version of what happened. In this formulation, the idea that there is a 'true' version of events—an idea at which the negative commentaries tended to baulk—has a point. French (2008, 9) notes that everything the audience sees in the film "is fact as viewed and interpreted from different points of view. There are no visual lies, no examples of what Wayne Booth dubbed 'the unreliable narrator', no false flashbacks of the sort Hitchcock pioneered in *Stage Fright.*"

For French (2008, 9), the audience is put in the position of Harry Caul in *The Conversation,* constantly replaying his tapes to try to gain an accurate understanding of what has been recorded. In this light, there is no reason why the contention that there is a true version of events to be uncovered among the web of stories is somehow less credible than 'ambiguity' and the contention that there is no truth beyond the characters' accounts. In fact, it might be argued that showing the faulty perspectives of characters and, especially, the putatively objective news service, is more critical than concluding, noncommittally, that 'there is no truth.'

Numerous other features of the narration of *Vantage Point* that would be acceptable in other movies are seen to be faults. The positive reviews question this, suggesting that the assessment of the film could go either way and that the hinge is the complex storytelling. Following a negative review in the London listings magazine *Time Out,* similarly negative comments were posted by readers of the webpage. Standing against nearly all of them, one commenter offered a positive review, asking essentially, "What was wrong with that?" But the comment also points to the film's liminal status between a thriller with demands of realist verisimilitude and complex storytelling. It points, especially, to the need for the characters to sustain the story, and this is a key issue not just in this film and thrillers in general but in the history of narrative. It has been argued elsewhere (Cobley 2013) that the Western tradition of storytelling since the Bible has promoted the psychological depth of characters as a key attribute of narrative, but this depth is often sublimated into *plot* as the repository of causality. In most thrillers, character motivation is subsumed by the consistency and verisimilitude of the plot—that is, satisfying the demands of what audiences believe is acceptable with reference to knowledge of other texts in the genre and with reference to public opinion or doxa (Cobley 2012). In this film, it seems that the demand for character and motivation are heightened by the complex narration's creating of an expectation of nuanced yet clear psychology, which the genre is not regularly compelled to meet and does not necessarily always warrant.

The film undoubtedly foregrounds human vision. Apart from the opening sequence in the newsroom and the identification of a CNN camera operator as a terrorist, and despite the use of mobile and remote devices by the attackers, the film has none of the trappings of surveillance thrillers such as *24* and *Spooks* with their constant use of monitoring technology (see Cobley 2010). But, as receptacles of witnessing, the role of human agents in the film is not always clear. Ambivalence about the status of characters is evident in the overblown claims of the filmmakers, aside from the 'luvvie' pronouncements from actors on the promotional DVD extras, about motivation and development. For example, the director claims that "each character in each story gains a different sense of who they are" (Travis 2009), but the screenplay writer, Barry Levy, is happy to refer to both Barnes and

Enrique, in a quasi-Proppian fashion, as fulfilling the function of "patsy" in the story (*Plotting an Assassination* 2009). *Screen Daily* suggests that the performances are "nuanced and compelling," especially those from the Venezuelan, French-Moroccan, and Spanish actors, and that they *avoid* "inspiring well-deserved criticism of Hollywood xenophobia" (Grierson 2008). This observation does not necessarily have any bearing on complex storytelling and closer to the mark is French's argument that *Vantage Point* is not concerned with issues of conscience or psychology but more to do with how people accept and then question identities, reappraise them, and are then misled by them. The film dramatizes identity as "a game into which we are thrust without knowing the rules, a jigsaw puzzle for which we're given pieces without knowing what the completed picture will reveal" (French 2008, 9). Notwithstanding Dennis Quaid's constipated expression for the duration of his appearance on screen, arguably the character motivations and performances are perfectly adequate for the purposes of the plot and the rewinding narrative of the film.

when everyman = american

Where characterization is more problematic concerns Lewis. Some of the reviews mention this character—probably because Forest Whitaker is another high-profile actor among the stellar cast—with French (2008, 9) noting the significance of his recording of the main story events on camcorder and others dismissing Lewis for his 'everyman' function. None of the commentaries notes how the character acts not only to stabilize the complexity of the narration but also to render it politically reactionary. One could say, then, that while the 'text' is a product of its readings, it is also important to the task of analyzing complex narrative to consider the text's *possible* readings. The history of texts, in particular those with rich semiotic resources, reveals that what is 'the text' changes according to the different readings that constitute it during different epochs. As such, it is necessary for the analyst to offer also a symptomatic reading of the film, a standard procedure in academic debate for some time but still not a part of the repertoire of middle-brow commentary. It entails invoking the hermeneutics of suspicion (Ricoeur 1970, 32), reading on the margins (Derrida 1984), and identifying fissures in the narrative (Macherey 1978). In film, such symptomatic reading was famously inaugurated by the editors of *Cahiers du cinéma* with their analysis of *Young Mr. Lincoln* (1972 [1970]). The key questions on this agenda are not so much about character motivation; nor are they about the consistency of the complex narration. For example, the brief narration close to the sleeper terrorist collaborator, Taylor, which was mentioned above, may be a flashback or may be a subsidiary narrative but nevertheless constitutes a lacuna. However, a symptomatic reading is concerned with what is revealed about the *political* project of the narrative in its

marginalia often running contra to its central features or stated intent. In one of the DVD extras, for example, Dennis Quaid denies that the film is in any way political; instead, echoing others involved with making the film as well as many of the positive and negative commentators, he claims that this is a movie about personal relations (*Plotting an Assassination* 2009). Yet, of course, the film is intensely political, both in the sense that the *personal is political* and, as argued, that the narrative participates in the renegotiation of the witnessing of 9/11. One of the most palpable devices in fiction for the purpose of occluding politics is to recast political issues as a matter of individual preference or motivation, to pose configurations requiring political judgment as situations calling for personal moral reform instead. Hollywood narrative, like much narrative in the Western tradition, has been complaisant in this respect. It is possible that one reason that audiences found the film to be off-kilter was that the narrative fragmented the Hollywood focus on individuals to the extent that the filmmakers have to assert in the DVD extras that Barnes is the hero of the film (although it is more like an ensemble piece), noting, too, that the Taylor character is really two people and the president is two people and that there are split priorities— or, one could even say 'subjectivities'—with regard to Veronica, Javier, and Enrique (*An Inside Perspective* 2009). The characters are not 'complex' in the traditional sense of having 'depth' but, instead, are 'complexified' by their priorities resulting from the conspiracy and riven by the narration of their challenged perspectives.

The problem with Lewis is a similar splitting that is, in this instance, obvious but unacknowledged in the narrative, the filmmakers' comments, and the observations of commentators. He is supposedly a tourist who is "abroad for the first time" (Travis 2009) and missing his wife and children from whom he is unhappily separated. His character and function converge around ensuring "that the little girl [Anna], the film's innocent symbol of hope, makes it through to the closing credits" (Jeffries 2008, 7). He is an "everyman" (Travis) who puts "family first" (Levy) (*Plotting an Assassination* 2009). Yet, if he is an everyman, why is he an American? According to the director, the Lewis character was originally slated to be a Pole (*An Inside Perspective* 2009), and with the history of Polish people as the butt of jokes in the US, it is not difficult to imagine how the original choice for the character might have transformed the way that the narrative could be read. However, as an American in Europe, like the entirety of the president's entourage, he takes on a politically charged complexion. Roused to go abroad, his character collapses the political events of the summit and the assault into a matter of family, home, and benign intervention. Observing this fact would be the standard fare of a symptomatic reading. In addition, though, Lewis is also "Zapruder" according to the claims of the director (*Plotting an Assassination* 2009), referring to the individual who produced the unwittingly iconic and necessarily evidential footage of the assassination of

President Kennedy. Because Lewis believes that he has seen and recorded the assassin in the shimmering curtain of an upstairs window, he is crucial to Barnes's investigations. He is at the heart of the film's plot, therefore, but also at the heart of the complex narration of witnessing. Later it is revealed that there was no 'assassin' except for a remotely controlled rifle. Lewis's perspective on the shooting is as faulty as the others, but his associated perspective on life is constructed as the keynote of the narrative—an ultimately conservative organizing principle.

conclusion

Contemporary complex storytelling is historically specific enough to amount to a social phenomenon rather than simply an artistic trend. Clearly, as a trend it arises from the popular success of certain complexly narrated films early in the last decade; it arrives at a time when film technology has developed to facilitate complex narration; it is also a consequence of the fragmentation of media and its bequest in the fragmentation of experience and the process of witnessing (see the essays in Buckland 2009b). Yet, the overriding factor for those concerned with the historicity of narrative must be that the complex narrative in question here is a post-9/11 development. *Vantage Point* is sometimes coy about invoking 9/11; nevertheless, as a thriller with a specific regime of verisimilitude, its plot and narration are more forcibly associated with the events of 2001 and the subsequent War on Terror than sci-fi and supernatural narratives.

The complex narration of a puzzle in *Vantage Point* is calculated to pronounce on both the process of witnessing and the trauma of terror. As Howie (2011, 32) puts it, using the phrase from the title despite not discussing this film:

> Without witnessing, there would be no emotional response to label *terror*. There would be no dead bodies, and ruined buildings and infrastructure, but if no one sees it, surely it cannot be called terrorism. *If a terrorist fells a tree in the woods, would the media report it?* Witnessing terrorism involves images, spectacles and a vantage point. 9/11 holds power as an image-event because that vantage point may have been anywhere across the world.

In sum, Howie's argument is that the media are responsible for witnessing. He presents a constructionist perspective on 9/11 and attendant media events, particularly during the War on Terror. The makers of *Vantage Point*, by contrast, use complex narration to show that the public sees something very partial and constructed in news because even eyewitnesses of events, on the spot, do not see reality. There is something behind news

and individual perspectives that is more complicated. Potentially, this puts forth a more radical position than constructionism.

A similar approach informs the semiotic analysis in this essay. Even while the text is understood as consisting of a number of readings, plus the text's relation to other texts, there is a need to acknowledge that the film is not only a construction of readers. It is a product of its own complex narrative techniques, inviting certain expectations within a historical context. Yet, *Vantage Point*'s complexity also delivers a political project that eludes the film makers and casual readers alike. In combination, its narration and its generic status problematize what might be expected of the film, but the narration also serves to problematize the film's apparent basic premises about witnessing, making them processes not just of storytelling but forms of geopolitical representation. *Vantage Point* demonstrates that the politics of narration and the politics of motivation do not necessarily coincide.

references

An Inside Perspective featurette. 2009. DVD extra. *Vantage Point.* Sony Pictures Home Entertainment.

Arendt, Paul. 2008. "Review of *Vantage Point*," March 8. www.bbc.co.uk/films/2008/03/03/vantage_point_2008_review.shtml.

Buckland, Warren. 2009a. "Introduction: Puzzle Plots." In *Puzzle Films: Complex Storytelling in Contemporary Cinema*, ed. Warren Buckland, 1–12. Oxford: Wiley-Blackwell.

Buckland, Warren (ed.). 2009b. *Puzzle Films: Complex Storytelling in Contemporary Cinema.* Oxford: Wiley-Blackwell.

Chang, Justin. 2008. "*Vantage Point.*" *Variety,* February 21. www.variety.com/review/VE1117936282/?refcatid=31&printerfriendly=true.

Cobley, Paul. 2010. "The Paranoid Style in Narrative: The Anxiety of Storytelling after 9/11." In *Intermediality and Storytelling*, ed. Marie-Laure Ryan and Marina Grishakova, 99–121. Berlin: de Gruyter.

Cobley, Paul. 2012. "The Reactionary Art of Murder." *Language and Literature* 21(3): 260–272.

Cobley, Paul. 2013. *Narrative*, second edition. London: Routledge.

Cobley, Paul and Nick Haeffner. 2011. "Narrative Supplements." In *New Narratives: Stories and Storytelling in the Digital Age*, ed. Ruth Page and Bronwen Thomas, 170–186. Lincoln: University of Nebraska Press.

Dargis, Manohla. 2008. "One Assassination Attempt, a Multitude of Perspectives." *New York Times,* February 22. http://movies.nytimes.com/2008/02/22/movies/22vant.html?_r=0.

Derrida, Jacques. 1984. *Margins of Philosophy*, trans. A. Bass. Hassocks: Harvester.

Doom and Malice. n.d. "*Vantage Point* Review." *The Daily Raider.* www.dailyraider.com/index.php?id=3328.

Editors of *Cahiers du cinéma.* 1972. "John Ford's *Young Mr. Lincoln.*" *Screen* 13: 5–44.

French, Philip. 2008. "*Vantage Point.*" *The Observer*, March: 9.

Gilchrist, Todd. 2008. "Pete Travis' *Rashomon* Retread Reads More Like a Less Funny *Groundhog Day.*" *IGN*, February 22. http://uk.ign.com/articles/2008/02/22/vantage-point-review.

Grierson, Tim. 2008. "*Vantage Point.*" *Screen Daily*, February 22. www.screendaily.com/vantage-point/4037398.article#.

Hall, Stuart and Paddy Whannel. 1964. *The Popular Arts: A Critical Guide to the Mass Media.* Boston: Beacon Press.

Howie, Luke. 2011. *Terror on the Screen: Witnesses and the Re-animation of 9/11 as Image-Event, Popular Culture and Pornography.* Washington, DC: New Academia Publishing.

Jameson, Richard T. n.d. "Review of *Vantage Point.*" Amazon.co.uk. www.amazon.co.uk/Vantage-Point-DVD-Dennis Quaid/dp/B0017LGEYM/ref=sr_1_1?s=dvd&ie=UTF8&qid=1359902125&sr=1-1.

Jeffries, Stuart. 2008. "I Struggle with Evil." *The Guardian,* March 6: 7.

Lotman, Juri. 1974. "The Sign Mechanism of Culture." *Semiotica* 12(4): 301–305.

Lotman, Juri. 1982. "The Text and the Structure of its Audience." *New Literary History* 14(1): 81–87.

Macherey, Pierre. 1978. *A Theory of Literary Production.* London: Routledge and Kegan Paul.

Mackie, Rob. 2008. "DVD Review: *Vantage Point.*" *The Guardian,* August 1. www.guardian.co.uk/film/2008/aug/01/dvdreviews.actionandadventure.

Plotting an Assassination featurette. 2009. DVD extra. *Vantage Point.* Sony Pictures Home Entertainment.

Ricoeur, Paul. 1970. *Freud and Philosophy,* trans. D. Savage. New Haven, CT: Yale University Press.

Robey, Tim. 2008. "Film Reviews: *Vantage Point, Four Minutes, Diary of the Dead* and More." *Daily Telegraph,* March 7: 18.

Total Film. 2008. "*Vantage Point.*" March 7. www.totalfilm.com/reviews/cinema/vantage-point.

Travers, Peter. 2008. "*Vantage Point.*" *Rolling Stone,* March 6. www.rollingstone.com/movies/reviews/vantage-point-20080306.

Travis, Pete. 2009. "Director's Commentary." DVD extra. *Vantage Point.* Sony Pictures Home Entertainment.

butterfly effects

upon a spectator

edward branigan

King Lear: "Pray you undo this button."
—*King Lear,* V, 3, 3498

illusions, seen and unseen

Films from the mid-1990s called 'mind-game' or 'puzzle' films work to forcefully highlight the connections among narration, interpretation, and moral stance. I will examine these connections by closely analyzing two films beginning with the issue of narration. Thomas Elsaesser argues that puzzle films

> set out to aggravate the crisis [in the spectator-screen relationship], in that the switches between epistemological assumptions, narrational habits, and ontological premises draw attention to themselves, or rather, to the "rules of the game." These rules . . . favor pattern recognition (over identification of individual incidents), and require cinematic images to be read as picture puzzles, data-archives,

or "rebus-pictures" (rather than as indexical, realistic representations).

<div align="right">(2009, 39)</div>

One of the methods that Elsaesser employs in analyzing the profound challenge these films pose to a spectator is based on an analogy with three types of enigmatic "picture puzzles" (2009, 40 n. 1).[1] Each derives from a type of perceptual illusion that I will rename and describe as follows:

1. 'camouflage' puzzles, which reveal something that was always there but hidden within a dense, conventional configuration (e.g., the hidden star illusion of Figure 13.1, *Donnie Darko* [2001], *A Perfect Getaway* [2009], *A Separation* [2011], and *The White Ribbon* [2009]);
2. 'flip' puzzles, which allow something new to stand out once a perceiver reverses and reorganizes certain elements of the background into the foreground or else mentally shifts elements of an ambiguous figure to make a new configuration (e.g., the duck-rabbit illusion of Figure 13.2 and *The Sixth Sense* [1999]); and
3. 'impossible' puzzles, which appear perfectly correct but whose largest perspectival representation proves impossible (e.g., M. C. Escher drawings, Figure 13.3, and *Lost Highway* [1997]). Also, presumably, this type includes puzzles in which the parts are impossible, but new possibilities emerge in the whole (e.g., with Gestalt-like principles, *La Moustache* [2005], *Post tenebras lux* [2012], *Inland Empire: A Woman in Trouble* [2006], and *Last Year at Marienbad* [1961]).

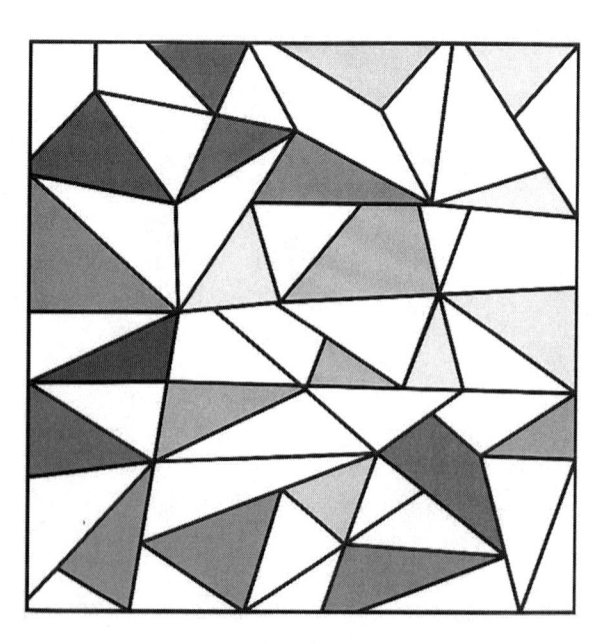

Figure 13.1 A camouflage puzzle, the hidden star illusion

Figure 13.2 A flip puzzle, the duck-rabbit illusion

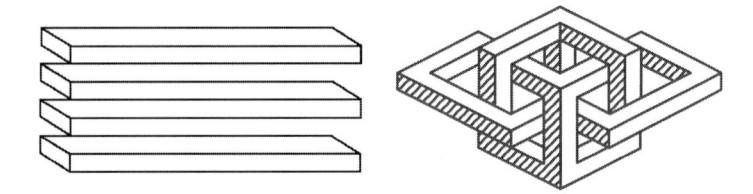

Figure 13.3 Two impossible object illusions

Analogues of these types of illusions may be pervasive during a viewing experience and may operate at various scales from the micro to the macro, from local short-term effects to larger scale narrative structures. As Elsaesser notes, puzzle films place a new priority on the recognition of *patterns*—seeing something this way and then that way. To solve interpretive problems, a spectator must struggle to fit together dispersed elements instead of relying merely on the directional arrow of cause-effect chains and trajectories of character development. Puzzle patterns have dynamic qualities since their parts typically appear across a series of shots or scenes, as Elsaesser suggests by mentioning "data-archives" and "rebus-pictures." Thus a spectator must integrate scattered elements in order to form an appropriate mental 'picture' (diagram, archive) that possesses an 'illusory feature.' Moreover, not all elements of the picture may be visible in the mise-en-scène, instead being heard on the soundtrack or intimated through editing or deployed as an aspect of narrative structure.

I wish to elaborate on the temporary illusions and troubles—perceptual and cognitive—that are generated as we interpret any film moment by moment. I will focus on the narration of *The Butterfly Effect* (Eric Bress and J. Mackye Gruber, 2004) and *The Sixth Sense* (M. Night Shyamalan, 1999) in order to show how a spectator makes meaning and formulates a moral stance by traveling in time—that is, by conceiving hypothetical time tracks through keeping in mind a small number of alternatives and possible

235

timelines—while recasting memories of what has already been seen utilizing an assortment of everyday psychological strategies. I will highlight the use of judgment heuristics and biases in managing one's evolving thoughts under the severe limitations of working memory.

Spoilers will abound in the following. It is particularly important that a reader of this essay has seen *The Sixth Sense,* because I will be arguing that a still deeper twist in the film depends crucially upon having experienced the film's spectacular ending on a first viewing, finally seeing the illusion of the entire film, the better to feel acutely the illusion still not seen.

interpretation as time travel: *the butterfly effect*

The Butterfly Effect fits the general strictures outlined by David Bordwell (2008a) for 'forking-path' or 'multiple-draft' films, and by Warren Buckland for 'slipstream fiction.'[2] It uses some of the conventions of the science fiction genre associated with time travel to tell a story in another genre just as *The Time Traveler's Wife* (2009) and *About Time* (2013) use time travel to further a domestic melodrama. *The Butterfly Effect* is essentially a college romance/domestic melodrama entwined with a crime story to form a series of typical Hollywood plots arranged as alternative timelines. Each plot is driven by a double causal strand of interactive romance/melodrama and crime where one causal line disguises its gaps while motivating action in the other.

Something about the fact of time fascinates us. The Internet Movie Database lists 1,300 time travel films and television episodes.[3] Is it that we embrace such films and their many close relatives[4] because we feel oppressed by, or ever-hopeful about, time? Time travel stories vividly put on display a basic method for interpreting texts and navigating our world—namely, the ability to assess *possibilities* for action in the form of branching networks of alternatives and to imagine fitting together multiple patterns (as with a Rubik's Cube). Surprise is also part of life, and with aesthetic texts we expect among alternatives the pleasantly bewildering unexpected. One can never quite tell about the future, which makes stories a telling experience.

The overall structure of *The Butterfly Effect* is diagrammed in Figures 13.4, 13.5, and 13.6. Figure 13.4 organizes thirty-five key story moments (comprising several shots or several scenes) into eight horizontal levels of reality that represent eight alternate timelines explored by the story. Numbers appearing in vertical columns represent variations on an event in the main timeline (A) caused by the protagonist Evan (Ashton Kutcher) traveling back in time to undo (redo) a past event. Each change, however, leads to unforeseen and disastrous effects in a 'new future,' necessitating further time traveling by Evan to make further changes to the past in order to set things aright. The epigraph of the film (1) explains that even small changes, like the flutter of a butterfly's wing, may lead to unforeseen effects, like a "typhoon halfway around the world."[5]

The notion of time travel involves irreconcilable contradictions, generally referred to as 'the temporal paradox.' An important question in telling such a story is where and how to hide the specific contradictions that will emerge given the premises of the story.[6] In the case of *The Butterfly Effect* these impossibilities arise most strongly in levels −1/2 and +1/2. The latter is anomalous in several different ways. Let us set aside messy problems—for example, the possibility that Evan's 'blackouts' on level A are *already the result* of his future time travels from other realities that have not yet occurred, a future perfect tense or a retroactive causality, or else the blackouts have simply caused themselves to spontaneously occur.[7] One can see that Evan's time travels by mind movements on the +1/2 level of 12, 14, and 24 (Or is 24 instead located on the B timeline?) do not result in any 'new futures.' Moreover, it is quite possible that 24 and 28 are identical to 7 and 5, and thus before Evan even suspected that he could time travel in A-14, he had already been time traveling from the alternate futures, C and D, into his original life in A!

In evaluating Evan's time travels, recall that only Evan's mind travels back into the body of his younger self living on the A level of time. Thus he does not 'live through' the newly fashioned timelines, only his mind becomes overstuffed with fresh memories of *having lived through* a newly formed 'future,' represented in the film through a very rapid montage sequence of the past of that new future (18, 23, 27, 31, 34) and represented in Figure 13.4 by a plot number within a circle. Evan's increasing accumulation of new memories exists alongside old memories. All of the memories remain available to help direct new changes to the past. Is there, then, a single Evan? How do his various bodies, memories, and environments make up an identity?

More troublesome on the +1/2 level are 20 and 28, which represent travels from timelines B and D to an earlier timeline, A, that has apparently been extinguished by previous changes that Evan's mind has made to the past. But maybe timeline A has not expired; maybe the other timelines have been superimposed on A with tunnels connecting to A. Which is to say that there may not be an essential, fixed timeline in a true matrix conception of events (cf. Figure 13.5)—that is, a privileged arrow of time (A) cannot exist amidst the other arrows. Couldn't one start anywhere in a true matrix and by time traveling reach or reconstruct any other time? What counts as the 'present' would be an arbitrary designation, dependent on the choice of a starting point. In this conception, time is no longer a river, but an area.

The −1/2 reality level is the most peculiar of the levels since Evan returns from reality level D to an event (6) that has been extinguished by a previous change (17) that resulted in reality level B. The new change/mishap (of 6/17 by 30) at level −1/2 has somehow managed to circle back to the *beginning* of the film (2/32) from where we no longer continue onward to level A

Figure 13.4 A diagram of thirty-five narrative moments distributed across the eight levels of reality associated with Evan, the protagonist of *The Butterfly Effect*

Reality Levels

-½	30						31	2 / 32	1 / 3
A	4	5	6	7	8	9	10	11 / 13 / 15	16
+½	20	28		24	14		12		
B	17						18	19 / 21	
C						22		23	25
D				26			27 / 29		
E	33						34		35
F	33						34		

Figure 13.5 A simplified version of Figure 13.4 showing only the distributed and parallel relationships of the thirty-five narrative moments in the form of a temporal database or matrix

as before (4 through 16, during which three titles had pointed toward the present at 11 as a reference point) but instead spiral onward to the end of the film in levels E (33–35) or F (33–34) according to the theatrical version or the director's cut. Both E and F are invoked through visits by Evan from level −1/2 to still earlier times on level A (33, 33). The film began in medias res (2), which concealed the fact that is now being disclosed (32) that Evan (at time 2) had come from the future (D) after having lived though previous timelines/lives (A, B, and C), and he now proposes (32) to return to very early times of his 'real' past, level A (33, 33), which is still somehow available for time traveling and mutation into a new timeline/life, E or F. All of this makes 30 a fairly bizarre turning point of the narrative as Evan has traveled to an event (6) that has already been changed (17, leading to life B) but manages to change it yet again (30) leading toward his fateful decision (32) and toward the climax of the film by jumping from level −1/2 to E or F.[8]

Figure 13.5 is a simplified version of Figure 13.4, showing only the thirty-five moments of the plot in order to better display the horizontal levels of reality along with the vertical parallels as particular events are repeated, and sometimes changed, in the course of Evan's time travels. Figure 13.6 is a branching line diagram of the relationships among the eight reality levels, where +1/2 is undefined and not diagrammed because it represents five simple 'visits' by Evan's adult mind to his younger body in A from A, B, and C that do not result in new lifelines (or possibly 7/24 is to lifetime B from C). For these five visits, there is no 'butterfly effect.'

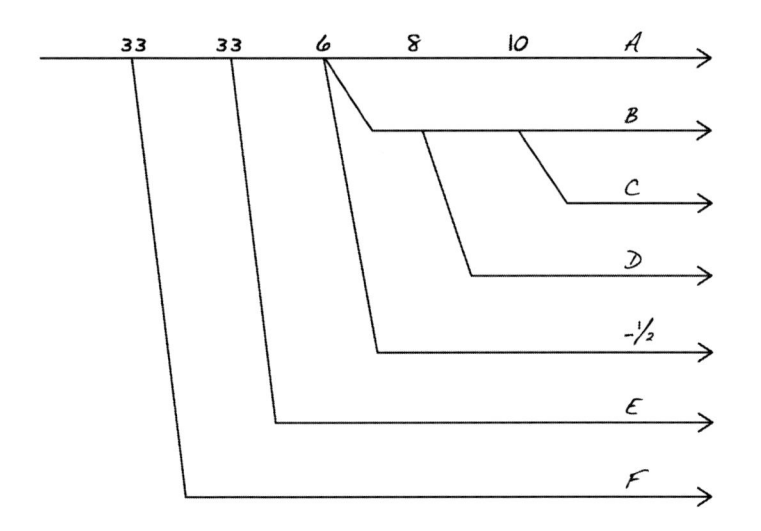

Figure 13.6 A branching line diagram showing the relationships among the eight levels of reality in *The Butterfly Effect*

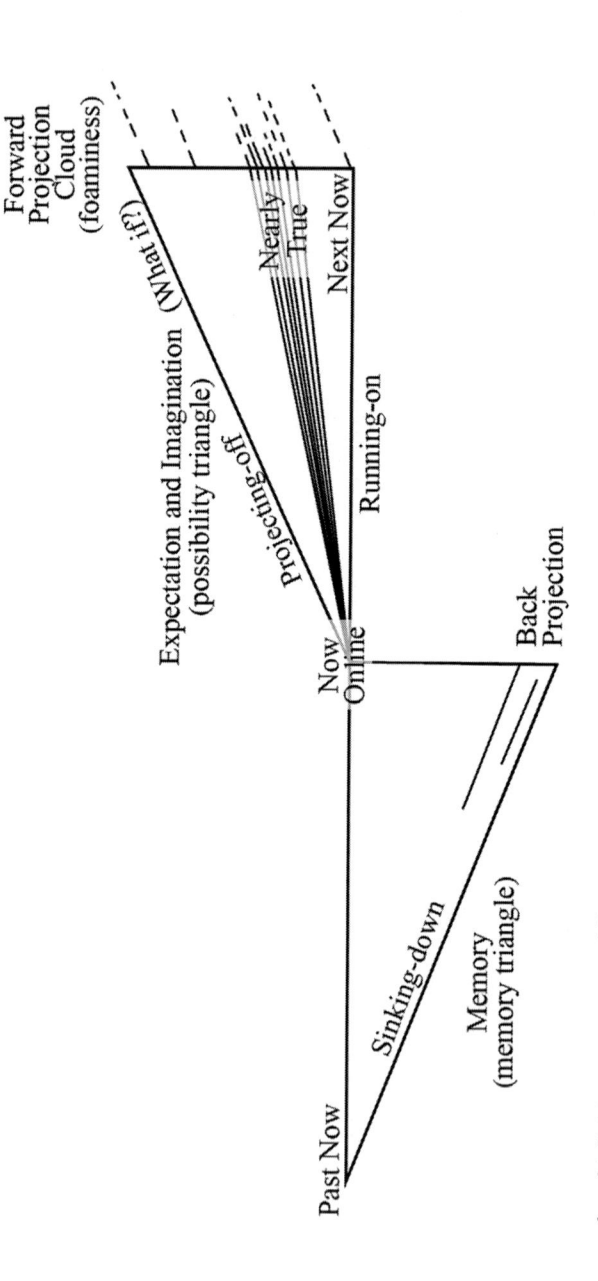

Figure 13.7 Temporal multiplicities at a moment of film viewing, including a set of possibilities that will become 'nearly true' (with apologies to Edmund Husserl, *On the Phenomenology of the Consciousness of Internal Time*). In the diagram, a series of "past now" points is shading off (*Abschattung*) by progressively sinking along diagonals down toward a triangle's base that connects vertically to the point "now online." The very smallest such triangle is formed by an impression immediately prior to "now online." From "now online," various points in the past are retrieved by projecting back along diagonals. A point further into the past generates a larger triangle. Possibilities for the future are imagined along forward diagonals. Further into the future generates a larger triangle.

moral stance

There are other interesting perplexities about the mechanics of *The Butterfly Effect,* but let us spend our (always scarce) time on the effect of the film upon a spectator's interpretive activity, which is anchored less by physics or imaginative physics and more by efforts to think and learn *about* ordinary life—to discover from a fiction a useful precipitate. Stanley Cavell reminds us that the knowledge we attain is "in its origin moral," given that it is "the precipitate of perceptual evaluations of the world, assessments of our interests and investments in it, of what counts for us, matters to us, or does not" (2010, 448; see also Cavell 2005; Levinson 1998).

Narrative is not disturbed by inconsistent or tangled premises, since its discursive activity owes little to deductive or inductive logic and much to familiar forms of abduction, routines, folk theories, norms, metaphors, presuppositions, models, and acquired schemata arising from a way of life. A spectator does not treat film as a scholarly treatise but, like Evan, mentally time travels to entertain possibilities and evaluate investments in the past, which, as Cavell notes, embody implicit commitments to moral values. Figure 13.7 is a diagram that is meant to be suggestive about a spectator's time travels at each conscious moment of 'now.' The process involves assimilating fragments of memory with hypotheses about the future—that is, thinking now about one's memory at a future time. The memory and possibility triangles in the diagram represent the fact that time is not linear for a spectator, but is a realm or, as in the triangles of Figure 13.7, an area.

The aim of narrative discourse is the materialization of a moral stance, a *point* that appears from a condensation of eventualities and *nearly true* possibilities. The point is usually most clearly stated at the end of a story during the phases of climax, dénouement, resolution, and epilogue. Nevertheless, the explicit endpoint needs to be read backwards through the text as a whole—in a retrospective act by a spectator—to weigh nuances and adjustments that might have to be made to the lesson of the ending.

narration as time travel (i)

The dimension of narrative discourse most intimately concerned with knowledge that encompasses a moral stance (Cavell above) is the *narration* of a story. Narration is a dynamic process that distributes and regulates our judgments about events and characters in a story world. It determines *how and when* a spectator is able to know what he or she comes to know at each moment, and indicates why this knowledge should be significant or interesting to possess.[9] Narration is a careful orchestration of secrets and lies. It comes from the future (= fate), since the end of a story is known by a narrator at the beginning and thus the telling of events must be precisely ordered with concealed details revealed piecemeal.

A spectator, however, travels through a text in the opposite direction, seeking to acquire the power to know embedded in acts of storytelling. For this reason, a spectator draws keen pleasure from those occasions when a time-traveling character exercises his or her power over a character unaware of the future and still living 'the past.' When we finally understand a story, we have internalized it and know how we ourselves *might narrate* the story. When it makes sense at last—keeping intact even some unrealized speculations—it is as if we had suddenly remembered having been there before and by our efforts of interpretation have merely been journeying 'back to the future.' There are, of course, many futures to be imagined in a story, many ways to imagine exerting one's power from the future, just as there are many spectators.

As evidence, let us briefly examine the narration of *The Butterfly Effect* and then consider how a spectator finds the story's moral stance within that narration to be finally so familiar. The most general narration in *The Butterfly Effect* is unrestricted, unseen, and unheard. It flaunts its power by providing an epigraph to guide interpretation of the film (1) and further exercises its authority to know by framing and organizing the scenes of Evan's original backstory (A, 4 through 16) by moving from 2/3 to an *objective* flashback showing 4. Superimposed titles are presented to mark the time: "thirteen years earlier," "six years later," and then "seven years later," until the present time has been reached again at 11. But we have not returned to 2/3. We believe it must be only a matter of time before we reach the doctor's office (2/3) in the present (11). The problem, however, is that time itself is the matter; new and different timelines have not yet been shown. Thus the three titles about chronology are misleading since what is being measured is not the previous thirteen years of Evan because at this point (2/3/32) he has actually come from a future timeline, D, which will not be shown in 4 through 16. Instead, unknown to the spectator, the thirteen years that are shown depict a timeline, A, that has long expired and been superseded. Nor is the Evan, "thirteen years earlier" that we next see at A-4, the same Evan who thirteen years later (at 11 through 16) has provoked the flashback (at 2). Rather, the Evan whom we have seen (at 2/3/32) has just finished living three quite different lives on the B, C, and D timelines.

Rather than continue to expand on the work of this powerful strata of narration throughout scenes of the film or consider how it prudently delegates storytelling from time to time to other (less knowledgeable) agents and characters (so as to better keep secrets), I will briefly examine a cunning instance of its exercise of power.

Scene 9 occurs at a movie theater. Near the end of the scene, Evan and Kayleigh, who are thirteen years old, engage in a significant conversation in the lobby of the theater, which comprises thirty-nine shots. All of the shots feature variations on a dominant color scheme of brilliant patches of glowing, wrinkled red (observe the walls) juxtaposed with a sickly lime and washed-out eggshell blue.[10] The scheme is disconcerting, its hues disconnected. The

identical color scheme recurs when the twenty-year-old Evan visits Kayleigh's (Amy Smart's) apartment when she has become a drug addict and prostitute (thirty shots in scene 25). The first scene occurs in Evan's lifetime A and the second in his lifetime C. Although direct causation is absent, the characters remain in the grip of a storyteller who is setting out patterns, here, using mise-en-scène as narration. If a spectator remembers at scene 25 the resemblance to the disturbing color scheme of 9, it can only be rationalized as an act of 'suppressed foreshadowing' of what will later befall—of what will have happened to—Kayleigh.[11] By feeling the noncausal connection lying within the pattern of plot lifelines, one begins to appreciate how events large and butterfly tiny (in A, B, and C)—events both notable and unnoticed—push one irresistibly toward a destiny (from A-9 to C-25). Despite chance and good intention, it is a destiny set by the storytelling that lies within a pattern of narration impossibly 'outside of story time.'[12]

The true willpower at work here is the narration acting behind, below, above, beside, and within a plot for the benefit of a spectator. Narration has many ways and means for scenes. What is reaffirmed impossibly across time (A-9 to C-25) is the efficacy of personal choice in determining Evan's character. A very old literary theme—character is fate—is reversed into fate is character. In the end, Evan will learn to sacrifice his love for Kayleigh, and hers for him, so he can ensure that she lives a full and beautiful life (35, F-34). Evan must hurt and reject her (E-33), or else in the director's cut, strangle himself in the womb before he can be born to love her (F-33). It all builds character, a fine, pure selfhood, no matter the many lessons and timelines necessary, and whether born or not.

Therefore at the very base of *The Butterfly Effect*'s moral stance is the free will of an individual to make moral choices that advance the ideals of a community (e.g., the ideal of true love, devotion to the One). This approach recalls the pragmatism of the philosopher William James and his stress on a conscious and caring "individuality" that "translates into a philosophical positive—a given of liberalism—a hold-out in freedom and the site of the personal and of 'full ideality'" (Lentricchia 1995, 445).

A different lesson awaits us with *The Sixth Sense*.

the sixth sense of a spectator

The end of *The Sixth Sense* is spectacular for a spectator. Dr. Malcolm Crowe (Bruce Willis) is revealed to have been dead for all of the scenes in the film, except the first, though he failed to realize that he was dead. Because Malcolm appears to interact with many different characters throughout the film, and the story apparently develops because of these interactions, a spectator never comes to suspect that he is dead and that only Cole (Haley Joel Osment) can see and talk with him. As mentioned earlier, the film is a 'flip' illusion. Except for the film's final moments, we believe Malcolm

to be alive—to have survived being shot in the first scene—and his wife's love for him apparently dead. At the end, it is suddenly reversed: Malcolm discovers he is a ghost and is dead, but his wife's love for him is proven undying. A spectator forgets that forgetting that one is dead is seemingly impossible within an already impossible puzzle of ghosts, seen and unseen.

I will argue that there is a still deeper illusion that outlasts the film's ending. Camouflaged within the 'flip' and 'impossible' puzzles is a story of a mother's systematic abuse of her child, Cole. Or, rather, Cole himself is a ghost created by Malcolm's mind as he lies dying on his bed at the conclusion of the opening scene. Cole is merely a stand-in interlocutor to help Malcolm as he tries to understand the motive of the killer, Vincent Grey,[13] who had come back as an adult to kill Malcolm, the doctor who had treated Vincent as an abused child when he was the same age as Cole. In effect, like Evan, Malcolm time travels to fix his past. Malcolm is desperate to understand his mistaken diagnosis of Vincent and to undo the damage that he has caused Vincent by (this time) healing Cole/Vincent. Among the many similarities between Cole and Vincent is that both have the same nickname, Freak. Malcolm confesses to his wife: "They're both so similar. Same mannerisms, same expressions, same things hanging over their head. I think it might be some kind of abuse."

Unlike *The Butterfly Effect*, which also has a double causal plot strand of romance and crime, Malcolm is only able to solve the romance problem. Since he fails to discover the *motive* of his killer, who has committed suicide, he again fails to help an abused child, Cole. The alive-dead-alive-but-dying twist at the end of *The Sixth Sense* puts the film in a class with Ambrose Bierce's famous short story "An Occurrence at Owl Creek Bridge," William Golding's novel *Pincher Martin,* and the films *Jacob's Ladder* (1990) and, arguably, *Point Blank* (1967). Since Malcolm never finds the answer to his killing, he cannot become an all-knowing 'dead narrator,' as in *Sunset Boulevard* (1950) and *American Beauty* (1999), nor become a benevolent meddler, as in *Ghost.*

Overall, the narration of *The Sixth Sense* aims for the knife-edge balance of Henry James's novella *The Turn of the Screw,* which poses the question of who is abusing two children—their governess, who is narrating the story, or the ghosts of two former members of the household. It may be that the governess herself is haunted, and not by ghosts, so that the story she tells speaks only of herself. In *The Sixth Sense* I believe that another storyteller, the nine-year-old Cole (Vincent), is haunted by a secret that he cannot name, that he has no language for, a thing so inconceivable that it can find no expression other than through fictions, fantasies, and nightmares. For Cole/Vincent, the haunting is not by ghosts but by the living, just as there was never a ghost at work but only the living in *Vertigo* (1958) and *Don't Look Now* (1973). In the latter film the continuing traumatic memory of a daughter's death combined with profound feelings of guilt eventually return with a vengeance to the parents. Similarly, Cole/Vincent Grey, whose father had

left the family, will return to his surrogate father, Malcolm, with a vengeance due to Malcolm's failure to diagnose the abuse and protect him from it. It is, in effect, Cole/Vincent who kills Malcolm.

Unless a spectator is inclined to believe in the real presence of ghosts, then the 'nearly true'[14] story of the plot combines with the film's story of the real and chronic problem of child abuse in our world to be the true subject of *The Sixth Sense*. A story of abuse appears in the interstices of the plot as a concealed and suppressed, but existent, timeline not unlike a possible world of *The Butterfly Effect*. The horror is, in fact, all in the family in this unusually dark family film from the Walt Disney Company. Cole/Vincent is being systematically brutalized by a psychotic mother, Lynn Sear (Toni Collette), who is suffering acute dissociation in which her personality is split into parts that do not recognize each other as in *Fight Club* (1999). It is Lynn who sees, and is haunted by, ghosts. We watch close up as she studies three photographs of Cole and finds therein the presence of 'ghosts.' The only other person seen with Cole in these three photographs is his loving mother dressed in red.

Notice at the same time the four close-up shots of Lynn's sharp red fingernails and recall the scratches on Cole's wrist and back. (More below on the color red.) Malcolm readily admits that the scratches on Cole may be "fingernail cuts." The theme of abuse puts *The Sixth Sense* in the company of such films as *The Butterfly Effect* (Evan, Kayleigh, and Tommy are abused when they are seven; Cole/Vincent is abused at nearly the same age), *In a Lonely Place* (1950), and *What's Love Got to Do with It?* (1993), as well as the many remakes and variations of *Dr. Jekyll and Mr. Hyde*, Guy de Maupassant's short story *Le Horla*, and perhaps also is reminiscent of the character Norman in *Psycho* (1960, 1998) and in the television series *Bates Motel*. In *The Shining* (1980), Jack Nicholson's young son has bruises on his neck and, like Cole, sees dead people. For these films, abuse is the enigmatic blind spot of narration.

narration as time travel (ii)

A spectator labors to master a stream of story information coming from the future (= narration) so as to be able to narrate the story from his or her memory as the story proceeds scene by scene (= comprehension), including the impact of what he or she imagines as nearly occurring—that is, what is imagined to be lying alongside or adjacent to the lines of the plot. I believe Figures 13.1, 13.2, and 13.3—depicting perceptual concealments and reversals, strange gaps and knots—serve well as visual metaphors for the obstacles encountered by a spectator's interpretive activities, which are heightened and exacerbated by mind-game films. To keep its secrets, *The Sixth Sense* must be meticulous about its staging, editing, and dialogue. No less must the film be painstaking about organizing and hiding its levels of narration. Figure 13.8 is a diagram of one possible set of levels and phases of narration that work to produce and camouflage the visualizations of *The Sixth Sense*.

Vincent Grey, ten years old ← his Mother

↓

Audio tape of Vincent recorded by Malcolm during Vincent's treatment (cf.
Vincent's stories with Freud's notions of "displacement" and
↓ "secondary elaboration")

Malcolm remembers listening to the audio tape – heard also by the spectator of
the film – in his basement (as he lies dying)
↓

Malcolm *visualizing*, filling out Vincent's *words* on the audio tape (as he lies
dying)
↓

Malcolm projects the nine-year-old "Cole" as a stand-in for Vincent (as he lies
dying): Malcolm must project "Cole" because, though he believes
the man who shot him might be Vincent, he does not know
Vincent's motive and wishes to "relive" Vincent's case to
↓ understand his mistaken diagnosis and thereby to undo the past by
at least accepting responsibility and by now "helping"
Cole/Vincent

Malcolm re-examines/re-lives the particulars of Vincent's case through "Cole" (as
he lies dying)
↓

Malcolm solves the problem about whether his wife truly loves him

↓

Malcolm fails to solve the problem of the motive of his killer, i.e., he again leaves
"Cole" to his fate as he had left Vincent to his fate
↓

Malcolm, shown lying on his bed, dies (?) happily at peace, saying to his wife:
"Goodnight, sweetheart"

Figure 13.8 Levels and phases of narration in *The Sixth Sense*

diagnostic evidence

There can be no question of analyzing every scene in *The Sixth Sense* or discussing the film's many fascinating equivocal images. I will instead list four key indications of the film's latent strata in order of appearance.

1. There are many reasons we do not pay proper attention to the intruder, Vincent Grey, in the first scene, who is wearing only underwear in Malcolm's bathroom. Listen to what he *says*.
2. Like the three titles discussed above that purportedly specify time in *The Butterfly Effect* (on level A), there are troubles with time in *The Sixth Sense*. The second scene opens with the titles "The Next Fall" and "South Philadelphia." They suggest a long recovery time for Malcolm from his gunshot wound. Our default assumption for the titles

is to interpret them as indicating an objective time and place, not as a focalization of narrative time through a dying character. Other examples of suppressed focalizations include *Shutter Island* (2010), *Fight Club, Proof* (1991), *Angel Heart* (1987), *Under Suspicion* (1991), and the title of the film *All Is Lost* (2013). One may wonder in this second scene who would have assigned Cole to Malcolm and have provided handwritten notes on Cole's and Vincent's cases. At this point in the story, as Malcolm is reading Cole's case, he has yet to meet Cole. As a ghost Malcolm can't touch things, interact with persons, or receive case notes. Moreover, Malcolm apparently hasn't noticed that he no longer needs a bathroom; nor has he noticed that for some reason he is unable to open the basement door (seen four times) when he goes to the basement to listen to the audiotapes. However, he is able, paradoxically, to make handwritten notes with a pen, change clothes, and presumably break a window. Though we do not conceive of Malcolm being a ghost in mind only, coherent psychologically, we are willing retrospectively to treat him as an actual ghost, impossible physically.

3. Did Cole steal Grandma's bumblebee pendant? In the dinner table scene in the kitchen, pay attention to Cole's face, and (try to) forget how he acted at the beginning of the scene when he threw a shoe at the television. It is cold in the room, the time supposedly of ghosts. Cole's mother, Lynn, demands that Cole take off the gloves that are keeping his hands warm. She is seen fiddling with the thermostat at the beginning of this scene as well as in an earlier scene. (Does a cold house attract ghosts, or do ghosts make a house cold? Or neither?) We tend not to forget Cole's angry actions at the beginning of the scene, but we do tend to forget that the dialogue in the scene begins with the mother's anger building toward rage as she orders Cole from the table without having had his dinner. We seem not to see Cole's increasing anxiety and fear of her as he puts his hands to his face. He is similarly *afraid* of his mother in two earlier scenes in the kitchen. In one of these scenes, the horrible ghost woman in the kitchen resembles Lynn from behind—and Cole calls her Mama—except when she spins around, and we see how *he* (figuratively) sees her.

Cole is sent to bed without dinner. The focus shifts to Cole's bedroom and the actions of the family dog. We must suddenly reorient ourselves. Is the dog, like Cole, able to see ghosts or at least sense their presence? How long is the corridor to Cole's bedroom empty? From what directions do the dog and ghost come? Do we experience two successive shocks about the ghost? Why won't the dog emerge from the closet while looking at Lynn?

I think of this and other scenes in the film as based on a principle of 'fractured proximity' or 'disconnected continuity'—that is, where a series of actions are presented as discontinuous in space and/

or time but are nonetheless interpreted as *emotionally* proximate so as to warrant seeing the pieces as a unified event despite causal disconnections.[15] The narrative pattern is as follows:

> orientation—predispositions confirmed—initiating event [interruption—disordered actions—disorientation— anger/fear/shock/disgust—an emotional image of the event is formed] renormalization—confirmation— press forward—the previous emotional image/mood lingers [interruption— . . .

4. The ghost girl's (Kyra's) story about being poisoned by her mother, who is now also poisoning her younger sister, is a direct parallel to the abuse suffered by Cole/Vincent at the hands of his mother. A pattern emerges in the stories of Kyra, her sister, Cole, and Vincent. Another pattern: The ghost girl's mother at the girl's funeral is inexplicably dressed completely in red with bright red lipstick and is standing next to a pair of vases of red roses. Cole's mother also dresses in red, and the next time we see her, she's wearing red-orange.[16] Dr. Hill (M. Night Shyamalan) is the only character in the film to suspect Lynn of abuse. He is not believed by a spectator because of the disparaging reaction of Malcolm and the niceties of Lynn, and because Dr. Hill is a foreigner—and a man with dark skin.

judgment heuristics and cognitive illusions

The Butterfly Effect is nominally about 'butterfly effects.' However, it is *The Sixth Sense* that truly submits its spectator to 'butterfly effects.' A great many tiny moments in *The Sixth Sense* are apparently of no consequence other than to activate rapid and familiar inferences, thus remaining invisible, except on second and third reflection after the end of the film—when renarrating the story to oneself. The spectator comes to realize how enormous successions of small mistakes in judgments lead to fundamental miscalculations.

Filmmakers are intuitive psychologists and philosophers, and conduct tests on their willing subjects with thought-experiment films. How are stories told and interest maintained? Filmmakers construct important aspects of their stories by drawing on the procedures and biases used for everyday reasoning, which amount to a spectator's sixth sense. The Appendix describes five common judgment heuristics and six cognitive illusions that are well-established in the psychological literature and prominent in practical reasoning. The Appendix also includes a detailed illustration of these interpretive strategies applied in *The Sixth Sense* toward designing a key mistaken idea for a spectator. Heuristic strategies are especially valuable to a spectator because judgments often must be made quickly under uncertainty while watching a fast-moving film narrative. These eleven procedures collectively help define

the cognitive and emotional images we form in response to images and sounds on screen that misdirect and hold secrets.

nearly true, after all

The Sixth Sense does not reveal its deepest twist at the end. The perpetrator of Cole/Vincent's injuries remains unknown. Should a spectator's interpretation end with the end, or begin at the end? While the target of a plot is a story (and the target of a story is a moral stance), it does not follow that a spectator's reconstruction of the events of a story is the end of interpretation or that finding only one story is a desirable end. I am not asserting that interpretations of a film are limitless—infinity is a much greater number than many scholars in the humanities realize, indeed infinitely greater. Nevertheless, it seems to me that what is *nearly* true of a film or what *would be* true of a film under certain new kinds of descriptions is a potentially valuable, and perfectly exact, way to think about a film.

What is realized in any narrative depends upon at least some important events that are *un*realized; likewise, the telling of a narrative depends upon at least some forms of narration that are near relatives of the devices employed. Part of the point of narrative is for a spectator to weigh and take seriously some of what is unrealized—that is, true on other occasions. Moreover, these altered/ulterior/alternative meanings, failed stories, and possible timelines for a film may become explicit in fragmentary and intermittent stories generated on the small scales of scene, gesture, phrase, metaphor, and character thought. Does the ending of a film cancel all of a spectator's speculations about a plot's causal matrix? One of the purposes of narrative reasoning is to demonstrate how certain effects that are desired may be achieved, how desire is linked to possibilities for being, and how events might and might not proceed.

ghosts

The ghosts are a metaphor but for what? My approach to *The Sixth Sense* has been to treat it as a story *about* human experience—a story that seeks to narrativize human experience. This film and films in general represent ways of thinking about and being in a world. Earlier we found at the base of *The Butterfly Effect*'s moral stance a notion of the purity of Selfhood, the ability to make free moral choices. For the philosopher Michel Foucault, however, the Self is subject to institutions and history, to the condition of larger systems. Thus the being of a self reflects also a normalized and institutionalized way of life, one complete with a system's contradictions and ghosts. Consequently, for Foucault

> undisciplined and anarchic individuality may be precisely
> the unintended effect of a system which would produce

individuality as an object of its knowledge and power (the disciplinary appropriation of biography), but which instead, and ironically, inside its safe, normalized subject, instigates the move to the underground where a deviant selfhood may nurture sullen schemes of resistance to a world in which paranoia is reason, not madness.

(Lentricchia 1995, 445)

This is the final reversal wrought by *The Sixth Sense:* the ghosts that haunt and drive Cole's mother from underground are traces of larger systems applying relentless pressure to a single mother. The madness that grips Cole's mother does not emerge from a vacuum. Signs of cultural and economic stress for a family lie within the fabric of the film.

More generally, ghosts literal and tacit are signs created by puzzle films to question certainties of self or system. Puzzle films strive to undo tight lines of thought in their own plots in order to open toward real world networks of crisscrossing not, and, or, may be.

notes

This essay is based on conference talks and lectures on *The Sixth Sense* presented since October 2000. I owe thanks for their sixth sense about film to Warren Buckland, Jeff Scheible, Philipp Schmerheim, and especially Melinda Szaloky. Thanks also to designer Lisa Hill for Figures 13.4, 13.5, 13.6, and 13.7.

1. Examples of the illusions are mine. Other types of illusions beyond these three types may also be relevant to puzzle films. See generally *Scientific American Mind* 2013.
2. On slipstream fiction, see the Introduction to the present volume. On forking-path films, see Branigan 2002; Schmerheim 2013; Schmerheim 2008; Abbott 2013. For a mapping of part of the area, see Berg 2006.
3. See www.imdb.com/keyword/time-travel/ (accessed October 12, 2013).
4. A few of the nearest puzzle film relatives to time travel films are as follows: *eXistenZ* (1999), *Run Lola Run* (1998), *Blind Chance* (1987), *Sliding Doors* (1998), *Groundhog Day* (1993), *Source Code* (2011) ('time reassignment'), *Haunter* (2013), *Edge of Tomorrow* (2014), *50 First Dates* (2004) (this and the previous four films involve time loops, familiar from videogame structure), *Melinda and Melinda* (2004), *The Double Life of Veronique* (1991), *Syndromes and a Century* (2006), *The Day He Arrives* (2011), *Certified Copy* (2010), *Sex and Lucia* (2001), *Lovers of the Arctic Circle* (1998), *Sauve qui peut (la vie)* (1980). The latter six films suggest the close connections among time travel, 'database' aesthetics, and 'network' narratives. In these larger frameworks, Evan's time travels in *The Butterfly Effect* can be seen as inventing a network (or exploring a database) of ever-new sets of links among himself (his selves) and the latent possible states of his friends, which abruptly become manifest. In *Palindromes* (2004), the plot remains singular, but the main character is played as a networked series of eight alternatives by eight very different actors; six different actors in *I'm Not There* (2007). In *Being John Malkovich* (1999), different characters travel to become one with the mind of the main character, John Malkovich. A

database aesthetic is based on experimental orderings and recombinations from a limited inventory of narrative elements, as in Bordwell's "multiple-draft" narratives (2008a). *Inception* is unusual in that characters leap from one database/matrix to another. *Je t'aime je t'aime* (Resnais, 1968) portrays the disorder possible in a temporal database. On network narratives, see Bordwell 2008b. Bordwell lists about 150 films since 1990 using the network principle.

It is also a short step from Evan's mental, but not bodily, time travels in *The Butterfly Effect* to such films of the creative process at work through unconscious corridors of time as *Providence* (1977), *Stranger Than Fiction* (2006), *Adaptation* (2002), and *Eternal Sunshine of the Spotless Mind* (2004). On the 'memory anxiety' variant of puzzle films, see note 9 below. For William Brown some of these sorts of puzzle films exemplify the radically new temporal logic of 'digital cinema' (2013, 115–122, passim). Derivatives of *The Butterfly Effect* include *The Butterfly Effect 2* (2006) and *The Butterfly Effect 3: Revelations* (2009).

5. The 'butterfly effect' of the epigraph (1 in Figure 13.4) is mostly misdirection. The film is principally about possible worlds, personal responsibility, and guilt. It is not just that Evan and his friends suffer the repercussions of his well-intentioned attempts to repair the past, but that his friends *fault* him for acts whose consequences he should have known.

6. The significance and value of a narrative fictional text does not necessarily fail because of irreconcilable contradictions in the plot. To feel acutely certain delicious paradoxes of time travel, watch the film *Primer* (2004) and then read Jason Gendler (2006), available through open access at www.nobleworld.biz/images/Gendler.pdf (accessed October 12, 2013). *Timecrimes* (2007) and *12 Monkeys* (1995) conceal the same paradox as *Primer* but with clever manipulations that keep at least the surfaces of the films mostly smooth. Here we are also not far from the many films that explore doppelgängers, doubles, twins, clones, and identity mutations (as in *Martha Marcy May Marlene*) (2011).

7. On difficult plot problems in *The Butterfly Effect*, see www.imdb.com/title/tt0289879/faq?ref_=tt_faq_sm (accessed October 12, 2013).

8. Two additional alternative endings to *The Butterfly Effect*—let's imagine adding reality levels G and H to Figures 13.4, 13.5, and 13.6—may be found on the DVD of the director's cut.

9. As Elsaesser states in the first paragraph of the text above, many mind-game films attack a spectator's epistemological assumptions by crafting unidentified, irregular, or unreliable narrations controlling the flow of textual knowledge. Since 'knowledge' is scarcely different than memory—a fact recognized by Socrates in Plato's *Theaetetus*—a major type of mind-game film deals with the narration of aberrant states of character memory, including, of course, both *The Butterfly Effect* and *The Sixth Sense* (whether one imagines Malcolm as a forgetful ghost or as trying to remember the motive of his killer while dying). A few mind-game films involving memory trauma: *Blade Runner* (1982), *Total Recall* (1990, 2012), *Open Your Eyes (Abre los ojos)* (1997), *Vanilla Sky* (2001), *Dark City* (1998), *Donnie Darko*, *Fight Club*, *Shattered Image* (1998), *Julia and Julia* (1987), *The Double Hour* (2009), *Mulholland Dr.* (2001), *Inception* (Cobb, Fischer), *The Element of Crime* (Fisher, 1984), *Memento* (2000), *A Beautiful Mind* (2001). See, for example, Hesselberth and Schuster (2008), available through open access at www.oapen.org/search?identifier=340042 (accessed October 12, 2013) and Poulaki (2011) (the film being analyzed, *The Final Cut* [2004], posits the idea of 'rememories').

251

Memory anxiety mind-game films exploit the general fact that no intrinsic feature of an 'image' can distinguish a memory image from an imagined image or any other kind of image. One must rely on narration to supply an appropriate 'context' for the image. But in mind-game films the context may itself require a context, and that context another context, and so on, hence, 'skepticism films,' for which see Schmerheim 2013. Specifically, in *The Sixth Sense,* which contexts should be assumed to define the focalizations of Malcolm and Cole?

The near identity of 'knowledge' and 'memory' points to the enormous importance of the *representativeness* and *availability* heuristics (see Appendix), which are employed in daily life almost without thought, especially in situations of high memory load (Fiske and Taylor 2013, 183)—for example, when watching a film. On judgment heuristics, see Kahneman 2011. Moreover, different forms of memory lead to different sorts of temporal experiences. Kay Young points to two different forms of attention that may yield different temporal experiences in forking-path narratives (2002).

The connections among knowledge, memory, and narration have crucial implications for media theories since in its architecture, processes, and contents a media object functions as artificial memory (see Branigan 2014). Rather than 'home is where the heart is,' perhaps one should say that 'home is where memory is.'

10. The scene in the lobby of the movie theater (scene 9, Figure 13.4) and the one in Kayleigh's apartment (25) are the most striking in the film using the glowing blistered red, sickly lime, and faint blue, though a few other scenes use variations on these colors. My comments on the psychological effect of color in the present essay are shorthand for a color theory based on intersubjective language games.

11. 'Suppressed foreshadowing' is a relatively common device in classical narrative to promote unity. It can be analyzed in several ways and intersects other sorts of narrations. It may be termed an *implicit extra-fictional narration,* which theorists often personify as 'the implied author.' Temporally, it may be thought of as a 'retrospective, nonsubjective flashforward' or as 'hyperdiegetic narration.' It is retrospective because the key feature of this implied authorial narration can only be recognized at a later time. Another example is as follows: for a time it appears that Evan is confined to a wheelchair (C-23), but eventually we see that he is simply being playful. However, in the next lifetime (D-27), he is an amputee and confined to a wheelchair. On the intricacies of suppressed foreshadowing, see Branigan 1992, 42, 90–91, 189–190, chap. 1 n. 60, chap. 4 n. 32, chap. 6 n. 53.

Another benefit of promoting a unified beginning, middle, and end through a tactical use of diffuse and suppressed gaps by an implied authorial narration is that at the end of the story the reader will blame himself or herself for not understanding sooner, rather than blame the storytelling for its duplicity. Roland Barthes asserts that narrative discourse always "is trying to lie *as little as possible:* just what is required to ensure the interests of reading, that is, its own survival. Caught up in a civilization of enigma, truth, and decipherment, the discourse reinvents on its own level the moral terms elaborated by that civilization: there is a casuistry of discourse" (1974, sect. LX, 141, original emphases). No doubt Barthes has in mind the double meaning of 'casuistry' (*la casuistique*), which points both toward elucidating moral duties and principles as well as toward specious

arguments and rationalizations. Again, we find knowledge, memory, narration, interpretation, and moral value entangled.

12. Todd McGowan argues that impossibilities linked to Evan's traumas and time travels are best described through Freud's concept of retrospective time, "deferred revision/action" (2011). Compare note 11 above. A distinctive feature of human thought is projective imagination or what Endel Tulving describes as "mental time travel" (1993, 67). An example of time travel in a film without traveling in time: *Before Midnight*. See also Branigan 2014.

13. The end titles of *The Sixth Sense* misspell Vincent's name as Gray, instead of Grey.

14. On the 'nearly true' of stories, see Branigan 2002 and note 2 above.

15. Daniel Barratt examines narrative comprehension within a framework of emotional arousal, which places an "emotional load" (2009, 67, 73, 81) upon a spectator's processing resources in working memory. I would add that the five explicit resolutions to the plot (69) places an "informational" overload (67) on a spectator's narrative comprehension, which serves to obscure the fact that Vincent Grey's motive for killing Malcolm is neither resolved nor connected to the plot about Cole's abuse. See also Lavik 2006. On "hot" cognition and mood-congruent judgment, see generally Kunda 1999, 211–263.

 It would be well to keep in mind that what is at stake in watching a film is a perceiver's *dynamic* memory span, which is two or three, not the seven items, plus or minus two, which is the capacity of static short-term memory. Bordwell emphasizes the numbers two and three (2008a). In *The Butterfly Effect* Evan has three basic alternate lives (B, C, D). In *The Sixth Sense* Malcolm has two sorts of lives (alive and dead or else, dying and reconstructed past).

16. Writer-director Shyamalan offers his views about the secrets of *The Sixth Sense* and the color red on the DVD and in an appendix to Peter Lerangis's clever novelization of the film (2000). The appearance of red herrings in a plot is literalized and taken to excess in *The Sixth Sense* as many of the appearances of red serve to distract from those occasions when red points to a truth.

references

Abbott, H. Porter. 2013. *Real Mysteries: Narrative and the Unknowable*. Columbus: Ohio State University Press.

Barratt, Daniel. 2009. "'Twist Blindness': The Role of Primacy, Priming, Schemas, and Reconstructive Memory in a First-Time Viewing of *The Sixth Sense*." In *Puzzle Films: Complex Storytelling in Contemporary Cinema*, ed. Warren Buckland, 62–86. Oxford: Wiley-Blackwell.

Barthes, Roland. 1974. *S/Z*, trans. Richard Miller. New York: Hill and Wang.

Barthes, Roland. 1977. "Introduction to the Structural Analysis of Narratives." In *Image—Music—Text*, trans. Stephen Heath, 79–124. New York: Hill & Wang.

Berg, Charles Ramírez. 2006. "A Taxonomy of Alternative Plots in Recent Films: Classifying the 'Tarantino Effect.'" *Film Criticism* 31(1–2): 5–61 (special issue on complex narratives).

Bordwell, David. 1989a. "Schemata and Heuristics." In *Making Meaning: Inference and Rhetoric in the Interpretation of Cinema*, 129–145. Cambridge, MA: Harvard University Press.

Bordwell, David. 1989b. "Text Schemata." In *Making Meaning: Inference and Rhetoric in the Interpretation of Cinema*, 169–204. Cambridge, MA: Harvard University Press.

Bordwell, David. 2008a. "Film Futures." In *Poetics of Cinema*, 171–187. New York and London: Routledge.

Bordwell, David. 2008b. "Mutual Friends and Chronologies of Chance." In *Poetics of Cinema*, 189–250. New York and London: Routledge.

Branigan, Edward. 1992. *Narrative Comprehension and Film*. London and New York: Routledge.

Branigan, Edward. 2002. "Nearly True: Forking Plots, Forking Interpretations— A Response to David Bordwell's 'Film Futures.'" *SubStance* #97 31(1): 105–114.

Branigan, Edward. 2014. "If-Then-Else: Memory and the Path Not Taken." In *Transmedia Frictions: The Digital, the Arts, and the Humanities*, ed. Marsha Kinder and Tara McPherson. Berkeley: University of California Press.

Brown, William. 2013. *Supercinema: Film-Philosophy for the Digital Age*. New York: Berghahn.

Cavell, Stanley. 2005. "Moral Reasoning: Teaching from the Core." In *Cavell on Film*, ed. William Rothman, 349–359. Albany: State University of New York Press.

Cavell, Stanley. 2010. *Little Did I Know: Excerpts from Memory*. Stanford: Stanford University Press.

Eisenstein, Sergei. 1988. "The Dramaturgy of Film Form (The Dialectical Approach to Film Form)." In *S. M. Eisenstein: Selected Works, Vol. 1 Writings, 1922–34*, ed. and trans. Richard Taylor, 161–180. Indianapolis: Indiana University Press.

Elsaesser, Thomas. 2009. "The Mind-Game Film." In *Puzzle Films: Complex Storytelling in Contemporary Cinema*, ed. Warren Buckland, 13–41. Oxford: Wiley-Blackwell.

Elsaesser, Thomas and Warren Buckland. 2002. "*Mise-en-scène* Criticism and Statistical Style Analysis (*The English Patient*)." In *Studying Contemporary American Film: A Guide to Movie Analysis*, 80–116. London: Arnold.

Fiske, Susan T. and Shelley E. Taylor. 2013. *Social Cognition: From Brains to Culture*, second ed. Los Angeles: Sage Publications.

Gendler, Jason. 2006. "*Primer*: The Perils and Paradoxes of Restricted Time Travel Narration." *Nebula* 3(4): 142–160.

Hesselberth, Pepita and Laura Schuster. 2008. "Into the Mind and Out to the World: Memory Anxiety in the Mind-Game Film." In *Mind the Screen: Media Concepts According to Thomas Elsaesser*, ed. Jaap Kooijman, Patricia Pisters, and Wanda Strauven, 96–111. Amsterdam: Amsterdam University Press.

Kahneman, Daniel. 2011. *Thinking, Fast and Slow*. New York: Farrar, Straus and Giroux.

Kunda, Ziva. 1999. *Social Cognition: Making Sense of People*. Cambridge, MA: MIT Press.

Lakoff, George and Mark Johnson. 2003. "Closeness Is Strength of Effect." In *Metaphors We Live By*, 128–132. Chicago: University of Chicago Press.

Lavik, Erlend. 2006. "Narrative Structure in *The Sixth Sense*: A New Twist in 'Twist Movies'?" *The Velvet Light Trap* 58: 55–64.

Lentricchia, Frank. 1995. "In Place of an Afterword—Someone Reading." In *Critical Terms for Literary Study*, second ed., ed. Frank Lentricchia and Thomas McLaughlin, 429–446. Chicago: University of Chicago Press.

Lerangis, Peter. 2000. *M. Night Shyamalan's The Sixth Sense, A Novelization*. New York: Scholastic.

Levinson, Jerrold (ed.). 1998. *Aesthetics and Ethics: Essays at the Intersection.* Cambridge: Cambridge University Press.

McGowan, Todd. 2011. "Not the Worst of All Possible Worlds: Sacrificing the Object in *Butterfly Effect.*" In *Out of Time: Desire in Atemporal Cinema,* 59–81. Minneapolis: University of Minnesota Press.

Poulaki, Maria. 2011. "Implanted Time: *The Final Cut* and the Reflexive Loops of Complex Narratives." *New Review of Film and Television Studies* 9(4): 415–434.

Schmerheim, Philipp. 2008. "Paradigmatic Forking-Path Films: Intersections between Mind-Game Films and Multiple-Draft Narratives." In *Erzählen: Reflexionen im Zeitalter der Digitalisierung/Storytelling: Reflections in the Age of Digitalization,* ed. Yvonne Gächter, Heike Ortner, et al., 256–270. Innsbruck: Innsbruck University Press.

Schmerheim, Philipp. 2013. "Skepticism Films as Complex Narratives." In *Skepticism Films: Knowing and Doubting the World in Contemporary Cinema,* unpub. ms., 179–189. Amsterdam: University of Amsterdam.

Scientific American Mind 22(3). 2013. Special issue on "Illusions: 187 Ways to Trick Your Brain."

Tulving, Endel. 1993 "What Is Episodic Memory?" *Current Directions in Psychological Science* 2(3): 67–70.

Young, Kay. 2002. "'That Fabric of Times': A Response to David Bordwell's 'Film Futures.'" *SubStance* #97 31(1): 115–118.

appendix

practical reasoning in *the sixth sense*

In many ordinary situations, the following reasoning strategies work quite well for solving problems, forming beliefs, and making decisions and plans. These strategies are among the interpretive techniques employed by a spectator of film. What follows are descriptions of five common judgment heuristics and six cognitive biases along with a detailed illustration of how a spectator employs these strategies to reach a conclusion about a specific problem in *The Sixth Sense*. The conclusion reached is profoundly misleading and sets the stage for the film's shock effects.

judgment heuristics: procedures for practical reasoning

1. REPRESENTATIVENESS. A judgment is based on the extent to which a particular *instance* that a person encounters serves to represent, or is similar to, a larger category, schema, or causal process. For example, we may judge someone to be a Republican who is white, wealthy, and tough on crime, or we may believe that a man's recent string

of rejections by women reflects a personality flaw, not bad luck, because the rejections match our *expectations* of the effect on women generally of a specific personal trait possessed by the man (Kunda 1999, 56–57). We often think in terms of *examples* for which there are hidden prototypes, stereotypes, categories, templates, folk theories, and procedural schemata.

2. AVAILABILITY. A judgment is based on the ease, or difficulty, of *finding examples* that fit the case under scrutiny; that is, on the availability of examples that can be brought to consciousness—retrieved from memory—because of one's present attention to an event; or else the ease, or difficulty, of *imagining examples* (also known as the Simulation Heuristic); or else the ease, or difficulty, of creating *explanations.* How common is it for college students to hold a job? For you to act in a shy manner? For you to contribute more than someone else to a collaborative project? If examples of employed college students, or our own shy behaviors, or our own contributions to a collaborative project (e.g., sharing housework chores) are *presently salient* or can be *readily brought to mind,* then one will judge these occurrences to be quite common (Kunda 1999, 89–90). This may well be mistaken. In addition, if we can easily project or imagine examples, or easily create explanations, then we will also judge an occurrence to be quite typical or an argument to be persuasive. For example, do we readily imagine enjoying live sporting events? Can we easily generate arguments for expanding public transportation? Do we often read about violent deaths in the newspaper but seldom about deaths from stomach cancer (Fiske and Taylor 2013, 182–183)?

Related to the availability heuristic is *priming,* which is any initial or recent experience (even unconscious!), including a person's general *mood*—and here is one reason why films establish mood—that brings to mind or nearly to mind some word, category, idea, schemata, feeling, or image. Priming is a powerful effect of a type of memory known as 'implicit memory.' Experiments have demonstrated that something "that has recently been primed is especially likely to be applied to the interpretation of novel information, even in unrelated contexts" (Kunda 1999, 22; also see 23, 249–250).

3. ANCHORING (ANCHORING AND ADJUSTMENT). Random and irrelevant *starting points* when beginning to solve a problem may have a dramatic impact on judgment. For example, how many African countries are in the United Nations? Are there more or less than ten? more or less than fifty-five? People who are given a lower number as a starting point consistently give a lower estimate of the number of African countries than do people given a higher number as a starting point (Kunda 1999, 102–103). In general, people adjust too little from an initial anchor. Also, "We may anchor on our own traits and attitudes [a form of egocentric bias] when trying to determine those of others,

and we may anchor on others' opinions of us when trying to assess our own attributes. As a result we may view others as more similar to us than they are, and draw stronger conclusions than we should from flattery or criticism" (Kunda 1999, 104).

4. FRAMING. Setting the overall conditions or *boundary conditions* for perceiving a problem has an effect on its resolution. For example, people are inclined to think more positively about something that has a 50 percent success rate than about the same thing if it is said that it has a 50 percent failure rate. Consider also the impact on our judgment of such devices in film as establishing shots, initiating events, reaction shots, and suspense.

5. PROXIMITY. We often judge that two things appearing together belong together: *closeness* is assumed to increase the strength of effect. A major principle of causal reasoning is that a prior event, which is temporally or spatially more *proximate* to the outcome than others, is more *likely* to be a cause of the outcome. For example, our core reaction of disgust depends on two factors: what the thing is and where it has been. The second factor has to do with 'what the thing has touched' or might have touched—that is, what it has been in contact with or near (i.e., proximity).

The power of proximity extends to our comprehension of language (and equally the editing of images). Consider these sentences:

1. David taught film theory to Edward.
2. David taught Edward film theory.

The first sentence is somewhat 'weaker' than the second because it allows the inference that Edward may have been inattentive to his lessons. It is weaker because the words *taught* and *Edward* are not as proximate as in the second sentence. There are many other linguistic examples of this principle of proximity—for example, 'John is not happy' versus 'John is unhappy'; 'She caused him to die' versus 'She killed him.' The first sentence of each pair is weaker than the second (see Lakoff and Johnson 2003).

In comprehending pictorial displays, an important gestalt principle is 'proximity.' Presumably, an offshoot of proximity in film is the 'same-frame heuristic' where editing places two individuals together in the same frame (in proximity) in order to suggest a sense of togetherness as opposed to isolating individuals in separate shots to suggest vulnerability or conflict. (See Bordwell 1989b, 178–179; Elsaesser and Buckland 2002, 89–90; and generally Bordwell 1989a, 138–142.) An example of this heuristic may be found at the beginning of *The Sixth Sense* in the editing of the bedroom scene. In addition, as Roland Barthes (1977, 94) observes, narrative often transforms mere consecutiveness and conjunction (proximity) into *causal* principles.

cognitive biases and illusions

1. THE FUNDAMENTAL ATTRIBUTION ERROR. We often underestimate the power of *situations* and changing environments to influence behavior, preferring instead to attribute a person's behavior to the expression of (inherent, static) personality traits, attitudes, goals, dispositions, tendencies, and values. This is a serious and frequent cognitive bias.

2. BELIEF PERSEVERANCE (PERSEVERANCE OF REFUTED INITIAL BELIEFS). What we *first* come to believe often continues to have an effect on us even if it is quickly proven false. This bias is related to primacy and recency effects, and to the availability heuristic (see above).

3. DISCONFIRMATION (CONFIRMATION BIAS). We tend to ignore or underutilize evidence that *disconfirms* our beliefs or hypotheses. In addition, *dissimilar*-ities are not favored. For example, negative metaphors—for example, 'No man is an island'—are extremely rare. We often rely on prototypes (i.e., like grouped with like—as in the representativeness heuristic above) and on examples that come easily to mind (as in the availability heuristic above) to establish relevancy and to create a network of links among similar items at the expense of recognizing difference.

4. VIVIDNESS. We tend to give very special weight to information or material that can be formulated in a *vivid* manner—that is, appearing in concrete, immediate, sensual, unusual, or intense form, as with imagery. Superordinate categories and certain kinds of abstractions cannot be visualized and hence cannot be vivid in this way. For example, we cannot visualize 'furniture,' 'vehicle,' 'object,' and 'capitalism,' or logical words such as 'not' (as in not similar, dissimilar), or abstractions such as 'First Amendment rights,' or the doctrine of 'chilling of speech.' Note that the word *chilling* here is an attempt to make vivid an abstract concept about what does *not* happen—that is, speech that is not expressed, that has been discouraged becoming a form of prior censorship. What is thus absent cannot be vivid—a degree zero of vividness—and is subtly disfavored.

 By contrast, we are able to vividly imagine seeing a 'chair' and a 'wooden rocking chair,' a 'car' and a 'red Toyota Camry.' These latter are basic level and subordinate level categories, and may be made vivid and imaged on screen and in mind. It may also happen that something concrete may be converted into an abstraction when the goal is to make it less vivid and less visible. For example, referring to the acquisition of telephone records as merely 'metadata' avoids conveying thoughts of intrusive acts of 'surveillance,' of being watched and overheard.

 Recall Sergei Eisenstein's insistent argument that if one wishes to understand the nature of film, one must avoid analogies and similarities to other visual arts—for example, painting and theater—because

the visual arts are too vivid at the expense of language, social relations, and ideology (1988, 178). Film tends to envelop us within dramatic images that encourage a kind of vividness of thought, but memorable images leave us ill-prepared to consider what may *not* have been shown and/or what has greater abstractness.

5. DILUTION EFFECT. *Irrelevant* information tends to dilute the impact of diagnostic information. For example, "People given information that they consider indicative of whether a social-work client is likely to be a child abuser (e.g., 'He is aroused by sadomasochistic sexual fantasies,' 'He has a drinking problem') viewed this person as quite likely to be a child abuser. But other people, who were given, in addition to this diagnostic information, some completely irrelevant information about the person (e.g., 'He manages a hardware store,' 'He has an IQ of 110') viewed him as less likely to be a child-abuser. In other words, the nondiagnostic information diluted the impact of the diagnostic information on judgment" (Kunda 1999, 69).

Are there implications here for how characters are constructed in a film? How secrets are kept in a plot?

6. FAILURE TO USE STATISTICAL HEURISTICS (e.g., the failure to use reasoning procedures based on randomness, correlation, sample size, base rates [prior probabilities], covariation, regression toward the mean, and conjunction analysis). For example, "Whenever you find an error that statistically naive people make, you can find a more sophisticated version of the same problem that will trip the experts. If I say to my graduate students, 'Do tall fathers always have tall sons?' they think of the textbook page on regression [i.e., regression to the mean—so that the answer is tall fathers do not always have tall sons; in fact, they are more likely to have sons who are shorter]. But if I say something like 'Isn't it interesting that, in French history, the best monarchs usually had average prime ministers, and vice versa?' they say, 'Yes, that's fascinating! I wonder why'" (Kunda 1999, 88, quoting Amos Tversky). It might be argued that narrative structure itself is an inductive fallacy, since it purports through a single instance to exemplify one or more covering laws.

a detailed illustration of a spectator's use of judgment heuristics and cognitive biases in constructing the character of cole's father in *the sixth sense*

The following illustrates the cognitive heuristics and biases described above by considering how a spectator builds a sense of *identity* for Cole's father in *The Sixth Sense*. The aim of this illustration is to provide greater specificity about the sources of a spectator's beliefs than simply ascribing a judgment of the father to the film's vague, negative attitude or 'point of view.'

What does a spectator remember about Cole's father? The impression is probably negative even though the father does not appear in the film, and very little is said about him. How did a spectator acquire this negative feeling and for what purpose—that is, what is its function in the film?

To begin with, the father's girlfriend is the object of ridicule by Malcolm and Cole, who can imagine the girlfriend peeing on herself (*vividness*) as she is working in a highway toll booth and unable to leave to go to the bathroom. Her menial work is *represented* as tied to a negative stereotype that is tied to the father. The *proximity* of the relationship between girlfriend and father provides a negative *framing* for our evaluation of the father. In addition, the film never shows us Cole's father (negative *anchoring* and degree zero of *vividness*—i.e., out of sight, out of mind), and so we infer that Cole *never, or only rarely,* sees and spends time with the father (*negative availability*). Hence we conclude that the father must have abandoned Cole for the ridiculous girlfriend in prototypical fashion for a *deadbeat dad* (*representativeness* based on a negative stereotype).

We do not consider that the father may have left Cole for unknown reasons since we favor present and confirming instances—not *disconfirming* and unknown (absent, *unrepresentable*) causes, which have no *vividness.* Moreover, the circumstances of a person are greatly underestimated in evaluating the person's behavior (*the fundamental attribution error*); in this case, the action of the father leaving the family. The father may have left for reasons that were connected to his wife. However, Cole's mother is shown in the film only as decent and kind-hearted, which is our most *available,* repeated, and *vivid* image. The horrible ghost woman in Cole's kitchen resembles Lynn from behind, and Cole calls her "Mama," but after she turns around, she is not recognizable as his mother (*to us* but not necessarily to him), and that is exactly the point: we are emotionally caught up in thinking about the undead rather than about Lynn after seeing someone walk toward the kitchen accompanied by (*proximity*) a stinger chord on the soundtrack, followed by our thoughts, which are being further *primed* by ominous nondiegetic music.

Therefore the father *by contrast* with the mother seems all the more heartless and selfish for we *expect* (*availability*) that he should have expected (as a *proximate* cause) his son to have had problems adjusting to the divorce, even if suicide attempts and hallucinations by Cole might be an extreme reaction. We conclude that the father arbitrarily left Cole due to inherently base motives (*the fundamental attribution error*), rather than that there was some external cause of his leaving.

We see that Cole keeps *next to* (i.e., *proximate* to) his bed a photograph of his father; that Cole wears his father's eyeglasses (*proximity*) without the lenses; and that Cole wears his father's wristwatch (*proximity*), which does *not* work and was *not* given to him by his father, who simply forgot it in a drawer, so *no vivid* image of the father's love comes to a spectator's mind—quite

the contrary. The *proximity* of the broken glasses and broken watch to the father acts as a reflection on his dysfunctional nature as an uncaring father. On the basis of these *vivid* and concrete symbols (that reflect positively on Cole's love for his father but negatively on the absent father), we conclude that Cole has a *continuing* need for his father, who is a pathetic, neglectful, and ineffectual man. Since the nine-year-old Cole is the only one who can see and speak with Malcolm (since Malcolm is either a ghost or dying on his bed), the spectator is not likely to learn anything further about the cir-cumstances of the parents' divorce (retrospective *framing* to motivate the concealment of information). Malcolm's status is not revealed until the end of the film (negative *anchoring* and negative *priming*)—after we have fully established our negative judgment of the father, which will persist (*belief perseverance*) even after the film's plot reveals that it is Cole's special powers to see and help ghosts that is the true cause of Cole's anguish (if we believe Malcolm is a ghost) rather than the absence of the father and abuse by the mother (if we believe Malcolm is dying on his bed and fails to discover his killer's motive).

cole's father filtered through cole's mother

Consider Malcolm's remark to Cole: "When your mother and father were first divorced, your Mom went to see a doctor like me and he didn't help her. So you think I'm not going to be able to help you." The *framing* of this information about going to a doctor *in the context of* a divorce and its *proximity* to a traumatic event (i.e., 'just after' the divorce) makes us overlook the fact that Cole's mother *did go* to see a psychiatrist about some problem. The circumlocution/euphemism of the phrase "a doctor like me" helps *prevent us* from summoning the implications (through *representativeness*) of the signifi-cance of the mother seeing 'a psychiatrist.' The remark, by avoiding a posi-tive statement that the mother had 'a problem' in favor of the negative "he didn't help her," works to keep the idea of 'a problem' unfocused and *not vivid* (*disconfirmation* is disfavored). Furthermore, the statement "and he didn't help her" *masks* the idea (inappropriate *framing*) that her problem may have *preexisted* the divorce and may be continuing (i.e., the phrase "when . . . first divorced" provides an inappropriate *anchor*). Instead, we are confident that we have seen the literal and only truth behind Malcolm's simple words, rather than merely 'one possible' truth. That is, we believe that the words are merely *anchored* by Malcolm (whom we trust), and he intends them only as a prologue to "So you think," which acts to refocus, *reframe,* our attention onto Cole and away from the mother and her 'problem.'

Incidentally, why is the word *Mom* in Malcolm's remark better suited to mislead us than repeating the word *Mother* or using the word *she*? To rephrase this question, Whose point of view—that is, which *framing* and which *anchoring*—is assumed by the word *Mom* but not by the word *Mother*?

The answer, I believe, is that the word *Mom* focuses on Cole and his perspective (since he is the one more likely to be using the word *Mom* in an affectionate way than using the general term, *mother*) while again turning us *away* from Cole's mother and Malcolm, both of whom have secrets. Note also the *dilution effect* of Malcolm's speech.

Malcolm is trying to help Cole, and we believe that Cole should accept that help. We never consider that there may be still another, disguised truth within Malcolm's words. Later in the film we use the same mistaken *frame* (i.e., a 'divorce' frame) when the mother admits:

> God, I am *so* tired, Cole. I'm tired in my body, I'm tired in my mind, I'm tired in my heart. I need some help. You know, I don't know if you noticed, but our little family isn't doing so good. I mean, I've been praying, but I must not be praying right. Looks like we're just gonna have to answer each other's prayers.

She confesses that she is "tired in my mind" and "I need some help," but these statements are *weakened* by their lack of *proximity* and then *diluted* by other information (because we know that 'prayers' are passive and do not suggest violent abuse), so we do not notice the implication that she may still be mentally unstable. The film often shows us the happy and loving side of her personality, such as giving Cole a fun ride in a shopping cart (enhancing the positive prototype of a nurturing mother—*representativeness*—that also minimizes *disconfirming* evidence). The fun ride in a shopping cart occurs just before Cole is seen angrily throwing a shoe at the television as the next scene opens, which immediately *anchors* a *framing* on Cole and away from the mother as the scene continues, and she bitterly accuses him of stealing Grandma's bumblebee pendant.

from bad dad to bad cole (and away from mom)

Could Cole have stolen the pendant? We do know (*availability*) that he steals statuettes from a church. But do the statuettes and pendant belong together in the same class (*representativeness*) because they prove that Cole is dishonest and a thief at heart? This question(*primed* by the second scene in the film when we see Cole steal a statuette from a church) remains in our mind (*belief perseverance*) even though we later come to know the special reason he takes statuettes. We discover that Cole employs the statuettes (*vividness* and *representativeness*) as a shrine inside the tent in his bedroom, where he seeks sanctuary when the 'ghosts' become angry. Cole is frightened and sincere, and not really a thief—so the thief prototype (*representativeness*) does not fit. Yet the *difference* between the statuettes in his bedroom and the pendant, which presumably would have no spiritual power over ghosts, never

fully enters our thinking (*disconfirmation*). Instead, we continue to believe (*belief perseverance*) that Cole's misbehavior likely includes both statuettes and the pendant and is due to his father's heartless act in leaving the family.

In trying to understand the mother's behavior we fail to weigh adequately the mother's circumstances—a struggling single mother with an inadequate income, working two jobs with no free time to come to Cole's triumphant performance in the school play. Perhaps also she cannot afford to have the thermostat fixed so the house isn't always cold. Again, a spectator is snared in *the fundamental attribution error*.

Cole's mother announces, "Oh, I don't care what they say. This thing [the thermostat] is broken." The thermostat is seen on three earlier occasions in the film, which *dilutes* the information that it is simply broken, and worse, if it were shown to be simply broken, that fact would *disconfirm* many of our interpretations of other actions in the plot, including the opening of the film when Malcolm's wife, Anna, goes into the basement and finds it cold, and soon enough (*proximity*) Malcolm is shot in the bedroom. We feel there is something bad about the cold; it can't just be cold; there must be something deeper, and else.

If there is something else, what is it that is being *represented* in the film—something as real and terrible in our world as the thought of malevolent ghosts or something closer to home?

solving suicide

facing the complexity of *the hours*

f o u r t e e n

l u c y b o l t o n

The Hours (2002) presents the stories of three women negotiating choices of whether to live or die. As a complex narrative, interweaving the women's stories across the generations from the 1920s to the almost present day, the film explores the question of how to live in the face of intolerable physical and mental suffering. Using unconventional storytelling and cinematic techniques in order to depict consciousness and memory, *The Hours* takes Mrs. Dalloway's existential concerns and elaborates them across the lives of Virginia Woolf, a 1950s housewife, and a contemporary party planner. *The Hours* challenges us to make sense of the allusions and links between the narrative strands and to understand the relevance to our own lives, leading us to ponder over the option of suicide and to make sense of the choice to die.

The film is situated in a literary, cinematic, and historical context, with several texts in circulation around it at all times. Directed by Stephen Daldry (*Billy Elliot,* 2000) from a screenplay by playwright and screenwriter David Hare (*Plenty* [1985], *Damage* [1992]), the film had the heavyweights of the British theatre at its helm. The screenplay was based on the novel *The Hours,*

written by American Michael Cunningham in 1998. Cunningham's inspiration for the novel was *Mrs Dalloway* by Virginia Woolf (1925). Woolf's novel is about a day in the life of Clarissa Dalloway as she plans a dinner party and encounters questions of how to live in post–World War I London, surrounded as she is by shell-shocked soldiers, lost loves, and unfulfilled longings. Of course Woolf herself is a figure of immense literary, historical, and feminist significance, and her biography (including her suicide by drowning) is a familiar tale in popular culture. By choosing to feature Woolf as a character in the novel *The Hours*, Cunningham is both drawing on and borrowing from the fame and reputation that attends her. Two other texts inform my reading of the film. These are the film adaptation of *Mrs Dalloway* by Marleen Gorris (1997) and Woolf's (2008) inspirational essay "The Cinema" from 1926. These texts all speak to each other and enhance an understanding of how the themes that Woolf investigates in her novel are explored cinematically in *The Hours*. Approaching the three-stranded narrative as a puzzle film requires us to go beyond simply making narrative sense of the stories, although this is the sensible place to start. The questions that the film leads us to consider are created by film form including editing, framing, focus and performance, sound, and music; additionally, the puzzling that the film prompts concerns existential philosophical and phenomenological reflection. This is, I concede, attributing a great deal of profundity to the film, but through close analysis of narrative and form I hope to demonstrate how *The Hours* instills such contemplation of life and death in the viewer through its specifically cinematic properties.

scene setting

A central concern of *The Hours* is the boundary between life and death: Why do some choose to die and others to live? When is a life worth living, and when is death a sensible option? The film depicts these questions being encountered by three women in different decades and countries: Virginia Woolf in 1920s London, played by Nicole Kidman (with a false nose); a 1950s suburban Los Angeles housewife, Laura Brown, played by Julianne Moore; and a party-planning publisher in turn of the century New York, Clarissa Vaughan, played by Meryl Streep. The film is also about Mrs. Dalloway and how her existence as a character and a concept is relevant to the lives of these women. Woolf is creating her, Laura is reading about her, and Clarissa is her modern incarnation. We see each woman in relation to her domestic life and also on her own, and what is at stake in the film are their states of mind and what they are thinking about their lives.

Virginia is portrayed as tormented, riven with the demands of creativity and mental illness. She struggles with her work, resists eating, and has a fractious relationship with her servants. Her husband, Leonard, played by Stephen Dillane, is constantly alert to her moods and movements. She has

to ask his permission to go out for a walk, and he keeps a watchful eye over everything she does, from what she eats for breakfast to how the characters and themes in her novel are progressing. Virginia's doctor says to her husband that "the main thing is to keep her where she is, and calm." We learn through Leonard that Virginia has tried to kill herself twice before and that they have moved to suburban Richmond in West London in an attempt to restore her peace of mind. She continues to be preoccupied with death, however, and the question of choosing to die is forefront in her existence: Should she kill Mrs. Dalloway in her novel? Someone else? Herself?

Laura Brown is more difficult to understand as a character because she does not seem able to express herself, and there is nobody in her life who understands her predicament. She is married with a son but seems desperately detached and lonely. She appears dissociated from daily life and in a state of distress and disarray. The most mundane household happenings such as the baking of a cake or ringing of the doorbell are difficult for Laura, who moves around her house in a state of being that appears to be hermetically sealed. Laura is shown avidly reading the novel *Mrs Dalloway,* and when she describes the novel to her neighbor Kitty she reveals the reason for its resonance with her: "It's about a woman who's incredibly confident; everyone thinks she's fine, but she isn't."

Clarissa Vaughan's life is on hold whilst she nurses her long-time soul mate, the poet Richard, as he is suffering from the mental and physical symptoms of AIDS. Like Clarissa Dalloway, she has a daughter, and she has a partner called Sally (which is the name of Mrs. Dalloway's childhood friend). On the day on which the film is set, Clarissa is organizing a party for Richard as he is going to receive a prestigious poetry award that afternoon. The imminent party juxtaposed with Richard's ailing condition creates a heightened emotional plane for Clarissa as she is forced to confront the artificial celebration of the occasion in contrast to the desperate sadness and loss that she feels about her and Richard's relationship, and the significance of that relationship for her. She claims that she is "unraveling"; her overwhelming love for Richard dominates her life, including her relationships with Sally, and her daughter, Julia.

Each woman is therefore enmeshed in circumstances that are emotionally acute and psychologically stark. As I claimed at the outset, in various ways they are hovering on the boundary between life and death. Virginia rejects death as her character Mrs. Dalloway's fate but embraces it for herself, choosing to commit suicide by drowning herself in a river. Laura initiates a suicide attempt but chooses to live differently. Clarissa is released to live for herself and her family through Richard's choice to end his life. The impact of suicidal choices on the lives of each woman is inextricably profound. The structure and form of *The Hours,* however, ensures that these dilemmas and their implications reach wider than this narrative context.

The film creates the experience of the women's crises in a variety of ways. Most markedly are the performances of the three lead actresses, which resound with emotional intensity and psychological complexity. Supporting performances also intensify the specificity of each woman's circumstances, particularly that by Dillane as the devoted and terrified Leonard Woolf, and John C. Reilly as Laura's happily well-meaning but obtuse husband. The faces of Kidman as Virginia, Moore as Laura, and Streep as Clarissa are shot in close-up and extreme close-up, enabling the anxiety and turmoil inscribed on them to dominate the screen. The camera also lingers on their faces and bodies as they experience emotion and contemplation, such as when Virginia closely surveys the freshly dead bird on the hastily assembled funeral bed or Clarissa sits in her chair gazing out of the window, unable to summon the energy to respond to Sally's entry to the apartment. The camera's focus on Laura's face and body enables Moore to convey a momentary delay in her responses to the people and activities in her life, thus creating the degree of detachment and bafflement that Laura feels. In this way, shot length and framing privilege their subjective experiences above narrative progression, and screen time is devoted to their consciousness and thoughtfulness.[1] We are also involved in their thought processes—for example, when we are able to follow Virginia's train of thought from when her nephews and niece find the dying bird and her sister, Vanessa Bell (Miranda Richardson), proclaims, "There is a time to die and it may be the bird's time." Virginia asks if Anjelica thinks the bird will like roses, drawing attention to the creature as a being that has a personality with preferences. She responds to Anjelica's question about what happens when we die by saying that "we return to the place that we came from," and observes that "we look smaller," to which Anjelica adds, "but very peaceful." We then see Virginia's anguish as she lies down alongside the bird on the ground and studies it closely, even after the children have run away (see Figure 14.1). The suggestion here is that Virginia is studying what death looks like, contemplating what it would be like to die, and realizing that choosing death is possible. The next shot is of Laura's face as she is lying down in bed, in a similar pose and from a similar angle as Virginia, before she gets up and goes to the bathroom to collect the pills with which we understand she has chosen to end her life. The crosscutting between the bodies and faces aligns the characters with the same deliberations and meditations on death.

It is through the film's manipulation of time and space in conveying the narrative that the thoughts and concerns of Laura, Virginia, and Clarissa are communicated—but how best to understand the affectiveness of the timeless questions with which they grapple? In other words, How are we incorporated into the themes and ideas expressed in this film?

Figure 14.1 Virginia contemplates the reality of death

a phenomenology of lived bodies and consciousness

The film invites phenomenological consideration in three respects: a feminist phenomenological approach grounded in the representation of three women's lived bodies; a phenomenology of conscious experience as the women on-screen think, imagine, decide, and intend; and a concern with haptic visuality as sensory experience. These approaches draw on the tradition of phenomenology from Husserlian concerns with describing psychological or mental activity, the inclusion of the body found in the work of Merleau-Ponty, the search for meaning found in Sartre, and an appreciation of the ways in which cinema's visuality involves other senses in its reception, as pioneered by Vivian Sobchack and Laura Marks.[2] Why turn to this tradition and these various approaches in order to understand *The Hours*? I suggest it is because the film insists upon confronting the viewer with the existential realization that death is preferable to life in some circumstances, and in order to have this profound effect the film has to immerse the viewer in the themes of the film, not just engross in the story.

A helpful place to start with this consideration is that of the concept of the 'lived body.' Iris Marion Young describes the lived body in this way: "a unified idea of a physical body acting and experiencing in a specific sociocultural context; it is body-in-situation" (2005, 16). Young argues that it is the task of feminist phenomenology to "understand how the rules, relations, and their material consequences produce privileges for some people that underlie an interest in their maintenance at the same time that they limit options of others, cause relative deprivations in their lives, or render them vulnerable to domination and exploitation" (2005, 25). Studying the film as being about three women's lived bodies would enable a feminist phenomenological encounter with the enculturated bodies of the women, making the film about female self-knowledge, honesty, sexuality, and the options

269

available to women at different times in history: Woolf wrote, dreaming of the day she may one day escape (as she describes it to her sister, Vanessa Bell); Laura was constricted to a life she did not feel she belonged to; Clarissa can make her life with a woman and have a daughter without knowing who the father was but has still not been able to lead a life for herself as she fulfills the function of Richard's caregiver. None of them can evade the life and death choices at the heart of all their lives, and indeed it is Richard's life that sheds light on the film's stance on suicide. As he suffers with hallucinations, physical pain, and weakness, Clarissa attempts to calm him by saying that the doctors say he can live like this for years. She means it as a positive affirmation of his ability to stay alive, but for him the promised life is not one worth living.

The film's themes then are not just about lives as women, so perhaps a more general bodily encounter is staged by the film. There are powerful bodily affects conjured by music, special effects, and sensory aspects of the film. The original score by Philip Glass seems to be constantly building to a crescendo, such that it can leave you almost breathless. The music links the lives of the women (and therefore their situations) as the one score accompanies all three narrative strands. The film also perplexes, leaving elements unknown and quandaries unresolved, keeping you in a state of tension tinged with apprehension. An involved sense of bodily engagement with one character's plight, however, is hard to maintain in such a choppy narrative. The choppiness is due to crosscuts between the different decades, lifestyles, costumes, dialogue, and colors of the three women's lives.

I suggest that because of this lack of consistency of character and milieu, a bodily phenomenological approach is not wholly adequate to unlock the affectiveness of *The Hours* and that in order to understand how the film asks the questions that it does it is necessary to describe how the concept of living is conveyed through thinking, and how we as viewers are led along a path of thought through the detailed creation of a sense of moments in time.

immersing and enmeshing

When writing about teaching Woolf's novel to students, Leslie Kathleen Hankins (2009) suggests that avant-garde cinema is appropriate for adapting a modernist novel such as *Mrs Dalloway* into a film. After getting students to watch avant-garde cinema, such as *Smiling Madame Beudet* (*La souriante Mme Beudet,* Germaine Dulac, 1922) or *J'accuse* (Abel Gance, 1919), Hankins invites them to write ideas for how some of the ideas in Woolf's novel *Mrs Dalloway* might be adapted. They then watch Marleen Gorris's film of the novel, which portrays Clarissa as a girl and as she is now. Hankins finds that "those who design innovative cinematic ways to capture the novel's depictions of reverie and hallucination are particularly disappointed by the failure of the films to adapt those passages with comparable levels of

imagination" (2009, 94). They then read *The Hours* and watch the film, the aim being to see how accumulated knowledge of *Mrs. Dalloway* enriches critique. Certainly the avant-garde films Hankins refers to have as a central feature the depiction of hallucination and imagination, but, as suggested by the scene in which Virginia encounters the dead bird described above, it is not necessary to attempt to depict exactly what is in an on-screen character's head in order to bridge that gap between spectator and film. *The Hours* weaves the spectator into a mesh of stories about suicide by presenting moments of clarity and significance.

From the outset we are immersed in the world of the film. The opening scene is of rushing, gurgling water. The camera is almost at water level, as if the spectator is facing the prospect of immersion. We then hear Virginia's suicide note read in voiceover, as we see her drown herself in the river—so the film begins at the point at which she has chosen to die. The following scene, the credit sequence, crosscuts between the three women as they are each beginning their day, establishing their lived bodies and aligning them with each other and Mrs. Dalloway through, among other things, the motif of the buying of flowers. As Virginia creates her first sentence, "Mrs Dalloway said that she would buy the flowers herself," Laura is shown to be reading it in the hardback version of the novel, and Clarissa announces to her partner that she will buy the flowers for her party herself. This sentence serves to establish the relationship of each woman to the character and the novel, and announces a connection between them. The pace and style of editing, and the energetic, urgent music, draws the spectator into the whirlwind of characters and lives on-screen, establishing their interconnectedness in an exaggerated style. There are also moments of pause, such as when Clarissa and Virginia look at their faces in the mirror: Virginia lowers her head to splash with water followed by a cut to Clarissa lifting her face from a bowl of water: both women are seen gazing at their faces in the mirror in a difficult-to-read state of impassiveness and appraisal.

These moments in the film are pinpoints of significance. They enable the plotting out of the shared conceptual concerns. The significance of a moment is itself a feature of the film as Richard bemoans the fact that his quest as a writer (which he considers himself to have failed) was to write about "everything that happens in a moment." When Julia and her mother discuss when she was happy, Clarissa replies that she has realized it was not a period of time, a summer or even a day, but that happiness was in one moment: the moment one summer when she was young and with Richard, when she rose at dawn and felt a sense of possibility. She describes how she felt that "this is the beginning of happiness; this is where it starts," but in fact she has come to realize that the moment *was* happiness: "It was the moment, right then."

As well as moments being explicitly discussed, there is one scene in particular that captures a moment as if to bring the notion to the viewer's

consciousness. When preparing for the party, Clarissa is surprised by the early arrival of Richard's ex-lover Lewis. Clarissa continues to cook in the kitchen, trying to converse with Lewis despite the undercurrents of emotion, resentment, and distress that are building in light of the fact that Richard 'chose' Lewis to be his lover instead of her many years ago, and yet she has been nursing Richard for years. She cracks eggs into a bowl, and the camera focuses on some of the eggs as she cracks them and drops them. Then the camera pauses to focus on the fall of one in particular (see Figure 14.2). The seconds it takes the egg yolk to drop from Clarissa's hand into the bowl are laden with a sense of time: her hand, older than the time when she was the girl she and Lewis are remembering; her nails, manicured and polished, incongruent with the slimy albumen; the other eggs she has already cracked and the ones yet to be cracked; the purpose for which they are going to be used and what they will become. The conversation with Lewis is referring to times far in the past, and the intervening period, and the present, and the future of Richard's death. There is a pause in the conversation after Clarissa has said she was saddened by the fact that Richard had not written more about Lewis in his novel, which is clearly based on Clarissa. This raises the issue of whether Richard was angry with Lewis and punished him by not writing about him or whether it was in fact Clarissa he always loved; it also asks the question as to whether Lewis feels aggrieved about it. The texture and tension of the surface of the egg yolk is evident, as is the noise of its sloppy passage into the bowl—this is a moment. It takes a long time to write it—as Richard said was his aim. In that moment there is so much weight: the egg yolk as the possibility of new life, its fall into the bowl, the certainty of its end. The timing of the moment in the conversation between Clarissa and Lewis enables the complexity of the shot to be so powerful and multilayered. This suggests that cinema can capture and convey a moment in a way that writing cannot.

Figure 14.2 Everything captured in a loaded moment

This moment may be inconsequential in terms of the narrative, but upon reflection it can be seen as a clue to the way in which the film is inviting us to think about the passage of time in everyday life. In his consideration of Stanley Cavell's philosophical film criticism, Andrew Klevan describes how "Cavell is especially alive to those moments that seem to be ordinary or straightforward, and which he reveals to be quietly mysterious" (2011, 51). Klevan quotes Cavell as saying he is concerned with "those *apparently* insignificant moments in whose power a part of the power of film rests" (Cavell, in Klevan 2011, 51). This egg yolk moment creates a pause in the film that is noticeable and yet enigmatic. It is only upon reflection that the significance of the moment becomes clearer. Klevan writes, "Cavell is always interested in how the moment relates to the film as a film: because understanding how the style of *this* moment works (successfully) is a way of understanding how *this* film uses the medium (successfully), that is, *how it reflects upon the medium*" (2011, 58).

This key egg-yolk moment, in the context of an ordinary kitchen task, unlocks the film's challenge to its characters and its viewers: to call attention to the moments that make up our hours that make up our days, which turn into our lives. This is, then, what Klevan calls "a matter of investigating the ordinary," as opposed to treating a film as a puzzle (2011, 60). This moment also demonstrates how film can do this in an affective way that can be understood phenomenologically as the viewer's experience of the filmic thought, here a filmic moment laden with memory, presence, and prescience.

In the scene where Virginia asks Nelly to go to London to buy ginger for tea, Lottie also cracks eggs into a bowl of flour, and each sharp crack punctuates the palpable tension between the nervous Virginia and the disgruntled Nelly like the crack of a whip, enhancing the viewer's experience of that tension. It is moments such as this that link the three stories, or align them, and some of the film's most significant moments are kisses, as each woman shares a meaningful kiss with another character. This picks up on Mrs. Dalloway's girlhood kiss with her friend Sally Seton in Woolf's novel: "Then came the most exquisite moment of her whole life passing a stone urn with flowers in it. Sally stopped; picked a flower; kissed her on the lips" (1992, 38). Mrs. Dalloway treasures this kiss as a precious gift, evoking the memories of how exciting and thrilling she found Sally when she was young. When Sally comes to Clarissa's party, this vital young woman has aged. She is married to a bald man and has had five sons, and her eyes are "not aglow as they used to be" (1992, 199). The moment of the kiss stands for something very significant for Clarissa Dalloway, and that is a moment of subjective significance, shedding light on her hopes, dreams, and fascinations at that time. This idea reverberates throughout *The Hours,* as kisses occur that are laden with meanings different for the kisser than the kissed. When Richard kisses Clarissa it appears passionate and sensual

as if between lovers, yet Clarissa meets it with a pause and then humorous deflection. Following Virginia's asking Vanessa if she thinks she will "ever escape" from the tormented life she is leading, Virginia grabs her sister's head and kisses her urgently on the lips in a way that could be interpreted as a last kiss. Vanessa is perturbed and runs away to the carriage to leave, hugging her daughter close, seemingly chilled by the experience. Laura and her husband share perfunctory kisses that are marks of convention and ritual, as opposed to the kiss Laura bestows on her neighbor Kitty, which I will now consider in some detail.

laura's kiss

Laura has tried to make a birthday cake for her husband but finds it a struggle and is unhappy with the result. Kitty rings the doorbell and this seems to paralyze Laura, who makes no move to answer the door despite her son's entreaties. Kitty lets herself in and teases Laura gently about why she should find it so difficult to make a cake. Laura makes coffee and tries to make conversation but asks facile questions such as, "Does Ray have a birthday?" and then chastises herself for being stupid. Kitty has in fact come to ask Laura to feed her dog while she goes into hospital to have a growth in her uterus examined. Kitty is distressed about the implications this might have for her fertility, and when comforting her Laura raises Kitty's face to hers and kisses her on the lips (see Figure 14.3). She then says to Kitty, "You didn't mind?" and Kitty replies, "Mind what? You're sweet." Laura's kiss appears to be sexually motivated as it is lingering and on the lips, and Laura's query suggests there was an experimental intent behind it. This scene asks questions about her mental state and her consciousness, what she is thinking about, and what is going through her mind. It conveys her disarray and her disorientation but gives limited and incomplete understanding

Figure 14.3 Laura kisses Kitty

as to what is going on. Questions are asked about her sexuality and the possibility is raised that she is a lesbian who is suffocating in a life of hetero-normative suburban convention.

In Cunningham's novel, this is explicit. Kitty and Laura's encounter is described in far more sexual terms, with Laura noticing Kitty's breasts, perfume, and brown-blond hair: "Kitty nods against Laura's breasts. The question has been silently asked and silently answered, it seems. They are both afflicted and blessed, full of shared secrets, striving every moment. They are both impersonating someone. They are weary and beleaguered; they have taken on such enormous work" (1998, 110). This description seems to fit the character of Laura in the film, but no such clarity is provided on-screen. "They both know what they are doing," Cunningham (1998, 110) writes, making it clear there is physical attraction between the women, whereas in the film it appears to be one-sided: Kitty seems to be unaware that there might be any sexual intent behind Laura's kiss.

Clarissa kisses Sally determinedly after Richard has died, in what seems like a statement of recommitment to their life together and indeed life itself. As with Clarissa Dalloway's kiss from Sally, these kisses seem to stand for female love: the possibility of female sexual love, yes, but also the symbolic expression of love between women. The kisses are multilayered and affective physically and emotionally. They are also concerned with fundamental questions about living and dying, and they stand as markers, leading the viewer through the film with ambiguous meanings. In phenomenological terms, I would argue that understanding of these moments is not simply through the bodily experiences of the film's women, or the conveying of their lived body experiences in terms of relationships, financial independence, family ties, sexual and work freedoms. In fact, through withholding clear pathways of conscious thought (such as Laura and Kitty's kiss) and creating a puzzle out of the film's main theme, the film asks of the spectator, Why do you choose to live? When would you choose to die? What is death? What is living?

In the kissing of Kitty scene, Laura's state of mind is oddly opaque, as it is in many of her other scenes. Her despair and detachment are clear, but it is not entirely clear why. When Laura is contemplating suicide she goes to a hotel to be undisturbed. She reads *Mrs Dalloway* on the bed and then surveys all the pills she has laid out on the bedside table. She falls asleep and appears to dream about encroaching death, which is represented on-screen as waters flooding in and enveloping her. The water is full of weeds and currents, like the river water that drowns Virginia. This scene is cross-cut with shots of Virginia considering whether or not to kill her heroine, as her sister chatters away in the background. This crosscutting makes her artistic choices seem acute and relevant to the real life being lived by Laura, and there is a sensing of Laura's death, even though she clasps her pregnant belly and gasps, "I can't." As she explains to young Richard later that day

when she collects him from the child-minder, "There was a moment when I thought I'd be much longer."

This is the narrative puzzle that now becomes solved in part. Laura is Richard's mother. There is a degree of secrecy and then disclosure about Richard's mother being Laura Brown, when the film cuts from Laura's aborted suicide attempt to a shot of Richard weeping over a photograph of Laura in her wedding dress. Richard's heartbreak over his mother thus becomes clear as he faces his choice to die, but her lot is more fully explained in the final scenes when Laura comes to his funeral. "So that's the monster," Julia utters to Sally: at last the three women get to learn what the woman Richard always said had killed herself is actually like. When Laura eventually has a chance to talk to Clarissa after Richard's funeral, and is given the opportunity to explain why she left her husband and two young children, Laura says of her life in those days, "It was death. I chose to live." We now realize the extent of Laura's choices. Her choice not to commit suicide was not to evade literal death. Her life was already deathly, so she chose life by planning to live differently. Her contemplation of suicide was in fact a choice to escape her living death, but she could not do it because of her unborn child and the certain death it would have been for her baby. But she made plans to live, and this meant getting away from her husband and family. She took a bus and got a job in a library in Canada, and a lifetime of exile and unforgiveness was a price worth paying.

Woolf would approve of the way in which the film immerses us in Laura's difficult life and offers a vision of the implications of living an honest life for a real person. In "The Cinema," Woolf writes that a filmmaker must ensure that "what he shows us, fantastic though it seems, has some relation with the great veins and arteries of our existence" (2008, 176). Although this is not a study of the adaptation of the novel, the comparison with the book of *The Hours* prompts the question of what film does differently. I suggest it creates affective and meaningful moments that perplex and inform us, leading us through a maze of questions in a way that integrates us into their examination and solution. Again in "The Cinema," Woolf criticizes the process of comparing a filmic adaptation to its literary inspiration, claiming, "Eye and brain are torn asunder ruthlessly as they try vainly to work in couples" (173):

> So we spell them out in words of one syllable written in the scrawl of an illiterate schoolboy. A kiss is love. A smashed chair is jealousy. A grin is happiness. Death is a hearse . . . it is only when we give up trying to connect the pictures with the book that we guess from scene by the way—a gardener mowing the lawn outside, for example, or a tree shaking its branches in the sunshine—what the cinema might do if it were left to its own devices.
>
> (174)

This is Woolf's attempt to understand film phenomenologically, locating the experience of cinema firmly in evocative moving images so that in *The Cabinet of Dr Caligari* "the monstrous quivering tadpole seemed to be fear itself, and not the statement 'I am afraid'" (2008, 174). Here Woolf is identifying exquisite moments that convey emotion and thought, preempting film phenomenology's concern with how the cinema can show and not tell. Woolf's concern for cinema to show "the continuity of human life" is achieved in *The Hours* precisely as she calls for in her imagined filmic version of Tolstoy: "by the repetition of some object common to both lives" (175). In *The Hours,* the common concerns are continuous across the lives of Virginia, Laura, and Clarissa, and the filmic moments that convey them do indeed have relations to the great veins and arteries of our existence.

I return to the opening scene of the film, the tumultuous river into which Virginia is about to walk, and I resee it now as the choice facing us as individuals. Would we choose to die? This is an incredibly relevant question: the individual's right to end his or her own life is something that is at the forefront of contemporary medical ethics and jurisprudence. But more than this, it is a question of how we choose to live. Virginia says to her husband Leonard that "you cannot find peace of mind by avoiding life." Clarissa says to Richard that "people stay alive for each other," but as Richard says, it is he who has to face the hours—these are the constituent blocks of our lives—and it is the hours of her life that Laura walked away from in order to work in a library, leaving her husband and two young children. Hours are made up of moments, and these are what the film conveys so exquisitely: how to capture it all in a moment.

facing the hours

Cunningham writes, "If you look with sufficient penetration, and sufficient art, at an hour in the life of anybody, you can crack it open" (2003, 137). This is what *The Hours* achieves: it cracks open the lives of the characters in the film by depicting their lives in a single day, made up of hours, and moments. Film is well equipped to trade in moments, as they can be created in a time that resembles real time, and yet is not.

The Hours evokes and conveys the emotional turmoil of women questioning how and why to live in a range of times, places, and circumstances. Through this encounter with the cinematic showing of their stories, cinema can be seen to 'flesh out' psychological issues and paradoxically enable the sharing of their solitude. In answer to Leonard's question, "Why does somebody have to die?" Virginia replies, "In order that the rest of us should value life more." Perhaps this is the intention of *The Hours*—more than a narrative puzzle, it is an investigation of ordinary lives. *The Hours* immerses the spectator in the increasingly crosscutting lives of Virginia, Laura, and Clarissa in a way that suggests their dilemmas are not only universal and

timeless but are particular to you as an individual. Their interrelationship across the decades and between art, life, sanity, sex, and death concocts a whirling maelstrom of existential solitude and plunges you right into the heart of it. The disclosure of Laura's choice in the final scenes of the film confronts you with the knowledge that existing can be deathly, and challenges you to face your own hours afresh.

notes

1. I discuss this concept in detail in my book *Film and Female Consciousness* (Bolton 2011).
2. For more general background to phenomenology, consult Dermot Moran (2000). For phenomenology and film, see Vivian Sobchack (1992, 2004).

references

Bolton, Lucy. 2011. *Film and Female Consciousness.* Basingstoke: Palgrave Macmillan.

Cunningham, Michael. 1998. *The Hours.* New York: Farrar, Straus and Giroux.

Cunningham, Michael. 2003. "First Love." In *The Mrs Dalloway Reader,* by Virginia Woolf et al., ed. Francine Prose, 136–137. New York: Harvest, Harcourt.

Hankins, Leslie Kathleen. 2009. "Teaching *Mrs Dalloway*(s) and Film." In *Approaches to Teaching Woolf's* Mrs Dalloway, ed. Eileen Barrett and Ruth O. Saxton, 91–96. New York: MLAA.

Klevan, Andrew. 2011. "Notes on Stanley Cavell and Philosophical Film Criticism." In *New Takes in Film Philosophy,* ed. Havi Carel and Greg Tuck, 48–64. Basingstoke: Palgrave Macmillan.

Moran, Dermot. 2000. *An Introduction to Phenomenology.* London: Routledge.

Sobchack, Vivian. 1992. *The Address of the Eye.* Princeton, NJ: Princeton University Press.

Sobchack, Vivian. 2004. *Carnal Thoughts.* Berkeley: University of California Press.

Woolf, Virginia. 1925. *Mrs Dalloway.* London: Hogarth Press.

Woolf, Virginia. 1992. *Mrs Dalloway.* London: Penguin.

Woolf, Virginia. 2008. "The Cinema." In *Virginia Woolf Selected Essays,* ed. David Bradshaw, 172–176. Oxford: Oxford University Press.

Young, Iris Marion. 2005. *On Female Body Experience: "Throwing Like a Girl" and Other Essays.* Oxford: Oxford University Press.

knowledge and narrativity in *premonition* and *the lake house*

g a r y b e t t i n s o n

On the morning of her husband's funeral, Linda Hanson (played by Sandra Bullock) heads into the backyard of her luxurious house to fetch her young daughter. Linda is visibly strained. Her husband's fatal road accident had occurred two days earlier. Yet the morning after the accident, Linda discovers her previous reality intact: her husband, Jim, is perched at the kitchen table, apparently oblivious of any tragedy. Now, on the third day, Linda's situation has inexplicably altered once again—Jim *is* dead and about to be consigned to the grave. Her comprehension of events radically disrupted, Linda turns to her child for clarity. The little girl asks: "Mommy, what was it like when Daddy died?" "I don't know, baby, I wasn't there," Linda replies. The child looks at Linda innocently: "So how do you know he died?"

Some characteristic features of the Hollywood puzzle film permeate this segment from *Premonition* (Mennan Yapo, 2007). Most flagrantly, the scene foregrounds the protagonist's deficient knowledge and comprehension and hints at inadequate information granted to the spectator. Like all puzzle films, *Premonition* puts knowledge palpably at the heart of the viewer's

experience—it orchestrates narrative interest by means of postponed knowledge (due to a suppressive narration riddled with suspense and curiosity gaps) and saturated knowledge (thanks to a densely concentrated montage filling in those gaps). In *Premonition* as in *The Lake House* (Alejandro Agresti, 2006)—another puzzle film featuring Sandra Bullock—the narration's maintenance of knowledge is integral to the apparently insoluble mystery at the plot's center.

But what kinds of knowledge do these puzzle films animate? As epitomized by the *Premonition* segment, knowledge is both *epistemic* (Does Linda truly *know* that Jim is dead?) and *ontological* (What is the nature of Linda's chronologically deformed reality?). These knowledge structures are the province of puzzle films generally (see Bettinson 2008, 161; Elsaesser 2009, 15; Wilson 2006, 81), and *Premonition* and *The Lake House* mine them for different rhetorical effects. In addition, *Premonition* and *The Lake House* solicit the spectator's *extratextual* knowledge as an aid to hypothesis construction. Operating against proximate historical 'backgrounds,' these films tap the viewer's familiarity with kindred texts (for instance, other Hollywood puzzle films or certain Sandra Bullock movies) in ways that sharpen and specify our hypotheses and expectations. Perhaps most importantly, *Premonition* and *The Lake House* exploit our *real-world* knowledge schemas, shrewdly targeting our default, bottom-up reflexes and harnessing these predictable responses to the narrative effects of curiosity, suspense, and surprise.

This chapter examines how *Premonition* and *The Lake House* put these knowledge structures to the service of narrative misdirection and surprise. By what narrational strategies do these films hoodwink the viewer? For all their narrational complexity, I argue, Hollywood puzzle films conjure temporary gaps, feints, surprise disclosures, and other tactics of deception by relying on the most basic of the viewer's cognitive propensities and proclivities. The plot twists of *Fight Club* (1999) and *Secret Window* (2004) hinge on the spectator individuating a single protagonist as two discrete persons. That viewers do this effortlessly is attributable to irresistible textual features (e.g., the film's discrimination of two physically distinct players) and norms of everyday perception and cognition (the basic 'person schema' heuristic, by which we recognize, individuate, and ascribe discrete traits to different human bodies). *The Sixth Sense* (1999) and *The Others* (2001) stake narrative surprise on the reliable assumption that viewers will construct the protagonist as an ontologically human agent, again by default to the person schema and other real-world heuristics. In the following analysis I shall suggest that misdirection in *Premonition* and *The Lake House* similarly rests on the viewer's basic cognitive dispositions. To this end, I examine how the films delay and disguise plot revelation, charting their sustained play of erroneous, conflicting, or mutually exclusive hypotheses.

These provisional hypotheses are enhanced by extratextual backgrounds. In particular, the viewer's familiarity with related films can

influence the local task of hypothesis framing. That Sandra Bullock's homicide detective in *Murder by Numbers* (2002) successfully deflects insinuations of madness may prompt the 'knowledgeable' viewer of *Premonition* to predict a similar surmounting of slurs by Linda. By contrast, the oft-used anagnorisis in *Shutter Island* (2010) may be vitiated for spectators cognizant of, in Thomas Elsaesser's phrase, recent Hollywood "mind-game films" (Elsaesser 2009). The claim is not that puzzle films generate narrative hypotheses by relying arbitrarily on the individual viewer's extratextual knowledge. Rather, intertextuality functions as an *intensifier* of hypotheses cued by the text, redundantly reinforcing rather than originating hypotheses ab ovo. *Premonition* and *The Lake House* rely on such strategies to enhance and sustain equivocal hypotheses, prevaricating on the narrative's closure.

the lake house

The Lake House toggles between two time periods. In 2006 Kate (Sandra Bullock), the departing tenant of an exquisite Chicago lake house, receives correspondence from the new resident, Alex (Keanu Reeves). Bizarrely, Alex claims to be writing from 2004. Further letters are exchanged through the property's mailbox. To the protagonists' disbelief, the diegetic world appears to have splintered into two epochs, between which the plot alternates.[1] On the 2004 level, Alex strives for intimacy with his supercilious father, Wyler (Christopher Plummer); on the 2006 level, Kate copes with isolation and loneliness. The protagonists fall in love with each other despite the temporal gap that separates them. By mail they arrange to meet at a future date in 2006, but Alex does not keep the appointment. The plot posits a counterfactual scenario in which Alex is accidentally killed on his way to meet Kate. At the climax, however, Kate (in 2008) uses the mailbox to forewarn Alex (in 2006) of this disaster, thereby preventing his death. In 2008, the protagonists are romantically united at their cherished waterfront home.

A remake of South Korean romance-drama *Il Mare* (Hyun-seung Lee, 2000), *The Lake House* may be traced to a 'background set' of pan-Asian romance films. In the 1990s the new South Korean cinema launched a cycle of films centered on romantic love and temporal disjunction: *Il Mare*, *The Contact* (1997), *Asako in Ruby Shoes* (2000), and *Bungee Jumping of Their Own* (2001) are salient entries. Thematizing providential fate, these films deploy an occasionally omniscient narration granting the spectator access to the romantic agents' coincidental encounters, mistimed nonconvergences, and divinely ordered network of relationships. This omniscience, however, is qualified by retardatory devices that defer and equivocate about the impending narrative resolution. As generically similar films emerged elsewhere in Asia (*Turn Left, Turn Right*, Hong Kong, 2003; *2046*, Hong Kong, 2004; *Cape No. 7*, Taiwan, 2008) and in the West (*Sliding Doors*, UK, 1998), a transnational film cycle coalesced.[2] This context made *Il Mare* a desirable

property for Hollywood studios capitalizing on a burgeoning puzzle film trend. Aligned with a Hollywood vogue for complex storytelling, *The Lake House* appropriates what is a fairly elaborate plot and *intensifies* its structural complexity, accentuating the puzzle dimension of its South Korean source.

Other pertinent intertexts reside closer to home. Sci-fi drama *Frequency* (2000) presents its protagonists communicating across two separate time levels, anticipating the temporal dislocations of *The Lake House*. The romance plot of *Wicker Park* (2004) zigzags between distinct time zones and echoes *The Lake House*'s penchant for refracted imagery. Alejandro Agresti's adroit casting evokes other precursors. Christopher Plummer's role recalls his stern patriarch in *Somewhere in Time* (1980), a time-travel romance in which temporal disparity thwarts the lovers' union. And the casting of Sandra Bullock and Keanu Reeves cannot but evoke their blockbuster hit *Speed* (1994). On an extratextual level, these last two precursors nourish incompatible suspense hypotheses already cued by the text. Whereas the euphoric ending of *Speed* primes us for romantic closure in *The Lake House*, the catastrophic climax of *Somewhere in Time* augurs romantic separation and dysphoric resolution. Only if the viewer possesses knowledge of these films will the extratextual amplification of hypotheses be activated. Again, though, cued extratextual knowledge enhances, rather than generates, hypotheses already aroused by the film. The main point is that extratextual meaning is one tactic by which *The Lake House* fosters contradictory hypotheses—a tactic yoked to the film's broader narrational preoccupation with ambiguation and deception.

Like many puzzle films, *The Lake House* reveals its capacity for deceptiveness at an early plot stage. Beneath the opening credits, Kate ruefully departs the eponymous house, leaving a note addressed to the next resident. Following an ellipsis, Alex moves in. This sequencing of events prompts a straightforward inference: Alex succeeds Kate as the new tenant. Some compelling narrational cues trigger this assumption of linear time, as when a time-lapse shot depicts a different season when Alex moves into the house (Figures 15.1 and 15.2). Most irresistible is the sequential ordering of events, which presents Alex arriving at the house *after* Kate has vacated it. The narration thus encourages an inference of linear progression, but this inference will soon be sharply invalidated. Kate's note, dated 2006, begets a revelation: Alex moves into the house not in the wake of Kate's departure (as implied) but two years earlier, in 2004. Now the viewer becomes aware of narrational misdirection. Initially, then, the narration sets up a false and misleading chronology, inverting causal events and exploiting the viewer's default assumptions of linear storytelling.

Misdirection here rests on fairly automatic, bottom-up inferences of cause and effect. In addition, the narration's range of knowledge is cunningly restricted. Establishing a strategy sustained throughout the film, this opening sequence disdains overt temporal markers, causing the viewer

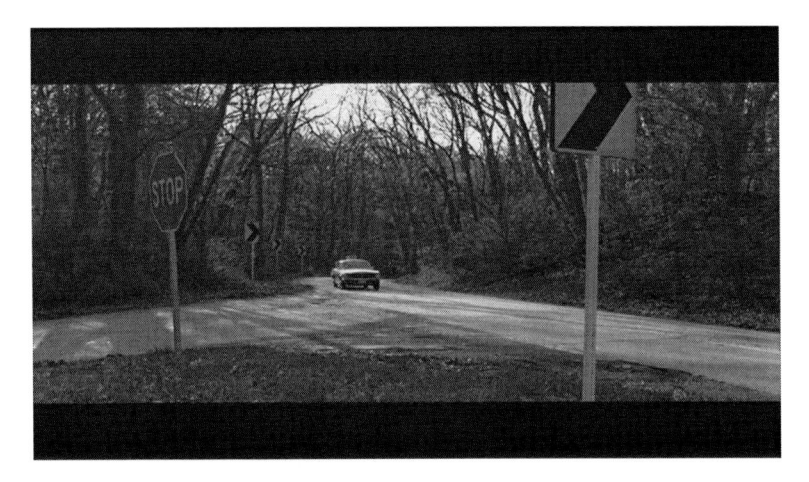

Figure 15.1 Forking paths: the credits sequence of *The Lake House* presents an emblem of plot structure . . .

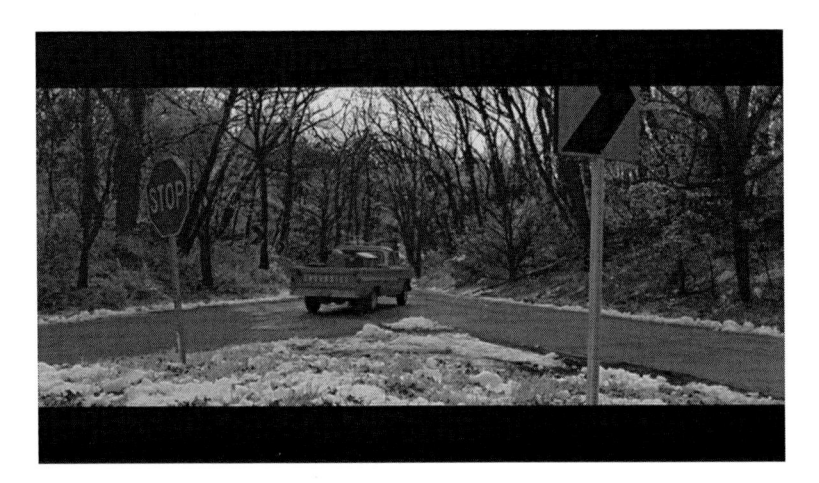

Figure 15.2 . . . and implies the fabula's linear progression

to err in her inferences about fabula time. Since *The Lake House* will repeat this deceptive gambit, its establishing narration is, in fact, quite communicative about the film's subsequent unreliability. Typifying the puzzle film's rhetoric of 'fair play,' this opening sequence self-consciously alerts the viewer to a potentially untrustworthy narration.

Some puzzle plots suppress a major twist, but *The Lake House* augurs its anagnorisis early on and then sets this predictable outcome against a rival possibility. Consequently, our construction of the story negotiates two competing, long-range hypotheses. At its most demanding, the narration forces us to oscillate between these simultaneous hypotheses, continually ranking each one probabilistically; consequently our predictions are thrown into rapid flux. At a broader level, the narration equivocates about

genre tropes. Chiefly, the time-disjuncture premise threatens the romance convention that the protagonists will meet in actual time and space. Part of the viewer's activity, then, involves constructing suspense hypotheses as to the probability of romantic union (i.e., will the protagonists surmount temporal impossibility and be romantically united—or not?). This dramatic crux governs the twin hypotheses the film cues us to formulate.

Soon after the protagonists begin corresponding, Kate (in 2006) witnesses a horrific traffic accident and tries without success to save the life of an injured pedestrian (Figure 15.3). Because the visual narration provides only glimpses of the male victim, thus restricting our perception in a possibly strategic way, we frame a crude hypothesis that somehow Alex is the casualty. (We have few other candidates at this early plot stage.) Our skepticism toward the narration is not unjustified—the film's earlier restrictedness primes us for the possibility that its narration might again harbor secrets. Early in the film, then, we hypothesize a tragic plot outcome: Alex dies in an accident, hence the generically anticipated romantic closure will be thwarted. Subsequent events promote this supposition. A scheduled rendezvous between the protagonists in 2006—that is, the year (hypothetically) of Alex's death—founders when Alex fails to show up. "Something must have happened," insists Alex when he learns, in 2004, of his own nonattendance. Moreover, the film's intertexts lend this hypothesis oblique substance. Allusions to *Somewhere in Time*, we noted above, cue the 'informed' viewer to expect a tragic denouement (or at least a bittersweet ending, depending on how one interprets the coda of *Somewhere in Time*). In sum, these tacit and implied cues provoke a suspense hypothesis that is both compelling and corrigible.

An alternative possibility, however, soon crystallizes. In 2004, Kate misplaces a paperback copy of Jane Austen's *Persuasion,* an item of sentimental

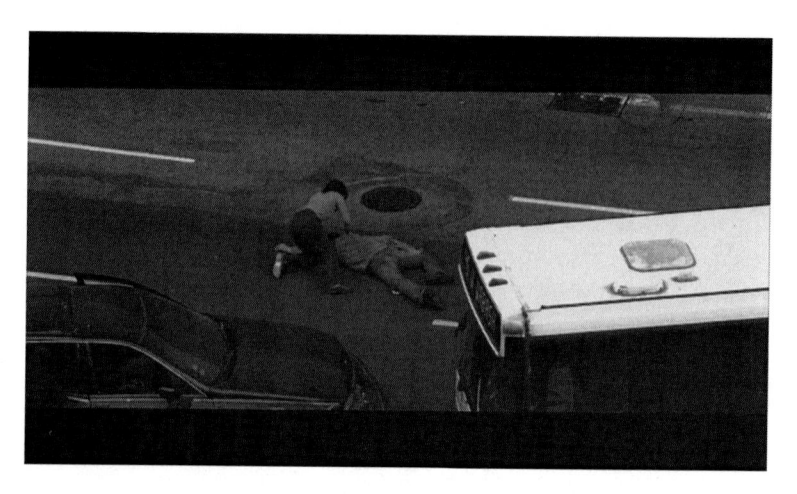

Figure 15.3 Kate (Sandra Bullock) attends a stricken pedestrian in *The Lake House*

worth to her. Alex retrieves the book, and we reasonably predict that he will return it to Kate via the mailbox as the Kate of 2006 requests. (Such feats are possible within this diegesis: another book—Wyler's memoirs— has already passed through the portal.) And yet Alex forsakes this action, instead pledging to return Kate's treasured text at an unspecified date. Why doesn't the plot simply permit Alex to use the mailbox method? It is here that our second hypothesis coalesces. Perhaps Alex will eventually deliver Kate's book in person, most likely at the film's climax (as per romance genre convention). This hypothesis contradicts our earlier one, positing romantic union and an uplifting ending as potential outcomes.

If this new hypothesis seems promising, it is demoted when Kate recovers her book sooner than predicted and in a way we had not hypothesized. Crucially, the novel is not personally conveyed by Alex. As a result, our second hypothesis loses luster. Because we have ascribed an inaccurate function to Kate's paperback, our prediction of climactic union appears wrongheaded. Now our first hypothesis reclaims primacy, as the narration cues a strong prospect of Alex's death and a low probability of romantic closure. Dysphoric closure now seems inevitable, but the narration's last curveball is yet to come.

As *The Lake House* builds toward its climax, it ratchets suspense by fluctuating between its twin prospective outcomes. After their abortive rendezvous in 2006, Alex and Kate cease correspondence. Two years later, Kate visits an architectural firm coincidentally managed by Alex's brother, Henry. The narration intercuts between Kate entering the offices and Alex with Henry apparently outside the company premises. Henry bids goodbye to Alex and greets Kate inside the building. Through this simple passage of action, the narration disqualifies a hypothesis it has maintained since the syuzhet's opening phase. If Alex exists in 2008, he could not have been killed in 2006. Thus the narration compels us to reinterpret foregoing events (Alex was not the figure maimed in the road accident; the romantic rendezvous was foiled by some other event) and readjust expectations about the narrative future (a romantic union between Alex and Kate is now not only possible but probable).

With scant time to reconstruct our hypotheses, the syuzhet furnishes yet another deus ex machina. At the office, Kate is startled to discover that Henry is Alex's brother. The viewer enjoys a brief period of omniscience here; apparently possessing mastery of the narrative, we simply anticipate Kate's reaction to what we already know. Shrewdly, though, this semblance of all-knowingness serves to put us off guard, setting in relief an imminent demonstration of the narration's restrictedness. At last the narration *truly* resolves its dual hypotheses: Henry reports that Alex was killed in an accident in 2006, thus confirming the viewer's initial suspense hypothesis.

How is this revelation possible? Retroactively, we realize this sequence has tacitly juxtaposed two time periods, crosscutting between Kate in 2008

and Alex in 2006. Suppressing overt temporal cues, the narration furnishes compelling data encouraging us to construe these parallel lines as contiguous. For example, Henry effectively 'crosses' both action lines in a way that implies continuity. A nondiegetic tune ostensibly binds both plotlines into a temporal unity. Not least, crosscutting itself harbors an irresistible suggestion of temporal coincidence. However, these highly persuasive signifiers of linearity prove to be so many narrative feints. Disarraying our mental construction of the fabula, the scene's narration causes our hypotheses to fluctuate. Within a brief narrational passage, we surmise that in 2008 (1) Alex is dead, then (2) Alex is alive, and finally (3) Alex is dead. Because hypothesis (1) seems invalidated at the start of the scene, its sudden rehabilitation elicits the viewer's genuine surprise, even though we had conjectured this outcome as early as the film's expository phase. Moreover, the scene's false bottoms lend the revelation of Alex's death a far greater emotional charge than had this information been presented straightforwardly. Equivocating about long-range hypotheses, this sequence achieves the kind of virtuosic coup de théâtre characteristic of the modern puzzle film.

We cannot say the film didn't warn us. This scene's duplicity springs from the same narrational stratagems established at the start of the film. Triggering default assumptions of linearity, the narration dupes us into inferential errors about fabula time. By presaging this gambit at the outset, *The Lake House* flaunts a self-conscious, misleading but fundamentally 'fair' narration.[3] It exploits both our innate cognitive propensities (e.g., grasping successive actions as linear) and our acquired knowledge of film grammar (e.g., identifying crosscutting with temporal continuity) to achieve its deceptive effects. In this respect, *The Lake House* epitomizes the puzzle film genre. Puzzle films trust that viewers will respond to particular stimuli in fairly routine ways, and these predictable responses are 'turned against' the viewer to generate more or less substantial revelations in the plot. *The Lake House,* like many puzzle films, misleads the viewer by exploiting automatic, nonconscious, and hence dependable responses. These films trigger and misdirect very basic cognitive habits intrinsic to both film viewing and everyday real-world experience.

Finally, the device of Kate's fugitive paperback—a conceit reworked from *Il Mare*—is strategically important to the development of our twin hypotheses. In essence, this device nourishes *both* hypotheses at judicious plot stages. Initially hinting at romantic union and exultant closure, it subsequently casts a miasmic pall upon the plot's third act. This mounting sense of foreboding, in turn, counterpoints the climax's initial hint at upbeat closure. As a motif recurring throughout the plot, Kate's paperback is a MacGuffin, sustaining incompatible hypotheses and molding the viewer's long-range expectations.

It also functions extratextually, alluding to a literary tradition of romance melodramas. Jane Austen's novel bears some comparison with

The Lake House but more pertinent, I'd argue, is another heritage novel: E. M. Forster's *Howards End* (similarly a romance fiction named for a house). Echoing Forster's famed exhortation to 'only connect,' Alex tells Henry of his yearning for 'connection' rather than 'containment,' the latter aspect personified by the brothers' remote father, Wyler.[4] Alex's pursuit of interpersonal attachment extends both to romantic and familial bonds, a desire to overcome both physical separation (from Kate) and emotional distance (from Wyler). The film thus motivates its narrative complexity by character psychology, reifying Alex's effort to 'connect' by an impossible-time premise that makes romantic connection a logistical impossibility.

The Forsterian topos of 'connection' and its antithesis 'containment' find expression in the film's mise-en-scène. Director Agresti conceives visual correlatives for the protagonists' inability to connect, employing naturalistic framing devices such as windows, mirrors, and doorways to segregate characters. Alex's dialogue motivates this visual motif: "Here you're in a box," he tells Henry at the lake house. "A glass box with a view to everything that's around you, but you can't touch it. No interconnection between you and what you're looking at." Throughout the film, Agresti shows the protagonists encased in figurative boxes of their own (Figures 15.4 and 15.5). He places Kate—whose surname, significantly, is Forster—behind transparent surfaces, so as to imply emotional separation. Likewise, he turns mirrors into apertures, isolating the protagonist from her surroundings (Figure 15.6). At one stage, Kate confides to a friend, "[This is the] story of my life: [I] keep everything at a distance." Like Alex, Kate rues all obstacles to intimacy. Thematically motivated, Alejandro Agresti's pictorial tactics evoke the tropes of containment and connection so intrinsic to the narration's complexity.[5]

287

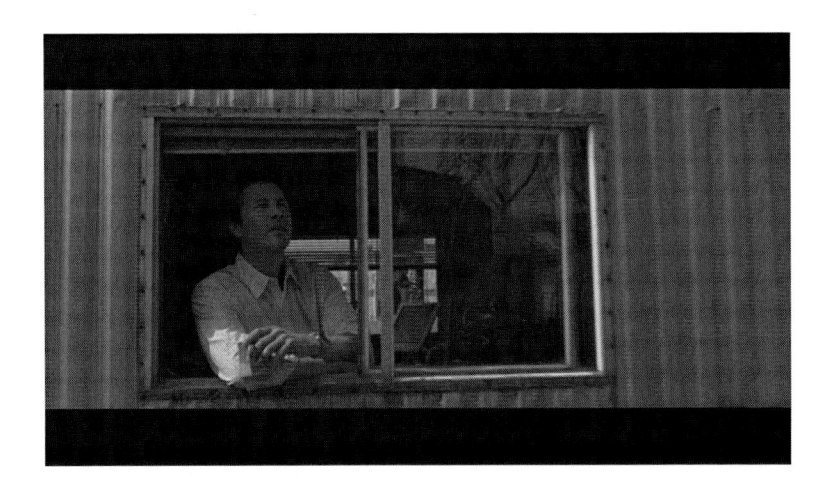

Figure 15.4 *The Lake House*: Agresti's mise-en-scène constructs figurative boxes around Alex (Keanu Reeves) . . .

Figure 15.5 ... and Kate

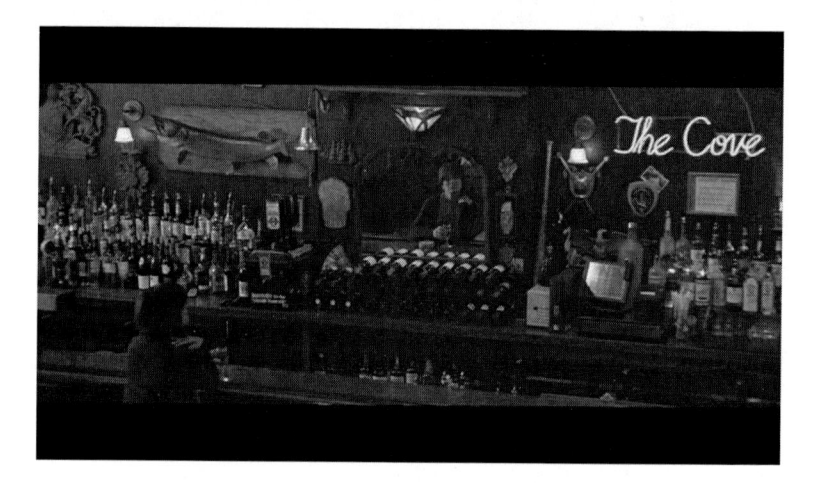

Figure 15.6 Aperture framing in *The Lake House*

Moreover, these visual motifs link *The Lake House* further to the puzzle film tradition. Mirrors are a major visual trope for films exploring themes of identity and individual self-discovery. More generally, puzzle films abound with motifs (like windows and mirrors) implying the flawed, partial, or ambiguous perception of the main protagonist. Sometimes the film's title evokes this aspect, as in *Premonition, The Sixth Sense* (1999), *Secret Window* (2004), *Hide and Seek* (2005), and *Dream House* (2011).[6] This theme of unorthodox perception, along with its visual embodiment, is central to *Premonition*.

premonition

If *The Lake House* exploits mise-en-scène to connote disconnection, *Premonition* invokes the same puzzle film motifs to suggest imperfect vision and knowledge. As in many puzzle films, *Premonition*'s characters fail to see

things. Equally they see things that might not be there. In puzzle films, seeing is not commensurate with knowing, and much of what Linda sees in *Premonition* confounds her comprehension. *Premonition* implicates the *viewer* in this perceptual and cognitive dissonance too, utilizing focal distortion as well as glass surfaces within the mise-en-scène to ambiguate story action. Some puzzle films anchor motifs of false perception to a protagonist whose knowledge is impaired. In such cases the viewer discovers this character's flawed knowledge only in retrospect. In *Premonition,* however, the heroine's mastery of events is placed in doubt almost from the outset. From this perspective, *Premonition* echoes other puzzle films in which the heroine must legitimate an inexplicable experience.

Premonition may be assimilated to a particular subset of Hollywood puzzle plot. At the broadest level, such plots throw the protagonist's mental stability—indeed, her or his very identity—into doubt, these essential traits construed as suspect by the dramatis personae, the viewer, and sometimes even the protagonist in question. The climactic phase of action disambiguates both the protagonist's mental stability and, more or less simultaneously, the central plot imbroglio, since these two phenomena are (it transpires) inextricably linked. From this broad format springs still more puzzle film subtypes. In the *anagnorisis plot,*[7] the pretext of a mystery suppresses and delays a major revelation involving the protagonist's sanity, identity, or ontological essence. Invariably in the anagnorisis plot, the protagonist's abnormal psychology is triggered by traumatic personal loss. By means of perspectival alignment with this self-deceiving agent, the narration motivates its characteristic devices of tacit suppressiveness and surprise gaps. In addition, these films teem with motifs of mirrors, windows, water, and other reflective surfaces, their mise-en-scène instantiating the protagonist's (and the spectator's) imperfect perception of events. Recent Hollywood examples of this puzzle schema are *Dream House* (2011), *Black Swan* (2010), *Shutter Island* (2010), *The Number 23* (2007), *Hide and Seek* (2005), *Secret Window* (2004), *The Others* (2001), *The Sixth Sense* (1999), *Fight Club* (1999), *Jacob's Ladder* (1990), and *Angel Heart* (1987).[8]

A major alternative is the *female fantasist plot,* which centers on a heroine about whose inexplicable experience the narration equivocates. Sympathy for the heroine's ordeal is qualified by a focalizing structure that elicits (at least some) skepticism about her state of mind. *Flightplan* (2005), *What Lies Beneath* (2000), *Black Swan,* and *The Others* exemplify this trend.[9] A variant of this format has been identified by Thomas Elsaesser (2009, 25) as the "paranoia mind-game film," in which "women—mothers—grieve for a child, or are haunted by the loss of children" and must prove the existence of the missing child to doubtful, dismissive, or obstructive figures in authority. Such films typically flaunt overt suppressiveness and curiosity gaps, stemming largely from narrational alignment with the heroine's point of view. *The Forgotten* (2004) and *Flightplan* are contemporary cases, but

cognate examples exist further back in film history. In Britain, *The Lady Vanishes* (1938) and *So Long at the Fair* (1950) dramatize a broadly similar scenario in which social guardians dismiss the heroine's testimony as make-believe. More complexly plotted is Otto Preminger's *Bunny Lake is Missing* (1965). Here again the heroine strives to overcome skeptics, but in this case the narration also solicits the *viewer's* skepticism by suspending proof that the eponymous child exists. Preminger's film also prefigures *Premonition, What Lies Beneath,* and several other supernatural thrillers (e.g., *Rosemary's Baby* [1968]) by pitting the heroine against a psychiatric establishment prepared to rationalize her trial as female hysteria, delusion, and madness. Still, *Bunny Lake is Missing* and its more recent progeny (e.g., Clint Eastwood's *Changeling* [2008]) generally avoid the perspectival restrictedness and ontological obscurity that characterize their contemporary Hollywood counterparts.

Like its predecessors, *Premonition* fastens its narration to the protagonist's range of knowledge. Restricting our knowledge to what Linda knows facilitates the narration's complexity, since the lack of 'external,' elucidating data preserves the plot's central conundrum. Alignment with Linda constrains our ability to frame hypotheses, but it also *shapes* the hypotheses that we frame, as I shall demonstrate shortly.

What constitutes narrational complexity in *Premonition*? As in *The Lake House, Premonition* radically disarrays narrative time. Both films misdirect the viewer by means of restricted narration and flaunted gaps, refusing to overtly distinguish time periods. Moreover, both films conjure narrative surprise by tapping the viewer's default assumptions of chronological linearity. When, in *Premonition,* the syuzhet presents Linda waking up to a new day having previously learned of Jim's death, the viewer naturally infers that fabula time has marched forward. But when Linda finds Jim in the kitchen eating breakfast, we must surmise that chronological fabula time has been deformed. The syuzhet has jumped backward to an earlier phase in the fabula, but the narration initially conceals this maneuver. Thanks to the narration's refusal to specify time, the viewer mistakes syuzhet advancement for fabula advancement. By fostering an inference of fabula progression, the narration elicits both temporal disorientation and narrative surprise.[10] As this example suggests, *Premonition* launches a strategy of unpredictability that augments the plot's puzzle aspect; part of the viewer's activity involves adjusting to unexpected shifts in fabula time, contextualizing anew the temporal relations of each successive scene. Thus our ability to frame suspense hypotheses is constrained by an unpredictable plot that scrambles linear causality. Some puzzle films postpone unpredictability until the major plot twist, but *Premonition* and *The Lake House* promote this device to a large-scale principle of organization.

For all their affinities, *Premonition* and *The Lake House* pursue differing strategies of complexity. In *Premonition,* for instance, we find not only restrictedness (as in *The Lake House*) but alignment with a possibly unreliable

protagonist. Both films, true to puzzle film tradition, arouse ontological doubts about the nature of the diegetic world, its laws and logic partly consistent yet partly at odds with our own world.[11] But *Premonition* goes further than *The Lake House*, placing in doubt the reality status of events, the psychological stability of the characters, and the veracity of things that purport to be true yet which contradict things that the protagonist (and the viewer) sees. Puzzle films thrive on epistemic uncertainty. When Linda's daughter asks, "How do you know [Jim] died?" she articulates the essential ambiguity at the heart of *Premonition*'s puzzle plot.

So much epistemic obscurity informs the viewer's activity. *Premonition* posits two explanatory hypotheses for Linda's situation and coaxes inferences that ricochet between them. Hypothesis 1 holds that Linda is paranoiac or psychotic. Hypothesis 2 holds that Linda is acted upon by an external, possibly malevolent, agent or agency. The film's narration summons, shapes, and steers both hypotheses, alternately promoting one or the other at strategic junctures. Cultivating the first hypothesis, *Premonition* marshals evidence of Linda's psychosis. An empty wine glass at her bedside; lithium pills scattered in a washbasin; allegations of child abuse, emotional dysfunction, and murder—all these elements accrue in the first act to discredit Linda's reliability. Moreover, the initial scenes 'resurrecting' Jim possess a distinctly hallucinatory cast, attributable to queasy POV editing and dissonant sound. Hinting at dream imagery, these stylistic cues encourage the viewer to postulate a subjective explanation for Jim's apparent revival. The narration's frequent recourse to devices funneling Linda's point of view—that is, its close perspectival alignment with her subjective experience—arguably inclines us to interpret Jim's miraculous return as Linda's delusion, hallucination, or skewed premonition.

Though *Premonition* aligns us with Linda's perspective, our experience is not identical to hers. Occasional disparities between Linda's knowledge and our own make us aware of the scrutiny to which other characters subject her—the narration furnishes omniscient cutaways to concerned facial expressions, overheard fragments of disquieted conversation, and so forth. These deviations from Linda's range of knowledge sharpen our doubts about the heroine's trustworthiness. Moreover, the misgivings of other characters cannot be wholly dismissed. Chiefly, two crimes are imputed to the heroine, implicating her in both Jim's death and an apparent assault upon her daughter. As the first act develops, then, the plot casts considerable doubt upon both Linda's innocence and her reliability as the film's focalizing agent.

Only slightly more credible is the second hypothesis, which postulates a conspiracy against the heroine. (If this hypothesis is more credible than the first, it is due to the film's title which hints that bizarre events might be explicated by the protagonist's extrasensory ability.) Peripheral characters come forward as potential suspects. These figures will ultimately be

exonerated, but this initial ruse exemplifies two strategies by which puzzle films attempt to gull the viewer. A favorite tactic is to cast a known actor against type, exploiting the viewer's extratextual knowledge so as to intensify cued hypotheses. Linda's ominous psychiatrist, Dr. Roth, is portrayed by Peter Stormare, a player identified in film with deranged or malevolent characters[12]—a context that bolsters our assumption of guilt when the plot pegs him as a suspect. Then there is the puzzle film's stratagem of intertextual allusion to misdirect the viewer's hypotheses. *Premonition* cues us to surmise that Dr. Roth is keeping his patient drugged, thus causing her to hallucinate. This premise recalls Roman Polanski's *Rosemary's Baby,* a supernatural thriller in which supposed female madness conceals a darker conspiracy. *Premonition,* I suggest, utilizes intertextual motivation to enhance and elaborate cued hypotheses. For the viewer reminded of *Rosemary's Baby, Premonition* prompts exfoliating hypotheses to take shape; for example, Is Roth working in league with Linda's aloof husband, whose alleged 'death' seems undetermined? These two strategies—intertextual casting and allusion—enable *Premonition* to gild its red herrings.

At a broader level, *Premonition* keeps its twin hypotheses in tension, permitting the viewer only an ambivalent interpretation of events. Gradually, however, the plot acquits Linda of insanity, even if it remains agnostic about the accuracy of her perception. If Linda isn't crazy, then the narrative has a genuine enigma to resolve: What has led to Jim's death and their daughter's appalling injury? Can Jim's death be averted? These central enigmas lend *Premonition* the architecture of a detective plot. If, as Tzvetan Todorov argues (1977, 50–51), the classic suspense plot navigates anterior and posterior time, *Premonition* hypostatizes this structure, literally thrusting its investigating protagonist into past and future contexts. Crucially, it is the heroine's (and the narration's) capacity to revisit past fabula action that enables our curiosity hypotheses to be resolved. Hence enigmatic and incriminating elements of the plot—such as the daughter's facial scars— are retrospectively disambiguated, exonerating Linda from wrongdoing. Invalidating false hypotheses, the plot can build momentum around Linda's principal goal: to prevent Jim from being killed.

Ominous horror iconography forecasts a grim denouement, but *Premonition*'s narration cues us to predict an upbeat closure, too. At an extratextual level, *The Lake House* (released one year before *Premonition*) may constitute an important reference point for *Premonition*'s contemporary audience. As another puzzle film headlined by Sandra Bullock, *The Lake House* is apt to fuel the 'knowledgeable' viewer's hypothesis of euphoric closure. At the climax of both films, the Bullock heroine must undo a narrative future sentencing her lover to death. In *The Lake House,* she succeeds in relegating Alex's demise to an *unrealized* counterfactual event, clearing the way for affirmative romantic closure. As before, extratextual knowledge reinforces dualistic hypotheses: the viewer familiar with *The*

Lake House might reasonably forecast an upbeat plot resolution in *Premonition,* but this hypothesis must be set against other—more ambivalent or downbeat—background films, such as *Rosemary's Baby, Don't Look Now* (1973), and *The Dead Zone* (1983).

In pressing toward narrative resolution, both *Premonition* and *The Lake House* confirm a palpable and overarching suggestion of inevitability. Though these puzzle plots advance unpredictably, they paradoxically frame events as ineluctable and predestined. In part, their overtones of fate stem from the puzzle format. Conferring a teleology upon the story events, puzzle plots usher the action toward a climax in which every piece of the story slots neatly into place. In addition, both films nurse a hypothesis that the narrative populace is meaningfully interconnected. Characters and plotlines converge in tantalizing ways. The romantic protagonists seldom meet, but their respective worlds intersect frequently. Thus the encounter between Kate and Alex's brother at the climax of *The Lake House* is not capricious—rather, it hints at the organizing design of an unknowable agency. *The Lake House* concludes with a potent conviction of destiny, germane to both romance and puzzle film traditions.

Premonition is similarly teleological, but it favors a more paradoxical and tail-chasing climax than does *The Lake House.* Its inevitability emerges from Linda's ability to foretell Jim's death, an inexorable event delivered at the climax. In contrast to *The Lake House,* fate is not to be averted; the heroine of *Premonition* cannot cheat destiny, despite being able to foresee it. A bleak determinism is revealed at the denouement. Linda precognizes her husband's death and only acts to prevent it *because* she foresees it, but in acting to prevent Jim's death, she inadvertently causes it to happen. The narration's jumbled time scheme conceals a fabula whose circularity is revealed only at the climax. Like other puzzle films, *Premonition*'s closure sends us back to the start in search of an originating cause.

The semblance of narrative closure in both *Premonition* and *The Lake House* belies the presence of what Meir Sternberg (1978, 50–51) calls "permanent gaps" within the work—that is, features of the story that remain unresolved even at the fiction's end. In particular, both films refuse to elucidate the ontological enigmas posed at the preliminary exposition stage. What governs the temporal illogic of the diegetic world? A providential or metaphysical causation? Brute chance? A psychological quirk peculiar to the prophetic heroine? A purely cosmic renovation of the story universe? Both films admit multiple interpretations. This is where, for example, *Premonition* departs from the standard detective tale, in which, traditionally, "no gap is left open" (Sternberg 1978, 182). Puzzle films often construct polysemous explanatory systems, riddling the text with permanently ambiguated gaps. These provocative gaps compel the repeat viewings identified with such films, prompting the viewer to revisit, and sometimes reinterpret, the film in a quest for comprehensive resolution.

conclusion

Extratextually, *Premonition* and *The Lake House* are united by a Hollywood star (Bullock) who seeks to diversify a career dominated by romantic comedies and action movies (see Krämer 2004). But beyond this, these two films share similar compositional principles. Temporal deformations generate ontological doubt; gap-producing focalization induces epistemic uncertainty; extratextual allusion amplifies suspense hypotheses; and narrational sleights-of-hand trigger manipulable viewer responses. Out of such strategies spring complex plots the objective of which is to evoke false inferences, mystify future developments, and engender a prolonged clash of hypotheses—all without violating the puzzle film's ethic of 'fair play.' This fair play principle, moreover, is essentially illusory, as Eyal Segal notes of the classic detective novel: "[It essentially functions as] an elaborate system of disguises and misdirections employed to minimize the reader's chances of making proper use of the 'clues' transmitted" (Segal 2010, 180). Both the illusion of fair play and the arousal of antithetical hypotheses are a key source of the puzzle film's aesthetic pleasure. By equivocating about plot resolution, the films' incompatible hypotheses prolong the viewer's gap-filling activity, thereby averting the disappointment of a too-predictable climax. In *Premonition* and *The Lake House,* as in puzzle films generally, conflicting hypotheses, piecemeal exposition, and other retardatory devices do not merely postpone narrative closure—they also engage the viewer in pleasurable cognitive effort.

In both *Premonition* and *The Lake House,* complex plotting conceals an essential conservatism. Central to both films is an affirmation of heterosexual romance and the nuclear family. Though *Premonition* climaxes tragically, it supplies romantic closure in the form of flashbacks that promote the value of marriage, family, and personal faith. At the symbolic center of both films is the domestic house, the monolithic nexus of family life. *Premonition* opens with Linda and Jim moving into their dream home; Alex renovates the titular lake house to make it fit for domestic intimacy. In *Premonition,* a child's jigsaw, glimpsed in various stages of construction, gradually reveals its true image: a smiling, happy family. (The jigsaw motif itself is another instance of puzzle film reflexivity.) If, teleologically, these films lead anywhere, it is to this affirmation of family and home. Narrative closure does not bring the characters into knowledge about their mysterious experience. No explanation is forthcoming for the time disparity in *The Lake House,* nor for the magical powers of the mailbox. We cannot unequivocally say that Linda's time-warp trajectory in *Premonition* derives from an innate sixth sense. Ultimately, the demystification of the characters' experience is less important than what that experience has taught them. And what the protagonists discover—what they 'see' clearly once the puzzle is complete—is the shining value of heterosexual union and the nuclear

family, ensconced in an inviting, hospitable house. It is this embodiment of family ideology that defines *Premonition* and *The Lake House* as quintessentially *American* puzzle films.

notes

1. The film's opening scene pictorially evokes the story world's bifurcation, adopting the topos of a forked road (see Figures 15.1 and 15.2). As Hilary P. Dannenberg notes, such metaphors connote "as yet unactualized future alternatives . . . express[ing] the idea that decisions are junctions in the road" (2008, 71).
2. The trend continues with films such as *Postman to Heaven* (South Korea/Japan, 2009), a romance drama that—like *The Lake House*—employs an archaic mailbox as a central motif, a restricted narration exploiting ontological knowledge, and a deferred, gap-filling montage sequence.
3. Confusing temporal order from the outset, *The Lake House* warns us to be alert for unemphatic temporal cues. In the scene under discussion, small inconsistencies in Henry's dress and appearance differentiate the cross-cut lines of action. That the sequence incorporates such inconsistencies shows that the narration plays fair. But I surmise that most viewers will not detect these details on first viewing, preoccupied as they must be with constructing the unfolding action, weighting antithetical hypotheses, and focusing attention on the main protagonists. Indeed, even if the viewer does spot this discrepancy, he or she still cannot ascertain the amount of time separating the two action lines.
4. Here again the casting of Plummer is apt. The actor's best-known film role is that of Captain von Trapp, the benevolent but emotionally withdrawn father in *The Sound of Music* (1965). Subsequent roles have played upon this aspect of Plummer's persona, the figure of the strict authoritarian a recurring reference point in the actor's career. See, for contrasting examples, Mike Nichols's *Wolf* (1994) and Mike Mills's *Beginners* (2010). Plummer also provides a hinge to the puzzle film genre by way of his roles in *12 Monkeys* (1995) and *A Beautiful Mind* (2001).
5. Precedents for Agresti's glass motif can be found in the film's most proximate intertexts, including *Il Mare*. E. M. Forster posits glass as a metaphor for separation in *Howards End* (1992, 238, 254). Other topoi link the three texts, not least the motif of a magnificent tree on the property's grounds (in the puzzle film, an emblem both of time and of the plot's proliferating formal structure) and the anthropomorphization of the fictions' sacred house.
6. For further discussion, see my 2008 "Effects of the Dominant in *Secret Window*," *New Review of Film and Television Studies* 6(2): 151–167.
7. I define the term *anagnorisis* broadly in the manner of Aristotle, as a moment of recognition and self-realization on the part of the protagonist; this dramatic event engenders a change in the hero's fortunes (see Aristotle 1996, 18).
8. Examples of the anagnorisis puzzle plot continue to emerge within world cinema, too, with Pawel Pawlikowski's *The Woman in the Fifth* (France/Poland/UK, 2011) a recent example. This film focalizes action around Ethan Hawke's displaced professor, whose delusional perception the narration

gary bettinson

hints at through prototypical puzzle film motifs (eyeglasses, mirrors, windows, and obfuscated POV shots).

9. Brian Yuzna's *Society* (1989) presents a male-centered reworking of this plot. Here an insidious community dismisses the troubling insights of an isolated teenager (Billy Warlock). Narrational alignment with the protagonist creates ambiguity around stock figures such as the hero's shady psychiatrist.

10. *Premonition* superficially recalls *Groundhog Day* (1993) insofar as the respective protagonists awake each day uncertain of their temporal context. Whereas for Phil (Bill Murray) each day turns out to be predictably the same, for Linda each day is impossible to foretell. A closer comparison is another Hollywood puzzle film, *Vanilla Sky* (2001), in which Tom Cruise's protagonist experiences time as chillingly unpredictable and incoherent.

11. Ontological doubt is a hallmark of contemporary and classic puzzle films. The plots of *Bunny Lake is Missing, Flightplan*, and *The Forgotten* pivot on epistemological and ontological questions: Is there really a missing child? Is the world and its structures truly as the heroine believes?

12. Stormare is probably still best known as the taciturn sociopath in *Fargo* (1996). Other prominent examples include the puzzle film *Minority Report* (2002). For other cases where the puzzle film exploits casting for misdirection, consider Jim Carrey in *The Number 23* (2007), Johnny Depp in *Secret Window* (2004), and Nicole Kidman in *The Others* (2001).

references

Aristotle. 1996. *Poetics.* London: Penguin.

Bettinson, Gary. 2008. "Effects of the Dominant in *Secret Window.*" *New Review of Film and Television Studies* 6(2): 151–167.

Dannenberg, Hilary P. 2008. *Coincidence and Counterfactuality: Plotting Time and Space in Narrative Fiction.* Lincoln and London: University of Nebraska Press.

Elsaesser, Thomas. 2009. "The Mind-Game Film." In *Puzzle Films: Complex Storytelling in Contemporary Cinema,* ed. Warren Buckland, 13–41. Oxford: Wiley-Blackwell.

Forster, E. M. 1992. *Howards End.* London: Penguin.

Krämer, Peter. 2004. "The Rise and Fall of Sandra Bullock: Notes on Starmaking and Female Stardom in Contemporary Hollywood." In *Film Stars: Hollywood and Beyond,* ed. Andy Willis, 89–112. Manchester: Manchester University Press.

Segal, Eyal. 2010. "Closure in Detective Fiction." *Poetics Today* 31(2): 154–215.

Sternberg, Meir. 1978. *Expositional Modes and Temporal Ordering in Fiction.* Indianapolis: Indiana University Press.

Todorov, Tzvetan. 1977. *The Poetics of Prose,* trans. Richard Howard. Oxford: Basil Blackwell.

Wilson, George. 2006. "Transparency and Twist in Narrative Fiction Film." In *Thinking through Cinema: Film as Philosophy,* ed. Murray Smith and Thomas E. Wartenberg, 81–96. Oxford: Blackwell.

contributors

Gary Bettinson lectures in film studies at Lancaster University. He has published on various aspects of complex storytelling in the *New Review of Film and Television Studies*, *Film Studies: An International Review*, *Asian Cinema* and in several edited collections, including *Puzzle Films: Complex Storytelling in Contemporary Cinema* (edited by Warren Buckland; Blackwell, 2009) and *David Lynch/In Theory* (edited by Francois-Xavier Gleyzon; Litteraria Pragensia, 2010).

Lucy Bolton is a lecturer in film studies at Queen Mary, University of London, and the author of *Film and Female Consciousness: Irigaray, Cinema and Thinking Women* (Palgrave Macmillan, 2011). She is currently researching the relationship between cinema and the philosophy of Iris Murdoch.

Edward Branigan is professor emeritus of film and media studies at the University of California, Santa Barbara. He is the coeditor with Warren Buckland of *The Routledge Encyclopedia of Film Theory* (2014) and the author of *Projecting a Camera: Language-Games in Film Theory* (1992), *Narrative Comprehension and Film*, and *Point of View in the Cinema: A Theory of Narration and Subjectivity*

in Classical Film (1984). With Charles Wolfe, he is the general editor of the American Film Institute Film Readers series.

William Brown is a senior lecturer in film at the University of Roehampton, London. He is the author of various articles and book chapters, as well as of *Supercinema: Film-Philosophy for the Digital Age* (Berghahn, 2013). He is also the coauthor, with Dina Iordanova and Leshu Torchin, of *Moving People, Moving Images: Cinema and Trafficking in the New Europe* (St Andrews Film Studies, 2010) and the coeditor, with David Martin-Jones, of *Deleuze and Film* (Edinburgh University Press, 2012). He is also a filmmaker, having directed a number of low- to zero-budget features, including *En Attendant Godard* (2009), *Afterimages* (2010), *Common Ground* (2012), and *China: A User's Manual (Films)* (2012).

Warren Buckland is reader in film studies at Oxford Brookes University. His areas of research include film theory (*The Routledge Encyclopedia of Film Theory,* coedited with Edward Branigan, 2014; *Film Theory: Rational Reconstructions,* 2012; *Film Theory and Contemporary Hollywood Movies,* ed., 2009; *The Cognitive Semiotics of Film,* 2000); contemporary Hollywood cinema (*Directed by Steven Spielberg: Poetics of the Contemporary Hollywood Blockbuster,* 2006); and film narratology (*Puzzle Films: Complex Storytelling in Contemporary Cinema,* ed., 2009).

Allan Cameron is a senior lecturer in media, film, and television at the University of Auckland, and author of *Modular Narratives in Contemporary Cinema* (Palgrave Macmillan, 2008). His work has also appeared in *Cinema Journal, Quarterly Review of Film and Video, Jump Cut,* and *The Velvet Light Trap.*

Paul Cobley, professor in language and media at Middlesex University, is the author of a number of books, including *The American Thriller* (Palgrave Macmillan, 2000) and *Narrative* (Routledge, 2001; 2nd ed., 2013). He is the editor of *The Communication Theory Reader* (Routledge, 1996), *Communication Theories,* 4 vols. (Routledge, 2006), *The Routledge Companion to Semiotics* (Routledge, 2009), *Realism for the 21st Century: A John Deely Reader* (University of Chicago Press, 2009), *"Semiotics Continues to Astonish": Thomas A. Sebeok and the Doctrine of Signs* (Mouton de Gruyter, 2011), among other books. He also coedits two journals, *Subject Matters* and *Social Semiotics,* and is associate editor of *Cybernetics and Human Knowing.* He is the series editor of Routledge Introductions to Media and Communications, coseries editor (with Kalevi Kull) of Semiotics, Communication, and Cognition (de Gruyter Mouton), and coeditor (with Peter J. Schulz) of the multivolume *Handbook of Communication Sciences* (de Gruyter). He was elected vice president of the International Association for Semiotic Studies in 2009 and is secretary of the International Society for Biosemiotic Studies.

Thomas Elsaesser is professor emeritus of film and television studies at the University of Amsterdam and since 2006 visiting professor at Yale University. His recent books include *Weimar Cinema and After* (Routledge, 2000), *Metropolis* (BFI, 2000), *Studying Contemporary American Film* (Hodder, 2002, with Warren Buckland), *European Cinema: Face to Face with Hollywood* (Amsterdam University Press, 2005), *Film Theory: An Introduction Through the Senses* (Routledge, 2010, with Malte Hagener), and *The Persistence of Hollywood* (Routledge, 2012).

Bruce Isaacs is a lecturer in film studies at the University of Sydney. He has published work on film history and theory, with a particular interest in the deployment of aesthetic systems in classical and post-classical American cinema. His most recent work is *The Orientation of Future Cinema: Technology, Aesthetics, Spectacle* (Continuum, 2013).

Geoff King is professor of film studies at Brunel University and author of books, including *Spectacular Narratives: Hollywood in the Age of the Blockbuster* (I. B. Tauris, 2000), *New Hollywood Cinema: An Introduction* (I. B. Tauris, 2002), *American Independent Cinema* (I. B. Tauris, 2005), *Indiewood, USA: Where Hollywood Meets Independent Cinema* (I. B. Tauris, 2009), and *Indie 2.0: Change and Continuity in Contemporary American Indie Film* (I. B. Tauris, 2013). A longer version of the analysis in this chapter is part of a forthcoming book, *Quality Hollywood: Markers of Distinction in Contemporary Studio Film*.

Richard Misek is a media practitioner and lecturer in digital arts at the University of Kent. Encompassing both filmmaking and scholarship, his work engages with experimental film and video, emerging media, digital spacetime, graphic design, architecture, and urban space. He is the author of *Chromatic Cinema* (Wiley-Blackwell, 2010).

Elliot Panek teaches at Drexel University. His research examines new media, persuasion, and narrative reception from sociological and psychological perspectives, using interviews, surveys, and experiments to understand more about how entertainment and social media affect our individual and collective lives. He has published articles on complex narratives and self-control as it relates to media choice.

Maria Poulaki is Lecturer in Film and Digital Media Arts at the University of Surrey. Previously she taught at the University of Amsterdam, Amsterdam University College, and University of Applied Sciences Utrecht. Her PhD research focused on the links between complex systems theory, narratology, and film/media theory. She has published in journals such as the *New Review of Film and Television Studies*, *Film Philosophy*, and *Cinéma & Cie* on this topic.

Paolo Russo is senior lecturer in film studies at Oxford Brookes University. He is on the editorial boards of the *New Review of Film and Television Studies* (Routledge), *Journal of Italian Cinema and Media Studies* (Intellect), and Bulzoni's *CinemaEspanso* series. Among his publications are the following: "Body vs. Technology. Myths and Identity in *Nirvana*" (2010); "The De Santis Case: Screenwriting, Political Boycott and Archival Research" (*Journal of Screenwriting*, 2013); "Migration Told Through Noir Conventions in Tornatore's *The Unknown Woman* and Garrone's *Gomorrah*" (2013), and "Suso Cecchi d'Amico" (2014). He currently researches and teaches film narrative, film history, genres, and screenwriting. He is also a professional screenwriter, currently collaborating with director Matthew Huston and Minor Hour Films (www.minorhourfilms.com). His feature film, *Three Days of Anarchy* (2006), premiered at the Tokyo IFF and at over thirty international festivals.

Jan Simons is associate professor of new media at the department of media studies and head of CIRCA (Creative Industries Research Center Amsterdam), University of Amsterdam. He is the author of *Playing the Waves: Lars von Trier's Game Cinema* (2007) and numerous essays on film, game theory, narrative, semiotics, and cognitive and linguistic approaches to (new) media.

Garrett Stewart, James O. Freedman Professor of Letters at the University of Iowa, was elected in 2010 to the American Academy of Arts and Sciences. He is the author, among many books on form and narrative in different media, of *Between Film and Screen: Modernism's Photo Synthesis* (University of Chicago Press, 1999) and *Framed Time: Toward a Postfilmic Cinema* (University of Chicago Press, 2006). The explicit method of the latter study was extended, and highlighted by subtitle, in *Novel Violence: A Narratography of Victorian Fiction* (University of Chicago Press, 2009), which was the winner of the 2011 Perkins Prize from the International Society for the Study of Narrative.

about the american film institute

The American Film Institute (AFI) is America's promise to preserve the history of the motion picture, to honor the artists and their work, and to educate the next generation of storytellers. AFI provides leadership in film, television, and digital media and is dedicated to initiatives that engage the past, the present, and the future of the motion picture arts. The *AFI Film Readers Series* is one of the many ways AFI supports the art of the moving image as part of our national activities.

AFI preserves the legacy of America's film heritage through the AFI Archive, comprised of rare footage from across the history of the moving image, and the *AFI Catalog of Feature Films*, an authoritative record of American films from 1893 to the present. Both resources are available to the public via AFI's website.

AFI honors the artists and their work through a variety of annual programs and special events, including the AFI Life Achievement Award, AFI Awards, and AFI's 100 Years . . . 100 Movies television specials. The AFI Life Achievement Award has remained the highest honor for a career in film since its inception in 1973; AFI Awards, the institute's almanac for the twenty-first century, honors the most outstanding motion pictures and

television programs of the year. And AFI's 100 Years . . . 100 Movies television events and movie reference lists have introduced and reintroduced classic American movies to millions of film lovers. And as the largest non-profit exhibitor in the United States, AFI offers film enthusiasts a variety of events throughout the year, including the longest running international film festival in Los Angeles and the largest documentary festival in the US, as well as year-round programming at the AFI Silver Theatre in the Washington, D.C., metro area.

AFI educates the next generation of storytellers at its world-renowned AFI Conservatory—named the number one film school in the world by *The Hollywood Reporter*—offering a two-year master of fine arts degree in six filmmaking disciplines: cinematography, directing, editing, producing, production design, and screenwriting.

Step into the spotlight and join other movie and television enthusiasts across the nation in supporting the American Film Institute's mission to preserve, to honor, and to educate by becoming a member of AFI today at AFI.com.

American Film Institute

Robert S. Birchard
Editor, *AFI Catalog of Feature Films*

Index

Index